To Betty,

For the love of art!

ART OF THE STATE

CELEBRATING THE VISUAL ART OF

NORTH CAROLINA

all the best, *Liza Roberts*

LIZA ROBERTS

PHOTOGRAPHS BY LISSA GOTWALS

FOREWORD BY LAWRENCE J. WHEELER

THE UNIVERSITY OF NORTH CAROLINA PRESS

CHAPEL HILL

MAJOR FUNDING FOR THIS PUBLICATION WAS GENEROUSLY PROVIDED BY THE FOLLOWING:

The Lewis R. Holding Fund of the North Carolina Community Foundation

The Josephus Daniels Charitable Fund
The Thomas S. Kenan III Foundation
Jim and Anna Romano

Text © 2022 Liza Roberts
All photographs by Lissa Gotwals (© 2022) unless otherwise noted.
Manufactured in Canada

The University of North Carolina Press has been a member of the Green Press Initiative since 2003.

Design by Lindsay Starr
Cover illustration: *Alo*, by Donald Martiny

Library of Congress Cataloging-in-Publication Data
Names: Roberts, Liza, author. | Gotwals, Lissa, photographer. |
 Wheeler, Lawrence J. (Lawrence Jefferson), 1943– writer of foreword.
Title: Art of the state : celebrating the visual art of North Carolina /
 Liza Roberts ; photographs by Lissa Gotwals ;
 foreword by Lawrence J. Wheeler.
Description: Chapel Hill : The University of North Carolina Press, 2022. |
 Includes index.
Identifiers: LCCN 2022022532 | ISBN 9781469661247 (cloth ; alk. paper) |
 ISBN 9781469671765 (ebook)
Subjects: LCSH: Art, American—North Carolina—21st century. | Art,
 American—North Carolina—20th century. | Artists—North Carolina—
 Biography. | BISAC: ART / American / General | HISTORY / United
 States / State & Local / South (AL, AR, FL, GA, KY, LA, MS, NC, SC,
 TN, VA, WV)
Classification: LCC N6530.N8 R63 2022 | DDC 709.756/0905—dc23/
 eng/20220526

LC record available at https://lccn.loc.gov/2022022532

Frontispiece: Detail of a work in progress by Damian Stamer, Durham.

FOR MY PARENTS

Judith and Stephen McDonald, *with love*

CONTENTS

FOREWORD

The air that North Carolinians breathe—for reasons natural and supernatural—infuses them with a love of making things, whether by their hands or the hands of their neighbors, whether for utility or beauty or both. North Carolina folks love their artists. Always have.

Liza Roberts in *Art of the State* has engaged the magic of storytelling to create the first contemporary and comprehensive look at the rich diversity—of people, places, and materials—which characterizes the art of North Carolina. She combines her experience as a journalist with her warm personal charm to open the voices of artists in every region of the state, both urban and rural, to tell their own stories. What inspires them? Why do they live where they do? How do their communities embrace them and encourage them? And, at the same time, how do artists embrace their communities and encourage them? By exploring a variety of issues that are transforming North Carolina, she listens attentively and thoughtfully weaves together stories that describe our shared belief that the arts make a difference in the ways we live—no matter where.

The mountain region of North Carolina is separated by hundreds of miles from the coastal plain. Each area, shaped by its own unique history and the special properties of the land itself, expresses its handmade culture differently. These influences shape intriguing and colorful stories which Liza artfully shows in full by empowering the artist as storyteller.

The large urban areas and the multitude of small towns which lie between have different stories and storytellers. The energy of change and indeed transformation wrought by commerce, research, and wealth in cities like Charlotte, Raleigh and the Triangle, Winston-Salem, and Greensboro is attracting artists who hope to benefit from engagement with a patron citizenry and an infrastructure of gallery and museum support. The artists in turn are feeding the creative dynamism of growth and sophistication—hallmarks of a new urbanity and a cool cosmopolitan character. *Art of the State* shows this metamorphosis with the real stories of visionary leaders who foresaw the power of the artist and supplied resources to activate and sustain their creative energy. In the hands of Liza Roberts, this book is as much about place-making as art-making as she deftly captures the energy of creative people on both sides of the equation.

Smaller traditional towns like Wilson, Kinston, and larger ones like Asheville have also seized upon the power of the artist to add excitement to community life. Adaptive reuse of abandoned agricultural and commercial buildings has made possible artist studios, galleries, restaurants celebrated for their world-class cuisine, and other visitor amenities—and pumped new life and relevance into these charming towns forced to reckon with economic change. By raising up the stories of the artists and change agents in these locales, Liza encourages us to celebrate and learn from them.

Throughout her narrative, Liza reminds us that since its founding North Carolina has been blessed with talented artists and art evangelists all breathing that same air. Whether in clay, wood, fiber, metal, or paint the artists among us have created exceptional interpretations of life around them.

FACING
Studio of Margaret Curtis, Tryon.

And their communities have celebrated them for it. Francis Speight, Hobson Pittman, Ben Owen, Harvey Littleton, Claude Howell, Maud Gatewood, Joe Cox—and many others—were household names in art-loving North Carolina through the last decades of the twentieth century. At the same time art-loving North Carolina ensured that its people would have access to great art always by creating art museums, generally with public funds combined with private patronage. The Mint Museum was founded in 1936, the North Carolina Museum of Art in 1947, and many more were started in small cities and universities across the state during the 1950s, '60s, and '70s. For Liza, the past is the foundation for her colorful discoveries in the North Carolina of today. She makes it clear that we have much to learn from the continuum of history.

Of greatest significance to the history of art in North Carolina in international terms has to be the legacy of Black Mountain College. Located a few miles east of Asheville, the college, from 1933 until 1956, taught art-making principles which would re-shape modern art. Under the tutelage of Joseph and Anni Albers, Bauhaus eminences, many of the artists who would go on to become recognized as the greatest artists of their time studied and made work there. Among them are Willem and Elaine deKooning, Robert Motherwell, Franz Kline, Robert Rauchenberg, Ruth Asawa, and Cy Twombly. Despite the era being removed from today by nearly seventy-five years, Black Mountain remains the long bridge from modern art to the contemporary art scene in North Carolina, which Liza portrays and celebrates here.

The convergence of talent, patronage, knowledge, and commitment to the art of our time has wrought a quiet revolution in North Carolina, which Liza probes as a personal witness and occasional participant. She shares her curiosity about this creative energy that is catapulting our state into a role as a major player in the complex and layered international contemporary art scene. The artist is central, to be sure, but now that includes artists from throughout the world, and world-class art collectors.

Active and passionate art collectors have become well-respected fixtures at international art fairs and referred to by many intrigued art dealers as the North Carolina Art Posse. The collectors, whom Liza profiles through their personal stories, are acquiring the great and closely watched emerging artists of the world, North Carolina artists included. They, in turn, inspire new collectors, serve on museum boards, and donate key works from their collections to the public domain. Liza reminds us that the influence of the collector/patron is not to be underestimated in bringing national recognition to the arts and artists of the state.

New galleries, proliferating artist studios, new and expanded art museums, and private-collector-curated art foundations can be found in cities large and small throughout the state.

As North Carolina has grown in population and wealth, the arts have grown as well, flourishing and adding new dimensions to community life. In *Art of the State*, Liza Roberts describes this phenomenon as a passionate observer and cheerleader of the arts. And, why, finally North Carolina? It must be the air we breathe.

LAWRENCE J. WHEELER

ART

OF

THE

STATE

INTRODUCTION

What is North Carolina art? Is it the pottery made famous by artists like Ben Owen III, whose family has been making earthen vessels in Seagrove for generations? Is it to be found in the new application of old techniques, like the wall-spanning frescos of Asheville's Christopher Holt? What about the delicate tissue paper creations of Durham's Maya Freelon, the massive sculptures of Thomas Sayre, the striking bronze figures of Stephen Hayes, or the floating plastic cubes of Christina Lorena Weisner?

All of it is North Carolina art. It's as varied as the population, and as exceptional as the evolving state that spawned it. True to its roots, breaking new ground, and ever more diverse, North Carolina art reflects the times in which we live and the people we are and are becoming. This is art that brings us together, that asks hard questions, that is beautiful, and that matters.

The state itself fuels this art, with its extraordinary and inspiring natural beauty, its affordability, and its quality of life. But the institutions and programs that have grown and expanded here to educate, showcase, employ, and connect this population of creators—and the communities and patrons they've spawned—are also responsible. This is true in Raleigh and Charlotte, but it's also true in our smaller cities and rural areas.

"There is a generosity of spirit in North Carolina that I want to say is unique," says artist Eleanor Annand. "Instead of creating an environment that feels exclusive, it feels more welcoming. I think that's contagious. It's been a huge part of my life here."

Why is Penland, where Annand lives and works, an artist magnet? Penland School of Craft and its surrounding community has made it one, a place where an artist can afford to live, work, and learn.

Why is Greensboro an artist magnet? UNC Greensboro and nearby North Carolina A&T State University are excellent schools that make art a priority. The Weatherspoon Art Museum has a national reputation. GreenHill Center for North Carolina Art is a tireless champion of our state's artists. And there's nowhere like the city's strange and wonderful museum, artists' residency, and collaborative learning lab known as Elsewhere to mix things up.

"Greensboro is this art hub that I don't know people are fully aware of," says Steven Cozart, an artist and educator who lives there. "You would think that it would be Charlotte, because Charlotte's a big city. Or Raleigh, because it has the Museum of Art . . . but in my opinion, it's Greensboro. In this one area, there is so much art, and so many art opportunities."

And why is rural Kinston, population 21,000, an artist magnet? Because it has subsidized housing for artists who engage with the community; because it has important and abundant public art; because it knows that art and economic opportunity go hand in hand.

"It's amazing what art does for a community as an economic driver," says Kinston entrepreneur and philanthropist Stephen Hill, standing on the rooftop of the O'Neil, the luxury boutique hotel he created in the hull of a long-dormant bank building in this former tobacco town. It's just one of a half dozen historic downtown buildings Hill has revitalized here, just a few blocks from the Thomas Sayre earthcast sculpture he helped bring to his hometown.

If art can spark an economy like Kinston's, the reverse is also true, says the artist Ben Knight, who lives nearby. While derelict buildings and empty sidewalks dampen creativity, a busy downtown can be an inspiration of its own, a creativity galvanizer. "Once it all comes together, it's like a room full of people," he says. "It's got life."

VISIONARIES

The programs and institutions that spark art-making are not here by accident. They're here thanks to a series of visionary decisions made by today's leaders and also by the leaders of the last century, decisions to create and fund museums, schools, and the making of art, decisions that were often impractical, frequently difficult, and always expensive.

It is thanks to these undaunted twentieth-century visionaries that the disparate resources of a largely rural state have become an outsized and excellent ecosystem for the creation, collection, and celebration of visual art, sophisticated and diverse by any measure.

"It has been intentional," says Libba Evans, former North Carolina secretary of cultural resources.

It had to be. North Carolina was a poor colony, and it became a poor state. Unlike historically wealthy Virginia to the north or South Carolina to the south, North Carolina was an agrarian, small-town state before the Civil War and after.

"A vale of humility between two mountains of conceit" is how Charlotte cultural leader Mary Oates Spratt Van Landingham described the modest Old North State vis-à-vis its neighbors in a 1900 speech. Unlike those neighbors, or like many northern states with big established cities and concentrations of wealth, there were no late nineteenth-century industrialists to collect, support, or share art in North Carolina. No robber barons to bequeath stores of treasures for public museums.

If art collecting was out of reach, art-making for its own sake was also a luxury, even as it was incorporated into the textiles woven, the pottery thrown, and the furniture made here for practical purposes. But as soon as pockets of prosperity emerged across the state, as the twentieth century dawned and railroads and industrialization turned North Carolina's timber, cotton, and tobacco resources into successful

furniture, textile, and commercial tobacco industries, a determined move to foster art began to gather force.

"A belief that the arts are important in people's lives is a core value of North Carolina," says Lawrence J. Wheeler, former director of the North Carolina Museum of Art (NCMA). Another core North Carolina value: Making it happen. After all, when the state wanted to educate its own back in 1789, it founded the nation's first public university.

North Carolina wanted more art and culture, and it would figure out how to get it, how to make it, and how to make it grow. All hands on deck.

"It goes back to 1924 when the North Carolina Arts Society was founded with the help of all kinds of people in rural counties," Wheeler says. That group, led eventually by Greenville native Robert Lee Humber, one of the state's first Rhodes Scholars and a tireless civic leader, determined that the establishment of a state museum of art was a first order of business.

"He came back from Europe, and he said: 'All of this beautiful art and culture and sophistication—we can do that in North Carolina,'" Evans says. By 1925, the Society was mounting Raleigh exhibitions, arranged by Warrenton benefactor Katherine Pendleton Arrington, of paintings loaned from New York galleries, and by 1927, the Society had acquired a bequest of paintings and funds from Concord native Robert F. Phifer.

The decision to expand on that was one of many—by elected leaders, business leaders, civic leaders, and entire communities—to purposefully bring art and culture from the wider world to this determined state. Perhaps the most pivotal moment in the state's art history came when the North Carolina legislature helped fulfill the Art Society's goal by creating the country's first state-funded art museum with an extraordinary $1 million appropriation for the purchase of art in 1947.

Another came two years later when the citizens of Winston-Salem, the state's postwar business capital, established the country's first municipal arts council.

It was also a milestone decision in 1961 when the administration of Governor Terry Sanford created the North Carolina Awards, a statewide celebration of the arts and humanities without peer in any other state; and it was another in 1965 when the legislature chartered the North Carolina School of the Arts as the nation's first public arts conservatory.

In 1971, the North Carolina Department of Art, Culture, and History became the country's first such cabinet-level state agency. (It is now known as the Department of Natural and Cultural Resources.) And in 1971, the state legislature made the groundbreaking decision to consolidate sixteen public colleges and universities into the University of North Carolina System, ensuring that education, most often including the teaching of art, would have a toehold in every corner of the state.

These decisions laid a fertile ground. They enabled and inspired art to be created, to be nurtured and funded, to be seen and appreciated everywhere from the mountains to the coast. It was these hard decisions that paved the way for the leaders and the extraordinary artistic eruption of this century.

VISIONARY PLANS

It's important to note that these moves were made decades before they really made practical sense, before North Carolina would emerge as one of the nation's fastest-growing states by population, decades before Charlotte would become the second-largest banking center in the nation, and long before Research Triangle Park evolved into an innovation magnet, home to more than 200 companies.

Before all of that, art was allowed to emerge here as an economic driver, made a powerful tool capable

of building and changing communities. The environment it created welcomed artists to live and work here, to take the education they'd received and put it to use in a place that honored who they were and what they did, that celebrated and valued it.

These groundbreaking decisions also set a precedent. They showed future North Carolinians that they, too, could grow and improve their communities and their state, and that art could lead the way.

Bank of America CEO Hugh McColl knew it was true when he made sure that the city he was helping to build with the bank he grew in Charlotte had not just commerce, but art at its core. When city leaders came together in Greenville in 1960 and in Wilmington in 1962 to form their own community-supported art museums, they did the same thing. When the state and Seagrove leaders founded the North Carolina Pottery Center as the nation's only statewide facility dedicated to pottery, they knew the power of such a move. The regional leaders who turned an old and empty hosiery factory in the tiny town of Star into a center for pottery and glass in 2005 knew it. Kinston's Stephen Hill transformed his hometown through the power of art, honoring that same proud legacy. And the artists of the once-withering Blue Ridge Mountain town of Marshall, who are currently bringing that town back to life with creativity and collaboration, know it in their bones.

New York philanthropist Iris Cantor also knew it when she made the extraordinary decision in 2009 to give her collection of thirty Rodin sculptures to the North Carolina Museum of Art, making the museum the repository of the most extensive Rodin collection in the South. She was responding not just to museum director Larry Wheeler, but to that same North Carolina spirit, which he made sure she knew: Art matters here. It is honored. It makes a difference.

The lawyer and art collector James Patton made a similar calculation when he donated 100 works of twentieth-century art valued at roughly $30 million to the NCMA in 2015. He wanted the people of North Carolina to experience the same joy he felt in the presence of the art he and his wife Mary had collected and lived with over a lifetime: "It does something for you," he said of the art he loved. "Something rich and powerful and exciting." The museum's chief curator Linda Dougherty agreed. "I think it's just amazing that they decided to give it to North Carolina," she said at the time. "It has an impact in so many ways."

Today, thanks in part to donors like Patton and strong state and municipal support, the NCMA and the state's other art institutions founded long ago are flourishing, and new leadership has taken the helm. Their excellence is so commonplace that it's easy to assume it's simply the natural order of things. It seems obvious that the capital city of a state as dynamic as this one would have a world-class museum at its heart. Why wouldn't the publicly funded North Carolina School of the Arts be ranked with the private Yales and Juilliards of the world? Of course, we may think, Asheville, another newly flush spot fueled by art, would have a beautiful art museum in a brand-new building downtown. And it's no surprise that we have one of the world's most esteemed schools of craft in Penland. The UNC System is phenomenal, therefore its many university art museums must be, too. Ditto our private college museums. Wilmington's a great historic city with a flourishing beach community, why wouldn't it have a museum as sophisticated as the Cameron Art Museum? It's only natural that the banking boomtown of Charlotte would have three art museums in an uptown cluster, isn't it?

Well, none of it happened yesterday, and none of it happened by chance.

FACING
Collector and benefactor James Patton in his Chapel Hill apartment, photographed in 2019 with two of his favorite works of art, *Daphne*, by David Park, and a sculpture by George Rickey. Mr. Patton died in 2020 at ninety-one.

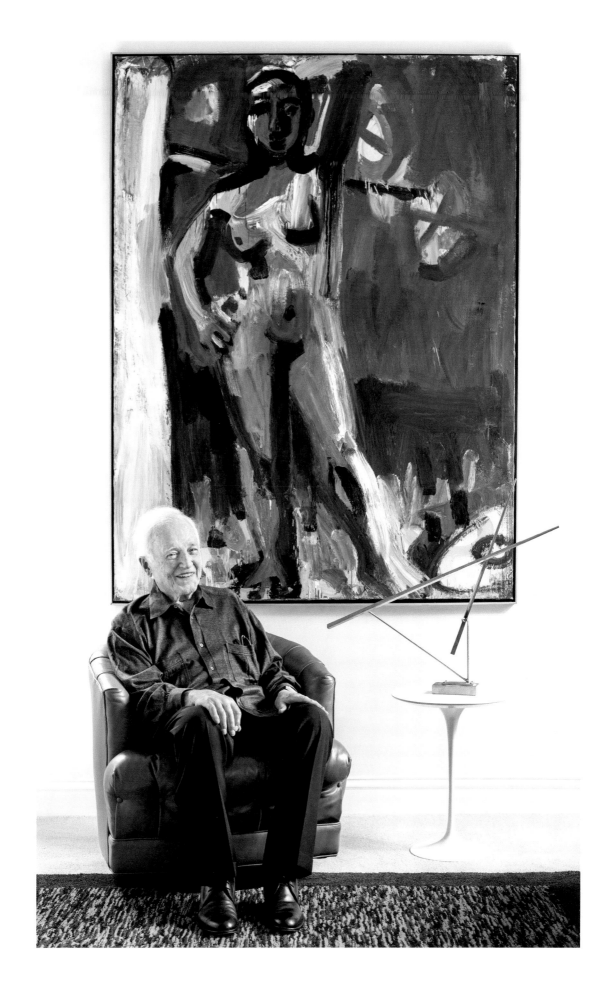

There was and is another vital North Carolina legacy at work in all of these events: generosity. A willingness to share, to invest in community, to include, to welcome, to work together. It's what made the alternative, art-focused Black Mountain College the magical midcentury place it was for art world luminaries like Josef Albers, Buckminster Fuller, Cy Twombly, and Richard Rauschenberg, and what keeps its legacy alive.

That spirit endures, with its unusual combination of sophistication and grit, its well-traveled worldliness and small-town kindness. Eighty of North Carolina's 100 counties are rural today, and about 40 percent of the state's 10.7 million people live in rural areas. So it makes sense that a generous, can-do mentality broadly persists, even in the state's cities and towns, where artists say it provides important creative fuel.

"There's the cooperative spirit that comes from making things for the necessity of it," says Roger Manley, an artist and also the director of the Gregg Museum of Art and Design at NC State University. On an artistic level, it means that "there's a kind of cross-pollination that happens that's really inspirational," he says. "People feed off of each other's excitement, and innovations. It's self-perpetuating."

Add to that organic wellspring a well-oiled machine of funding resources for artists from the municipal level on up to the North Carolina Arts Council, a state-run funder with a nearly $10 million annual budget. It is one of the only statewide arts councils in the country to make grants to individual artists.

"I am a believer that this is one of the best states for the visual arts because all the communities across the state have been so supportive, and artists come from all over because they hear that," says Rory Parnell, co-owner of Raleigh's long-established Mahler Gallery.

The communities are supportive, and so are the many museums and art institutions that anchor them: "An incredible swath of fantastic arts institutions," as artist Page Laughlin puts it, across the state.

They're fantastic, but they're also accessible. That's more than just a convenient fact. It can also catapult a career. "I've been so fortunate to have so many curators in this region I've been able to work with," says Durham artist Stacy Lynn Waddell. "What an opportunity to be able to call Linda Dougherty [chief curator at the NCMA] and have her come to your grad studio," for instance. Others like Trevor Schoonmaker at the Nasher Museum of Art, and the team at the Weatherspoon, have also been supportive, Waddell says. "These are curators at really important museums, not just regionally, but across the country."

Influence and access, plus community and affordability, beauty and space, history and change. It's a rare and potent cocktail. "I am a North Carolina artist," says Durham performance artist Stacy Kirby, winner of 2016's prestigious $200,000 ArtPrize. "My family is from North Carolina, but it's deeper than that. I feel like if I moved somewhere else, I would lose my connection to source. A source that is more than just intelligence. It is a source of spirit. A source of purpose."

Edie Carpenter, curator at the GreenHill Center for North Carolina Art in Greensboro, agrees. "We have two things in North Carolina," she says, "the history of support of culture, and this beautiful backdrop for it."

THE ART OF THE STATE

This book tells that history and illustrates that backdrop, showcasing art, artists, and the art world in six different regions across the state, beginning with the fertile mountains, concluding with the coast.

In each chapter, a small number of individual artists are profiled. Chosen to represent the breadth and depth of art being made in these regions and the diversity of the people making it, these artists are at the top of their game, but they're not alone. Consider them a tip-of-the-iceberg, representative sampling, an indicator of just how deep North Carolina's pool of talent is, how varied, and how fascinating.

They are also a testament, not only to their own creativity and drive, but to the state that nurtures and celebrates their work, and has done for more than a century.

"I don't know that there's a more vibrant art scene in the Southeast," says UNC Greensboro chancellor Franklin D. Gilliam Jr., "than there is in North Carolina."

CHAPTER 1

THE MOUNTAINS

Elizabeth Brim came to Penland School of Craft as a printmaker with short-term and humble aims: she wanted to learn something about ceramics so she could get a teaching job. She learned ceramics, she got the job, but she couldn't stay away from Penland. More than forty years later, Brim is not a ceramic artist, she is a renowned blacksmith artist, and this beautiful mountain community has long been her home.

Brim's story is important not because it is unique, but because it is common. There's something alchemical about this school in the mountains, something that draws artists in, stretches their creativity, transforms their work, and never lets them leave.

"When I finally got my chance to go to Penland, that changed my life," says paper artist Eleanor Annand. "Oh, I found it," she told herself. "This is the way I want to learn. These are the people I want to surround myself with."

Robyn Horn, a nationally recognized Arkansas wood sculptor and painter, first visited Penland at the urging of legendary wood artist Stoney Lamar back in the early '90s, and has returned annually with her husband John Horn, a letterpress printer, ever since. As chair of the Windgate Foundation, the prominent Little Rock–based institution founded by her family, Robyn Horn has also, for many years, steered substantial grants to the school.

"It's just a whole other world," Horn says. "It's something that is hard to explain to somebody who's not an artist. It's like finding your people." The level of talent among teachers and students alike there is remarkable, she says: "The quality is the thing."

Lucy Morgan might have said something similar back in 1929 when she founded Penland as a way to teach local women and others to weave and sell their works. In some of the same buildings Penland still

uses today, Morgan added additional crafts, more students, and eventually earned the school a national reputation for hands-on craft education. "The joy of creative occupation and a certain togetherness" is how she reportedly described the fabric of Penland's community in its early years, "working with one another in creating the good and the beautiful."

Nowadays, the people creating that good and beautiful include a core group of professional artists on extended residencies and those teaching classes and taking them, plus curious creative folks who want to try their hand at something new.

The cross-currents make for an unusually inventive community, a tight and collaborative one that stretches beyond campus to the surrounding area, where Penland alumni tend to migrate once their time on campus is complete.

"One year, there was only one [child] in the Montessori school whose parents weren't either a potter or glassblower," says Jennifer Bueno, a glass artist, former Penland resident, and current Penland neighbor. Her children had become so accustomed to the idea that every grownup is an artist that when one of them broke a toy at an out-of-town friend's house, her son came running: "Mamma! Where's the studio?" he shouted. "They don't have a studio," she replied. "And he looked at me, and he says, 'Well, how do they fix things?'"

Sequence

Eleanor Annand

ASHEVILLE

Sequence, by Eleanor Annand, 2019. 52 × 45 × 3 in. Cast cotton paper, milk paint. Courtesy of Eleanor Annand.

Eleanor Annand was a graphic designer and letterpress printer when she became fascinated by the properties of paper and the idea of turning its two dimensions into three.

"I started trying to think of different ways to use these old presses, to make something a bit more unexpected with the machine," says the North Carolina native and NC State graduate. As a resident at Penland in 2017, she began making modular paper forms that could be assembled in different compositions, and then using paper as a material she could mold, cast, and sculpt.

Her cast paper shapes, like the ones in *Sequence*, are often curvy, wiggly, even alive—but the patina she creates with a coat of cloudy milk paint gives them a look of something antique, possibly preserved.

She learned to make molds for casting paper pulp from a ceramicist at Penland, focusing from the beginning on organic and rounded shapes as a way to explore the versatility and three-dimensional potential of the medium.

Her modular pieces, by contrast, are often geometric. To make them, Annand prints and paints the surface of paper, has it die-cut, then folds and glues it into shapes she puts together in spontaneous compositions. "I have a general idea of what I'm going for, but I really need to have that conversation with the material or with the forms." The process is important to her. "I think of that as a way of capturing time. It's premeditated to a certain extent, because I've created the forms I'm going to be working with. But that spontaneity is built into the final piece."

Time is a constant theme; the way light and shadow play on her three-dimensional works, and the way their appearance changes throughout a day, is something she considers deeply. "When I boil everything down, that idea of capturing and also releasing time plays a big part."

Annand has shown her work all over the country and internationally. □

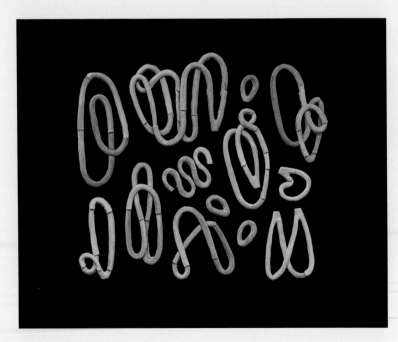

Veer

Thomas Campbell

ASHEVILLE

Thomas Campbell always had an idea he'd be a metal worker.

During the seven years he worked as an industrial steel fabricator for his family's 135-year-old Little Rock, Arkansas, steel business, he enjoyed cutting and welding, building conveyor trusses, coal chutes, and making other heavy, large-scale industrial implements.

But about five years in, he realized he wanted to put his skills to more creative use. "I got pretty curious about what I could do with it on my own," he says. He began "fiddling around on my lunch break" and staying in the shop after work to craft his own designs, furniture at first. He took woodworking classes at the nearby University of Arkansas Little Rock at night, and a small metals class taught by artist David Clemons.

When Clemons and his wife, Mia Hall (who is now director of Penland), convinced Campbell to consider a fellowship program at Penland, he thought he'd focus on making functional, design-oriented work. He became a sculptor instead.

"I was able to develop a new understanding of the material and what it was capable of, and what I was capable of doing with it," he says. "I think that naturally leads to sculptural work."

Campbell considers Hoss Haley a mentor and a major influence: "That relationship has been monumental in my development," Campbell says. "We have similar backgrounds, and he really values the experience I had in industry; it drives a lot of his work as well."

Campbell is also a teacher. "When students ask me how I started making sculpture, and why I make sculpture, I always say, I got tricked into it by Penland," he says, laughing. In fact, he does still make functional objects out of metal. "I really enjoy the challenge of creating something that has a function, and making sure that it functions really well," he says.

With his sculpture, Campbell says he hopes to honor the men in his family who have worked in the family steel business for generations. "It's a new direction for my family's tradition." □

Veer, by Thomas Campbell, 2019. 32.5 × 7 × 6.5 in. Painted and blackened steel.

"This is the area in the US that is most densely populated by practicing craft artists," says Penland director Mia Hall, who followed Jean McLaughlin's two decades of transformative leadership at the school in 2018. "It's impressive, living in this community, and being surrounded by these artists that are doing what seems to be almost impossible in other parts of the country—that is, to have a successful practice, and live off your creativity. It's just so refreshing."

PERFECT STORM

There's more to it than camaraderie. The area offers a reasonable cost of living, affordable housing with space to make art, natural beauty and inspiration at every turn, and the practical benefits of a collaborative community. There's always someone to learn from, or borrow equipment and materials from, to lend a hand on big or complex projects; there's always an influx of new people to mix things up, and alumni returning with the seasons. "Artists naturally gravitate towards other artists," says Leslie Noell, Penland's program director.

Importantly, there are collectors here, too, people who come to buy art. The Penland auction weekend—the school's annual fundraiser—is one example, where bidders and buyers often include major collectors. Washington, DC–based Penland benefactor Fleur Bresler, considered one of the country's foremost collectors of American craft, purchased Anne Lemanski's *Tigris T-1* for Crystal Bridges Museum of American Art during the 2019 auction weekend, for instance. "I fell in love with it," says Bresler. Though Lemanski's tiger was "too big for my apartment," she jokes, pieces of the artist's that do fit, collected in previous years, include a gun made out of "very Victorian-looking paper dolls," a "snake with an attitude," a bird, and a jack rabbit. Bresler credits Kathryn Gremley, who runs the Penland gallery, with introducing her to Lemanski's work. "She's got a wonderful eye."

During that same 2019 auction weekend, Durham collectors Renee and Ralph Snyderman bought Hoss Haley's monumental *Union 060719* for the North Carolina Museum of Art. They were among hundreds of other collectors from around the country who supported these local artists, as they've done for years and continued to do even through the pandemic, when the auction went virtual.

CRAFT AS A VERB

As the line between craft and fine art continues to blur here and other places where art is made using craft techniques, Penland's national and international reputation continues to grow. Many consider the very idea of separating fine art and craft anachronistic, the vestige of a fustier, hierarchy-focused era.

"I think you'd be hard-pressed at Penland to find someone who would argue for the division of the two," says Gremley. "I've been at the gallery now for over 25 years and I don't get the question as often as I used to." It doesn't come up because materials and technique alone can't define a work of art. "You've got a whole group of fine artists who are using craft-based materials, so it's pretty hard to make that division."

Among the other distinctions that don't have much use anymore are those that categorize art or artists by medium. "A lot because people ask, 'Does Penland have a sculpture studio?'" Gremley says. "And I say, we have sculpture in all the studios. Elizabeth [Brim] works in steel, and she's a sculptor, of course. And Christina [Córdova] works in clay, but she's a sculptor."

"Everything has diversified in the creative field," adds Program Director Noell. "That interdisciplinary overlap and cross pollination has taken off universally."

It's also true at a school like Penland, long steeped in the teaching of skill, that the world of ideas is more important than ever.

Collectors

Jim and Betty Becher

BITTERSWEET FARMS,
ENNICE

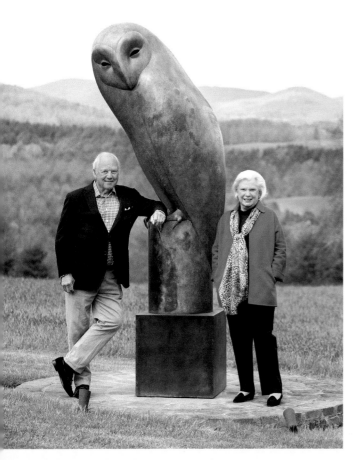

For Jim and Betty Becher, art is a way of life and a way to celebrate it. Art is a ticket to learn about and explore the world, share it widely, and do it together.

"I am not a detached intellectual," Jim Becher says. "I like the emotion, the talent of the artist, and how it comes through to me."

It's a feeling he's delighted to share. When Betty became fascinated by a monumental bronze barn owl sculpture by the famous British sculptor Geoffrey Dashwood, Jim hatched a plan. A few weeks later, they were in England. When Jim turned down a dirt road, Betty had no idea where he was going. "He said, well, I called Geoffrey Dashwood, and he invited us for lunch." She was thrilled; they had lunch with the artist, and he offered to show them his sculpture garden. "And there was the barn owl," Betty recalls. "And Jimmy said, 'Why don't you go stand by it, because it's your birthday present.'" Jim laughs: "The trip was all downhill from there."

Barn Owl now has a sweeping view of the Blue Ridge mountains from its perch at the couple's Bittersweet Farms in Ennice. The owl is in good company: a leaping hare by Barry Flannagan is nearby; so are massive, recumbent bulls and other works by renowned American sculptor Peter Woytuk. Several works by Luis Montoya and Leslie Ortez make striking statements, including a giant bunch of asparagus, one of beets, and another of apples, which the couple commissioned to stand in their orchard.

A large and handsome vessel by North Carolina's Mark Hewitt is inside the couple's nearby party barn, and a swirling nestlike creation by Patrick Dougherty added to the whimsy of the Becher collection before it biodegraded, as Dougherty's works all do. (The couple also underwrote the giant Dougherty piece in the West building at the North Carolina Museum of Art, where Jim has served for many years on the board of trustees.)

In their house at the top of a hill, the Bechers have amassed a significant collection of American paintings from 1850 to 1950, including nearly every one of the Ashcan School of painters. Robert Henri, William Glackens, Childe Hassam, and Everett Shinn are all well represented. Building this collection has been a longtime labor of love for Jim, who began buying art as a very young man. With his first paycheck, he spent an unreasonable sum on a sporting painting by David Hagenbaumer: $120, "and I took two months to pay for it." It's still on the wall where he can enjoy it, as are all the works he and Betty have collected over the years.

"I bought every painting in this house because I like it, never for its value or its future value," Jim says. "I've never sold a painting. I don't buy them to sell them."

John Coffey, the recently retired Jim and Betty Becher Curator of American and Modern Art at the North Carolina Museum of Art, has been a longtime trusted adviser. The Bechers endowed Coffey's position, and have donated many works of his choosing to the museum.

"I got really involved in pursuing these treasures that John had identified" at auction, Jim says. The Bechers have made other significant philanthropic contributions to the museum, and to arts institutions in Winston-Salem, where they also reside.

On a recent visit to Bittersweet Farms, the couple's favorite painting, a Robert Henri portrait of the artist's rosy-cheeked daughter, had just returned from loan to Reynolda House.

"I missed her," Jim says. □

Jim and Betty Becher, photographed at their Bittersweet Farms in Ennice with *Barn Owl*, by Geoffrey Dashwood.

Fallback

Rachel Meginnes

BAKERSVILLE

Rachel Meginnes takes old quilts apart to make them new, turning them into works of contemporary art in the process.

Growing up in Vermont, Meginnes learned to weave; she later studied weaving and dyeing in Japan, and apprenticed as a rug weaver in the United States. All of it taught her to make "craft with the intent of building and creating, not taking apart."

In graduate school, Meginnes began to head in the other direction. For a piece about the Iraq war, she removed threads from a piece of fabric every day to represent each soldier reported wounded or killed. "That was the beginning of the process."

She continued to deconstruct fabric, but began to reject the idea that everything she made had to have an overt message. She decided to focus instead on reinventing the old textiles she manipulated and making the process itself meaningful. She'd remove threads, sand down the holes she'd made, and paint them. "I thought of them as landscapes, in a way."

When she arrived for a three-year residency at Penland, stacks of old textiles in hand, she had the freedom to experiment with embroidery and other techniques. One day, she took an old North Carolina quilt off the pile with the idea of removing the top and piecing it back together differently. "And when I started to peel it away," she says, "I saw there was an entire quilt inside the quilt. . . . It was fascinating, just absolutely beautiful." She came to learn that this was not uncommon; that when old quilts became threadbare, they'd often be used as batting for new quilts, meaning that an old quilt became a new quilt's inner layer.

"That was the piece that started the real work with quilts."

That work involves taking old quilts down to their component parts and reconstituting them entirely to become "a pure appreciation of color and form and pattern." Some are made entirely of the inner batting, sanded, perhaps, or painted; others have the original pattern of the quilt printed onto its old batting.

In a continuing evolution, Meginnes's latest work includes using quilt components as fibers to weave on a loom. "I love the exploration," she says. "I love seeing what something can turn into."

Meginnes's work has been exhibited internationally and is in the collections of the US Art in Embassies program, the Cameron Art Museum in Wilmington, and the University of Little Rock, Arkansas, among others. □

Fallback, by Rachel Meginnes, 2019. 8.75 × 9.25 in. Deconstructed quilt, hand stitching, acrylic. Courtesy of Rachel Meginnes.

"I think that we're in a period right now where you acquire skills in order to develop ideas," Gremley says, "You're not necessarily committing yourself to being a ceramic artist" or a metal artist, or a painter, or a weaver, or any other one kind of artist. You're simply an artist. Materials, skills, and techniques are acquired in service to your concept, and not the other way around. "I'm not saying that that's true of everybody," Gremley says, "but there certainly are a high number of artists who fit that mold right now."

PIONEERING TRADITION

Artists who want to learn skills, of course, need to learn from those who have specialized. And those people are in large supply at Penland, and also all over the region. "There's a really long, rich history of traditional craft in the Appalachian range," says Noell.

Some of that comes from European immigrants who had to make what they needed. And some comes from indigenous peoples, like the Eastern Band of Cherokee Indians, a 16,000-strong population headquartered about two hours east of Penland in Cherokee, North Carolina, within an area known as the Qualla Boundary. Owned outright by the Cherokee, the Qualla Boundary is home to about 8,000 descendants of a group who were not forcibly moved to Oklahoma along the Trail of Tears in the 1830s.

Today, the group's Qualla Arts and Crafts Mutual—which claims to be the oldest Native American cooperative in the nation—showcases traditional and contemporary Cherokee art including pottery, baskets, woven textiles, paintings, and woodcarving. Joshua Adams is among the young Cherokee artists represented by Qualla who honor their 11,000-year Cherokee heritage even in the making of their own contemporary works. This art reflects that heritage as well as the beauty of the natural environment and the spirit it engenders, which does not know boundaries. Artists of all kinds are lured to it, and to one another.

"Western North Carolina definitely has been a mecca for ceramic artists, potters, glass artists, and glassblowers . . . they're really drawn to each other. It just creates its own momentum," Noell says.

For artists working in ceramics and glass, shared overhead studio expenses and a community of extra hands are vital to making their work, as are the space to make it and the necessary natural resources. For ceramics, those include clay, of course, and wood for firing kilns. Both are abundant in the region.

For glass, a combination of mined minerals known as batch is required. Uncoincidentally, the area around Penland is a prime place to mine many of them, including feldspar and silica, a form of quartz. After Harvey Littleton, the man considered to be the father of the studio glass movement, left Wisconsin in 1977 to set up a studio near Penland in Spruce Pine, he founded Spruce Pine Batch Company to supply these minerals. The company still manufactures and distributes batch and other glass-making materials to artists all over the country.

"These natural resources are specific to this place, and these mountains," Penland's Noell says. "The glassblowers around here don't have to order it by the pallet, they just run down the road and throw it in their trucks." From collector Bresler's perspective, it's this immersive local network that helps make the area's artists exceptional, fueling deeply rooted, time-honed skills.

There's something else the region offers, too: solitude. "There's a certain amount of independence," Bresler says. "Some of the artists tend to be loners. And the area gives them that ability."

ASHEVILLE

The landscape does allow artists to tuck themselves away, to focus hard and to work, but importantly, it also allows them to engage with the world, and not just intermittently at bucolic Penland.

Continencia

Jeannine Marchand
SPRUCE PINE

Jeannine Marchand was a potter at Penland in 2000 when she began to explore other art forms. As a core fellow, she found herself welding, forging, making furniture, blowing glass, casting glass, and taking photographs. One day, when she was developing black and white photos in the darkroom, she had an epiphany: "This is what I want my work to look like," she thought. She began to use plain white clay as the foundation of her pared-down palette.

Shadow and light also play a big part in her work, as do the organic shapes in the photographs she takes of nature and the influences of her life and upbringing in Puerto Rico, where she was born and raised. Marchand says she's inspired by her creative parents, especially by her mother, who sewed every dress she wore. "There was always fabric spread on the dining room table."

The first time Marchand made a ceramic sculpture that looked like that fabric, it was a happy accident. As she was stretching a slab of clay, a piece tore off and flew across the room. "When I went to pick it up, it looked like fabric," she recalls. "I didn't know that clay could do that, that it had those qualities. So I started working with that."

The pieces became more refined as she experimented. She began sanding the surface "to allow light to travel uninterruptedly" across it, and to incorporate the shapes she loved in the world outdoors. Marchand was studying psychology at St. Joseph's University at the time, and realized something elemental about the work she was making: "I liked what it did in my nervous system when I looked at them," she says, "and I wanted to share that with other people."

Marchand has an MFA from Cranbrook Academy of Art. Her work has been exhibited across the country and internationally, and is in the collections of the Museo de Arte Contemporaneo de Puerto Rico, the Fuller Craft Museum, and the Maxine and Stuart Frankel Foundation for Art, among other museums. □

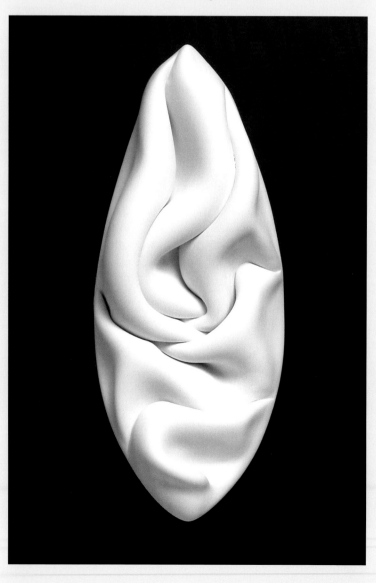

LEFT
Continencia, by Jeannine Marchand, 2014. 17½ × 7½ × 4½ in. Clay. Photograph by Tom Mills.

FACING
Soft Blue Cluster, by Thor and Jennifer Bueno. 24 × 24 × 5 in. Sand-etched hand-blown glass and steel. Photograph by Steve Mann.

Asheville is an easy hour's drive. A boomtown at the beginning of the twentieth century with the Art Deco architecture to show for it, Western North Carolina's largest city took a major hit with the Depression and didn't truly recover until the 1980s. Its buildings remained largely unaltered in that time, giving today's downtown Asheville a retro charm, which, coupled with its recent rapid economic growth, has helped make it an emerging hub for art.

Tracey Morgan knew these factors were swirling when she and her husband decided to move here in 2015. After decades in the New York art world, Morgan wanted to get out of the city's vortex and open her own gallery. She knew she was coming to a place steeped in the craft tradition and wasn't certain what to expect about the local appetite for contemporary art, but was willing to give it a serious shot.

Morgan found a space she could afford, off the beaten track in Asheville's semi-industrial South Slope, and immediately, she says, talented artists started sending her submissions. She also began seeking them out. Among them were Colby Caldwell, Hannah Cole, Margaret Curtis, Rachel Meginnes, and Gesche Würfel. It wasn't long before the Tracey Morgan Gallery roster was full with contemporary North Carolina artists working in various media, many in photography.

"I can see why this is a hotbed of creativity," Morgan says. "The sharing of ideas is a big part of it."

Soft Blue Cluster

Thor and Jennifer Bueno

ASHEVILLE

Inspired by the nature that surrounds them, Southern California native Thor Bueno and South Carolina native Jennifer Bueno make blown glass sculptures that look like scattered river rocks, raindrops, cairns, constellations, and points of reflected light.

The couple, who both have MFAs (Jennifer has two), met while blowing glass in Washington, moved to Penland for a three-year residency, and then set up a joint studio nearby.

It was when they were each making their own individual glass art, and trying to make room for it all, that Jennifer started putting some of Thor's work, glass faces and masks, on the wall, mostly to get it all out of the way. "I started arranging them, and putting them up, and that sort of stayed in the back of our minds for a while."

Then Thor—who was a founding member of a glassblowing performance art group called the B Team early in his career—made silvered discs of mercury glass and put them on the wall in a splash pattern, and another seed was planted. It was when they combined the earthen, matte texture of a vase they'd made with those scattered orbs that the work they're best known for today began to evolve.

The artists each still make their own work— Jennifer's is inspired by satellite imagery, and Thor's is more organic—but say they enjoy the process of creating art together. It's rewarding, and it's also practical. Glassblowing, after all, is a technically complicated undertaking, an expensive one, gritty and physically taxing, potentially dangerous. Teamwork makes it easier. "Glassblowers are the truck drivers of the art world," says Jennifer Bueno, citing an early artist of the studio glass movement, possibly Harvey Littleton. "You've got to keep it all running." □

Mundo

Randy Shull

ASHEVILLE

Asheville artist Randy Shull and his wife, Hedy Fischer, spend part of the year in Asheville and part of it in Merida, Mexico, where the colors and rhythms of life often inspire Shull's art.

Made of handwoven hammocks and acrylic paint, *Mundo* refers both to the hammocks of the Yucatan and to the geodesic dome that Buckminster Fuller failed to erect out of alternative materials at North Carolina's Black Mountain College—as well as the success Fuller claimed for trying. It's "a reminder that my own high failure rate in this hammock series is very much part of the creative process," Shull says.

In the state of Yucatan, where Merida is the largest city, hammocks are a way of life—they are woven by hand on stand-up looms and commonly serve as beds. While quarantining in Merida during COVID, Shull bought hammocks in the Merida markets, layered them with paint, and let them cure in the sun.

"As an artist who sometimes makes furniture, I see the hammock as an ancient furniture form that has stood the test of time, uses very little resources, and is super easy on the body, casting it into a sense of dreamy weightlessness," Shull says about these works. "In a way, I continue my investigation of furniture through the use of the hammock, it just takes on the form of a painting."

Shull says that living in both Mexico and Asheville provides him with an ongoing creative reboot and an intriguing set of contrasts to consider. "I really enjoy having the dialogue between the two places," he says. That dialogue was on display when Shull's hammock series traveled to Asheville for a solo show at the Tracey Morgan Gallery in 2021.

Shull received a BA in furniture design from the Rochester Institute of Technology, and the refined, sometimes colorful furniture he makes is in the permanent collections of the Brooklyn Museum of Art and Design, the Renwick Gallery at the Smithsonian, the Gregg Museum of Art and Design, and the Mint Museum, among others. □

Mundo, by Randy Shull, 2021. 77 × 70 in. Acrylic on hammock. Photograph by David Rubio.

ottf [3.21] (from the Forest Floor Series), by Colby Caldwell, 2021. 82.5 × 60 in. Archival ink jet mounted on dibond and hand waxed. Edition of 3. Reproduced by kind permission of the artist and HEMPHILL Art Works and Tracey Morgan Gallery.

From the Forest Floor Series

Colby Caldwell

ASHEVILLE

With an office-issue digital scanner, Colby Caldwell ventures into the woods, finds a promising spot, and literally scans the forest floor, its trees, its moss and dirt.

The idea came to him when COVID hit, and he was tired of being indoors. He jerry-rigged a small, battery-operated generator to power his scanner, took it outside, and began using it the way you'd use a camera, to point up and out at things. Then he realized he could point it down, directly at the ground.

"I wanted to actually literally try to get inside the natural world, to look at it in a different way."

It works because unlike a camera, which receives light, a scanner emits it. As its light bar travels slowly over its glass surface, Caldwell picks the scanner up and moves it to another spot, for another slice of forest, another point of view. The result is a series of highly detailed, layered images, so close-up it's as if the viewer is nose-to-nose with the tree, the bark, the moss. "I think of it like collecting field recordings," he says.

He's also challenging the expectations of the tools he chooses to use. In some instances, he does that with various forms of photography, including digital, video, phone, and film cameras; in this case, he's exploring the possibilities of an overlooked piece of office machinery. "I'm not interested in the latest, best, fastest . . . I'm interested in subverting whatever the tool is."

Caldwell's work has been shown nationally and internationally since 1998. He taught art and photography at the Corcoran School of Art in Washington, DC, and currently teaches at Warren Wilson College in Swannanoa, North Carolina. He is also the cofounder and program director of Revolve, an experimental artist-run gallery/studio/performing space in Asheville. □

Collectors

Hedy Fischer and Randy Shull

ASHEVILLE

Hedy Fischer and Randy Shull have been active collectors of contemporary art from around the world for more than twenty-five years. They live part-time in Merida, Mexico, and part-time in Asheville and in both places are fully immersed in the world of art. Their collection—which includes a significant number of important works by Latin American and Mexican artists; African American artists; artists of the African diaspora; and women—often delivers a message.

"It's not art in a beautiful sense, necessarily," Fischer says, "it's art in a more contemplative sense. We're interested in work that speaks to our time."

The collection is large enough that they rotate it regularly; recently, works by Kevin Beasley, Aaron Fowler, and McArthur Binion, all highly acclaimed young African American artists, were on display. The couple's collection of works by Trenton Doyle Hancock, who was one of the youngest artists ever to be featured in the Whitney Biennial exhibition of American art, represents the largest collection of Doyle Hancock's work in private hands. (In this photograph, they are in front of the artist's *The Bad Promise*.)

In addition to the work they do with their Pink Dog Creative art hub in Asheville, the couple mounts museum-quality exhibitions from their personal collection at 22 London, their Asheville warehouse/studio property, and opens these shows to the public.

Shull and Fischer also sponsor an ongoing community mural project, art workshops and classes for young people, and gallery exhibitions for nonprofits. Fischer, for her part, also sits on the board of trustees of New York–based Art21, which produces films about contemporary art, and on the board of Asheville's Black Mountain College Museum, which Shull designed. Shull is on the board of trustees of the North Carolina Museum of Art.

"One of the things that is important to us both is community involvement," Fischer says. □

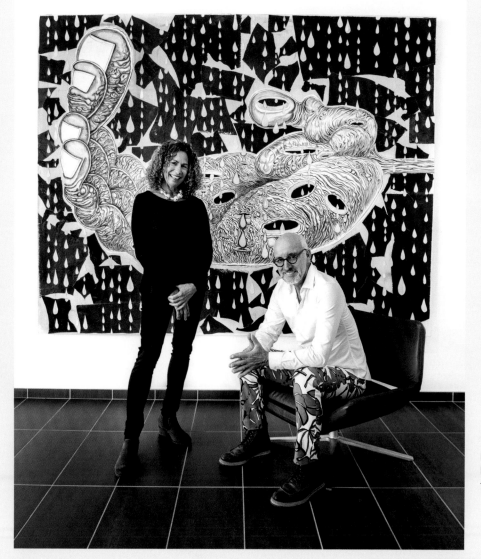

Hedy Fischer and Randy Shull, photographed in their Asheville home with Trenton Doyle Hancock's *The Bad Promise*.

Some of these artists are the product of several excellent undergraduate studio art programs within a reasonable distance of the city, at UNC Asheville, Appalachian State University, Western Carolina University, and Warren Wilson College. Importantly, there is also a master's program in studio art at Western Carolina, and the nation's first master's program in critical craft studies at Warren Wilson, in partnership with Asheville's Center for Craft.

As Morgan built her list of artists, art lovers and collectors also sought her out. "There's a group of really sophisticated people, and they keep moving here," she says.

Galleries like hers, Blue Spiral, Momentum Gallery, and several others are some of the many beneficiaries of that growth. So is the Asheville Art Museum, which completed a new building in 2020 for its collection of American art and Western North Carolina art. Also a beneficiary is the city's Center for Craft, which began as an interinstitutional center of the UNC System and is now an independent nonprofit in a newly renovated facility.

Growth in the mountain region generally has also benefited other art communities, like the one in Blowing Rock, where the Blowing Rock Art & History Museum mounted a photography exhibit guest

To Think Again of Dangerous and Noble Things

Hannah Cole

ASHEVILLE

Asheville artist Hannah Cole paints weeds. It's what she sees on her daily walk and an example of the relentless, resilient presence of the natural world around her, emerging even between the cracks of the sidewalk beneath her feet.

"My project has always been about finding beauty where other people overlook it," she says. "What I believe in is the magic of every day. You don't need an unfettered mountaintop or a miraculous experience, there's just beauty everywhere."

Before she lived in Asheville, Cole lived in Brooklyn, and she painted what she saw and found beauty there, too, including manhole covers and grates.

"The very first thing I noticed walking around Asheville was how green it was," she says. She immediately went out and bought twenty different tubes of green paint to depict it.

Cole says she's interested in painting weeds not only because their vigor captures her imagination, but because she finds their defiant demand to be acknowledged inspiring. "Weeds are nature without permission," she says. "And there's no definition of a weed, there's no basis in science. Weed is just a judgment . . . it's more about who belongs, who gets the sunshine, more than anything else. I'm really interested in that analogy."

The insistence of nature finds its way into most of her recent work. *After the Storm*, her painting of fallen, scattered leaves and branches on asphalt, was chosen for the cover of a new novel by North Carolina author Ron Rash. "That to me is a great integration of the urban environment, but nature still having its way."

Cole studied at Yale University and Boston University, has had many solo exhibitions of her work, and has been shown internationally. □

To Think Again of Dangerous and Noble Things, by Hannah Cole, 2019. 24 × 30 in. Acrylic on canvas. Private collection, Florida. Courtesy Tracey Morgan Gallery, Asheville. Photograph by Aubrey Holland.

curated by former North Carolina Museum of Art director Lawrence J. Wheeler and collectors Carlos Garcia-Velez and Allen Thomas Jr. in 2021.

Meantime, the once-obscure Asheville neighborhood around Morgan's gallery has boomed, making it expensive for her to stay. "I have to think," she says. "Am I going to be another pioneer in another neighborhood, or look for a really small space? Or do pop-ups in empty storefronts?"

Architect and artist Randy Shull and his partner Hedy Fischer could advise her well. They were among the collectors who first welcomed Morgan (Shull is also an artist whom Morgan now represents), and have also experienced the phenomenon of Asheville's creative growth.

Together in 2010 Shull and Fischer turned a 20,000-square-foot former textile warehouse on the edge of what is now Asheville's River Arts District into Pink Dog Creative, a creative hive that's home to thirty artists' studios, exhibition spaces, a coffee shop, and two restaurants. Pink Dog puts on regular exhibitions of art with a social focus, raises funds and awareness for local nonprofits dedicated to social justice and equity, and has become both a linchpin of the city's creative community and a symbol of its growth. The couple also share a 9,000-square-foot studio/warehouse called 22 London, where they present exhibitions from their own important collection of contemporary art, some of which hangs in their stunning modernist house in North Asheville.

In an artists' city like this one, it's fitting that an artist like Shull is behind some of its growth. That equation was also part of the decision to hire him to design the Black Mountain College Museum + Art Center downtown.

Built on the idea that art, architecture, design, and craft are all of a piece, and that art-making and the study of art are central to a liberal arts education,

Black Mountain College was a groundbreaking, experimental school in nearby Black Mountain from 1933 to 1956.

The college attracted a number of students and faculty from the Bauhaus school in Berlin who were eager to leave Hitler's Germany, including Josef Albers, who became its first art teacher, and his wife and fellow artist, Anni. Other renegade spirits including Buckminster Fuller, Cy Twombly, Willem and Elaine de Kooning, Robert Rauschenberg, Franz Kline, and Ruth Asawa joined them. The result was intense creative foment and output, a high-octane cross-pollination of creative spirits. Its impact is still felt, not only within this region and this state, but across the wider world of art. Even today, its legacy is attracting artists.

Hannah Cole is one. When she and her husband were considering leaving New York for the South, she had one stipulation: it had to be somewhere with a lot of artists. "The one thing I knew from being an art history major was Black Mountain College," she says. "I told my husband, I think the only place you could probably talk me into would be Asheville."

Roger Manley, the director of NC State's Gregg Museum, shares Cole's fascination, even going so far as to recreate some Black Mountain magic of his own. Every few years since 1992, Manley has rented the former site of the college—it has been home to Camp Rockmont for boys since 1956—and invites as many as 100 artists, writers, scientists, entrepreneurs, and other interesting types to gather for a week of no-frills, Black Mountain–style collaborative creativity.

He calls the gathering "META"—it's strictly invitation-only, so don't ask if you can go—and there's no catering, no housekeeping, no formal plans; the only requirement is that everyone has to chip in with cooking, cleaning, and the like, and must teach the group something, or share something with it—a performance, a reading, a work of art, anything at all.

Floorman

Bob Trotman

CASAR

From his remote home in Western North Carolina, Bob Trotman makes sculptures, mostly in wood, that question, provoke, and satirize traditional ideas of power. The suited, bewildered gentleman who finds himself on the floor in *Floorman* is a quintessential Trotman work. Businessmen in various states of peril or displacement are a constant theme. "It has to do with my antagonistic relationship with my father and with patriarchy in general," he says, "and with capitalism and with being a company man."

Born and raised in a traditional family in Winston-Salem ("you know, country club, Junior League, very conscious of what other people thought, the whole shebang"), Trotman worked as an English teacher after college before joining a group of friends in the mountains to help fix up a piece of property. It was 1973. The physical labor was "such a relief" and the carpentry work so satisfying that Trotman stayed and began to make furniture, what he calls "California hippie furniture, very organic biomorphic forms."

"I did not have a view of being an artist," he says, "I started off wanting to be a woodworker."

His furniture was successful. A manufacturer in New York picked up one of his designs, and Trotman's travels to that city exposed him to "real art, not crap. I had not seen real contemporary art before that. It got under my skin." Soon he was making sculpture-furniture hybrids, including a table made of a person "bending over in a yoga pose, with feet and elbows on the floor, doing a backbend." Eventually, he began making sculpture that was not functional, but it would be many years before he stopped making furniture altogether.

Most recently, Trotman has taken up pyrography, "a fancy name for woodburning." He compares the works that incorporate this technique to the work of the '60s art star Marisol, known for her figurative work in wood. In one small recent piece, Trotman says, "A business guy from the waist up is holding his head with both hands clasped against his temples, it's a very uncomfortable pose, and he's screaming. Sort of like Munch's *Scream*, only a lot more enthusiastic."

Trotman still lives right near the mountain place he first went to in 1973, with his wife, in a 115-year-old farmhouse, next door to one of the friends he'd originally joined there. "I love it," he says. "It seems so real to me." His oldest son, Nat Trotman, is a well-known curator at the Guggenheim in New York.

Trotman's work is in public and private collections including Crystal Bridges Museum of American Art, the North Carolina Museum of Art, the Gregg Museum of Art and Design, the Renwick Gallery of the Smithsonian Institution, and the Museum of Art and Design in New York, among others. He has received fellowships from the National Endowment for the Arts and the North Carolina Arts Council. □

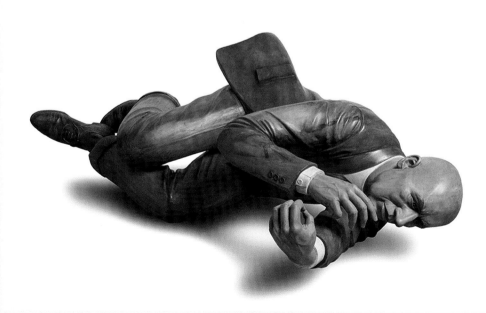

Floorman, by Bob Trotman, 2011. 59 × 48 × 78 in. Wood, paint, wax. Photograph by David Ramsey.

Poems and songs and books and films and even an opera have resulted from these weeklong free-for-alls. So have long-lasting friendships and collaborations. "It has succeeded beyond my wildest dreams," Manley says. "Of all the things I've done, it's probably the thing I'm proudest of."

LEGACY LIVES ON

Indeed, Black Mountain College's spirit is alive and well, and not just on its former campus.

In Marshall, just a half-hour's drive from Asheville, artists who live and work in the same ingenious, category-defying, art-centered way as their Black Mountain forebears are remaking a once-dying town on the French Broad River into an emerging creative haven.

Josh Copus is one. A ceramic artist who lived and worked in Asheville's River Arts District back when it was still a bunch of run-down warehouses, Copus is now an owner of Marshall's historic downtown Old Marshall Jail, which he and a few friends have transformed into a boutique hotel and bar that showcases the building's heritage.

Becoming an entrepreneur, a keeper of history, and a place-maker is all of a piece with his art, Copus says. When he looked at an empty, deteriorating jail building on the railroad tracks in the center of a dying town and imagined it returned to useful life with its story intact, he used the same skills and talents he brings to the making a piece of sculpture: imagination, creative problem-solving, determination, enthusiasm, and practical fabrication skills, among others.

"Seeing creativity as a resource: this is what I try to teach my students and explain to people," he says. "I do think artists are tragically undervalued as makers . . . as visionaries."

Fifteen minutes down the road, Marjorie Dial, a ceramic artist and South Carolina native who calls Portland, Oregon, home most of the time, is one of the people he's talking about. "When I stepped foot on the property, I was immediately struck by its obvious beauty, nestled in the foothills of the Blue Ridge Mountains, with creeks running on either side," she says, recalling the first time she visited the former pottery that she bought and transformed into Township10, an artist's retreat and residency. "I could picture the buildings I was going to build. The tobacco barn that was fallen down—I could envision having that restored, and having it be a place for music." Like Copus, Dial's vision was more than aesthetic, it was about building a creative community. "It wasn't a place for me, personally, it was for community building. I had this feeling of stewardship."

Today Township10—on the former site of potter Alex Matisse's East Fork Pottery—hosts a long-term resident artist and caretaker as well as shorter term residencies for artists, curators, writers, and other creative people steeped in the world of art. "I'm not an entrepreneur," Dial says. "This is not a business. I'm interested in building community, and interested in the different forms of exchange that happen among artists."

Rob Pulleyn clearly had a similar idea when he saw an abandoned, 1925-era high school building—situated, improbably, on Blannahassett Island, a ten-acre teardrop in the middle of the French Broad River, across from the then-deteriorating town of Marshall—and saw its brick structure restored and filled with artists. Today, twenty-six high-ceilinged, large-windowed studios populate the building with creative people.

"A lot of the studios were classrooms, and still have chalkboards in them," says resident artist Juli Leonard, a photographer. "There was a metalsmith in my space before I got there. When I arrived, she had written on the chalkboard: 'Welcome to this magical place.' I would say that's actually true."

Dial agrees. When neighbor and chef (and winner of a James Beard Award) Camille Cogswell turned up on Dial's doorstep with a freshly baked pie shortly after Township10's debut open house, it was a delightful but not entirely unlikely surprise. "There's something really special going on around Marshall," Dial says. "The people I'm meeting are living their dreams, and bringing a purity to it." (Cogswell, for her part, is an Asheville native who left Philadelphia in 2021 for Walnut, near Marshall, to launch a new enterprise.)

The magic that attracts one of the nation's top chefs and many of its most creative artists is spread far beyond any one community. Many artists say it's in the earth and the air up here.

"I think it's a lot of things," Copus says. "I think the land is magic. The place is special. You feel it when you're here. These mountains are so old, and so deep. And then there's that momentum." He's speaking of the groundswell that turns a charming but once sleepy city like Asheville into a community of art; that makes a near ghost town like Marshall come back to life; that spreads like pollen, making art bloom in places hidden.

"There are a lot of artists out here," Leonard says. "But you have to find them. They're often hermits—they really draw from the natural environment, and they're very humble about what they do. They're not going to brag about themselves, or even tell you. You have to ask."

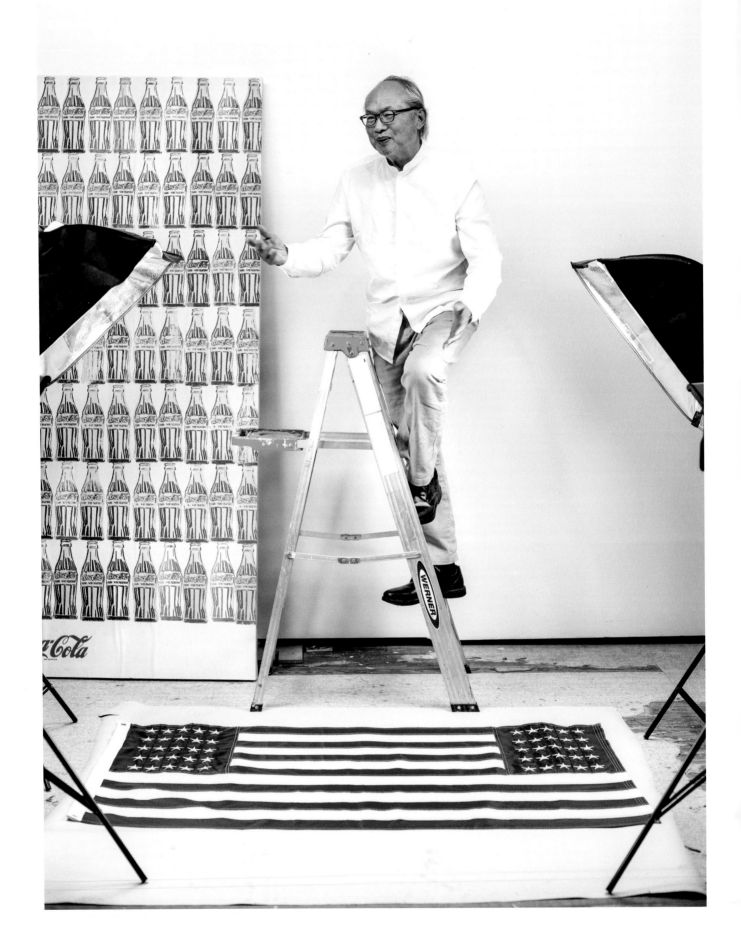

MEL CHIN

The only visual artist in North Carolina ever to win a MacArthur genius award, Mel Chin manages to hide in plain sight in his home state, where only the most art-informed even know he's here.

Tucked into a distant corner of Yancey County near the Tennessee border, this world-renowned artist has space and time for his creativity to expand and his engagement with the wider world to ignite. His poetic and massive public sculpture, augmented reality, subversive video, collage, and interactive installations—works that address issues as wide-ranging as climate change, political divisiveness, the environment, community health, and the Black Lives Matter movement—are conceived of and often constructed here, on the grounds of his sprawling, leafy compound.

Chin says his conceptual work is a tool for civic engagement and a way to raise awareness of social issues. Through art, he believes questions can be asked and possibilities raised in uniquely effective ways. "I have always described the practice of art as providing an option, as opposed to an answer," he says, sitting back in the shade of a porch at his stone house on the grounds. Ivy and overgrown shrubs blur its edges. The Cane River rushes nearby.

He was here in 2019 when the MacArthur people called to tell him of his remarkable award, including its no-strings-attached check for $650,000. Chin "is redefining the parameters of contemporary art and challenging assumptions about the forms it can take, the issues it can address, and the settings it can inhabit," the Foundation said in announcing its decision.

"When people ask about what inspires you," Chin says, "I no longer speak in terms of inspiration, but of being compelled. Because how could you not?" The issues that compel him are not necessarily new, he points out, but they're freshly in the headlines, which provide new opportunities.

Remote as he is, much of Chin's work is done in collaboration with others, near and far. His sixty-foot-tall animatronic sculpture *Wake*, which resembles both a shipwreck and a whale skeleton, was created with UNC Asheville students, and was installed in Asheville's South Slope after forming the focal point of a larger installation in New York's Times Square. There it was accompanied by *Unmoored*, a mixed-reality mobile app he designed with Microsoft that depicted the square as if it were twenty-six feet under water, submerged by rising sea levels. It was one of several installations in a New York City–wide survey of Chin's works in 2018.

The creative expression of scientific information and the use of technology to inspire empathy is a Chin hallmark. One ongoing project uses plants to remediate toxic metals from the soil; a Mint Museum installation used oceanographic data to create "cinematic portraits" of the Atlantic and Pacific Oceans; a

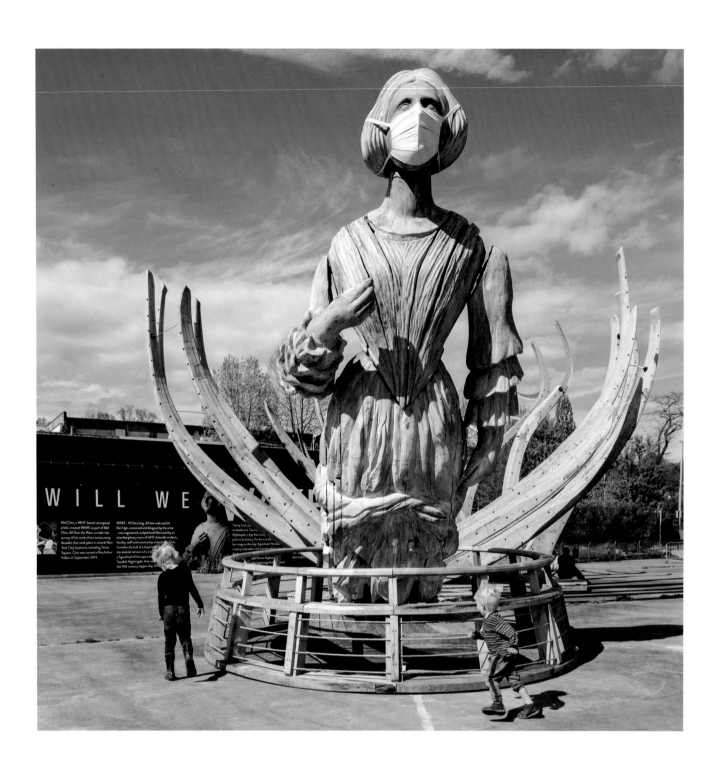

Wake, by Mel Chin, as installed in
Asheville's South Slope, 2021.

viral, community-based work circulates hand-drawn $100 bills to draw attention to lead contamination in soil, water, and housing. "You could say that I'm involved with the process of bridging science and community," he says.

Community in the traditional sense seems far removed from his remote corner of the world, but Chin's dogged social conscience, regular travel, wide network, and the connected reality of twenty-first-century life keep him plugged in. He's turned the stately, 1931 stone mansion at the center of his compound into a rambling archive and workshop for his many artistic pursuits. Originally built as a library and community center for the creation and distribution of local crafts, it became part of a regional study on poverty and was visited in 1934 by Eleanor Roosevelt, served as a school, and was used as a birthing hospital. The place had fallen into disuse and disrepair when Chin acquired it in the late 1990s as an inexpensive place to store his work. A few years later, he left New York and moved here himself—not into the mansion, but into the relatively modest house a few feet away, one originally built for the hospital's chief doctor.

Chin says he was drawn to this part of the country not just for space and the chance to live deeply within the natural world, but also by the region's history of racial injustice and his own lifelong commitment to fighting it. The American-born child of Chinese immigrant parents, Chin grew up in Houston in the 1950s, worked at his parents' grocery store in the city's predominantly African American Fifth Ward, and became aware of and thoughtful about issues surrounding race from an early age.

"To be engaged in the world," he says, "it's OK to be in places where the engagement is very real and uncomfortable." Lately, that engagement transcends geography. "It's an important time," Chin says. "We're at this bridge. It's about consolidating a commitment to actually begin again, listen more, and re-orient actions, and respond." The role of an artist, he says, is to "excavate" the questions such issues provoke, provide a starting point, and draw collective attention. Still, Chin points out that from his perspective, the "job description of artist" is constantly evolving. "People think it's kind of funny when I say that I'm still trying to be one, to be an artist. But I mean it, actually." ∎

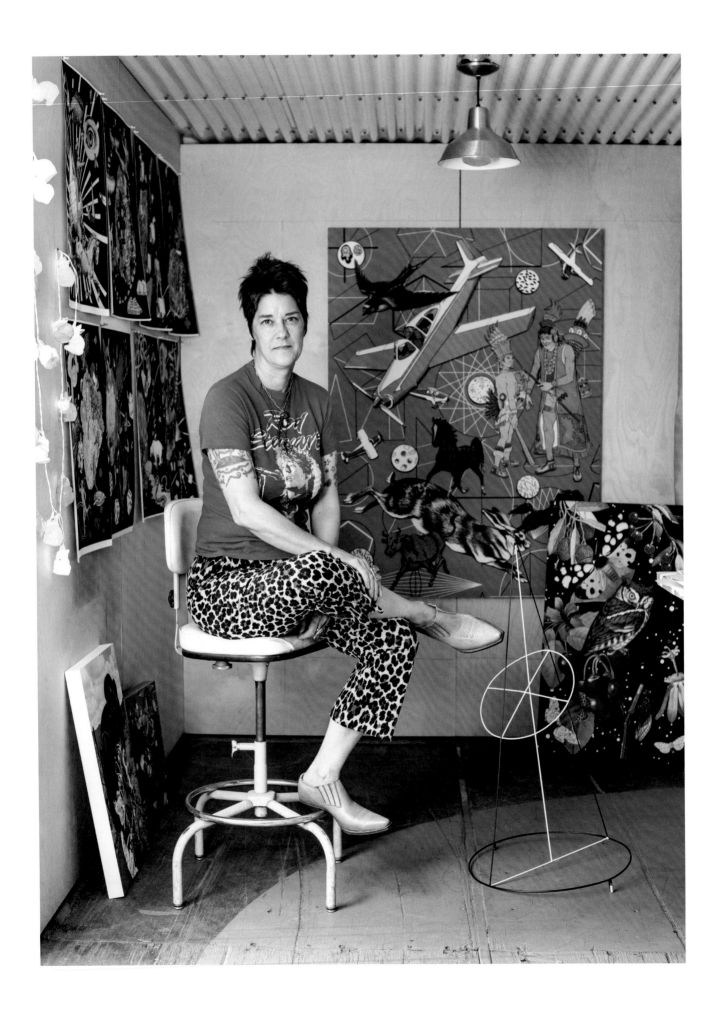

ANNE LEMANSKI

SPRUCE PINE

If you've seen any of Anne Lemanski's cosmic, colorful animal sculptures in person, you know they look as if they might twitch, or pounce, or slink on by. The skins that cover them, psychedelic prints and unexpected patterns, somehow add to this unlikely effect. Perhaps her multicolored tiger, or her ocelot, or her amazing rabbit, has emerged through a looking-glass portal from some magical realm and wound up in our own?

You're not far off.

Lemanski's Spruce Pine studio is in fact an otherworldly laboratory of creation where she doesn't just make an animal, she learns it inside out. She studies its physicality and psychology, figures out how its haunches tense when it sits back, how they loosen in a run, how its brow might scowl at distant prey. Then she replicates all of that with copper rods she bends, cuts, and welds into a three-dimensional sculpture, an armature. In an upstairs made of shipping containers, another act of creation happens, guided not by realism but by intuition. Here she will create a skin for that armature, make it out of digital photographs or prints or collage or all three, and print it on paper. She will draw and cut a pattern as if she were making a dress or a suit, and sew it all on, piece by piece, with artificial sinew. Her tools, simple ones, she has used for decades. The same pair of wire cutters for thirty years. The same X-Acto knife. She has no assistants.

On a warm and wet spring weekend, Lemanski is learning mink. Her giant mastiff, Dill, sits nearby. Photographs of mink in every position and resolution surround her, filling a wall and all the tabs on her computer. She's learning about what minks eat, how they're bred for coats, about the recent killing of 17 million COVID-infected mink in Denmark. "Millions! I'm not exaggerating. I was horrified." She shivers. She has entered the world of mink and she is living in it. The armatures for a few mink in different positions are underway; one is complete. She holds it in her hands. "Once the armature is done, that's the most important part of capturing the animal. I ripped this one apart like three times. And finally, one day, it just clicked."

In the shipping containers upstairs, where she'll make the mink's skin, is also the place where Lemanski creates the collages that form a significant counterpart to her sculpture. Composed of illustrated images X-Acto knifed from the pages of pre-1970s textbooks, comic books, picture books, and children's encyclopedias, they combine giant squid with convertible cars, pigeons with mermaids, skeletons with alphabet blocks, chewing gum with polar bears. There are butcher's maps for cuts of meat and colored-dot tests for colorblindness, and constellations and cockatoos, a century's worth of illustrations shaken and stirred into a cocktail of nature and man, science and myth, technology, geometry, and

FACING
Anne Lemanski in her
Spruce Pine home studio.

THE MOUNTAINS 31

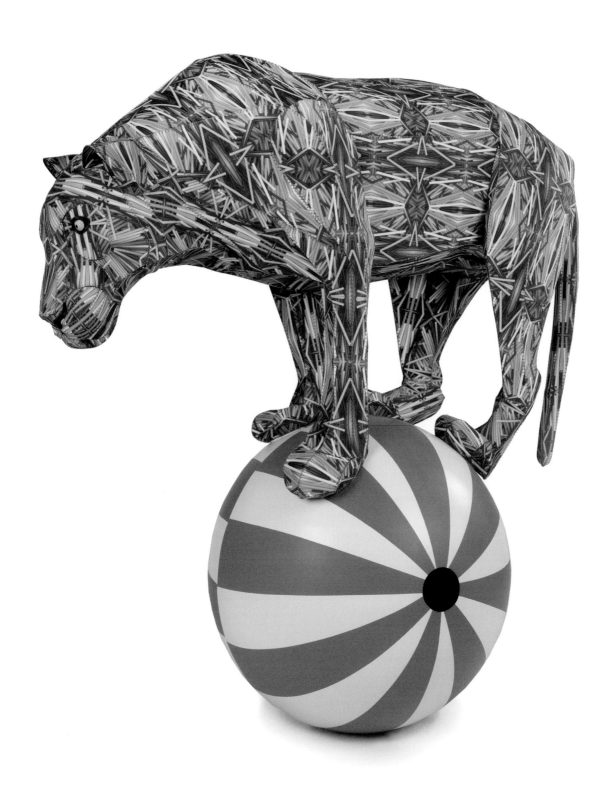

Tigris T-1, by Anne Lemanski, 2018. 64 × 61 × 30 in.
Copper rod, archival print on paper, artificial sinew,
epoxy, and plastic. Photograph by Steve Mann.

things that are cool. A series made during COVID, *Metaphysical Mineral*, explores the properties of a series of eight different minerals. *Quartz* includes a high diver in a '50s-era swimsuit, a white stallion, a swarm of bees. *Sulphur* gets a winding snake, a stick of dynamite, a cigarette.

These individual component images are one-of-a-kind and cannot be replicated; to do so would be to lose the unmistakable texture and character of the Ben Day dots used in printing from the 1950s to the 1970s (made particularly recognizable by the pop artist Roy Lichtenstein). "I've tried [copying them] and it just doesn't work," she says. "And I love it. I just love it." So when she uses these images in a collage, Lemanski tacks them down lightly with a little loop of tape so she can take them off and use them again. This technique also adds to the three-dimensional look of the collages once they're printed.

She credits a residency at Charlotte's McColl Center with launching this kind of work. Inspired by the possibilities of the Center's large-format digital printer, she made twelve small collages and printed them in huge dimensions. These prints ended up forming the basis of a solo exhibition at the Center which also included sculpture, in this instance a "three dimensional collage" that incorporated some of the printed collage animals themselves. A four-inch image of an impala in one print, for instance, became a life-size impala sculpture in the center of the room which she "skinned," in a meta twist, in digital prints of the tiny image's own fur. "That was a challenging piece to make."

So was the tiger on the ball which was acquired by noted collector Fleur Bresler for donation to Crystal Bridges Museum, a career-catapulting moment Lemanski is still pinching herself about. Her work is also in the permanent collections of the Mint Museum, the North Carolina Museum of Art, the Asheville Art Museum, and in many private collections.

What's next is what excites Lemanski most. "I believe my best work is ahead of me," she says. "I really am looking forward to the work I'm going to make in the future. I think it's going to be on a large scale, and I just want to keep pushing the work forward. It's the unknown of the future that keeps me going." ∎

PETER GLENN OAKLEY

There are no goddesses, saints, or angels in Peter Glenn Oakley's oeuvre of marble sculpture. Oakley's gods are the icons of the industrial and information age: an iPhone, a stapler, a cassette tape. A personal computer, a typewriter, a camera, a gun. A modern pantheon, as all-controlling as any sky full of gods, and all in a meticulously detailed, trompe-l'oeil-level, hyperrealistic style so convincing that a viewer can easily be tricked into thinking they're looking at the real thing. And thinking, as they do, about the significance of the object that has been so laboriously, beautifully rendered, and what function it serves, and what it means if that function is removed, and all that's left is a simulacrum.

"The more I can get somebody going like this," Oakley says, leaning over to stare at and study the 1940s-era Leica III he's carving from a block of black marble, "their eyeball is just moving around on this thing that they thought they had seen a thousand times and didn't care about. But now suddenly it's an interesting visual experience."

In an age when marble sculptors typically design their works digitally and let a robot do the major carving, Oakley buys his marble from Italy in blocks,

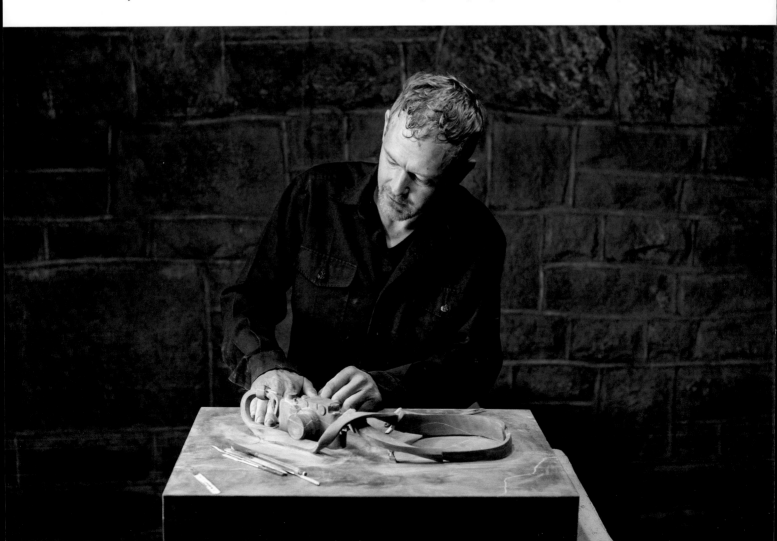

measures and maps it, and does the laborious, time consuming, highly risky work of carving it with his own hands.

Oakley does this work in a damp warehouse on the Swannanoa River that most recently served as home for squatting hippies who left behind rainbow-striped, tilting walls made of unmortared bricks. He does it with tools older than himself, like a height micrometer designed to make machine tools, and beside an ancient, fired-up woodstove he installed himself, with '70s-era electronic music turned up high (on this particular day, Kraftwerk, German pioneers of the genre).

His sculpture has been exhibited at museums including Crystal Bridges Museum, the North Carolina Museum of Art, SECCA, and Telfair Museums, and is held in many museum and private collections. An Appalachian State University graduate and former rock climber and stonemason, Oakley started tinkering around with sculpture in 2003, "a couple of figurative things like a head and a hand—I ruined those." He was dissatisfied with the work, but also with the fact that he only had enough stone to carve a piece of something, nothing in its entirety.

Meantime, he was also working as a carver of signs and gravestones. The work provided him with access to old, damaged gravestones, and it was when he had one of these in his hands that he thought: "I could do a Styrofoam takeout box. It wouldn't be miniature, and it was something I could do with the materials I had."

There were layers of meaning behind it, too, but Oakley's not keen to discuss too deeply the symbolism of his work, preferring that viewers look hard and

draw their own conclusions. The guns he's carved include a standard-issue police officer's Glock, a surefire attention getter. "Whether you like guns, or whether you hate guns, either way, it's like: there is a gun in the room. And then you realize it's a stone sculpture. And now you're looking at a sculpture with an endorphin rush. And that's pretty cool."

The Swingline stapler he's finishing is not just an interesting shape, he believes it represents an important tool in the evolution of data management, a first collating machine. Also, like all of Oakley's subjects, it was designed and fabricated by humans. Already "made," in a sense. "There are designers who sat around and discussed this and made it look that way. It's already been addressed."

The Leica he's carving is a beautiful object. It is also a paradox, a machine made to look at and record the world rendered blind, transformed into an object itself to be observed. The piece also makes reference, he says, to the Leica Freedom Train, a covert operation funded by the founder of Leica that reportedly smuggled hundreds of Jews out of Germany in 1938 and 1939, before the Holocaust.

The piece is almost complete, but to finish it, he'll have to carve away a vital little piece of marble that supports its curving strap. Oakley's not worried.

"I like a little bit of risk," he says. ▪

CRISTINA CÓRDOVA

PENLAND

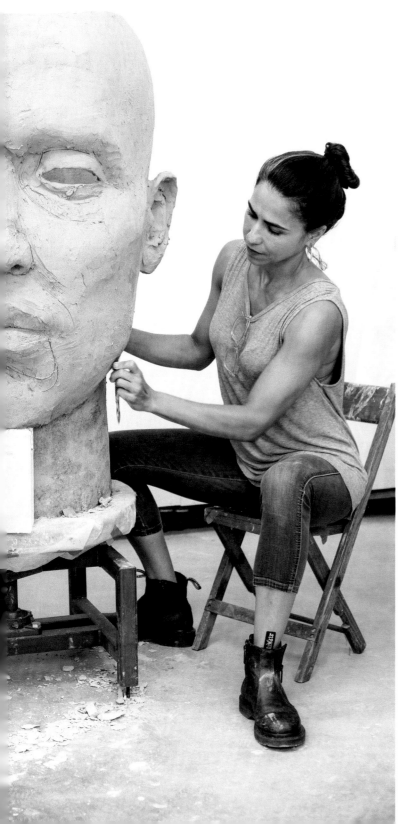

"*I was always very creatively inclined,* and very restless," says sculptor Cristina Córdova, as she moves—glides, really, with nothing like restlessness, with ease and focus—around a massive head she's shaping out of clay in her Penland studio.

She molds it with elegant hands, quickly, decisively, certain about what she wants this clay to be. Like the work that has made her name, it will become real, it will be soulful, thoughtful, disarming, alive. Its eyes will be hollow, but they will express sadness; its face will be impassive, but it will express stoicism.

Córdova credits her mother with nurturing her creativity from an early age, steering her toward the career that has made her one of the most respected sculptors in North Carolina and a pillar of the Penland community since 2002. She credits a ceramics teacher with first showing her the potential of clay, the possibility that it could go beyond representation to "embody any idea." At that point, she says, "The material revealed itself to me in this really exciting way. And I never looked back."

Still, it took some time to settle on her subject. Gradually, "I started to become a little bit more excited, more empowered to start specifically to focus on the figure." It was a focus borne in part by her heritage. Growing up Catholic in Puerto Rico, she says, in a house with literally hundreds of depictions of saints all around her, the idea of using a figurative work of art "as a way of harnessing your emotional energy and pulling it into something sacred" was a

Cristina Córdova, photographed in her Penland studio with a work in progress that became *Vestigio*, 2020. 40 × 29 × 28 in. (pedestal 30 in. round). Ceramic.

mechanism she'd internalized. Though her current work is not religious, Córdova finds that it's understood "at a different level" in Puerto Rico, where "Catholicism is not a choice, it's woven into the culture, so people come to the work with a shared insight."

Her subject may come naturally, but that doesn't make it easy. Depicting the figure in clay is a challenge. Early in her career, Córdova found herself stuck in between two worlds, the sculptural tradition of working in the round with a live model, and the more organic ceramic tradition. Eventually, she settled on a hybrid approach, one that includes not a live model but a series of blueprints (as seen on the wall behind her) that provide her with the measurements and dimensions she needs to create a sculpted three-dimensional figure.

The head before her—not necessarily a man nor a woman, as is sometimes the case with her figures—is imagined instead of representational, and so its blueprints are designed merely to keep her to scale, leaving room for improvisation. In other instances, she uses a series of photographs to help her create more precise blueprints.

Córdova gestures to the head before her: "I'm called right now to do things that are big, almost monolithic. I think it has something to do with what we are experiencing [with the pandemic]. I'm not interested in intimate, or narrative-oriented work. I'm interested in big statements."

Big statements seem called for by the importance and magnitude of our internal worlds in such a situation, she says. "The isolation, the uncertainty, the newness—to have to take all this in without being able to respond in our normal ways . . . recourse is very limited. So you're holding this inside of you, and that's all you can do, is hold it, and witness, it, and be with it. And so we need a big container for that right now. So I'm making big containers."

It's not a simple process. Beginning with a large doughnut-shaped piece of clay that's laced with sand and paper pulp for stability and structure, Córdova then patches in a perpendicular slab, and then another, and then adds rings of clay, providing "the basic topography." From there, she more fully fleshes out and articulates the shape of the head and face.

Having worked "all over the place in terms of scale" over the course of her career, the process of working in such large dimensions now excites her. "This to me is a starting point. I really want to get bigger. I have no idea how I'm going to do that."

Córdova's award-winning work is in the permanent collections of the Renwick Gallery of the Smithsonian American Art Museum, the Museum of Contemporary Art of Puerto Rico, and many others. ∎

DAVID HARPER CLEMONS

David Harper Clemons in his Spruce Pine studio.

On a summer day in his storefront studio, David Clemons grips a piece of sterling silver with a pair of calipers and blasts it with a flame. The metal quickly turns scarlet, and then soft, and then he twists it, slowly, into a gentle curve.

It will become a brooch with a refined but organic shape, like many of his works of art. It is a wide body of work, encompassing pieces in metal and other media: fine jewelry like the pin in his hands; conceptual pieces that address racial identity and social issues, like a sterling silver paper sack crumpled around a forty-ounce bottle of malt liquor; graphic design and handmade books that tell tales he's written and illustrated; vessels of exquisite shapes, sometimes hiding secrets (a coiled snake within a cup); fanciful, elaborate contraptions he calls "devices and oddities" that are influenced by his fascination with the Victorian era; and unapologetically beautiful and purposeful objects like light fixtures and cutlery.

Clemons says he is fascinated by traditional metalsmithing techniques and by challenging those traditions, and also by making a social statement with his work and asking hard questions. He is inspired by the intrinsic qualities of his materials, which often influence what he does with them.

He picks up an articulated, geometric necklace made of pewter and oak. Its design, he says, was informed by the properties of both materials. Pewter has a low melting point, around 425 to 450 degrees, while wood doesn't scorch until it hits 500 to 550 degrees. "I realized I had a range where the pewter

was going to work with the wood and not just burn the wood up." He had another idea, too: the pewter he was using was alloyed with antimony, which expands slightly when it transitions from a liquid to a solid state. "As the metal cooled and expanded," he reasoned, "it would lock together with the wood." So he made crenellated cut-outs in the wood, like puzzle pieces, for the metal to expand within. The result is so seamless it almost looks as if the oaken pieces are dipped in pewter, not joined up to it.

It's a cerebral and practical approach to art-making, not unlike his first creative efforts.

"My initial interest in art was comics," says the El Paso native. "I love comic books. It was something I first got into as a way to help with dyslexia. I couldn't always figure out the words, and sequential images

helped me. But then I really would just kind of get lost in the images." It was a natural next step to create his own drawings, and in doing that, he was also following in a family tradition. "One of the things I feel fortunate about is that I have a lot of artists and craftspeople in my family," he says. "I don't think a lot of minorities have that as an active role model."

His grandfather, for one, was a custom gunstock smith who carved woodwork on guns for the US Army, and showed Clemons how to try his hand at the craft. His aunt was a custom tailor, his grandmother a quilter. "There was always an emphasis on the arts, and crafts, and the idea that you could actually provide for yourself doing that." A respect for craft and technique informs all his work, from representative or functional pieces to those that are more conceptually driven, often focused on social commentary.

Lately, he's focused on the latter, particularly around the subject of racial identity. His message and his medium are matters he always considers carefully, but especially with these pieces. "I don't ever want [these works] to come from a place of blatant or pure anger, because that's perceived by your viewer. And then the message you're trying to get across gets lost. It gets lost in the raised emotional stakes you put them in."

He considers: powerful art "should work like great comedy," he says. "Think about Richard Pryor. He had some really tough stuff that he dealt with. You laughed at it. But then a couple of hours later, or the next day, you're still ruminating over that. I didn't even realize, wow, that was a really deep cut. You know?" ∎

A necklace of pewter and oak held by artist David Harper Clemons in his Spruce Pine studio.

CHRISTOPHER HOLT

ASHEVILLE

When Christopher Holt spent two years creating a giant fresco to depict the often overlooked people who make up Asheville's Haywood Street Congregation, he was making a bold and lasting statement about human dignity.

He had shared weekly meals with many of the hundreds of people who dine regularly at the faith-based nonprofit devoted to the homeless and working poor, and considered them remarkable as individuals and as a community. Holt knew he wanted to commemorate these people who are regularly pushed to life's margins, and honor the place that nurtured them, too. He knew the medium had to be fresco. "Fresco has a living quality that is unlike anything else," he says. "This medium was made for a place like Haywood Street. You can see why in Italy during the Renaissance it became the main medium, because of the way it can capture and tell a story—and remain that way."

A fresco represents a uniquely indelible commitment. Unlike a mural or painting, a fresco is an intrinsic part of the wall itself, literally part of the plaster. The Reverend Brian Combs of Haywood Street Congregation agreed that an enduring work of art was fitting for his community. "What poverty makes invisible," he says, "art makes immortal."

"Fresh" in Italian, the word "fresco" refers to the wet plaster that captures an image permanently and with an unmistakable glow. "It's what really holds the light and makes fresco unique," Holt says. "And gives it its power."

Christopher Holt with *Haywood Street Fresco* at Haywood Street Congregation in Asheville.

He came to the project well prepared. He'd spent a decade as an apprentice to Asheville fresco master Ben Long, one of the nation's few expert, Italian-trained practitioners of this 1,500-year-old art form. Long taught Holt every step of the laborious process, which includes meticulous compositional mapping; sketches called cartoons; the making of plaster with lime, sand, and local horsehair; laying it on in layers; underpainting; color testing; and the final, no-going-back, indelible painting itself. Rev. Combs helped Holt forge the plan, and the artist then spent a year crafting the fresco's composition, drawing portraits of regulars and volunteers, and putting together a five-strong artist team to make the twenty-seven-foot-long, ten-foot-high work of art a reality.

It was the project of a lifetime, but Holt's artistry is not limited to the medium. One recent project had him silver-leafing and oil painting the narthex of the Greg Poole Jr. All Faiths chapel at Dorothea Dix Park with more than fifty vignettes of the history of the site. Part of the chapel's transformation into the park's new welcome center, the commission involved months of research and, Holt says, another opportunity to honor a place that restores the spirit.

He prepared for it in some of the ways he'd prepare for a fresco, with life-size sketches on ten-foot-high paper tacked up on his studio walls.

And the natural world lures him as well. Holt spent a chunk of time during COVID lockdown on the French Broad River, painting en plein air. "2020 was meditative," he says. "I was painting, and it was freezing, but it was so freeing. I am a mountain boy, and so that part of me is always calling my name. And I think that's why I'm still here. I do all kinds of travels, but always come back to the mountains." ∎

Haywood Street Fresco, by Christopher Holt, 2018–19. 9½ × 27 ft. Fresco at Haywood Street Congregation, Asheville. Photograph by John Warner Photography.

JOSHUA ADAMS

CHEROKEE

Joshua Adams, a member of the Eastern Band of Cherokee Indians, says love of his heritage fuels him to make art. "The preservation of the culture is the jumping-off point," he says, "not only because I'm Cherokee and was born and raised here, but because from my perspective, that's the best blessing an artist can have: an ancient culture to draw upon to create things."

The things he makes are primarily sculpted in wood, but Adams also carves stone, paints, and works in photography, pottery, and 3D printing. Ancient Cherokee legends a key source of inspiration. "It's just like finding gold. You read that legend, you get that image of a piece of art. It's like gold."

Lately, he's been researching a legend called Tsu Ka Lu, or Judaculla, which is represented by a petroglyph on a giant rock outside of Cullowhee, North Carolina. The largest petroglyph in the state and one of the largest in the Southeast, Adams says the Cherokee believe that this carving tells the legend of "a giant spiritual being that falls in love with a Cherokee woman" in an ancient village, the ruins of which have been discovered on the Cullowhee site of Western Carolina University. Adams is working with the university, which is his alma mater, to commemorate the site with works of art.

"It's a learning opportunity," he says. "It's crucial for Cherokee culture to find these sites and learn from them."

Growing up near Lake Junaluska, where he lives today, Adams was surrounded not only by Cherokee culture, but by Cherokee art. "I think it was kind of preordained by my mom" that he become an artist, he says. "My family are all woodcarvers. At family reunions, there would be wood, and knives, and carving going on . . . my grandfather had a carving room at his house. Absolutely, I knew, from really early on, that I would be an artist."

As a teacher of traditional woodcarving at Cherokee High School, Adams says he's constantly considering the ways a multicultural existence influences Cherokee culture. As a teenager, he loved graphic novels and graffiti art, and still finds inspiration in those forms of expression. But the chance to pass down a love of his culture is what excites him most. "It puts history in a different light when we can see that this was all here" for so many centuries before our lifetimes, he says. "It's pretty astounding."

Adams's work has been exhibited all over the world, and won many awards, including First Place in the Sculpture division at the renowned Southwestern Association for Indian Arts' Santa Fe Indian Market,

FACING
Joshua Adams carving in his classroom at Cherokee High School.

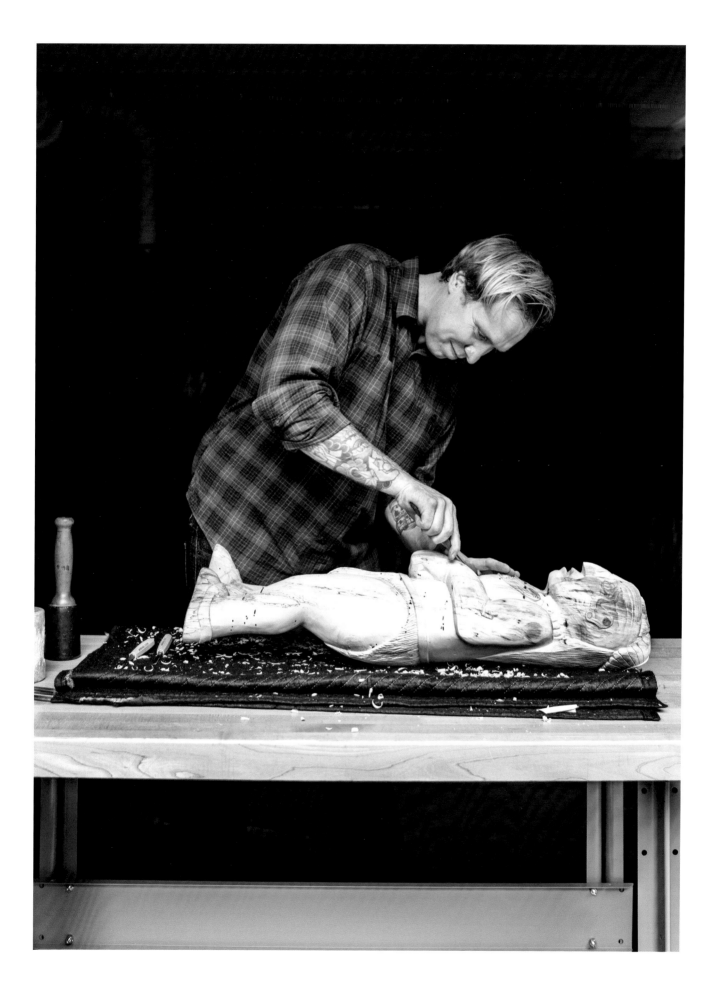

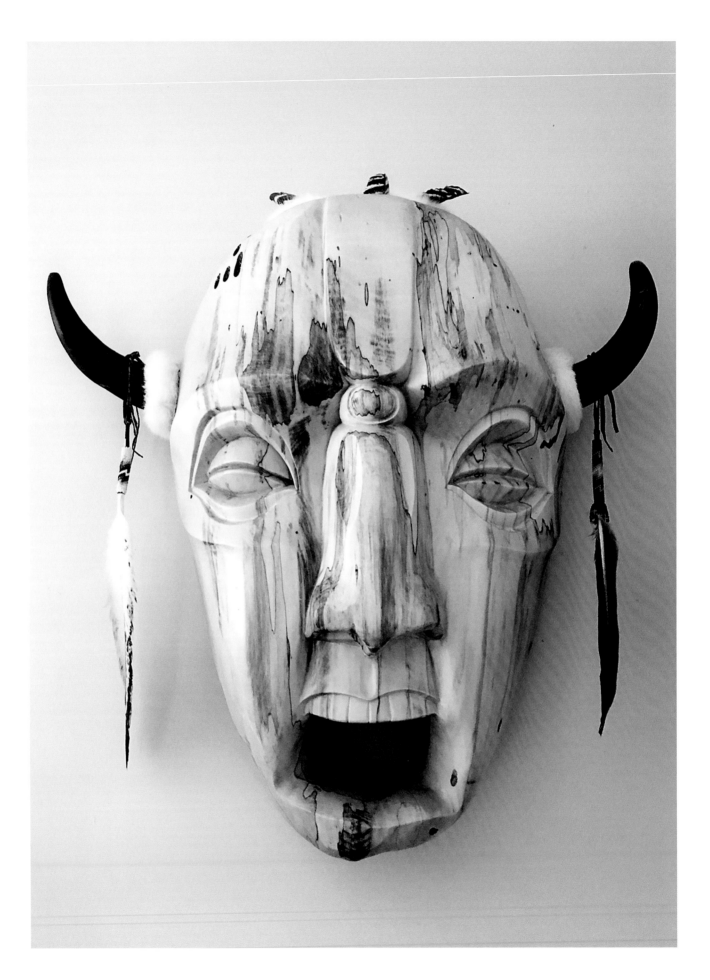

the world's largest Native American art show. His work has also been the subject of a solo exhibition at Western Carolina University and is in the permanent collection of the Asheville Art Museum. In 2018, he curated *Renewal of the Ancient*, a showcase of millennial Cherokee artists put together by the Museum of the Cherokee Indian and the Cherokee Preservation Foundation. ■

ELIZABETH BRIM

PENLAND

Elizabeth Brim is so singular a person, embodies so many contradictions with such delight, that it's hard to know where to begin in describing her, or how to accurately do her justice with words. She's a rebel who overflows with graciousness. She welcomes visitors to her dark and sooty studio with a smile sunny enough to shine through a COVID mask. Her hair is neatly French-braided and tied with a silk ribbon; her Carhartt jeans are smudged and baggy. She may be known for wearing a string of pearls while she forges iron, but she doesn't really, not every day, anyway. The heat's not good for them. But the ribbon in her hair? She's naked without it.

The technique she uses to make her delicate work is macho and medieval, the tools even more so. One is a great green beast of a machine, a power hammer built in 1909 that she threw a 100th birthday for twelve years ago. Others include a coal forge to heat the iron up, an anvil to bash it on, the hammers she's made herself.

"See that wiggly looking thing on that top shelf over there?" Brim asks, pointing to an abstract, heavy iron sculpture. "That was the first sculptural piece I made. And then the next thing I made was a pair of high-heeled shoes. So I got into my girlie accessory stuff pretty quick." A Grimm's fairy tale inspired the shoes, the one about the twelve dancing princesses who sneak out of their castle every night "and dance their shoes into tatters" only to be followed by a man who learns their secret and gets to pick one to marry. "Well, I thought, if they had indestructible shoes, they could party forever."

She entered the shoes in a blacksmithing art competition in Madison, Georgia, and beat out a field of men in overalls with fire pokers to earn first prize. She laughs out loud with joy to recall that 1988 victory today. An apron with twirling strings and a delicate tiara followed; then a satin cushion for the tiara to sit upon (a piece that required inventing a technique to compress air between two seamed iron squares). Was there a message in these works? "Well," she says, nonplussed, "it's just what I would think of to make."

All the while, Brim focused hard on refining her technique, perfecting her hammer skills. More than anything, she says, she wanted to be as skilled as any other blacksmith. Along the way, she built a body of work that subverts not only fairy tales but antiquated gender expectations in ways that are clear as well as subtle, and all tied directly to the dangerous, difficult process that forges them, the heavy material that composes them, and the disarming woman who makes this trailblazing, difficult, unlikely path seem like a delightful, funny, even natural thing to do. She'd say it first: Penland made it happen.

Brim first came to Penland forty years ago as a printmaker. Her goal was to learn ceramics so that she could get a job teaching at Columbus College, but

FACING
Elizabeth Brim in her
Penland home studio.

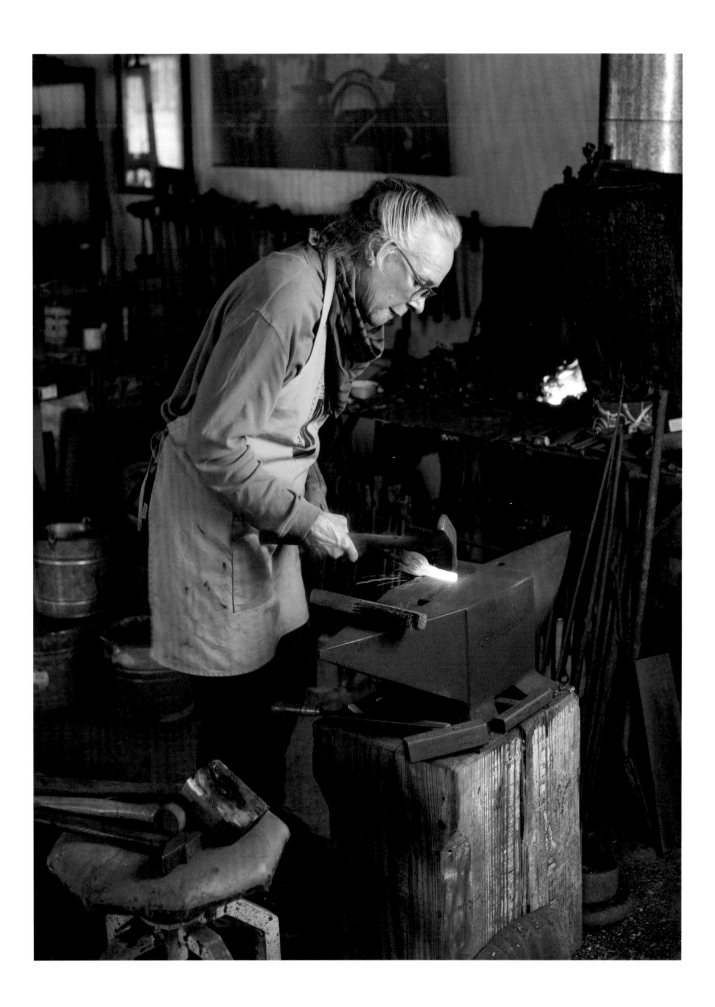

something bigger happened: "I fell in love with Penland, the atmosphere, hanging out with cool creative people all the time, and working in the studios, and I also loved the landscape, and the mountains, and the flowers. So I started coming back."

One of the first things she did was take a metal-working class to learn to make jewelry. In that class, they also made tools. "Here's one I made," she says, taking one off a rack. "We heated up these ends, and hammered them flat like this, and I thought: 'This is FUN.'" She liked everything about it: "I liked that it was more physical. I liked that it was dirty. I liked the way the studio smelled."

So she went back and asked the men who worked there if she could make a hammer. "They said sure and handed me a chunk of metal." She spent a week, all hours of the day, "working, working, working, as hard as I could, by myself, and I wasn't getting anywhere." Maybe she just wasn't strong enough, she thought. Maybe she didn't have what it took. Maybe she should go back to jewelry making. But she returned to the iron studio one more time. This time, she realized that the forge she was working on was blocked with a clot of old coal called a clinker. "There I was beating my brains out on metal that was cold." She got the clinker out, the metal heated up, and the

Tutu, by Elizabeth Brim, 2002. 26 × 24 × 12 in. Forged and fabricated steel. Photograph by Tom Mills.

result was the respect of the blacksmiths in the shop, the hammer in her hand today, and the career that has made her name.

Brim's work has been exhibited widely, is in many museum collections, and has won countless awards. She has taught blacksmithing not just at Penland but at schools and workshops all over the country. Many learned of her work on Anthony Bourdain's *Raw Craft* series, where she and her art were the subject of an episode.

It's not a path she could have imagined even after she got that first taste of forging iron. She recalls the moment she called her mother to tell her she was going to take an actual blacksmithing class: "She got real quiet for a minute. My mother is a very proper southern lady. She's ninety-four years old right now. So she got real quiet. And then she said: 'Elizabeth. I do not approve of that. That is not a ladylike thing to do.' So I told my friend Tom, who's a jeweler, that my mother didn't think it was ladylike, and I was concerned that my mother didn't approve of what I was doing. And he said: 'Ahh, just wear a string of pearls and you'll be ladylike.' And that's what I did." ∎

Elizabeth Brim holds a forged flower in her Penland home studio.

MARGARET CURTIS

TRYON

You can't study a Margaret Curtis painting without going on a journey. There are distances to travel and burdens to carry. Powerful forces are at work; they must be faced, acknowledged, vanquished. It all ends well, though. It ends in survival. That much is clear, because the protagonist has lived to tell the tale.

At the end of a small street on a hill in the lovely town of Tryon, in a house surrounded by so many flowering plants and trees that the bees make an actual racket, Curtis lives with her husband and two sons and she paints.

What she paints is as ripe as her surroundings. Beautifully rendered, even lush, her work draws a viewer in before letting them piece together the disquieting places she's brought them. These are emotional places, drawn from memory, experience, and imagination, of childhood and motherhood and family, illness and anxiety. Something's wrong, even in scenes that should be dreamy, like family picnics or days at the pool or ladies knitting in chairs, and Curtis paints it all. The dreaminess, the wrongness.

"This is my most hopeful apocalyptic painting," she says, stopping to laugh when she hears her words aloud. Before her is a painting of a naked woman piggybacking a naked baby down an endless, unprotected arroyo. In the far distance—beyond false-front cacti and trees, beyond a rocky and rickety plywood path—lies the dark green mountain promise of shade and safety.

Margaret Curtis in her Tryon home studio.

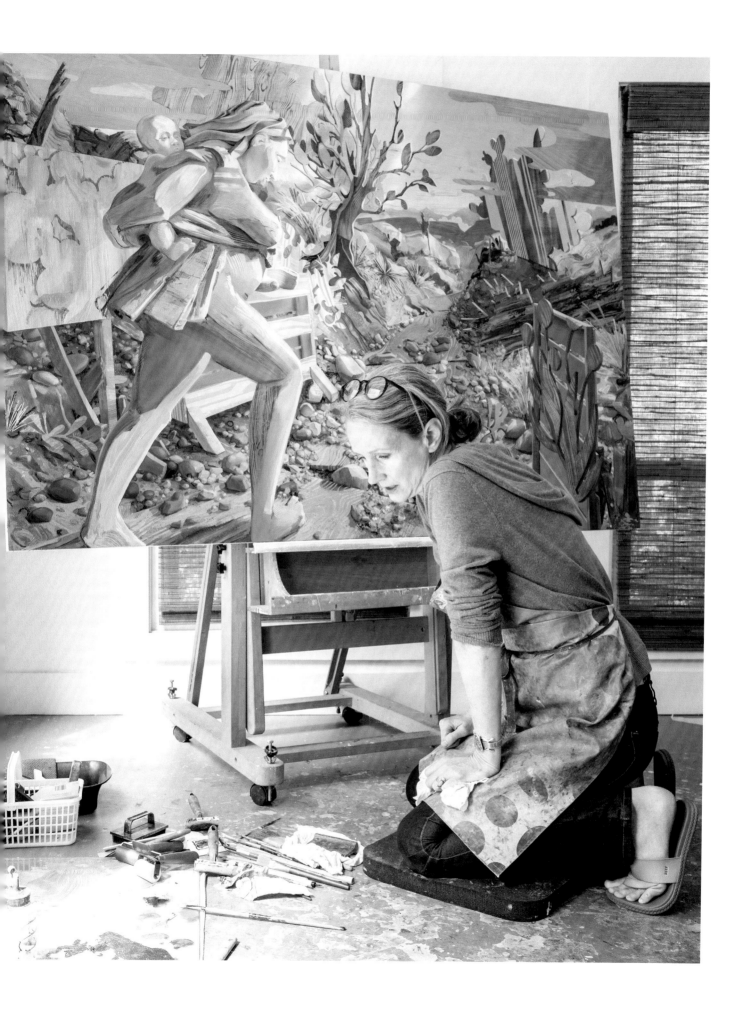

Though Curtis rejects painting as a "display of skill," she can't help but demonstrate it, even as she keeps the physical work of her paintings evident, the strokes and the textures and the time it took to make them. "I work in layers," she says. "It's my spirituality. I think we're all going to be like this little layer in the canyon wall one day," she says, pointing to a bit of desert strata, "and it keeps me humble."

When Curtis begins one of the paintings she makes on wood panel, she often lays down an underpainting of bright, glowing orange. This seems incongruous until you realize that orange is the color of flames, of heat, of energy. You can see it peek out, not only from the fires she paints so frequently, but in the bounce of light within a landscape, in the grain of the wood in a tree or a chair, in the crackle of the tension she wields like a torch.

Another surprising element in Curtis's work: the added element of print. Curtis carves and uses stamps to create textures like ropes, or wallpaper, or woodgrain, or even (in another surprise) ball fringe, that bit of frippery that trims curtains and hats and little girls' dresses. Curtis loves ball fringe. Like many of her motifs, it's got a dark side; in *Portrait of My Anxiety*, ball fringe crawls kudzu-like over the face and body of a frenetic knitter whose face is fraught with demons, her walls on fire. As with many of Curtis's works, the idea for this painting came to the artist fully formed: "I just saw this image of hands, of a figure, totally covered in knots, and the hands knitting."

Curtis's ability to turn the flash of an imagined image into a masterful painting—one that yanks a viewer in, tells them a story, and shakes them up before it slows them down again to admire, to study, to look and think and feel—is what makes her one of North Carolina's most admired painters. *Harper's Magazine* and the influential *Hi Fructose* have recently featured her work, and she's had several recent solo exhibits including at the Tracey Morgan Gallery, the University of South Carolina, Swannanoa's Flood Gallery, and the Hickory Museum.

The Ice Sculpture, by Margaret Curtis, 2019. 48 × 60 in. Oil, pencil, watercolor, spray paint on panel. Courtesy of Margaret Curtis.

But success is not new to her. As a young artist in New York, the ink on her magna cum laude Duke University degree still damp, Curtis won the kind of recognition most young artists dream of. Her work was featured in the groundbreaking feminist *Bad Girls* exhibit at the 1994 New Museum of Contemporary Art in New York, launching her into other major group exhibitions and solo ones throughout the city. She was represented by New York's PPOW gallery for many years, and her paintings were reviewed and featured in *Art Forum,* the *New York Times,* and *Art in America*, among many others.

In the decade and a half since she moved to this leafy spot at the base of the Blue Ridge, Curtis's work has grown in new directions while staying true to its bold and questioning roots. "I'm really interested in how the personal is political, or how the biographical becomes allegorical," she says. "There are these tensions that I deal with all the time, so I'm constantly having to work through them." ∎

FACING

Hoss Haley outside his Spruce Pine home studio with his dog, Rose, and Union 061419, along with other works that comprise Correction Line, his solo exhibition at Penland School of Craft in 2019.

HOSS HALEY

SPRUCE PINE

Hoss Haley's steel sculptures stand like elegant typography on the landscape, like giant sans-serif letters, semicolons, exclamation points. Linear, spherical, bold, and approachable, they're meticulously crafted of Corten steel he ships in from Alabama 10,000 pounds at a time, hauls into his studio with a bridge crane, then mashes in presses he made himself out of parts collected from a scrap yard.

Haley puts his hands on one of these machines: "It pushes about 30 tons," he says. "I can move a lot of metal with that." Not enough, it turns out, for everything he wants to do. He gestures to another: "which prompted building this machine, which pushes about 110."

It takes a lot of wherewithal, clearly a whole lot of power, and a great deal of ingenuity to turn five-foot-square sheets of weathering steel into a malleable artistic medium, to then take these rectilinear, ninety-degree parallel planes and collide and combine them with unexpected and often sudden curves.

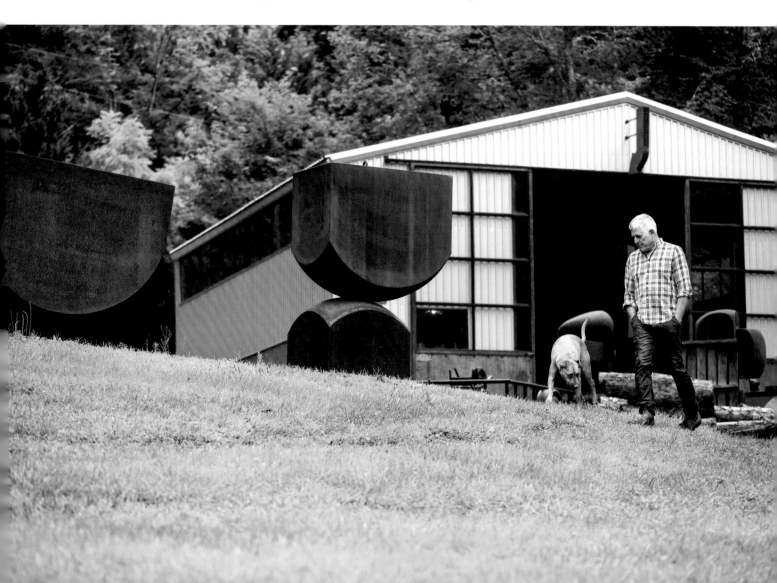

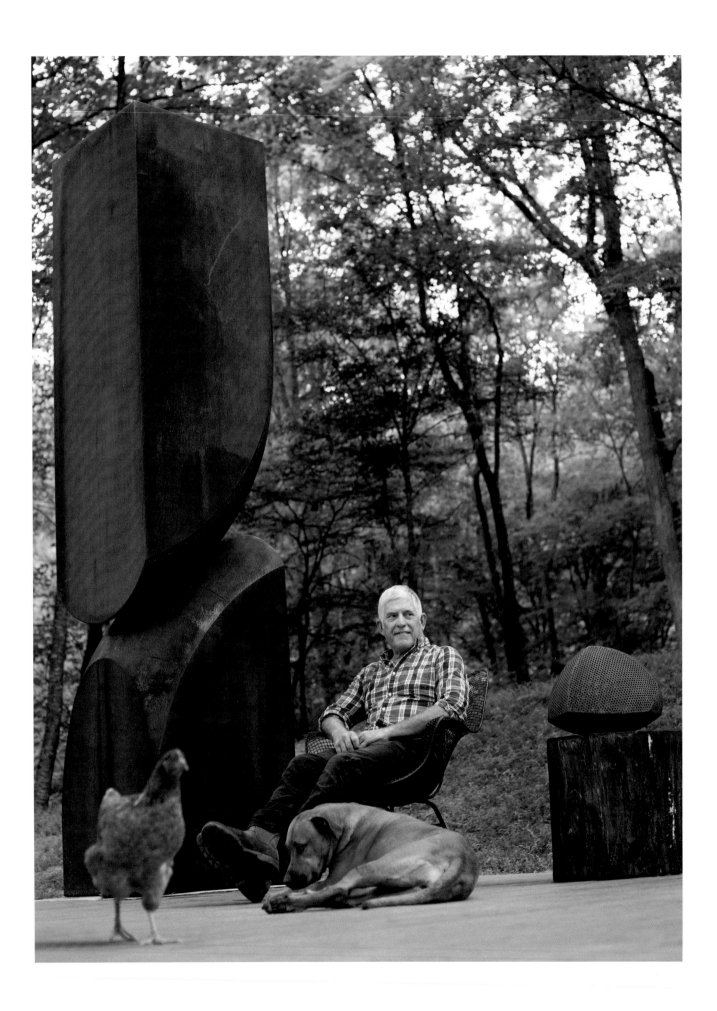

"It's the tension between those two things that I find kind of juicy," he says. That place—where man meets material, where straight and curved abut and lines diverge—has fascinated Haley since he was a boy on his family's 3,000-acre Kansas wheat and cattle farm, with its wide open vistas and curving horizon, its strict geometry of fencing and property lines. Also on the farm was a sizable metalworking shop where Haley learned to weld and make things, including machines. Including art.

Today, after more than twenty years in North Carolina, his work remains rooted in that past. "It's an ongoing conversation between myself and the machines and the material and my worldview, and goes all the way back to the fact that I grew up on a farm in Western Kansas. It's all in there. It's part of this big stew."

The machines are a main ingredient. "I needed to build the presses to do specifically what I needed from them." In the process, "they become part of the conversation." As with any tool, he says, he's wary of their power to guide or limit his creativity. "I'm always trying to think about work in a way that doesn't rely too heavily on what the machinery wants to do or is capable of doing," he says. Still, "It's a weird little dance, because I kind of have a love for the machine. So it's a constant dialogue."

Another internal and ongoing conversation for Haley involves the role of craft in the making of his art. He believes the word "craft" is most useful as a verb, and he's careful to keep it that way, "in service to the idea" rather than the point of it all. "So that if I decide to leave a weld, or take the weld away, that decision is based on where I'm trying to go with the work, not that I'm trying to show you some aspect of my ability to make crap."

It's been a long time since Haley had to convince anyone of his ability to make art, "crap," or anything else. His large public works are focal points at the Charlotte Douglas International Airport and the Charlotte Area Transit System, at Penland, in downtown Charlotte, and on the campus of NC State University, to name a few prominent spots. He's in the permanent collections of museums including the Mint Museum, the Asheville Art Museum, and the North Carolina Museum of Art, where his *Union 060719* now stands on a rise at the entrance, proudly welcoming all comers.

Some have compared Haley's work with that of the celebrated Richard Serra, who also makes massive, moving works of Corten steel. Haley credits Serra with inspiring him to consider the power of mass and volume in his work. "Serra taught me that sculpture could go beyond the visual experience," Haley says. "You could actually feel its presence." ∎

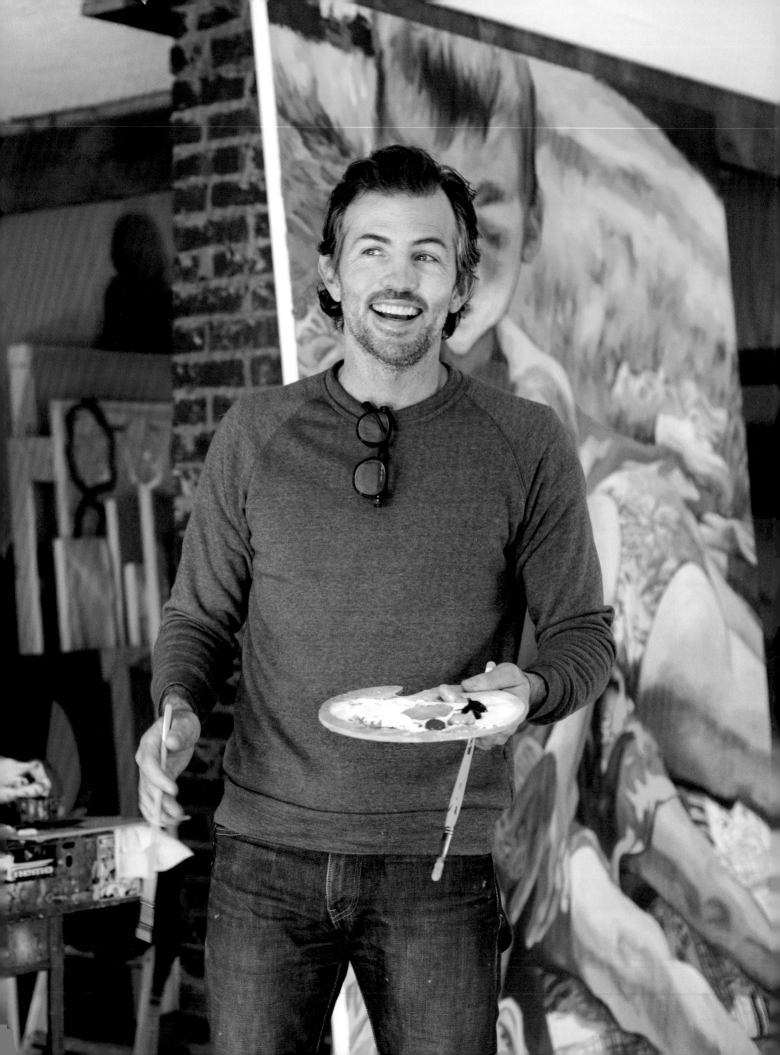

CHARLOTTE

Bank of America chairman and CEO Hugh McColl Jr. looked out the window of his office in the tallest building in North Carolina, over the expansive city he'd helped to build and grow, across the busy streets of the Fourth Ward he'd revitalized, and something he saw bothered him. The year was 1995. "There was a burned-out old church I looked at every day," he recalls. It stood six blocks up North Tryon Street, uptown's grandest avenue, a stone shell without a roof, left derelict since a fire had gutted it a decade earlier. "It came to me that it had perfect northern light, and you could create art studios in it."

For a man who'd built a national bank, who'd revitalized Charlotte's urban center, who'd helped secure NFL and NBA franchises, who'd poured philanthropic dollars into education and affordable housing, "art studios" might have seemed an unlikely idea.

But as Charlotte well knows, Hugh McColl loves art. He believes in its power.

"My main goal was to build a great city," McColl says. "And I don't think you can build a great city without art."

And so McColl bought the church, a 1927 Gothic Revival sanctuary, and set to turning it into an urban artist's colony, Charlotte's first. Four years later, the nonprofit Tryon Center for Visual Art (later renamed the McColl Center for Art + Innovation, in his honor) opened its doors, with more than 30,000 square feet of studio and gallery space. Since then, it has provided residencies to more than 400 artists from all over the world, a who's-who list, launching their careers, and convincing many to stay in North Carolina to pursue them.

"To me, it was a great alternative to grad school," says artist Matthew Steele, who left Indiana for a McColl residency in 2012, then stayed on staff for six years running its media lab while making his own art. Today that work is in collections around the world, and Steele has made Charlotte his home.

FACING
Painter and musician Scott Avett at
work in his Concord home studio.

Nothing Is Working (Victory)

Matthew Steele

CHARLOTTE

Infrastructure inspires Charlotte artist Matthew Steele. Bridges and highways and architecture and other physical manifestations of technology demonstrate to him the lengths human beings will go to "transcend the greatest obstacles we know."

Steele came to Charlotte in 2012 for a McColl residency and has made the city his home. "I've always been interested in the manufactured world," he says. "I came from a super small town in Indiana . . . and I knew the feeling I had when I would go to a city or a large industrial space, and just how alien it felt. I think I'm still narrowing in on that feeling."

Nothing is Working (Victory) is built upon a trestle construction meant to evoke a scaffold. He built it at a low moment, after a series of rejections for proposals he'd submitted for public art commissions. "I just thought,

nothing is working. I'm just going to make whatever I want." So he took the iconic form of the Greek statue *Winged Victory of Samothrace* at the Louvre and "depicted that idealized sculpture as this sort of grim, dark oil-covered mess . . . it's a very angsty piece." But the process taught him to make organic, volumetric shapes he hadn't been able to create before. And a few weeks later, he got a call to make a piece of public art—one that called on his newfound skill.

"I remember a thought I had in college about people in the world that we build. It's so easy for us to think of [them] as separate, but in fact, we are kind of the new nature. We make our beehives, and we make our own beaver dams. We're animals. We're just sophisticated." □

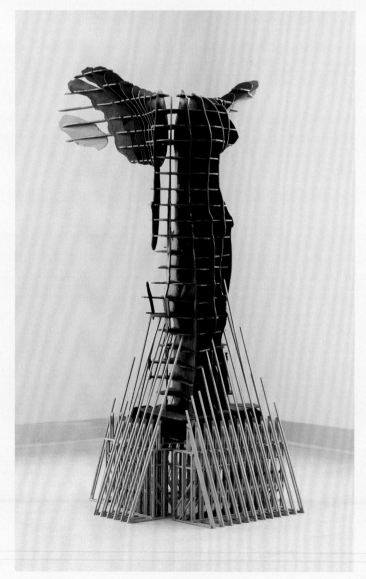

Nothing Is Working (Victory), by Matthew Steele, 2019. 71 × 51 × 45 in. Luan, walnut, 23-gauge nails, rubber, paint. Photograph by Lydia Bittner-Baird.

An ever-growing population of working artists like Steele are at home here, in a city that increasingly bears the hallmarks of McColl's vision—the one beyond banking. In addition to the Charlotte Symphony Orchestra, Charlotte Ballet, and Opera Carolina, Charlotte is now home to three of the state's most important museums of art, thriving arts districts, grassroots-grown and artist-led collectives, and a fleet of established galleries.

"What attracts people to a city is culture," McColl says. "In order to become successful, a city has to embrace all the arts, the performing arts, the visual and creative arts. . . . Art allows people to express ideas and goals in ways that are unusual, that gets people's attention, and awakens the right spirit in people."

The establishment of the McColl Center represented an important step in the city's art evolution, but it wasn't Hugh McColl's first investment in its art scene. He'd already commissioned the largest secular fresco in the country for the lobby of the Bank of America headquarters building—a famous triptych by North Carolina's Ben Long—and helped finance Long's frescoes at the Charlotte-Mecklenburg Police Department, inside the dome of the bank's TransAmerica building, and at the First Presbyterian Church downtown. He had also amassed one of the most extensive and valuable corporate art collections in the world, one today worth billions of dollars.

But McColl wasn't alone in bringing a cultural heartbeat to this banking city. Wachovia Bank (sub-

Airbnb Japan

Chris Liberti

CHARLOTTE

Charlotte artist Chris Liberti was reading the novel *1Q84* by Japanese author Haruki Murakami when he decided to look up some of the places described in the book. Images of these cities in Japan online began to capture his imagination. "I would look up street names in the neighborhoods that were in the book, and find these apartments, and dive deeper into that world."

A series of paintings resulted, including *Airbnb Japan*, which capture a pared-back Japanese aesthetic through a layered and vaguely imagined lens. There is also a timelessness to these works that comes from another source of inspiration altogether: "I like to look at pre-Renaissance altar paintings, like Giotto, and Lorenzetti, Fra Angelico," he says. "There's a lot of these interior spaces they use. I just mix between my space, and that pre-Renaissance space, and some of these things that I'm finding online."

When COVID hit and he was stuck inside a lot, the Buffalo native, who is also a writer and producer of music, says he got the urge to paint more outdoors. These works also layer imagined places and real ones, evoke ancient art, and have a dreamlike quality. "There's so much green here, so many trees, and even just that alone, looking at trees and getting inspired by something as simple as a shadow of a tree on a wall or on the ground . . . these things that you see over and over work their way into your work." □

Airbnb Japan, by Chris Liberti, 2020. 36 × 36 in. Oil on wood. Courtesy of Chris Liberti.

sequently Wells Fargo), Duke Energy, and the Leon Levine Foundation would join Bank of America to fund the creation of an uptown campus to house the Bechtler Museum of Modern Art, the Harvey B. Gantt Center for African American Arts + Culture, and the Mint Museum Uptown in 2010. All three now form a cultural juggernaut at the crossroads of Stonewall and South Tryon Boulevard, an arts "campus" known as the Levine Center for the Arts. To help sustain these three museums and provide financial stability to other Charlotte arts institutions, McColl spearheaded the multimillion-dollar THRIVE Fund at the Foundation for the Carolinas in 2013.

Among its beneficiaries is the Mint, established in 1936 in the original, 1837-built branch of the US Mint in Charlotte's Eastover neighborhood. It is North Carolina's first art museum, and holds one of the Southeast's largest collections of art on two campuses, including American art from the colonial era through World War II; craft and design including works in clay, glass, metal, wood, and fiber; and American, contemporary, European, and Native American art. The Mint also has the largest public collection of work by Charlotte native Romare Bearden, and one of the largest collections of North Carolina pottery in the world.

Its uptown branch is next door to the massive, mirrored *Firebird* by Niki de Saint Phalle, which marks the entrance to the Bechtler. Founded in 2010 by artist and collector Andreas Bechtler to house a collection partly amassed by his parents, Hans and Bessie Bechtler, and partly by himself, the collection includes works from the important art movements of the twentieth century with work from artists including Pablo Picasso, Andy Warhol, Le Corbusier, and Joan Miró.

Across the street is the Harvey Gantt Center, named for the city's first Black mayor, who held the office from 1983 to 1987. On the site of the city's historic Brooklyn neighborhood—a center of the Black community in the 1960s—the center showcases art by Black artists and celebrates the art and culture of African Americans.

Charlotte art collectors Judy and Patrick Diamond say they could think of no better venue for a public exhibition for their important collection of African American art. "The Gantt is extremely meaningful for the African American community and the whole community," Patrick Diamond says. "It has major responsibilities, with what our society is wrestling with." In 2018, the couple loaned the Gantt works from the remarkable collection they'd built over a lifetime, including pieces by artists Romare Bearden, Elizabeth Catlett, Sam Gilliam, and Henry O. Tanner. "When you own these works, they really don't belong to you," says Patrick Diamond, who also worked to raise funds for the Gantt as it was being built. "You have a moral responsibility and obligation to share them."

The Gantt, Bechtler, and Mint represent a fulcrum for the city's arts community, but the beating heart of art-making is a just few minutes farther afield, much of it on two former industrial sites.

MAKING ART

The arts district known as NoDa is one. Named for its main street, North Davidson, the area was once a textile mill village that had been neglected for decades. Since the 1990s, it has been home to artist studios, galleries, shops, restaurants, and bars. The transformation began in 1985, when the artists Ruth Ava Lyons and her husband Paul Sires bought and renovated first one dilapidated building, then several, leased them to fellow artists at low rates, and established a leading gallery called Center of the Earth. That gallery is closed now, but their legacy is alive.

"They're considered the mother and father of the art district," says artist Elizabeth Palmisano who has rented a Brevard Street studio from the couple.

Collectors

Judy and Patrick Diamond

CHARLOTTE

As a young couple, when Judy and Patrick Diamond first started to collect art, Patrick Diamond says they "had no idea we were collectors, or the wonderful experiences that are available for collectors to share the work they've collected."

They picked up their first piece of art in Tanzania and continued to add pieces to their collection everywhere they went for decades, always with an eye to honoring African American history and culture. Over the years, they amassed a significant collection of works widely appreciated for its depth and breadth.

The collection includes twentieth-century artists like Charlotte native Romare Bearden as well as Margaret Burroughs, Jacob Lawrence, Charles White, Elizabeth Catlett, Richard Hunt, Hale Woodruff, Sam Gilliam, and Henry O. Tanner, in addition to current artists like Radcliffe Bailey and Cedric Smith.

Patrick Diamond remembers the time he and Judy met Bearden in 1985 as if it were yesterday: "We had Bearden to ourselves for an hour. It's an experience I still pinch myself in disbelief about. Judy and I have been so fortunate in so many ways."

When Charlotte's Harvey B. Gantt Center for African American Arts + Culture mounted an extensive exhibition of the couple's collection in 2018, the museum credited the couple's "passion and astute eye." The couple's collection has been shown widely, in as many as twenty museums and universities.

Seeing the public learn from and experience the joy of the art that is so meaningful to the two of them "is one of the most thrilling and heartwarming experiences a collector can have," Patrick Diamond says, especially in a setting as meaningful as the Harvey Gantt Center, a museum Diamond worked for and helped raise money to build and that's named for a man he respects and calls a friend.

Nothing, however, can compare to the joy of loving and living with meaningful art, he says. "I can hardly explain it. Sometimes art can be absolutely mesmerizing, and that's what it was for me, and is today."

Judy and Patrick Diamond are shown here in their Charlotte home with a few of their favorite pieces: Romare Bearden's *The Baptism* hangs on the wall; beside it stands a Zimbabwean stone (Shona) sculpture by Tonderai Marzeva, *United Family*; to the immediate right of Judy Diamond is an untitled steel sculpture by Benjamin Parrish. And the Zimbabwean stone (Shona) sculpture by Obert Nyamupapira on the far right was purchased by the couple from the estate of Maya Angelou. □

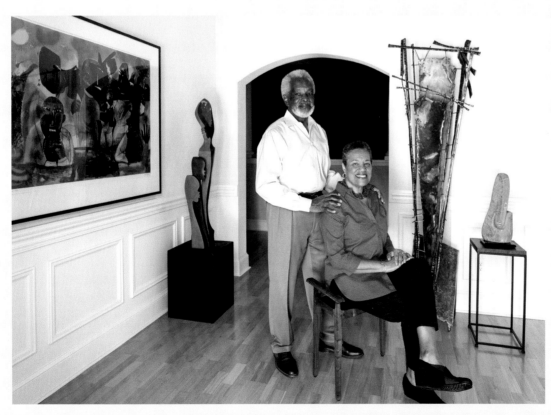

Collectors Judy and Patrick Diamond in their Charlotte home.

Rite of Passage

Beverly Y. Smith

CHARLOTTE

Charlotte native Beverly Y. Smith took her first textile class at UNC Charlotte, where she was pursuing a degree in art education. She became intrigued with quilts and their connection both to her grandmother's handiwork and to African textiles. She made one of her own, her professor entered it into a statewide contest, and it won. "From then on, I started working with quilts to tell my story, to share my southern culture and African heritage," she says.

She makes these quilts—large-scale works that tell stories both personal and universal—in downtown Charlotte's Grace AME Zion Church, built by emancipated, formerly enslaved people in the historic Brooklyn community. She'd been working there for a while when she learned an extraordinary fact: The cousin she'd grown up learning about, Israel J. Jackson, the minister who'd died of a heart attack in 1954 as he preached in the pulpit—had passed away just feet from where she sewed. It was his church, and she had no idea.

"I have pictures of him," she says. "I have his last sermon, discussing prayers people use when they're approaching death." She and he share the same ancestors, born into slavery. The coincidence is all the more uncanny given the subject and material of her work: Black American family stories, told in the generations-old medium of quilts.

In *Rite of Passage*, a young girl is wearing plaid sneakers, just like Smith's own first pair, and a garment made from a vintage 1940s feed sack like the ones her mother made and wore during the Depression.

Next, Smith is planning a quilt about the historic church itself, possibly including a buggy and some children. "My jumping-off point is research. Then I will start doing sketches, and gathering images." From photographs, she'll sketch the faces of actual people, then transfer them to canvas. On a sheet of paper as large as the eventual quilt (many are more than six feet tall and four feet wide) she'll sketch out the whole design, and then she'll start sewing. "I'm bringing back real people, and the real life of Brooklyn." □

Rite of Passage, by Beverly Y. Smith, 2020. 75 × 45 in. Mixed media quilt, graphite, paint, vintage feed sack. Photograph by Dan Ormsby.

"My rent for this studio space is well below where it should be for the location," she says, "they're really following through on that idea of holding space for creatives close to the city."

The seventy-six-acre Camp North End is a newer locus of art-making, just north of Uptown. In the 1920s, it served as a Ford Motor Company Model T assembly plant; in the 1940s the US Army used it as a supply depot; a decade later it became a missile factory. Today, it is a creative hub. Home to artists' studios, creative businesses like event venue and gallery Dupp + Swatt, and restaurants including the Black-owned, James Beard Award-nominated Leah & Louise, it's buzzing even at the early stages of development.

Goodyear Arts Collective is a Camp North End focal point. The nonprofit, artist-run residency, gallery, and event space provides free and inexpensive studio space for working artists. Founder and codirector Amy Herman, a noted photographer, has built Goodyear on the principle that artists need four essential things: time, space, money, and community.

"It is completely unheard of that for almost six years, I've had a free space to come and paint," says Holly Keogh, a young painter who was the collective's

More Charming, More Vague

Holly Keogh

CHARLOTTE

Fleeting glances, frozen in time. Images lost to memory. Alternative storylines for events documented long ago. Holly Keogh's paintings capture them all in a dreamy, evanescent style, where light and air blur the edges of moments that may be the ones taking place right before—or after—the moment that probably matters.

Using still frames from old Super 8 family movies and snapshots taken by and with members of her extended family in England and Scotland, Keogh creates scenes seen through a squint, stories becoming fictive in the retelling.

She's a first-generation American, and these images were the way her tight-knit clan kept in touch for many years, sending them back and forth across the ocean.

"I started pulling them out and painting the ones that were not framed on the mantelpiece, the ones that were not selected," she says, "pausing on the very specific half-seconds of silent videos and re-imagining them. So, out of context, I'm kind of the director now."

The way the UNC Charlotte graduate uses these images today is as if she's trying to crack a code: Who are these people, and how do they connect? Am I one of them, or something else? "I've grown up in Charlotte, and at the same time, have never really been Southern," she says. "My work is an exploration of that, being American as well as being European, and figuring that out . . . it's an interesting dynamic, when you look like everyone else." □

More Charming, More Vague, by Holly Keogh, 2020. 60 × 72 in. Oil on canvas. Courtesy of Holly Keogh.

first resident artist and is now attracting national attention. "I genuinely believe that if I had moved to a bigger city, I would be working so much [at a day job] to afford a studio, I definitely wouldn't have had as much time to paint as I do now." As a result, her work wouldn't have evolved and matured the way it has, "and I might not be painting at all."

More than forty artists have gone through the Goodyear residency program since its inception; in 2021, its nine open residencies attracted more than 200 applications, all from current Charlotte resident artists. Just a few years earlier, Keogh says, "I would have thought I knew every artist in Charlotte. But there are so many names on the list [of applicants] we've never seen, and the caliber of artists among the new residents is amazing. They've been living here, and we just didn't know."

Also providing opportunities for a growing artist population is BLK MRKT, a gallery and studio space designed to provide "a safe creative environment for

Sampled Spaces

Thomas Schmidt

CHARLOTTE

A flat, two-dimensional piece of paper, when crumpled, becomes a three-dimensional object. When exactly does that transformation happen? The question has long fascinated Charlotte artist Thomas Schmidt, who is interested in "the volume of a skin."

The professor of interdisciplinary 3D studio and digital fabrication at UNC Charlotte takes a series of painstaking steps to make a ceramic piece like *Sampled Spaces*. He crumples a large sheet of material, sets it with a fiberglass epoxy, makes a large plaster mold of it, slices it into sections, then slip casts them individually. "It slows me down," he says, "it brings me back into this gesture of crumpling paper."

Through this process, paper becomes both the subject and the material of the work. By assembling these ceramic squares purposefully, he brings an element of control into the arbitrary result of crumpling, and invites a viewer to study the result. "I love having elements that are only visible to someone who's looking closely," he says.

As an artist working with ceramic material, Schmidt says he feels privileged to work in a state with such a rich history of pottery, and has spent time in the Seagrove area, meeting and working with potters. "We're so fortunate to be connected to this lineage of working in clay," he says. "In my teaching, I'm always promoting forward-thinking and experimental, progressive ways of working. I also think it's really an incredible resource to be able to tap into our histories." □

Sampled Spaces, by Thomas Schmidt, 2018. 44 × 73 × 4 in. Cast porcelain and graphite. Photograph by Michael Blevins.

artists of color" that puts on exhibits and workshops for emerging artists and community members.

Some of these communities' emerging artists are coming out of Charlotte's universities, including UNC Charlotte, which has a robust undergraduate art department run by artist Lydia Thompson. The university is considering adding a cross-disciplinary MFA program, which could give the local visual arts scene an additional shot in the arm. Queens University of Charlotte and the historically Black Johnson C. Smith University also turn out undergraduate studio art majors and employ working artists.

Davidson College, in nearby Davidson, North Carolina, also plays an important part in the ecosystem with its highly regarded art program. The college's 2,700-piece permanent collection includes works by Rodin, Rembrandt, de Kooning, and Motherwell; its Van Every/Smith Galleries, directed by Lia Newman, regularly exhibits and acquires the work of international, national, and North Carolina artists.

Mushrooms

Meredith Connelly

LAKE NORMAN

Lake Norman resident Meredith Connelly makes sculpture out of light in an effort to stop people in their tracks and see the world with fresh eyes. "I am inspired by science, nature, and technology," she says. "I think that sometimes we have a tendency not to slow down and see what is right in front of us, or below us."

Her installations at the US National Whitewater Center in 2019 and 2020 led viewers down illuminated paths and around installations tucked into the forest in the shapes of glowing mushrooms, nests, butterfly eggs, pods, and crystals.

To map out and create these immersive works of art, Connelly downloaded a GPS tracker on her phone and spent a week hiking in the trail-less woods, looking for pieces of nature that inspired her to sketch: a mossy rock, a fungal formation. "I would walk up and I could visualize, oh, I want to do 60 pods suspended here in the trees. And then I'd work backwards to achieve it," researching materials, lighting, and power sources. "How do you find a soft, textural material that withstands cold temperatures and UV rays, and things like that? That's where my love of material came into play." Love of nature, too: "The architecture of nature is so organic and asymmetrical. I looked at all of those intimate elements of the natural space and wanted to highlight that."

The UNC Wilmington graduate says she doesn't have a didactic message she's trying to get across with her work. "I create as if no one else is going to look at it," she says. "And then I put it out, and the goal is that each person has their own experience." □

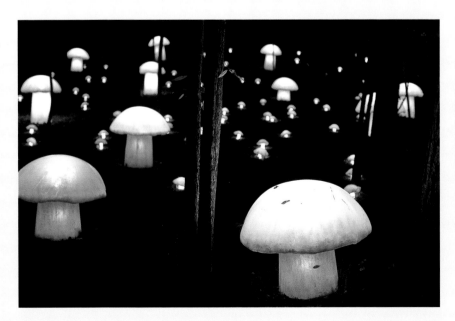

Mushrooms, from *Lights*, a multisensory illuminated trail experience created by Meredith Connelly, at the US National Whitewater Center in Charlotte, 2020. 8 in. high with cap diameters between 4 and 8 in.; cast fiberglass mushrooms 36 in. in diameter, with caps ranging between 3 and 4½ feet high; 45,000-square-foot footprint; 200 mushrooms made from thermoplastic. Photograph courtesy of the US National Whitewater Center.

Collectors

Chandra and Jimmie Johnson

CHARLOTTE

Chandra Johnson didn't grow up around art, but when she was working as a model and living in Europe, she began visiting museums and galleries, and working with creative people, artists among them. Art became something that mattered to her, something she wanted to share with her husband, NASCAR champion Jimmie Johnson.

"It's something I've grown to really enjoy," Jimmie Johnson says. "Certainly my interests have been much more related to motor sports, and not in the art space. I felt like there were some hurdles to clear that I would never quite clear, and that art wasn't really for me. . . . But then I started meeting these artists, and I got it."

"We were young collectors, and it was so fascinating to learn," Chandra Johnson says. "And when we started to become friends with artists, we wanted to support them."

Though the couple was based in Charlotte, they were also in New York and other places where art was happening. Chandra had an idea: "I thought, why don't I bring all of our friends who are artists to Charlotte. I'll produce an exhibition for them, to introduce them to a new audience, and vice versa." In 2013 she took over the fifth floor of the Mint Museum (it was being used for storage at the time) and put together a pop-up exhibit. "And that's how it all started. It steamrolled from there. . . . I had no idea if people would be interested in contemporary art in Charlotte."

They were. And if Johnson never planned to open a gallery—her SOCO gallery in Charlotte is now one of the city's most esteemed—or to travel to art fairs, or to represent artists, all of that has been the ultimate result. "It just happened organically, and it's amazing to see where it's come," she says. "I'm not an academic, I'm not a curator. It's really been through passion and love and the fact that we wanted to help support these careers."

She sits back in her Charlotte living room, where art is hung, gallery-style, from floor to ceiling, considering. "It's been an incredible journey. And I think what's so amazing about it is that it has created a platform for incredible artists to come to North Carolina, and also a platform for North Carolina artists to be pushed out into the world."

The couple's collection includes works by Henri Matisse, Sean Scully, Damian Stamer, Holly Coulis, and Jackie Gendel, among many others. They are pictured here in the study of their Charlotte home with some of the many art books they love; on the wall is a skull by Scott Avett; the furry horned chair Jimmie sits in is by Nikolai and Simon Haas, known as the Haas Brothers. □

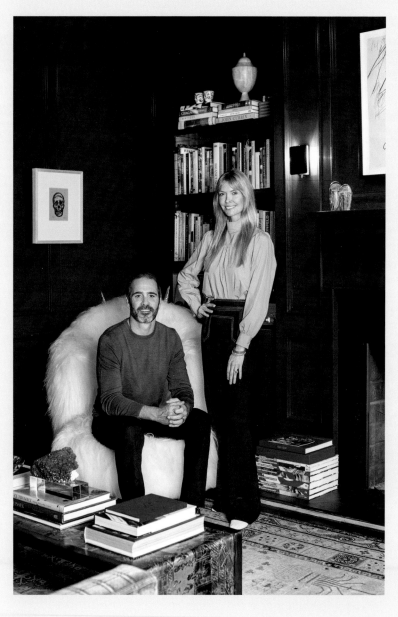

Chandra and Jimmie Johnson
in their Charlotte home.

In 2018, Newman oversaw the acquisition of the monumental *Wind Sculpture (SG) I* by acclaimed British Nigerian artist Yinka Shonibare, whose work has been installed in London's Trafalgar Square and at the Smithsonian's National Museum of African Art, and is part of the collection of the North Carolina Museum of Art. In 2020, Newman brought North Carolina stick sculptor Patrick Dougherty to campus to install a piece called *Common Ground*, a series of swirling sapling huts built with the help of a fleet of student and community volunteers.

Newman's network and influence is wide. When she saw a need for the stories of Charlotte artists to be told, she helped start a blog, HappeningsCLT, to tell them; when she perceived that the city's arts institutions weren't collaborating as much as they could, she got together with Queens University professor of art and curator Hilary Burt to gather commercial gallery directors and museum curators to discuss what they were all planning for the year ahead, "so that we can figure out where collaborations could happen."

More and more, these collaborations involve the grassroots art scene. Goodyear, BLK MRKT, and the other collectives in town including the public art initiative Brand the Moth and Charlotte Art Collective are fueling the making of art. Clayworks, a fifty-year-old nonprofit that teaches ceramic art, provides opportunities. So do artist coworking spaces like Hart Wizen and C3Lab.

"They're allowing artists to decide that they could stay here, too, and they'd have an opportunity to grow," Keogh says. She has found opportunities in Charlotte not only with her own work, but by supporting others' as well. A year after her solo exhibit at Charlotte's prestigious SOCO Gallery, Keogh curated a group show there called *Reasons to be Cheerful* that included eight Goodyear artists, a dancer, and a poet.

The gallery, owned by collector Chandra Johnson, has also given Keogh and other local artists exposure to the art world beyond North Carolina through its presence at art fairs like New York's Armory show, and by bringing visiting artists with national reputations to local artists' studios. "I would never have met these artists if we were in a bigger, bustling place," Keogh says. "It's wild, living in Charlotte, some of the artists I've gotten to meet that are not from here at all, through that gallery having such great, curated shows."

There's a growing connection between the city's emerging artists and grassroots art collectives with established galleries like SOCO, Hodges Taylor, and Hidell Brooks and uptown museums like the Mint. Many credit Mint curator Jennifer Sudul Edwards with shaking things up and bringing emerging artists to the fore. Her exhibit *It Takes a Village*, "a celebration of the vibrant, grassroots art happening throughout Charlotte," filled the uptown Mint's galleries with works by artists from Brand the Moth, BLK MRKT, and Goodyear Arts in June 2021.

Edwards and Queens University's Burt were two of the founders of the Sphere Series in 2017, a monthly lecture created to engage with emerging and established artists, and to bring national and international art leaders to Charlotte to discuss contemporary art. Sphere also works to connect the city's arts institutions. When Davidson College's Newman acquired the Shonibare sculpture, she partnered with Sphere and the Mint, which had a show on African prints up at the same time, to host a lecture by an art historian on African textiles.

COMMUNITY OF PHOTOGRAPHERS

Charlotte creatives in the realm of photography have long had their own community in The Light Factory Photo Arts Center, founded in 1973 and credited with nurturing entire generations of Queen City photographers. Part photography school, part

Portrait of My Father

Linda Foard Roberts

WEDDINGTON

Portrait of My Father, from the series *Passage*, by Linda Foard Roberts, 2005. 28 × 36 in. Toned gelatin silver photograph. Courtesy of Linda Roberts.

When Weddington-based photographer Linda Foard Roberts received a Guggenheim Fellowship in 2020, it was just the latest in a career of accolades. *Portrait of My Father* showcases the nuanced underpinning of much of her work, which evokes memory, loss, nature, human rights, and family, and addresses issues of personal and historic significance.

Portrait of My Father represents "man's search for answers to the meaning of life," she says. "This work began as a way to connect with my father and my mother and as a search for my own spiritual beliefs, and it became much more than that."

For more than twenty years, Roberts has photographed her family, still lifes, and the North Carolina landscape around her using large format cameras and old lenses. "I realized I wanted to document not what is new to me, but what is a part of me," she says. "With this work, I am trying to capture humanity and time, exploring the many facets of life that connect us as human beings."

When her children went to school, Roberts began to photograph her parents, and asked her father if she could photograph him holding his Bible. "As I was fumbling under the dark cloth," she recalls, "he began to read his favorite passages to me." Her father's religion and all religions are spiritual quests, she believes: "We are all looking for answers to meaning in our lives." For an artist, there are few richer subjects: "Artists have been contemplating spirituality and studies of the universe throughout history."

Roberts's photographs have been exhibited internationally and throughout the United States. Her work is in numerous private collections and in the collections of museums including the Bechtler Museum of Modern Art, the North Carolina Museum of Art, California's Museum of Photographic Arts, and the New Orleans Museum of Art. She is a recipient of a North Carolina Visual Artist Fellowship grant and in 2016 published her first monograph, *Passage*. □

exhibition space, part community engagement project, The Light Factory has exhibited the work of internationally renowned photographers like Ansel Adams, Diane Arbus, and Sally Mann, and nurtured the talent of some of the city's own most esteemed photographers.

"It's why there are so many great photographers around Charlotte," says Linda Foard Roberts, one of the finest. Roberts joined the Light Factory in high school so she could use its dark room, after having learned how at Myers Park High School "under the direction of the great Byron Baldwin." Well known in Charlotte for his impact on young artists, Baldwin, a Light Factory founder, has also exhibited his work all over the country and is in multiple significant museum collections. His eager student would go on to serve as director of the nonprofit he helped to found, and to build a major career of her own.

She's not alone. The nonprofit "has been invaluable to me," says Carolyn DeMeritt, a Charlotte native whose work has also been widely exhibited and is in many museum collections. The Light Factory "has been my education . . . a place to see really, really good photography without going to Atlanta or Washington, DC." She took an initial class there in the 1970s and mostly taught herself after that. "But there was always this community of photographers who were willing to help you, or push you."

Despite its impact, the nonprofit has sometimes slipped under the wider art-world radar. "We've always said that the Light Factory is the best kept secret in town," DeMeritt says. "For a long time, it was really

Tired

Carolyn DeMeritt

CHARLOTTE

Charlotte native Carolyn DeMeritt has been using a square, medium-format camera since she began taking photographs in the mid-1970s. "I think I see things in a square," she says.

Her photographs, often of women and girls, capture fleeting moments, elusive emotions, awkwardness, wonder, beauty, and aging. If adolescent girls filled her frames in the 1980s, DeMeritt's more recent work is centered on a friend in her own eighties, the Alabama artist Pinky Bass, and Bass's "infinite grace."

DeMeritt has taken a long series of portraits of Pinky, "a thirty-year portrait of her, and still going." The juxtaposition of these photographs with DeMeritt's earlier images of girls is one that intrigues her. "These two series in a way connect for me," she says. "Nobody has connected them before."

She has a digital camera these days but still loves to shoot in black and white film. Her subject matter also evolves. "I've never said it so directly, but it's about me, I guess, or my life, or my situation at the moment." She's happier to let her photographs speak for themselves. "I love [the North Carolina painter] Maud Gatewood," DeMeritt says. "When she was asked to make a statement, she would say 'the work is my statement.'" □

Tired, from *Infinite Grace Series*, by Carolyn DeMeritt, 2017. 15 × 15 in. Archival pigment photograph. Courtesy of Carolyn DeMeritt.

better known across the country. You would somewhere and you would say, 'I'm affiliated with the Light Factory,' and people knew what that was. And then in Charlotte they'd say, 'What is that?'"

Thankfully, Charlotte's museums and galleries have not been in the dark. Hodges Taylor Gallery, The Mint, SOCO, and others have held many exhibitions of Light Factory photographers over the years.

MAKING ART ACCESSIBLE

Gallerists like Lauren Harkey at Hodges Taylor, Katherine Hidell Thomas and Rebecca Brooks of Hidell Brooks, and other galleries including the Elder Gallery and Sozo Gallery all proudly showcase the work of North Carolina artists working in all mediums, and make a point of connecting those artists with the wider community.

Chandra Johnson of SOCO is one who makes a point of introducing her exhibiting artists to everyone in the room at an opening. She knows what a difference it can make to have a regular conversation about art with its maker, how hearing that artist's story and understanding his or her process or inspiration can open up a whole new world.

Johnson's husband, famed NASCAR champion Jimmie Johnson, has experienced the dynamic firsthand. "The opportunity to meet Damian [Stamer] and to meet Liz [Nielsen] and many other artists that have been shown at SOCO has changed my perception of art," he says. Getting to know them as people provided an entry that the more formal dynamic of museums hadn't always offered: "I have a better appreciation for it, now that I've met the artist. I understand the journey to being showcased in a museum, and I understand how meaningful that is," he says.

Artists at work in Charlotte today say they feel lucky to be in a place where those kinds of interactions are happening, to be able to catch the wave of growth that galleries like SOCO have helped to create.

"In the eight years that I've been here, I have seen a strong and vibrant art community that's growing," says artist Thomas Schmidt. "The fact that Charlotte's not a major city has some advantages for artists. In some ways, I think being in a smaller city allows you to network and connect with the art community more easily. People are extremely friendly and supportive of one another here," he says, "and I think as the city grows, there's a desire, a hunger, for creatives to come out and share their work."

Art will build a great city, Hugh McColl says, and he'd also agree that a great city will build great art. As his "first love," McColl believes that art does something nothing else can. "It enriches the fabric of your population. It invites different people with different ideas to bring a whole new perspective."

SCOTT AVETT

CONCORD

Inside a modest farmhouse along a rural Concord road about an hour from Charlotte, past fields and barns and slow-moving farm equipment, the internationally famous folk rock star Scott Avett stands and paints.

On canvases ten feet tall and equally wide, he paints what matters to him most: his family, his children, his wife. The profound but fleeting magic and everyday toil of it all; the pride and exhaustion; the hubris and humility. Like his music, these works, he says, are also about his faith.

What may surprise his Avett Brothers fans to learn is that Avett believes his creativity is visual before it is musical, that music doesn't come first, that painting and music are in fact equal manifestations of his artistic impulse. "Ultimately," he says, "it's all activity."

In many ways, it's hard to separate one from the other, the activity of his music and the activity of his visual art. They're largely of a piece in this house-turned-studio. A guitar hangs just feet from his working canvas; in an upstairs loft there are

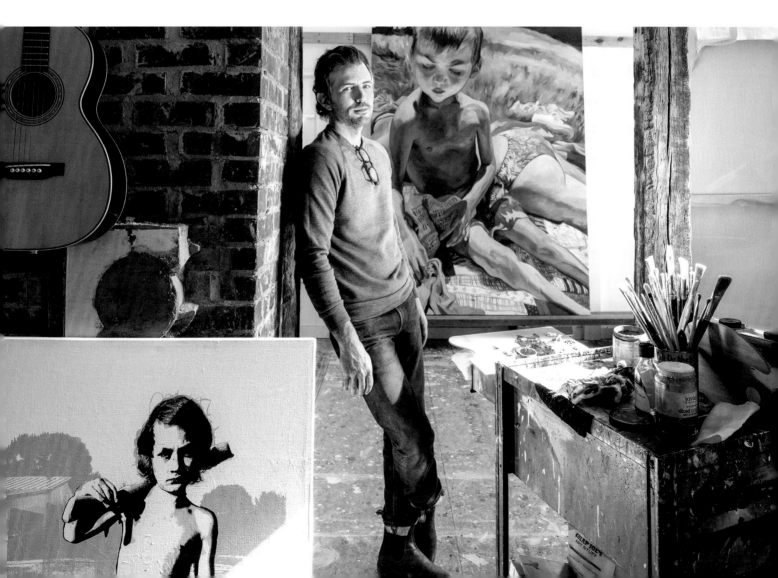

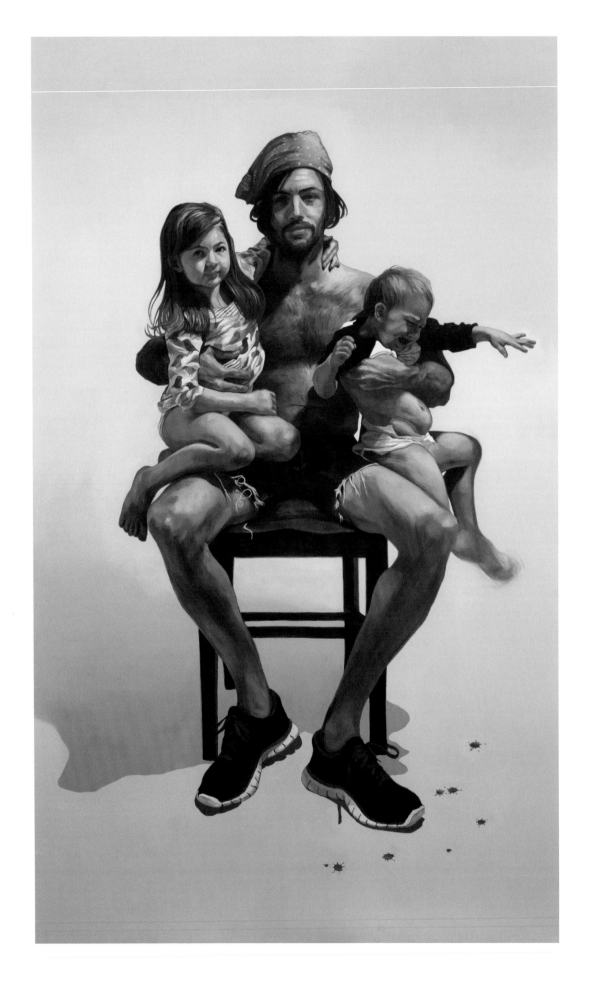

more instruments and a tucked-away place to write and play. Downstairs is divided into a high-ceilinged painting studio and a smaller area with a silkscreen press and a desk, where he thinks and reads, draws and prints. On any given day, there are several projects underway. Their proximity is great when they feed one another; when they compete, it can be distracting. Avett listens to music when he paints, sometimes; on one particular day the storytelling songs of country singer Larry Jon Wilson were in the air. Beyond, in another reach of this large working farm, are his house and his family, including three young children. His brother and band partner Seth lives across the street, and he gestures with his arm: "We grew up right over there."

Until his celebrated solo exhibition in the winter of 2020 at the North Carolina Museum of Art, Avett's paintings—which he'd been making off and on since he earned an undergraduate art degree at East Carolina University in 2000, and had fronted some album covers—were not widely known. The pandemic came on that show's heels, canceling a year's worth of the Avett Brothers' shows and giving him more time to paint and to read. His conversation is peppered with references to books he's read, some art-related, like painter David Salle's *How to See*; others religious and spiritual, like Trappist monk Thomas Merton's *New Seeds of Contemplation*, or the works of the Franciscan Richard Rohr, or the Buddhist D. T. Suzuki, and "all the old mystics." The time also gave him the opportunity to experiment.

In one instance, intrigued by what he read about the British American painter Malcolm Morley's techniques, Avett decided to try painting with a grid to guide his structure, and with a split down the middle of his canvas, effectively creating two related but separate paintings in one. Paradoxically, the grid opened him up, he says, to be more creative. "When I identify and acknowledge limitations, then I can work freely within them," he says.

He also began choosing "arbitrary" images to depict, instead of picking images purposefully and asking himself to represent their meaning. Instead, he told himself: "Whatever image you pick, whatever it is, trust it, follow it." The results were immediately gratifying: "I started seeing all of these connections happening on canvas and in life, and in social commentary, and in family life, everything, everything. There were all of these connections happening."

Those connections are more than serendipitous to Avett. "It's unity," he says. "I think it's my relationship, our relationship, with God. I do."

Reading Leo Tolstoy's *The Kingdom of God Is Within You* in 2008 "broke the door open for me," Avett says. He'd been skeptical of Christianity earlier in his life, but reading changed the way he understood it. First he read the autobiography of Mahatma Gandhi (which Avett learned of when he read a sermon delivered decades earlier by his grandfather, a Methodist minister), in which Gandhi mentions Tolstoy's book as one of the most important influences in his life. And then Avett read the Tolstoy book, and about the author's own definition of Christian spirituality based on universal love.

That definition is one Avett says he's always thinking about, something that informs his daily life, his relationships with his family, and the art that he makes.

One morning during COVID, he was walking in the woods near his house, and stopped to look at some rocks in a creek. "And at that moment, it was really clear to me that *that* was everything." He came back to his studio and drew the creek with pencil, but decided he wasn't finished. Then he painted it, using the grid, which freed him not to overthink the effort. "Symbolically, it's about the connection with the land and with the earth, but that's kind of low-hanging fruit. To me, it's speaking about everything. I just trust that that is, and I'll follow it," he says.

As with all his painting, "I don't know why I'm doing it, and I don't need to know," Avett says. "This is just me swinging my hammer. And the more I swing it, the more I figure out how some of it works." ∎

FACING

Fatherhood, by Scott Avett, 2013. 106 × 65 in.
Oil on canvas. Courtesy of Scott Avett.

CHARLOTTE 75

LYDIA THOMPSON

CHARLOTTE

Wheeled carts toting ceramic houses roll unsteadily forward, presenting an upright facade, a vulnerable core, and an uncertain future. Handsome clay figures that are part human, part tool, and part architecture stand with dignified, expressive faces, even as their functional purpose subverts their humanity.

Raising questions about power, culture, work, and home, Lydia Thompson's art is inspired by ancestral memories, by the effect of migration and upheaval on individuals, families, and cultures, and by the intersection of work, honor, and meaning. Her work is in museums around the world and in multiple private and public collections.

In her home studio near UNC Charlotte, Thompson draws on her degrees in art and ceramics, her Fulbright Hayes grant-funded study of Nigerian architecture, and her research into the effect of space and place on culture and imagination to make her art.

A professor and the chair of the Department of Art and Art History at UNC Charlotte, Thompson began making her *Post-Migration* series to address questions about the long-lasting effects of movement across space and time. It's a personal question, and a universal one. Her grandparents and parents left Mississippi and Georgia for Ohio as part of the Great Migration of African Americans from the American South to the cities of the North, but her work is meant to address migration of all kinds, in all places.

"Once you migrate, what happens after you get there? Is this an empty promise?" she asks. Anyone forced to migrate, human or animal, "they're all trying to survive," she says. "They're all trying to thrive." Maybe they do. But what happens to the next generation, after their pioneering parents die? Do they invest in those homes and communities, or is their connection too tenuous, their resources too few? Have their lives and education taken them further afield?

Thompson fits into the latter camp. "My mother sent us to art school when we were little, and I played the violin, I played piano, I played flute. She exposed me to all of these wonderful things. . . . That's why I am who I am, is because of her." Set on a trajectory of artistic and academic success, Thompson set sail into the wider world and didn't look back. "You want me to come back to this community? I can't do that."

In the wake of such a generational shift, formerly proud, upwardly mobile neighborhoods—originally populated by determined migrants—can fall into disrepair, become food deserts, maybe eventually become gentrified. Thompson's wall-less houses and churches on rickety wheels but with sturdy facades reflect this hybrid. "I'm trying to focus on what's in between, and I left the sides open so you could see. The wheels are constantly in motion, this thing is constantly happening, it has not stopped." Some of her houses have birds upon them, some have spikes inside, or bits of furniture, abandoned pieces of lives left behind.

A fascination with home and the structures that define it is at play in her figurative work as well. Rooted in her study of the adobe architecture of

FACING
Lydia Thompson in her
Charlotte home studio.

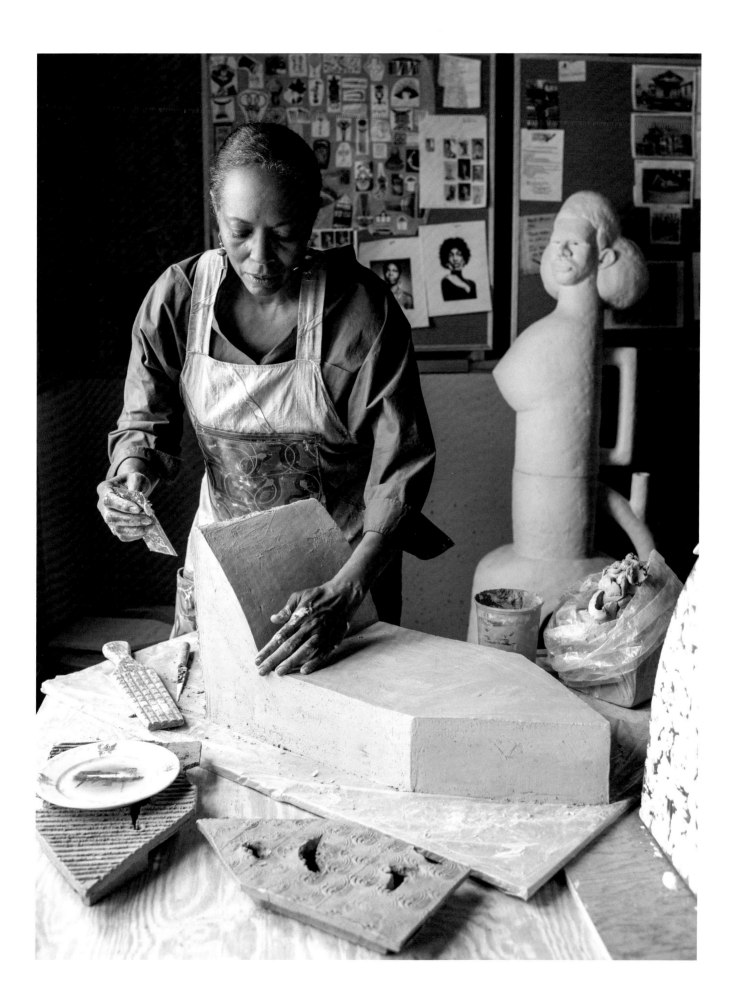

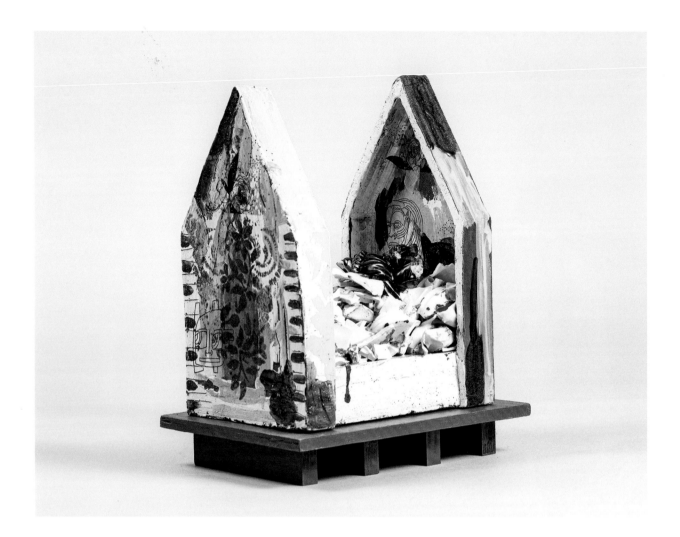

Nigeria, Thompson's figures reflect the organic nature of adobe itself. "I love that connection between the body and the architecture and how the two interact with each other," she says. Also intriguing to her is the Nigerian weavers' use of tools called heddle pulleys, heirlooms passed down from one generation to the next, used to control the warp of a loom. "I love the idea of how stories are told or shared, not always verbally, but through the hand."

Her combination of those things—the architecture, the humanity, the handed-down elements and stories—results in figures that have tool-like elements, like handles on top and bases that look more like pulleys than legs, making shapes that resemble portals, not end points. Are they man or machine?

"This is what we need to think about. We need to think about who we are as humans. We need to think about the landscape and we need to think about where we live," she says. "I also see my images as reminders of the past, and current lessons that we need to learn about the persistence and preservation of one's own culture." ▪

Changing Over, by Lydia Thompson, 2021.
12 × 15.5 × 9 in. Ceramic and wood.
Photograph by Kamau J. Bostic.

SONIA HANDELMAN MEYER

CHARLOTTE

Sonia Handelman Meyer at
her Charlotte home.

On a crisp fall day, the trailblazing 102-year-old photographer Sonia Handelman Meyer sits up straight in the backyard of the house she shares in Charlotte with her doting son Joe and his wife. She smiles, offers a wry joke about being the subject of a photograph instead of its taker, and cradles her beloved Rolleicord in both hands. The camera she bought secondhand in 1942 for the then-princely sum of $100 and used to take the remarkable photographs of New York street life that made her name is in mint condition. Nearly eighty years later, Meyer is looking pretty good herself, willing to be on the other side of the lens, and eager to reminisce.

A member of the famed New York Photo League from 1943 to 1951 and one of its only women, Meyer took seriously the cooperative's mission to document with "artwork, not just snapshots" the reality and complexity of city life as a way to effect social change.

Her photos capture the rhythm, dignity, and pathos of street life in Harlem, Spanish Harlem, Greenwich Village, and Coney Island in that postwar period, including images of children, immigrants, and the poor. She photographed the newly arrived Americans of the Hebrew Immigration Aid Society; she photographed an anti-lynching rally at Madison Square Park; she photographed the patients of Harlem's Sydenham Hospital, the first hospital in the country to integrate. She photographed everyday people at work, on the subway, and on the street,

Girl on Stoop, by Sonia Handelman Meyer,
Spanish Harlem, 1946–50. Original
print size: 10 × 10 in. Gelatin silver print.
Copyright Joseph T. Meyer. Courtesy of
the Sonia Handelman Meyer Photography
Archive, LLC.

but mostly, she says "I photographed children and reflections of my city: rough-edged, tender and very beautiful in its diversity."

It was a calling that took her by surprise. The New Jersey native was twenty-two and working in Puerto Rico for the US Army Signal Corps during World War II when she met a young photographer whose photos of Puerto Ricans in their environment moved her. "They were . . . so real. So honest. So beautiful. It was a signal to me that this was what I wanted to do. It was a form of art that I could do."

When Meyer got back to New York a year later, she sought out the Photo League, took classes, and soon was on the street, documenting what she saw. "Things would catch your eye," she recalls. "And more than catch your eye, it would catch your heart." She worked alone, "always alone, and fast. I saw something that hit me, and I shot it, and moved on. I didn't stay around to talk." Her Rollie, as she calls it, allowed her to be stealthy, looking down into the camera as she held it by her side: "I think most of the people that I shot didn't even know that I was shooting."

Many of her images became iconic.

"You take a picture of small children, and their playground is a muddy lot on the corner of a street, with nothing to play with except dirt, and sticks and stones, and their own imagination," she says. "They don't know that they're poor. They don't know that they're deprived. I think I got some of that in there. It's the look on their faces . . . it's almost all feeling. Feelings say everything. If you don't care, if you don't care about children, if you don't care about grownups who are hungry or can't find jobs, or streets that are not cared for, or homes that are scarce—if you don't care about that, then you may not care about the photographs. But I think these photographs hit people right in the gut."

She participated in exhibits with the Photo League, the International Center of Photography, and the Museum of Fine Arts in Houston (among others), but she did not become famous. Partly that was a function of being female in a male-dominated organization and time; partly it was the result of the league being disbanded when the McCarthy era dawned and the league was listed by the US Attorney General as a "subversive organization." Around the same time, Meyer got married, moved to the country, had children, and began to dabble in nature photography. She put her Photo League prints and negatives in boxes and pushed them beneath her bed, where they remained for several decades.

Then, in 2007, after she'd moved to Charlotte to be near her son Joe, he had the idea to call his friends Dot Hodges and Christie Taylor at Hodges Taylor Gallery to tell them about her work. They humored him, saying sure, send us your mother's photos. "So I scanned them and emailed them over," he says, "and two seconds later, they called back and said: 'Get your mother in here!'" The gallerists promptly offered Meyer a one-woman show. It was her very first, at eighty-seven.

Today, Meyer's work is in the permanent collections of the Metropolitan Museum of Art, the Mint Museum, and the Bank of America Corporate Collection, among others. It has been a remarkable decade of recognition after most of a lifetime of obscurity, she says, but nothing to compare to the years she spent on the streets of New York with eyes peeled and her camera ready.

"It was just a wonderful time," she says. "A wonderful time." ∎

HERB JACKSON

DAVIDSON

"I don't want you to know how I work unless I tell you, because I want it to seem spontaneous." Herb Jackson is in his Davidson studio, surrounded by the unmistakable art that has made his name, the vibrant, abstract paintings that convey energy and light and appear to have been made with swift, gestural strokes.

"No," he says, "I'm working about that much at a time." He holds his fingers up in a narrow pinch. "The tricky thing is to make it not look like that. It's a little archaeological. There's a lot of drawing that goes on. I can work for hours on an area, and the next day completely cover it." These palette-knifed layers accumulate, day by day, sometimes into the triple digits; many he scrapes away or sands with pumice. "If it's not up to what I want it to be, then I just keep working." Light and shape and color and texture shift and morph, disappear, and reemerge. About two-thirds of the way through, a painting "will begin to assert itself"; when they're finished, "they tell me."

Art has been communicating with Jackson since he was a child. He won his first art award when he was still a teenager as part of a juried exhibition at

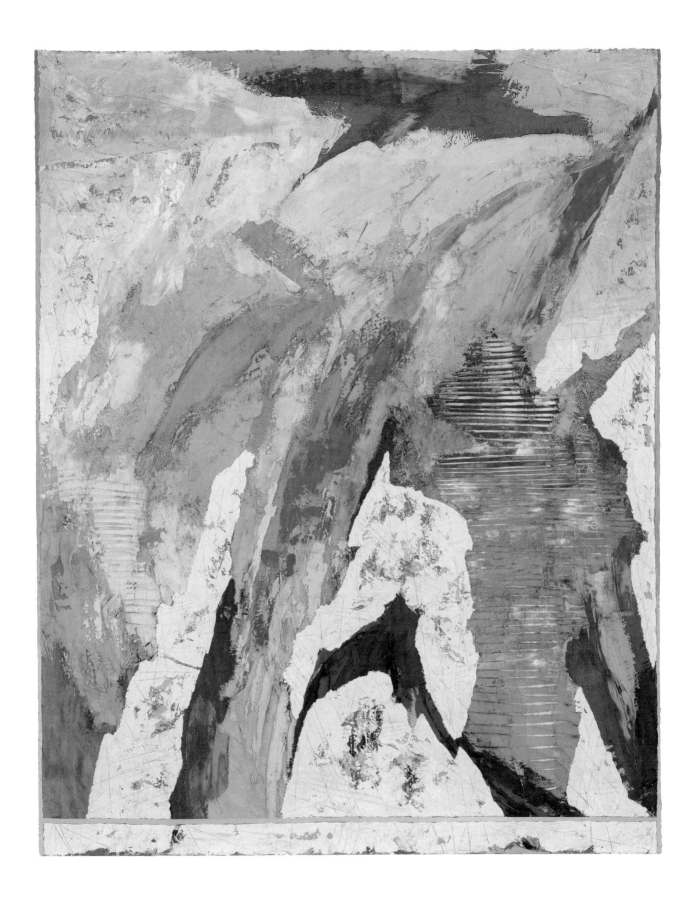

the North Carolina Museum of Art; his work has now been collected by more than 100 museums including London's British Museum, has been shown in more than 150 solo exhibitions around the world, and has won him North Carolina's highest civilian honor. After college at Davidson and an MFA at UNC–Chapel Hill, he returned to this college town to teach, eventually serving as chair of the Davidson art department for sixteen years.

Along the way, Jackson created a prolific and ongoing series he calls *Veronica's Veils*, in which all the works are the same size (60 by 48 inches) and format. The name refers to the historic Christian relic thought to have received an image of the face of Jesus when Saint Veronica used it to wipe his face at the sixth Station of the Cross. Jackson says these works "have nothing to do with Jesus, but have a lot to do with Veronica and her luck, being at the right place at the right time." When one of his paintings "comes into being," Jackson says, "that's basically my Veronica moment."

That moment coheres not any particular concept, but the confluence of everything he's ever experienced, "which is much bigger than any one idea." All of that can take some wrangling. "Occasionally, they'll go beyond what I expected as far as challenging me, and I'll put them up there and stare at them for several days, to just be absolutely sure. Because once I decide you're finished, then I don't go back in." To do so, he said, would violate a painting's integrity. "There are paintings from eighteen years ago [in which] I might spot something I would have done differently. But I was a different artist then."

The Raleigh native has been drawing every day since he was a young child and selling paintings since he was twelve, time enough to be many different artists. He's still amazed by the experience and the process. "Where a painting comes from and how it comes together for me is still mystical, and has been for sixty years." He credits his subconscious, but assumes some of his inspiration must come from art and travel and nature, from exploring the woods and creek and digging in the earth near his childhood home in Raleigh near the old Lassiter Mill. Some also must come, he says, from the pre-Renaissance and Byzantine paintings of the Kress Collection, which formed the foundational basis of the North Carolina Museum of Art in its original downtown home—works he regularly took the bus to go see.

"Those paintings were so formative for me. If there hadn't been the North Carolina Museum of Art, I don't know what would have happened to me." ∎

ELIZABETH PALMISANO

CHARLOTTE

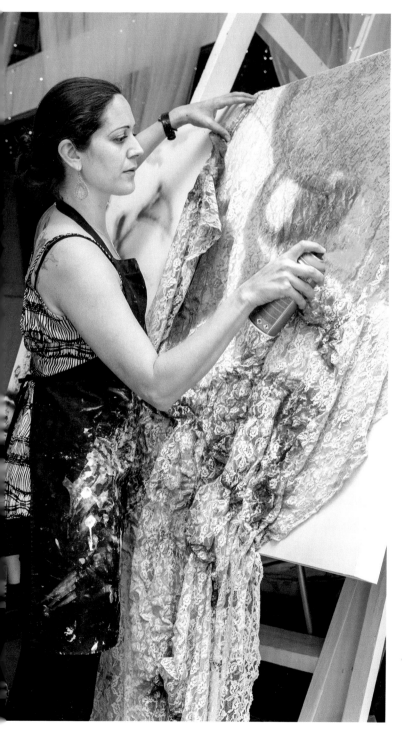

It might not be typical for most artists to use discarded paper towels, scraps of thread, or the detritus of an office shredder in their art, but it's second nature for Elizabeth Palmisano. It's a method born not only out of respect for the environment, but out of necessity.

"I grew up in poverty. In a culture of poverty," she says. As a child in South Carolina and as a young adult living on her own without a high school diploma, she not only had no access to art materials, she didn't know "artist" was something someone could be. Those roots underpin everything she does today. "I've had to use upcycled materials," she says. "I had no choice."

Once she had a stable job working in a preschool, she began making art, but didn't consider its potential. The first time she took discarded scraps and reworked them entirely into a piece of handmade paper and sold it at an art show, she says, it was a revelation; she felt she'd performed a work of alchemy.

"It made me think of the way I grew up and where that came from. Using someone else's trash. You figure it out when you have no other choice. You can't [say] 'I'm not going to eat today. Or I'm just not going to get to work today. Or I'm just not going to have clean clothes today.' You figure it out. And I think that has served me well."

Elizabeth Palmisano in her
Charlotte studio.

Incantation, by Elizabeth Palmisano,
2019. 102 × 144 in. Mixed media textile.
Photograph by Terri Lynn Honea.

In late 2019, when Elizabeth Palmisano filled a giant wall at Charlotte's Mint museum with *Incantation*, an ethereal, abstracted skyscape made of handmade paper, paint, and collage, it was the first time many viewers had encountered fiber art in a blue-chip museum. "Boundary-pushing" is how the museum described the piece, both for its use of recycled materials and for "breathing new life into objects not typically considered for use in the creation of art."

It's clear that the process of taking something discarded, breaking it down to its elements, and reworking it into something valuable, something beautiful, is not just empowering for Palmisano, it's metaphoric.

Paper as a Luxury, her North Carolina Arts Council–funded project that includes a series of free workshops in which she recycles discarded fibers into handmade paper in underprivileged communities, is as important to Palmisano as her own art, for which she continues to win awards and grants. "These are my people," she says. She wants to keep it that way:

> Moving from a place of poverty into what would be considered middle-class has been the weirdest experience for me. This year, when I file my taxes, it will be the first year I don't qualify for an income credit. I am not living below the poverty line. I live in a safe, clean neighborhood. . . . I've never lived like this before. And that almost, it makes me feel guilt in a way, because . . . it feels like I've left my people behind. But I was talking to a mentor of mine. He said: "People in poverty don't help people in poverty. You can't be in crisis and be of service. You can't pour from an empty cup." ∎

Elizabeth Palmisano at work.

KENNY NGUYEN

CHARLOTTE

"Every time I start a piece, I imagine there's a body underneath it," says Quoctrung Kenny Nguyen, a former fashion designer who makes rippling, three-dimensional sculptures out of paint-soaked silk in his Charlotte garage studio. "Instead, there's this absence of a body, in sculptural form. I think it's beautiful like that."

Torn into strips, dredged in paint, and affixed to unstretched canvas, Nguyen's silk segments fuse to become a malleable but sturdy material he molds with his hands and pins in place. Every time he hangs a piece, he changes the pin placement and with it the object's shape, shadow, and energy. Some have a "more architectural feel," others are more organic.

These works explore and illustrate Nguyen's experience with reinvention, cultural displacement, isolation, and identity. His chosen material, with its direct ties to the cultural history of his native Vietnam, is a key component. "Identity is changing all the time," he says, "and the work keeps evolving, in a continuous transformation." It all begins with the fabric in his hands. "Silk is already a transformation: from the silk worm, to the silk thread, to a piece of silk. So it's holding a metaphor." More than one: "People see silk as a very delicate thing," he says, "but actually it's one of the strongest fibers on earth."

Over the last few years, Nguyen's work has earned him solo exhibitions and dozens of awards, residencies, grants, and fellowships. Saatchi Art named him a 2020 Rising Star, one of the thirty-five "best young artists to collect" under the age of thirty-five from around the world.

He couldn't have imagined that kind of success when he immigrated here in 2010 from Ho Chi Minh City with his family. He was nineteen, had an undergraduate degree in fashion design, couldn't find a job, and spoke no English. "It was just a culture shock. You can't communicate with anybody. You feel so isolated. Homeless, in a way. I was struggling."

Art called him. Nguyen enrolled at UNC Charlotte to study painting—the artist Elizabeth Bradford was one of his teachers—and found himself yearning for a way to incorporate his own culture and passions into the work.

In the end, the way it came together was a happy accident. Unpacking his things at an artist's residency in Vermont, where he planned to continue painting the "very flat, very traditional" types of canvases he'd been creating until that point, Nguyen realized he'd left most of his colorful paints and brushes behind. All he'd brought was a bucket of white paint, a few skeins of silk, and some canvas. "What can you do with that?" He wondered. "And you know, it just happened." Quickly, he decided he was on to something: "The material was speaking for itself." Bits of transparent silk dripped off his canvases, letting light shine through. "I decided I didn't want the frame anymore. I decided: let's sculpt it."

To get there, though, he knew he'd have to manipulate silk in new ways. "Silk has such a value with the Vietnamese culture," he says. "For me, to destroy a piece of silk, to cut it into pieces . . . that's a big deal for me. I pushed myself to do that." ▪

Kenny Nguyen in his Charlotte home studio with *After the Monsoon*, 2020. 72 × 80 × 5 in. Silk and acrylic on canvas.

CHAS FAGAN

CHARLOTTE

"For me, it's always the history."

Chas Fagan takes history seriously because his art bears an unusual responsibility. His statue of Ronald Reagan stands in the rotunda of the US Capitol building. His Rosa Parks, Mother Teresa, and Elie Wiesel are carved on the walls of the National Cathedral. The Vatican chose his portrait of Mother Teresa to serve as the Catholic Church's official image on the occasion of her canonization, and hung it stadium-size from the facade of St. Peter's Basilica.

These works and countless others play an important role in recording the history of leaders and legacies, but equally important to Fagan is that they depict their subjects' humanity. "No matter who it is, I'm always looking for the person that I'd like to spend time with."

At the foundry in Seagrove that casts his work in bronze, another saint, Benedict, a father of Western monasticism and the patron saint of Europe, stands before Fagan, nearly fully formed in clay. This Benedict is a well-built man, over seven feet tall, with a kind face; the drape of his robes and the thorns at his feet are unmistakably biblical. He's headed to a church in Pennsylvania once he's complete, but first, Fagan climbs a ladder to work a curl of his hair. The artist commutes from his home in Charlotte to sculpt large-scale works in clay like this one on-site, because they'd be too big to move here once complete. He works in an oil-based clay that stays pliable, allowing him to come back to it day after day. As with all of his large

works, Fagan first made a smaller model, a maquette one-eighth this size, in his home studio. Then he replicated it in giant dimensions out of sculptural foam and covered it in clay; the meticulous refinement of that clay takes many weeks.

When it's done, the statue will be cast in bronze with the lost-wax process, a method largely unchanged since the third millennium BCE, requiring several steps and skilled craftsmen to complete. First, the statue will be cut into eight segments. Each will be coated in rubber and plastered with a slurry of hemp and gypsum, a "mother mold." Once removed, this mold—rough-hewn outside, but finely detailed inside—is filled with molten wax. The wax hardens and makes a hollow cast of the original clay piece. Then a system of pipe-like "sprues" are attached, making a path for molten wax to depart and molten bronze to enter. This whole thing is dipped several times in a liquid ceramic formula and then in sand, creating a hard ceramic cast inside and out, with the wax cast sandwiched in the middle. It's fired in a kiln, and when the central wax melts out of the sprues, molten bronze is poured into the space left behind. Once cool, the ceramic shell and sprues are cut off, and the bronze casting emerges, ready to be refined and welded to the statue's other pieces.

Fagan explains this process, which has completed dozens and dozens of his works over the years, as if it's all in a day's work. It may be now, but none of it is anything he could have imagined as a younger man.

Charlotte sculptor Chas Fagan at work on
Saint Benedict in the studio of Carolina Bronze
Sculpture foundry in Seagrove, NC.

A graduate of Andover and Yale, Fagan earned a degree in Soviet studies before he realized that he didn't want to pursue politics or diplomacy. He'd always drawn, had cartooned for the New Haven paper in college, but it wasn't until he started selling cartoons more broadly and illustrating for ad firms in Washington, DC, to pay the rent that he considered pursuing art as a career. When his quickly drawn portrait of Ronald Reagan made the cover of the *Weekly Standard* magazine, his phone began to ring. It hasn't stopped. Fagan has painted portraits of all forty-five US presidents and sculptured countless historical figures. One of his latest commissions, a larger-than-life-size sculpture of Rev. Billy Graham, will represent North Carolina in Statuary Hall in the US Capitol.

Much of his inspiration goes back to his childhood in Brussels, where he lived as the son of a diplomat and was exposed to work of the European masters:

You'd see these amazing pieces of art, and you'd try to imagine what it was like at the time they were made . . . then you get the story it's supposed to tell, and why it means something for that age. All of those things start to feed into themselves. The story in the story in the story. And I think it's necessary that we keep doing that. We need to be able to look back and tell stories of the past. We've done it forever. As humans, it is vital. We need to know where we came from, and where we're going. ∎

A rubber mold taken from Chas Fagan's sculpted clay bust of William Wilberforce, a British member of Parliament who led the movement to abolish the British slave trade in 1807. The mold lies in two pieces for airing on the foundry floor.

JOHN W. LOVE JR.

CHARLOTTE

John W. Love Jr. on the train tracks
behind his Charlotte studio.

Nobody forgets meeting John W. Love Jr.

There's his swashbuckling appearance: part pirate, part athlete, part dapper gentleman-about-town. There's his energy, distilled and directed; his conversation, woven with otherworldly tales and unpredictable tangents, and the way he braids them like skeins of cosmic, mythic yarn. His assuredness seems cellular, and his vibe, his aura: how can one man be simultaneously so esoteric and so grounded?

"As a writer and performer, I'm always acutely aware of the narrative that is present or the narrative that is yearning to be," he says, standing on the gravel of a vacant lot in Charlotte's Belmont neighborhood, staring into the sun, posing for a photo. "So whenever I'm being photographed, whenever I'm embodying a moment of any kind, in an intuitive fashion, I try to slip into whatever narrative is upon me, no matter how real or surreal it happens to be. Does that make sense?"

Whether it does or doesn't, you're riveted, and so is he. Charlotte's celebrated artist provocateur is an irreverent master of the game of attention, using performance, installation, video, sculpture, literature, and his very persona to spellbind his audience and provoke questions about identity, gender, sex, and power; to ponder and explore the meaning and wellspring of creativity, creation, and dreams. He does it with poetry and story and bawdy humor, he does it with elaborate installed constructions

and metaphor and empathy. Numerous fellowships and awards have followed, notably a Guggenheim Foundation Fellowship, a Hugh McColl Award and a $100,000 Creative Capital grant.

Much of Love's art involves a multigenerational pantheon of characters including The Perpetually Pregnant Man (a central, narrating presence), and others including Black Lilly Billy, Sister Neeqa, and Salt Daddy.

"It's all me. Even when I am playing a character or characters that are seemingly nothing like me, it's all me. . . . Because I am the channel, the vessel through which it all comes."

A trained actor, singer, and dancer, Love has been tapping into ideas and entire worlds since he was a child growing up in Northwest Charlotte, where his "lovely, wonderful" parents created an environment "where being bright, being smart, questioning, all of that was encouraged." As a result, "My vivid, vivid, vivid imagination has always been my playground."

He uses it for art and harnesses it for his role as a sage with a guru-like following. People listen when he speaks, when he says things like: "I'm responding to the environment by being in it, harmonizing with it, becoming one with it. So the heat is not a problem when I become one with the heat, the light shining in my eyes is not a problem when I become as brilliant as the light shining in my eyes. So that's what I was doing, you know, in the photo shoot. I was embracing, engaging, being, becoming. Dancing with dust."

During the pandemic, Love's guided meditations—which he previews on his Instagram page with a series called *Calm Yo' Ass* that has followers including the supermodel Naomi Campbell and the artist

Articulating a Point, by John W. Love Jr., 2019.
3.5 × 12.5 in. Glass, alum, salt, fleur, whispers.
Photograph by James Fedele.

Kehinde Wiley—exploded in popularity. The pandemic also put some work on hold, including an ambitious installation called *The Cathedral of Messes* funded by his Creative Capital grant. But Love's not concerned. Living in an interstitial state, whether that's a moment in time or within an identity that's neither here nor there, is one of his specialties.

"It's all about the in-between spaces. So much of my work is about the blurred line. So why would I not lean in to what's in the blur?" ▪

ELIZABETH BRADFORD

DAVIDSON

In a former cotton shed on Mecklenburg County land her family has owned since the 1800s, Elizabeth Bradford paints the natural world around her. With extraordinary, saturated colors and meticulous, zoomed-in details, her landscapes can be exotic, surprising, even strange. They are also poetic: meditative celebrations of the beauty, interconnectedness, and geometry of the natural world.

On canvases nearly as tall as she is, Bradford takes countless hours over many weeks to represent in paint the magic she finds in nature. Sometimes it's an eddy of water, as seen in the painting in this photograph. Sometimes it's the messy bank of a receded river, where roots protrude and collide. Trees, fields, ponds, creeks: Bradford finds wonderlands in them all. Representational, but with deep, twisting tentacles into abstraction, her canvases beg the viewer to look hard.

Visitors to the Cameron Art Museum in Wilmington had the chance to do just that with twenty of her canvases in a powerful one-woman show in 2021; it was just one of many prominent exhibitions of her work over the course of her career. Her work is also in the permanent collections of museums including the Mint, the Weatherspoon, and Blowing Rock, as well as in many top corporate collections.

Bradford's work began to "develop a power" when she started backpacking in the mountains of North Carolina about nine years ago, she says. With two friends, she started "going into a lot of obscure places, wild places, where the world is crazy. . . . It's like they say. Truth is stranger than fiction. The wild is stranger than anything I can dream up."

It's also more meaningful. The wilder the land, the more Bradford says she found to care about. "I'm on a mission to sensitize people to the beauty of the earth," she says. To take things "that aren't obviously beautiful and to render them beautiful." She does that in large part with unexpected, vibrant color, something she once eschewed as a "cheap trick." But after a number of years of hewing as close to the actual color of the natural world as possible, she decided she was selling herself short. "Why are you being this ascetic?" she asked herself. "Why are you denying yourself access to something you love so much? And so I started pumping up the color. And as a result I've gotten more imaginative, more intuitive. More soulful."

Actively challenging herself has become an ingrained habit, one begun the year she turned forty and made a decision, a promise to herself: "Instead of getting bummed out about getting old, every year for my birthday I would pick something I didn't think I could do, and I would spend a year trying to do it." That first year, she decided she would paint a painting every single day for a year. At the moment, her challenge is learning to speak French.

And so as she ages, Bradford's world gets more and more interesting. Not that boring is an option. "The world is just so complicated and fascinating. There are just not enough years of life to do everything you want to do." ▪

FACING
Elizabeth Bradford at her Davidson home studio with *Creekbed, Old Fort* in process, 2021. 48 × 36 in. Acrylic on canvas.

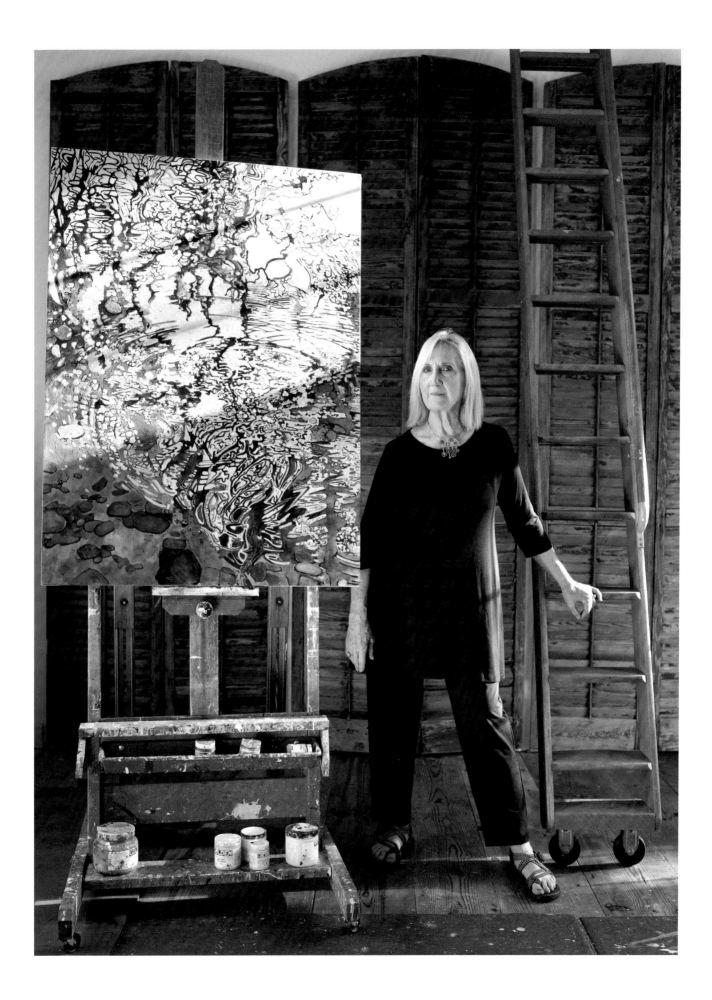

BARBARA ELLIS

CONCORD

For Barbara Ellis, the process of making an abstract painting is like playing jazz, like taking a chaotic collection of discordant notes and turning them into unexpected music. Marks and colors made intuitively find their way onto the canvas, where they jostle and mix; Ellis finds a thread and follows it through, creating a composition as she goes.

She does this in a 100-year-old brick building that originally housed Concord's city water works, the place where ten years ago she rented a studio and walked away from the thirty-eight-year corporate career that had kept her from pursuing a lifelong artistic calling.

"I needed to be free."

She found her freedom in painting, which took many forms; she found her calling in gestural painting rooted in abstract expressionism. "That's where I learned how to really let loose and express what lives inside of you. And how to turn it into composition by addition and subtraction." Since then, Ellis has had solo exhibitions in and around Concord and Charlotte, and been part of many prestigious group shows including the GreenHill Center for North Carolina Art's *NC Women Abstract Painters* show in 2020.

A fifth-generation Manhattanite who has lived in North Carolina for nearly twenty years, Ellis always had artistic talent, but didn't consider pursuing it as a means of self-expression. She felt societal and familial pressure to attain financially stable professional success, so she earned a bachelor's degree in commercial art with the hopes of becoming an advertising art director instead.

Barbara Ellis at work in her Concord studio.

In 1978, she landed a job at one of New York's top ad agencies, McCaffrey & McCall (later acquired by Saatchi & Saatchi) and hoped to work her way up. After a while, she realized that was unrealistic. "It wasn't going to happen. I was the wrong gender. I was the wrong color. I became disillusioned." She had responsibilities, including a daughter, and needed to find a career she could build. She found it in publishing, and then in a lucrative job with American Express, where she stayed for sixteen years. Along the way, she painted when she could, took art classes when she could. "I had a best friend who said to me, you're not doing your art. You're not being responsible to the artist inside of you. And I said, honey, I'm doing the best I can. Because corporate sucked the life out of me. It sucked the creativity out of me."

When she moved to North Carolina to be near her daughter and grandchildren, she took another office job before she finally decided to paint full time. "At a certain point, I realized: You have a purpose, and you're really not living out the purpose," she recalls. "We create our own realities. We have been created, and we in turn have the ability to create. It's a fundamental truth of life, and I have seen it manifest, and it has been a joy."

Music is always playing while Ellis works; on this day, jazz, the soundtrack of her childhood. Musicians like Cal Tjader were always on the record player at home; her father would play along on bongos. She grew up knowing a good bit about the genre and about her great-grandfather, Lucky Roberts, a storied figure in the Harlem jazz scene of the 1940s. He was a prolific songwriter (*Moonlight Cocktail*, made famous by the Glen Miller Orchestra, is one of the songs that still bring royalty checks to Ellis's mailbox); he was also a famous pianist who played with Duke Ellington and the owner of Lucky's Rendezvous, a popular jazz club.

Ellis puts herself in a mindset not unlike one her great-grandfather might have had when he composed a piece—letting a concept or an emotion guide the way, letting the notes follow. "I take an idea and I ruminate on it, kind of think about it, have it be in my spirit while I work," she says. "And then when I'm done with the work, I write about it."

It's a physical, full-body process, almost a dance, requiring a good deal of energy. The restrictions of COVID and "all the noise in the world" at that time had her making subdued paintings with a more muted palette. "I wanted to make work that was quieter, had less excitement, less color."

The freedom to choose that shift, to reflect what matters to her, to spend her days immersed in it, is one she's grateful for every day. "It's all come together in a wonderful way," she says. "I have a place to be, and I can be me." ∎

ABOVE
Redux 1, by Barbara Ellis, 2019. 22 × 19 × 1 in. Oil over acrylic on gallery wrap. Courtesy of Barbara Ellis.

FACING
Juan Logan in his Belmont studio with two of his *Elegy* works, each 67½ × 83¼ in. Acrylic on shaped canvas.

JUAN LOGAN

BELMONT

On a sprawling industrial site on the banks of the Catawba River, beyond a cabinet maker, a boat rental, and a rum distillery, past hundreds and hundreds of pallets of overstocked, shrink-wrapped, big-box merchandise—lies a repository of an entirely different sort.

Here, in an open, 5,000-square-foot space, stand sculptures and paintings, drawings, prints, and multimedia creations that address, mostly through abstraction, many of the issues of our time: race and memory, history and geography, stereotype and expectation, imagination and potential. It is the massive studio of the artist Juan Logan, the place where he creates and stores the work that has made him, over the course of a career spanning more than fifty years, one of our state's most accomplished contemporary artists.

"Race, place, and power" and the way these things intersect is how Logan boils down the themes he explores in his work, in this space. Wearing the uniform

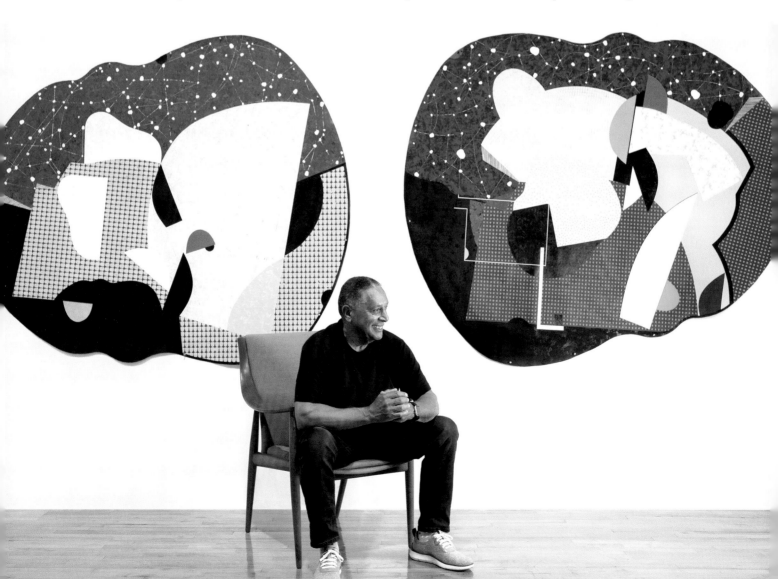

of black T-shirt and jeans he has made his own for most of forty years, the former UNC-Chapel Hill professor of studio art is a voluble host, eager to unpack the meaning and message of his work, which surrounds him in a vibrant, living archive. He does it through story.

There's the story of a treacherous treadmill used to try to break the spirit of enslaved people in Jamaica in 1837—which inspired *The Sugar House*, a sixteen-foot canvas of paint, glitter, lottery tickets, and thousands of glued-on puzzle pieces.

There's the story about the high school shop teacher who encouraged him to make his first work of art, an eagle carved of white birch. This is a man Logan is so determined to credit with launching his life's trajectory that he spells his name: "Harold McLean, that's M, C, capital L, E, A, N." McLean told Logan that what he made didn't have to be like anyone else's. "It can just be yours," the teacher said. The words unleashed something in Logan: "It changed everything."

There's the tragic story of his father dying of a heart attack after a doctor didn't believe his chest pains were real. It's an example, Logan says, of racial bias, and one of his many inspirations for work that address injustice, oppression, and alienation.

And then there are the many stories of home. The shape of a canted roofline in one of his works has him describing his own 114-year-old house, which was built by his great-grandfather and grandfather. It's a ten-minute drive from his studio in a neighborhood Logan illustrates with a quickly jotted map: "Here's my house right here. Here's my mom's house over here. Here's my aunt's house here. There's another aunt here. Here's my sister's house here. Here's my uncle's house down here. And then my grandfather's road, that's named after him." The foundation of another house his great-grandfather built out of handmade bricks and lived in after slavery still stands in the woods nearby. "These things serve to anchor you in a particular way," Logan says. "I think more than perhaps other places, the South does that for so many people."

Memory, collective and individual, its importance and its evanescence, is a recurring theme. "The absence of memory, how it depletes us . . . how it kills us. It leaves us very alive, but missing so much."

A repeated image throughout his work over decades, beginning in the late 1970s, is the silhouette of a black head. The subtle shape shows up in painting, drawing, collage, and sculpture (including *Beacon* outside Charlotte's Harvey Gantt Center), as a symbol of memory, loneliness, identity, and of the Black experience. "All of our imaginings, and everything we ever were or will be takes place there first. It is who we are." The featureless cameo offers a blank-slate Rorschach challenge to the viewer: what do you fill in here?

Other symbols that make regular appearances in Logan's colorful, abstract work include starry skies, clouds, maps, and boats. Like a poet, he uses these allegorical images in individual works and as leitmotifs to represent many things: the collective unconscious; the workings of the world and the role of the individual in creating it; reserves of knowledge; the power of imagination and perception. Most important, Logan says, is not what he says these things mean, or what his own point of view might be, but what they provoke or challenge in the viewer.

"For many years now, I've tried to simply ask better questions. I think that's the only thing that allows us to deepen our investigations about what we're doing, regardless of discipline. If we can ask better questions, we'll learn more, be able to do more."

Doing more is clearly not a problem for Logan. At least a dozen new projects in various stages surround him; so are countless completed works from a long and celebrated career that has seen his work shown

across the country and around the world in solo shows. He has pieces in the permanent collections of some of the nation's foremost museums, including the Whitney Museum of American Art, the Philadelphia Museum of Art, the Smithsonian's National Museum of African American History and Culture, the Baltimore Museum of Art, and the Mint.

But he's not ready to slow down. "We want so much out of this. And we are here for such a brief period of time. So we try to do as much as we can for as long as we can, with the hope that someone will take the time to preserve it and pass it on and share it with others." ∎

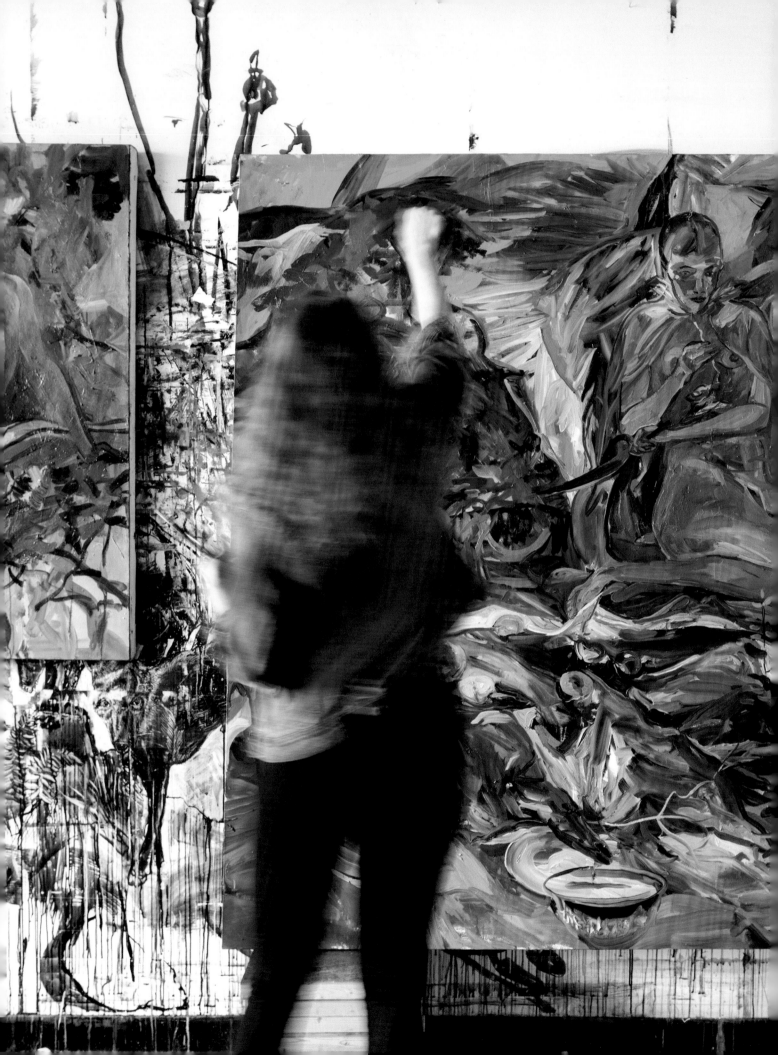

THE TRIAD

Before Franklin D. Gilliam Jr. left Los Angeles to become the eleventh chancellor of UNC Greensboro, he and his wife, Jacquelean, longtime art collectors, had never been to North Carolina. They knew they were coming to a vibrant university with an important role in educating minority students and first-generation college students, but they had no idea they were coming to a city and state filled with art.

"I just didn't know," says the former dean of UCLA's Luskin School of Public Affairs. "I didn't know." Six years later, their collection—and their group of friends—has expanded to include many North Carolina artists, and their appreciation of their city and state's art world has inspired them to expand that community even further.

Franklin Gilliam has committed to a major new art facility on campus, and Jacquelean Gilliam has become involved with the university's nationally renowned Weatherspoon Art Museum and several local art organizations. She works firsthand with

groups of elementary school students to expose them to art, and serves as a trustee for the North Carolina Museum of Art. The art scene "is so vibrant and so busy and so full of life," she says. "I don't know if I expected that."

The couple found it fast. Just a few minutes' drive from the Gilliams' art-filled chancellor's residence are more than a dozen well-established organizations dedicated to visual art, and an arts district amid downtown's reborn former tobacco factory buildings.

There's the strange and remarkable "living museum" known as Elsewhere, filled to the rafters with objects for visiting artists to compile into original works. An experiment in collaboration since 2005, the nationally reputed Elsewhere is host to thirty-five resident artists and a springboard for more than fifty projects every year. Installations, artworks, events, and fundraisers to support art in many forms make Elsewhere a creative hub in constant motion.

FACING
Jennifer Meanley at work in her
UNC Greensboro studio.

Collectors

Jacquelean and Franklin Gilliam

GREENSBORO

UNC Greensboro chancellor Franklin D. Gilliam Jr. and Jacquelean Gilliam, pictured at the chancellor's residence in Greensboro in front of a painting by Milton Resnick, on loan from the university's Weatherspoon Museum of Art.

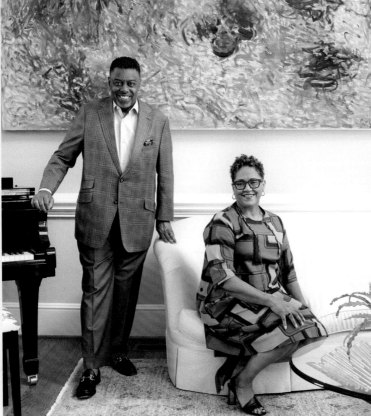

Jacquelean and Franklin Gilliam collected art together for years before Franklin Gilliam became chancellor of UNC Greensboro. In Los Angeles, where he'd served as the dean of UCLA's Luskin School of Public Affairs, the couple had immersed themselves in the city's art scene, collecting art by local artists and national ones.

Arriving in Greensboro in 2015, they promptly did the same, finding themselves surprised by the local and statewide art world's depth and breadth. "I'm so happy that it is so vibrant and so busy and full of life," says Jacquelean Gilliam, who is now actively involved in several university and community art organizations and is a trustee at the North Carolina Museum of Art.

The vibrance they've found is on view at the couple's chancellor's residence, where art from their own collection—including works by Andy Warhol and several pieces of African art—hang on large walls among pieces of modern and contemporary art, some on loan from the university's renowned Weatherspoon Museum of Art.

"It's an interesting juxtaposition between the contemporary art and the African art," Jacquelean Gilliam says, standing before one of the Weatherspoon's significant abstract expressionist works by Milton Resnick. "It provides for some interesting viewpoints."

She considers herself fortunate that her husband shares her interest in art. "He's very vocal and involved in the selection of the pieces."

He laughs: "I would say that I—retain veto power," he says.

"Well," she says, also laughing, "I'm a little out there."

One thing they don't debate: their love of North Carolina art. Among the North Carolinians on their walls are Elizabeth Bradford, Steven Cozart, Beverly McIver, who has become a particularly close friend, and the Raleigh painter Clarence Heyward.

"I have a little bit of an addiction, I must admit," Jacquelean Gilliam says. "I have a closet upstairs that is just overflowing with art." She rotates pieces in and out so that the couple—and their many, many guests—can enjoy them all.

Pre-COVID, the Gilliams had an average of 6,000 people through the house every year, including students, faculty, staff, and community groups. The opportunity to share art with so many people is important to the couple. "Art doesn't do much good if it's sitting in a vault," Franklin Gilliam says, quoting Juliette Bianco, director of the Weatherspoon.

When Jacquelean brings in groups of young community members, she often invites a curator or arts educator to speak to them about the art, and about careers in the field of art. "That has been refreshing for me, to be able to introduce young people to a variety of ways into the arts, to explore it, if they've never thought of it as a possibility." She also hopes that regardless of their future careers, young Greensboro residents understand that art can be part of their life.

"You can appreciate it based on your own feelings and experiences," she tells them. "It's a universal language that transcends North Carolina. No matter where you go, you can appreciate it." □

Nearby is the African American Atelier, a gallery and youth art program dedicated to African American art and artists, including a recent exhibit of the artist Steven Cozart. There s the art gallery at Guilford College, a small liberal arts school with a sizable permanent collection of twentieth-century American art, some Renaissance and Baroque art, and a significant collection of Central and West African art.

On the campus of nearby North Carolina A&T (the nation's largest among historically Black colleges and universities), there are two galleries dedicated to the art and culture of African American life in North Carolina, including important twentieth-century art; there is also an extensive African heritage collection comprising more than 6,000 artifacts. These works are housed in a handsome neoclassical building with a monument to the "A&T Four" (also known as the "Greensboro Four") in front. Honoring the four freshmen who made history in 1960 with their sit-in at the Woolworth's lunch counter in Greensboro, the sculpture was made by Asheville native James Barnhill, who earned his master's degree in art from UNC Greensboro (UNCG), and teaches art at A&T.

Figure Eight

Patricia Wasserboehr

GREENSBORO

A professor of art at UNC Greensboro for two decades, Patricia Wasserboehr was a figurative sculptor when she came to the university in 1982, working primarily from life, making figures out of clay and casting them in plaster and sometimes bronze or other metals.

"I was a rather astute observer of form," she says, "and at some point, I decided to work figuratively, from imagination." When she stopped using models, she entered the world of abstraction "with a keen respect and ability to draw from my life," studying the work of artists who had followed a similar path, including Isamu Noguchi and Constantin Brancusi. "Some colleagues used to refer to my work as anatomical extraction," she says.

In the 1980s, Wasserboehr began carving stone, which she enjoyed but found prohibitively time-consuming given the demands of her full-time job (she also served as department head for over a decade). "I began to work in materials that were easier to carve within a time frame, and that was Styrofoam."

Cast in metal, these forms referred to, rather than replicated, human figures. Others referenced Samurai saddles (a response to the Fukushima disaster in Japan), hyperbolic curves, and other shapes. She also used 3D software to program robotic arms to rough-cut stone in Italy, and brought students along to study stone carving there. Exposing students to art, teaching, and helping to launch careers has been hugely gratifying, she says. "I'm so proud to be part of that enterprise." □

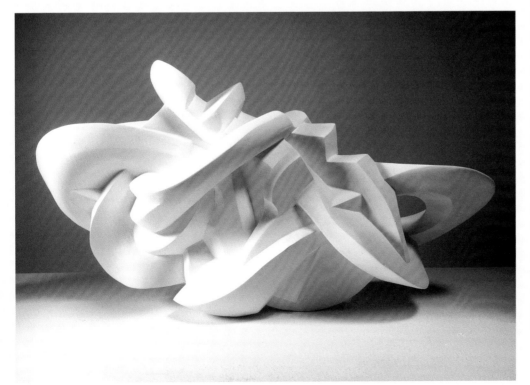

Figure Eight, by Patricia Wasserboehr, 2020.
12 × 21½ × 8 in. Hydrocal plaster and milk paint.
Photograph by Dan Smith.

Collector

Adair Armfield

GREENSBORO

Adair Armfield is the kind of collector every artist hopes to find: excited to see the world through another's eyes, open to experimentation, and delighted to add another piece of art to her already sizable collection. Most of all, she is committed to supporting artists and art in her community.

At her house in Greensboro, Armfield has art on every wall and on most every surface. It's an eclectic collection that includes paintings, photographs, and sculpture from artists all over the world, with a strong contingent

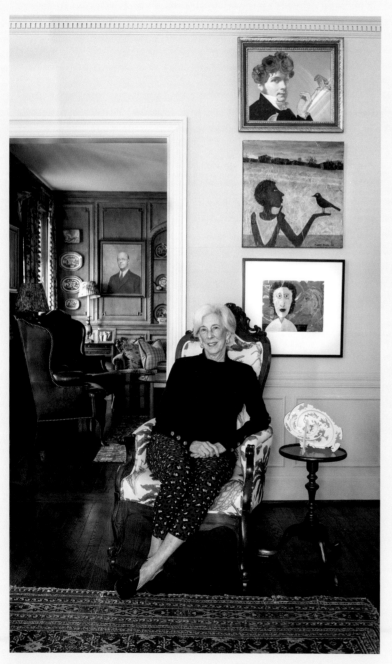

of North Carolinians. A very partial list of those includes John Rosenthal, Minnie Evans, Romare Bearden, Felicia van Bork, Maude Gatewood, Richard Fennell, Margaret Hill, John Beerman, Elizabeth Alexander, Francis Speight, Clarence Heyward, Suzanne Brooks, Rebecca Fagg, Gilbert Carpenter, Elizabeth Darrow, Louis St. Lewis, Elizabeth Matheson, and Roy Nydorf.

At her house in the mountains, there's all of that and more. Some of the walls there are two stories tall, and every inch is art, much of it collected at GreenHill, where Armfield has long been a volunteer and major benefactor.

Armfield says she loves to live with art and wants her community to live with it, too. Through the Edward R. Armfield Sr. Foundation, which she chairs, Armfield recently underwrote a GreenHill-designed online arts curriculum for the Guilford County Schools to enrich students' lives during the pandemic. In 2016, she and the foundation brought an extraordinary work of public art to the heart of Greensboro by underwriting internationally renowned Janet Echelman's *Where We Met*, a wafting net of woven fibers above the city's central LeBauer Park.

"We wanted children, and everyone, to be amazed by it, to learn from it," she says. Named for her late husband, founder of the textile company Armtex Corporation, the foundation is a longtime supporter of education, efforts to reduce poverty, programs for children, and the enhancement of public quality of life.

Armfield is pictured here at her home in Greensboro beneath paintings by Raleigh artist Louis St. Lewis (top), and two by Elizabeth Darrow. The sculpture of intersecting porcelain plates with flower cut-outs is by Winston-Salem's Elizabeth Alexander. In the room beyond, a portrait of Armfield's grandfather, painted by George Dan'l Hoffman, hangs near some of Armfield's collection of blue and white Canton china. □

Adair Armfield in her
Greensboro home.

There's the GreenHill Center for North Carolina Art—the only organization in the state exclusively dedicated to the visual art of North Carolina which as the Gilliams speak is filled with the abstract, geometric works of Knightdale artist Heather Gordon, an installation called *Shift Happens* inspired by the impact of the pandemic. (Just a few months earlier, GreenHill held its annual curated exhibition for more than 100 North Carolina artists; a few months later, it will house a retrospective of esteemed North Carolina artists Rebecca Fagg and Jack Stratton.)

And on the UNCG campus, there's the Weatherspoon. Acknowledged as the first art facility in the UNC System (it began in 1941 as an expansive classroom using art for the teaching of art), the small but mighty museum is a North Carolina jewel with a national reputation for its collection of modern and contemporary works. At its center is a 1950 bequest from the collection of textile heirs Claribel and Etta Cone that includes sixty-seven works on paper and six bronzes by Matisse, original Picasso prints, and other important European and American modernist works. The museum's collection has grown significantly since with savvy acquisitions, and now numbers more than 6,000 works representing major art movements from the beginning of the twentieth century to today.

The museum's mission has also evolved. Juliette Bianco, who left Dartmouth College's Hood Museum of Art to become director of the Weatherspoon in 2020, says her goal is to put the museum at the center of innovative teaching, community building, and the exploration of diversity and inclusion. "Meeting Chancellor Gilliam, I saw an opportunity for something quite rare," she says. "I realized that a shared purpose between the museum and the university could propel the museum to serve the community more deeply, moving the university's goals forward."

Those goals are educational and they are socioeconomic. As a federally designated Minority Serving Institution (UNCG is one of the most diverse institutions in the state, with about 50 percent students of color), UNCG also ranks number one in North Carolina for social mobility (enrolling and graduating the highest percentage of students eligible for Pell grants, according to *U.S. News & World Report*).

"Greensboro has a long and complicated history, and the University's drive to create opportunity for social mobility is really compelling," Bianco says. "This is a university with a mission. . . . And we have the opportunity for art to be part of realizing that mission. It's a point of pride and also a driving force for the Weatherspoon."

CONNECTED THROUGH ART

To be sure, the museum has been making an impact through art for decades. "When I saw the collection as a child," says Edie Carpenter, now the director of curatorial and artistic programs at GreenHill, "there would be contemporary art just everywhere." The daughter of Gilbert Carpenter, a twenty-six-year director of the Weatherspoon and onetime head of the UNCG art department, Edie Carpenter has never forgotten the impact the Weatherspoon's collection made on her: "You'd see Donald Judd. It would just be right there hanging out near the stairwell. You'd see the Calder mobile, in the stairway where students would go up and down. There was a sense that you were right in the midst of it, and I think that that kind of radiated out."

Outward and onward. "To have an art scene, you need to have patronage, you have to have education, you have to have emerging artists, and you have to have a public," Carpenter says. "That legacy is still here."

It's certainly alive and well at GreenHill, which has been bringing North Carolina art to North Carolinians since the 1970s, when Greensboro's art community first began to ignite, thanks in no small part to Carpenter's father. Among his innovations was bringing in established working artists, like New Yorkers Andrew Martin and Peter Agostini, to teach UNCG students. Agostini, a major American sculptor, would leave his studio on Prince Street in New York's SoHo every week to come down to teach, Carpenter recalls; Martin eventually moved to Greensboro full-time and became one of the state's most influential painters.

"There was this sense that Greensboro had this connection to the heart of really what was going on in the greater art world."

That world is wider now, with artists of international renown like Nick Cave coming as visiting lecturers to this city in the middle of America's ninth most populous state, a city which has long had art in its soul, and not just visual art. *The Greensboro Review* has been a leading literary magazine since 1966, and the city has been home to a host of famous writers including Randall Jarrell, James McGirt, and William Sydney Porter (O. Henry).

Music, too, especially country, blues, and jazz, has deep roots here. On spring and summer evenings, it's often playing live under the diaphanous canopy of one of the largest outdoor art installations in the Southeast. Janet Echelman's *Where We Met* wafts in the air above the musicians and audiences on Greensboro's 17,000-square-foot "front lawn" at LeBauer Park, which was created downtown in 2016.

The internationally acclaimed Echelman made the shimmering net out of 35 miles of technical fibers and 242,800 knots; the result is a mesmerizing, morphing cloud of pink and blue, orange and purple that traces the pattern of the six railroad lines of North Carolina's historic textile region, with individual mills dotting the routes, and Greensboro at the center.

"We wanted children, and everyone, to be amazed by it, to learn from it," says Adair Armfield, who underwrote the installation with a $1 million grant from the Edward R. Armfield Sr. Foundation, which she chairs. Named for her late husband, founder of the textile company Armtex Corporation, the foundation is a longtime supporter of education. As an inveterate lover of art with a significant collection that includes many North Carolina artists, Adair Armfield has long supported the arts as well, and was gratified by the ability to combine art and education with the Echelman piece.

"We are convinced that there is a place for art in education," she says, "to make schoolchildren aware, to make adults aware, of what can be done with art, and how fantastic art can be." For such a work of art to serve as the anchor of a new city park means that anyone can see and experience it, Armfield says. "For children, it must look magical up in the sky, for them to think that somebody wove that, somebody made that."

Sharing art and celebrating it together is something Greensboro does particularly well, says Steven Cozart, an educator and one of the painters represented in the Gilliams' collection. "Greensboro is this art hub that I don't know people are fully aware of," he says. "You would think that it would be Charlotte, because Charlotte's a big city. Or Raleigh, because it has the Museum of Art . . . but in my opinion, it's Greensboro. In this one area, there is so much art, and so many art opportunities."

Weatherspoon director Bianco says the museum is one of several local institutions dedicated to creating them. She is committed to inviting and involving the community in the museum's programs, which, like admission and now museum membership, are free.

"How can a campus-based museum truly be part of building a community for and with its students, and for and with its community?" Bianco says she asks herself. "We should be questioning what is the role of art museums, and how can we help make meaning together." She is one of a team putting together a major project called Tate + Gate, a visual and performing arts facility being built on a heavily trafficked corner of campus near the museum that will use interactive installations to immerse people in art and welcome them to campus.

"A lot of our students are from small-town North Carolina, or inner-city Durham or Charlotte," Chancellor Gilliam says. "Many don't know museums. They've never been exposed. If you can introduce them to the arts while they're on campus in a way they might not get in their hometowns," he says, the impact can be significant. "Eighty percent of UNCG students stay in North Carolina," he notes.

Jacquelean Gilliam nods: "And so imagine," she says, "imagine the implications this will have for generations."

Pass/Fail Vol IX: Odera

Steven Cozart

GREENSBORO

Greensboro-based artist and educator Steven Cozart is color-blind but makes paintings about color—the color of skin—and about race and identity. Using the concept of a "codec" (a computer program that compresses information to enable the quick transfer of data) as a metaphor for skin tone, he has built a body of work that addresses the way he says people determine human "value" at a glance.

"It's something we do every day, right? Based on what we see, we immediately have this whole plethora of information attached to it. This laundry list of things and judgments."

In *Pass/Fail Vol IX: Odera*, Cozart shows a young girl holding a paper bag up to her face. It's a reference to a discriminatory practice used to measure a person's worth based on the lightness of their skin.

"The goal of the work is to begin a conversation within a public space about why these things are so prevalent within the African American community," he says. "The whole purpose of the work is to get people talking to each other." □

Pass/Fail Vol IX: Odera, by Steven Cozart, 2018. 10 × 10 in. Acrylic, pastel, and collage on wooden panel. Courtesy of Steven Cozart.

Exposure to the arts may not be new for the nearly 1,400 students at the UNC School of the Arts in nearby Winston-Salem, but the impact of their education will also measurably enrich the state, as it has done since 1965 when the school was established as the first public arts conservatory in the nation.

Like the North Carolina Museum of Art, the School of the Arts was the result of the dogged determination of a few visionary individuals and a groundbreaking appropriation of state money. Libba Evans, the former North Carolina secretary of cultural resources and longtime Winston-Salemite, credits a small team with making it happen. Governor Terry Sanford; John Ehle, an author and UNC–Chapel Hill professor; and Joel Fleishman, then a Sanford legal assistant, originated and promoted the idea that the state should expand its system of higher education to include an arts conservatory—something no other southern state could boast.

Fleishman, currently a professor of law and public policy sciences at Duke University, is to be credited with initially encouraging Sanford to seriously promote the arts, hire Ehle as an aide, and consider creating a conservatory, says Tom Lambeth, who worked alongside Fleishman as an assistant to Sanford at the time. Fleishman won't take all the credit, but does acknowledge sharing Ehle's opinion that arts education in the UNC System was inferior at the time, and that the arts should be taught by artists, not by scholars.

Their conservatory idea got traction in 1963 when the General Assembly passed a groundbreaking bill to charter a state school of the arts with a $325,000 appropriation. Several cities leapt to claim it. Raleigh, Charlotte, and Greensboro were all in the running, but none were as focused, determined, or organized as the group from Winston-Salem.

That group included J. Gordon Hanes Jr., president and CEO of Hanes Corporation and a state senator at the time; Hanes's wife, Helen "Copey" Hanes, and Hanes's cousin, Philip Hanes. Smith Bagley of the R. J. Reynolds family was also instrumental.

"Winston-Salem at that time was such a wealthy city, post–World War II," Evans points out. Home to the headquarters of five major corporations traded on the New York Stock Exchange—R. J. Reynolds Tobacco Company; Piedmont Airlines; Hanes Corporation; Wachovia Bank and Trust Company; and McLean Trucking Company—Winston-Salem was the business capital of the state. "And they really loved the arts," Evans says.

That was already evident nearly two decades earlier, when a group of Winston-Salem Junior League women (who called themselves the "Petticoat Brigade") decided their hometown could benefit from one of the community arts councils they'd heard about in the UK.

Milton Rhodes, a longtime president and CEO of the Winston-Salem Arts Council, recalls in an oral history for the National Endowment for the Arts that this group decided their city should capitalize on and expand the strong arts program and Moravian heritage of Salem College, which was founded in 1772, making it the oldest women's college in the nation. When the group created the Winston-Salem Arts Council in 1949, it was the nation's first.

That proud heritage was well established when the 1960s-era group bent on securing the School of the Arts for their city launched a telephone fundraising campaign to support the bid. Smith Bagley and Copey Hanes were among the ringleaders of an effort to call every number in the phone book, netting $922,000 in three days, Lambeth says. It sealed the deal. The city contributed the former James A. Gray High School, the phonathon money was used to convert it, and the first state-funded art conservatory was born. The Ford

Foundation made a substantial commitment, and other funders followed, many shepherded by Philip Hanes and Bagley, Fleishman says.

"They provided enlightened leadership," says Lawrence J. Wheeler, former director of the North Carolina Museum of Art. "They believed the arts were important, and they believed they needed to come together."

Nearly sixty years later, the School of the Arts is still unique in the nation as a public, residential conservatory of art. "It's a campus with such a strong sense of community," says Will Taylor, the school's assistant dean and director of visual arts. "There's a lot of room to interact with artists from all arenas." His drawing students may sketch in a dance studio, or collaborate with students studying music or drama, broadening their vocabulary, sensibility, and reach. "Our students are really versatile," he says. In 2021, its School of Drama was ranked fourth in the world by the *Hollywood Reporter*, after the Juilliard School, Yale University, and NYU's Tisch School of the Arts.

The Infinite Library

Paul Travis Phillips

WINSTON-SALEM

An art instructor at Salisbury's Rowan-Cabarrus Community College, Winston-Salem-based Paul Travis Phillips makes philosophical art about language. About what it can and cannot do, about how we use it, abuse it, and change it, and about how it eludes us.

"Thoughts are way more complicated than words allow us to really express," he says. Displayed visually, as it is in his work, Phillips believes language can provide an extension of itself, he says, possibly superseding "conventional" language.

"Language has always been really difficult," says Phillips, who has dyslexia, "but I'm fascinated by ideas. And without language, ideas are not able to be shared effectively."

At the same time, he believes the act of reducing ideas into words can erode meaning. "I've always been highly suspicious and skeptical of anything that seeks to reduce and simplify," he says. The act of reducing something, he says, "is, in effect, an act of deconstruction. And if you deconstruct something too far, then it becomes useless, meaningless, or essentially ineffective."

That's true for ideas, and it's true for people, he believes. "I think we are fools to think that we ever really effectively communicate the complexities that are rolling around inside of any person." □

The Infinite Library—sirlzur p. 218, no. 5, by Paul Travis Phillips, 2019. 60 × 80 in. Oxidized iron paint (rust) on canvas. Courtesy of Paul Travis Phillips.

Untitled, Paper Doll Series 3163

Page Laughlin

WINSTON-SALEM

Page Laughlin, a professor of art at Wake Forest University and the chair of her department, is best known as a painter, but her work has also included site-specific installations, alternative media drawings (candle smoke on goose eggs, for instance), and community-engagement projects with art as a tool.

Her *Paper Doll* series of oil paintings begin with a photograph of a female volunteer that Laughlin alters digitally and then reproduces as a line drawing. From that drawing she creates a digital print, and on top of that print she creates her paintings. A substantial group of these works focuses on young women working, most often picking up and carrying objects. Laughlin intends for them to illustrate "the concept of working and labor in the broadest sense . . . and the idea of the things we carry. We carry our families, we carry our children, we carry responsibility, we carry caretaking, we carry work."

The women in the series are emblematic. "They're not portraits of a singular person. I don't really think of myself as a portrait painter at all." The process of creating them in the studio is fluid. "I'm an additive and reductive painter. I put it on and take it off, put it on and take it off," she says. "What I want to do is have a degree of complexity, so that you want to keep looking again and again, and find something different each time you come back. That may be what I'm searching for." □

Untitled, Paper Doll Series 3163, by Page Laughlin, 2018. 48 × 36 in. Oil and digital ink on paper. Courtesy of Page Laughlin.

Having all five disciplines on one campus is a major boon, says Thomas S. Kenan III, who also helped found the school and has stayed actively and generously engaged as a trustee and benefactor since the 1960s. The Kenan Institute for the Arts, founded by his father and chaired by Kenan, thrives today as an independent foundation to help support innovations at the school. Among the many initiatives it has funded over the years is a program to send School of the Arts students to Penland School of Craft for summer classes.

Kenan credits Mary Duke Biddle Trent Semans—a philanthropic force in North Carolina and fellow founder and benefactor of the School of the Arts—for igniting his love of the arts in general, and for visual art in particular. "She really influenced me so much," Kenan says, not only in appreciating art in and of itself, but in valuing the civic good it engenders: "The arts bring people together," he says. "They bring all races, all classes of people together."

"The City of Arts and Innovation" continues today to believe in the importance of art for all, and on public-private ideas and partnerships to make it happen. Its standout art museums—the Southeastern Center for Contemporary Art, the Diggs Gallery at Winston-Salem State, and Reynolda House Museum of American Art—are all examples.

MUSEUM CLUSTER

The Southeastern Center for Contemporary Art (SECCA) began as a nonprofit art gallery in 1956 for local artists, but grew considerably in 1972 when the Hanes Foundation gave the gallery the stately house of James G. Hanes—Gordon Hanes Jr.'s father, and the former mayor of Winston-Salem—to serve as its base. The English Hunt–style mansion and its thirty-two acres of grounds provided a grand new home.

After an initial focus on artists from the Southeast, SECCA broadened its scope to include contemporary art from all over, blazing a trail in the process. It made a meaningful impression on a young Trevor Schoonmaker, who grew up in Winston-Salem and is now the director of Duke University's Nasher Museum. "Growing up in the '80s, SECCA was a really thriving, cutting-edge, contemporary art space," he says, "because there was money for the arts in Forsyth County."

These days, SECCA is an affiliate of the North Carolina Museum of Art and has a hybrid model, exhibiting national and international artists as well as regional artists, with an emphasis on showcasing new talent from the region. "We're taking the name "Southeastern" to mean art that originates here, as opposed to where we happen to be located," says Director Bill Carpenter.

While SECCA focuses on contemporary art, across the street at Reynolda House Museum of American Art, works from every era in American art history are on display. Founded in 1965 as a nonprofit institution by Charlie Babcock (husband of R. J. Reynolds and Katherine Reynolds's daughter Mary) on the site of the magnificent 1917 Reynolds family estate, it became a public museum in 1967 under the leadership of Mary and Charlie's daughter, Barbara Babcock Millhouse, who quickly took on the job of filling her childhood home with a premier collection of American art.

Millhouse had already been collecting art on her own for about ten years when she took the helm as a young woman, and had learned to trust her instincts. With an art history degree from Smith College, she was well versed in the subject, but felt disconnected from the prevailing scholarship at the time.

"There was something more to art than any of these professors had ever said," she recalls thinking.

"I felt so strongly that something was missing. They had never mentioned the aesthetic appeal of art, how inspiring and energizing great art can be, just like music. I felt that, but I didn't know why or how. I still don't know why or how, but I've spent my life trying to figure it out."

It was the late 1950s, and abstract expressionists were in every gallery in New York, but Millhouse was drawn to realist works. She abandoned an early interest in Old Masters when she realized how many forgeries and "school of" paintings proliferated, and turned her attention instead to American paintings. "In American art we have very few forgeries," she says. "If I was looking at an Edward Hopper, it would be an Edward Hopper. If I was looking at a George Ennis, it would be an Ennis."

But at the time, "American art wasn't quite mainstream." Outside of Winslow Homer, Albert Remington, and Albert Pinkham Ryder, she recalls, American artists were not part of any accepted canon. "It was so unpopular that people didn't even know that 50 years of American art existed. . . . When we started the collection, people had not even heard of the Hudson River School."

Undeterred, Millhouse began collecting. Her focus was galvanized by the art historian and gallerist Stuart Feld of Hirschl & Adler Galleries (a curator at the Metropolitan Museum of Art at the time), who gave a lecture and slide show on the subject of the American painter John Singleton Copley at Reynolda. "I said my God, these are good," Millhouse recalls. "These are great." At Smith, Millhouse had only learned of English portraitists, like Thomas Gainsborough or Sir Joshua Reynolds. "It was a total revelation." Soon, she was seeking out works by other Americans, like Frederic Church and William Harnett. "I just wasn't tarnished by the scholarly thinking at the time," she says. "The reason we got such a good collection was because nobody was interested."

Today, the Reynolda collection is considered one of the country's finest collections of American paintings, and includes works of all kinds from three centuries of art. A busy exhibition schedule at the museum runs the gamut—from postmodernist art to Dorothea Lange, from the Black experience at Reynolda to Georgia O'Keeffe. The museum, which is now formally affiliated with its neighbor, Wake Forest University, also includes the historic Reynolds house and gardens and has a mission of offering a deeper understanding of American culture to diverse audiences.

Reynolda trustee Endia Beal first got to know the museum through her former role as director of the Diggs Gallery at nearby Winston-Salem State, a historically Black university. Awarded "Best Fine Arts Program" in the nation under Beal's direction by *HBCU Digest* in 2019, the gallery is home to one of the largest and most significant collections of African American art in the South, including public art by muralist John Biggers, a North Carolina native; sculptors Mel Edwards and Tyrone Mitchell; and North Carolina native mixed-media artist Beverly Buchanan.

Beal brought a fresh take: "I was interested in exposing my students to contemporary artists who were addressing things they were experiencing in their lives," she says. Several of the artists whose work she brought on campus have gone on to illustrious careers, among them Jordan Casteel, who has been exhibited in major museums around the world; John Edmonds, who was included in the 2019 Whitney Biennial (a prestigious exhibition known as the longest-running survey of American art); and NC State graduate Lamar Whidbee. "Some students hadn't been into a gallery space in their lives, and I wanted them to see themselves in art."

The gallery was founded by James G. Hanes Jr. (who was so instrumental in helping to found

the School of the Arts) and named in honor of his friend James Thackeray Diggs, a painter and former Winston-Salem State professor. While the Diggs has a key role to play in promoting artists of color in the region, Beal says the city also has the Delta Arts Center to thank for increasing awareness of the contributions of African Americans to the arts and humanities for more than fifty years.

"When I think about Winston-Salem and the arts, and artists of color, I think about Delta Arts Center," she says. The nonprofit provides exhibitions, programs, performances, classes, and workshops in the arts. Its landmark 1972 exhibition *Reflections: The Afro-American Artist* was considered the first major exhibit of its kind in the state. The organization regularly mounts major solo exhibitions of national artists like Minnie Evans, Eugene Grigsby, and Elizabeth Catlett and has made important donations to public collections throughout North Carolina, including an eighteen-piece collection of furniture by nineteenth-century African American master furniture maker Thomas Day to the North Carolina Museum of History in Raleigh. It also collaborates with local organizations including Reynolda House, the School of the Arts, and Winston-Salem State.

From Beal's perspective, efforts like these and those of the city's other art institutions are expanding its art scene for the better.

"There's a constant evolution," she says. "We are constantly growing, constantly evolving, and having open conversations with the community about what artists need. I wouldn't say we've arrived, but the conversation has evolved." ∎

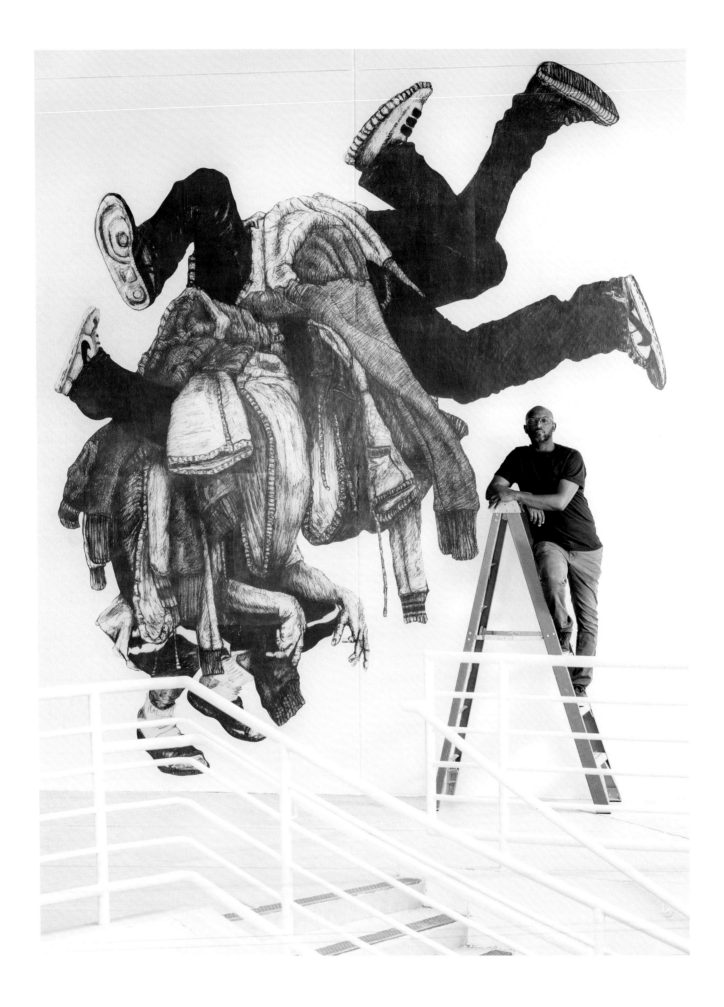

ANTOINE WILLIAMS

GREENSBORO

Antoine Williams was in his early twenties when he made an important decision: if he wanted his work to be seen, he'd have to take matters into his own hands.

He'd earned a fine arts degree from UNC Charlotte a couple of years earlier, and was busy making art that responded to the world around him, about politics, about the war on terror, about "how ridiculous all of it was." But the traditional gallery route seemed impenetrable. Not only to him, but to the other young artists he knew. "People were literally afraid of us. We were walking into galleries, and I remember one gallery. I asked: 'Can we do an art show?' And they were like: 'We don't have metal detectors.' So. It was a lot of that." The group, which included Marcus Kiser, John Hairston Jr., and Wolly Vinyl, had another hurdle, too. Traditional art venues weren't the obvious places for the audiences they sought. "A museum can be a scary place if you've never been there."

Williams knew that firsthand. A first-generation college student from "rural, working-class, conservative" Red Springs, North Carolina, Williams never knew an artist or much about art growing up, but his imagination was allowed to flourish. "It was cool to be a creative kid growing up in a place where you could run outside and go in the woods and play. I was always daydreaming, and I was always either drawing or making stuff."

He tapped into that wellspring when he decided to bypass the gallery world to cofound the artist collective God City in 2005. The group rented industrial spaces, put together pop-up shows, and got the word out with flyers. "We were really into hip-hop, and politics, comic books. We would do exhibitions . . . in any place that would take a bunch of young Black dudes." Over a seven-year run, the group forged collaborations with poets, filmmakers, dancers, and DJs. "It was all these groups of Black and brown people making art, outside the major institutions. Over time, it became a community in Charlotte. . . . It was this really beautiful time."

The establishment took notice. Kimberly Thomas, a curator at the Mint Museum, became a God City regular. In 2008, she included work by Williams and Hairston in a 2008 exhibition about contemporary portrayals of Black masculinity called *Scene in America.*

Since then, Williams has not struggled to get his art seen. Addressing cultural identity, signifiers of class, race, and power, and the stories and myths society tells about them, his work has been exhibited at dozens of galleries and museums including the North Carolina Museum of Art, the Weatherspoon Art Museum, Raleigh's Contemporary Art Museum (CAM), and at SECCA. Williams has had prestigious residencies and fellowships at Duke University, the McColl Center, and Michigan State University,

FACING
Antoine Williams, photographed at SECCA in
Winston-Salem with his mural *A Moment of Rest
While Convincing Monsters That I Am Human.*

among others; he has won several grants, and currently teaches art at Guilford College in Greensboro.

But his work remains his own. *A Moment of Rest While Convincing Monsters That I Am Human*, the SECCA mural he is shown beside, was made following the nationwide uprisings over the deaths of George Floyd and Brionna Taylor, an effort to depict both the injustice and the exhaustion of that fight. "Those marches were for the bare minimum, just so that the justice system would work. Not that it would do anything extraordinary. Just work." In depicting a man hunched over beneath a mountain of clothes, Williams indicates "how absurd it is, but also how exhausting it is." Hoodies, jeans, and sneakers refer to the distorted, negative stigma society puts on these signifiers of young Black men; the enormous heap indicates how they "constantly have to deal with the piling on of these perceptions." The burdened figure persists, but pauses, "needing to take a break, and reclaim humanity."

Having his work at the entrance of SECCA is just the kind of broader visibility Williams sought when he decided to cofound God City, or to eventually earn his MFA at UNC–Chapel Hill. But Williams resists the idea that he's now part of any kind of art establishment. "I just always feel like an outsider," he says. "I'm still very much the little kid running through the woods in Red Springs, hanging out at the carwash, or playing basketball, hanging out with my parents or cousins. I always sort of feel that's who I am. But I understand that I am in a different place as far as my career." Still, "I don't feel like I've achieved success. I'm just working." ∎

Elizabeth Alexander uses an X-Acto knife to cut flowers and leaves from a roll of wallpaper in her Winston-Salem home studio.

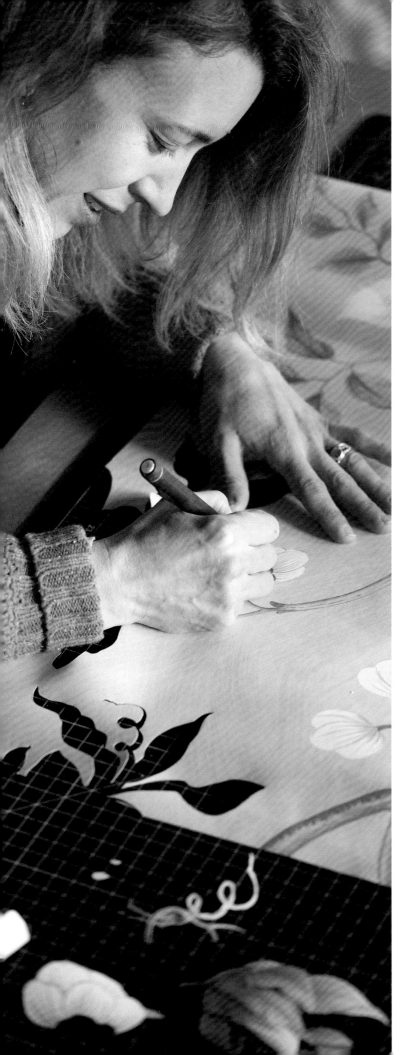

ELIZABETH ALEXANDER

WINSTON-SALEM

Unmade and then remade, the way a memory becomes a story, Elizabeth Alexander's objects and installations are askew in subtle and obvious ways. A chandelier has crashed to the floor. A rug has unraveled and woven itself back again in new shapes. The fringe on a lampshade has grown to seaweed-like lengths. There's an alive quality about them, an energetic thrum. "I've been told about my work that people feel that if they left, and came back, there'd be more of it," she says.

Painstakingly cut from wallpaper with an X-Acto knife and reassembled into sculptural collage and fantastical tableaus, her florals transform the stuff of fussy domestic interiors into something subversive and gorgeous.

When Alexander first started making this kind of art, it was meant to "challenge the feminine, pulling the feminine out of domestic space to challenge gender roles and expectations and power structures," she says, but since the pandemic, the work has taken on another important aspect: "I see it more as a portrait of the space, and the humanness of the space." Though home is often held up as a haven, presented with perfection, the pandemic, she says, has laid bare some of its truth, that home is a place filled with "living and breathing and crying and fighting and loving, those parts of life that are a little more intense." Now, she says, "the work pulls that curtain

NEXT SPREAD
Elizabeth Alexander in her Winston-Salem home studio with *Let Him Speak First (positives),* made of deconstructed wallpaper, cast paper, glue, and wood.

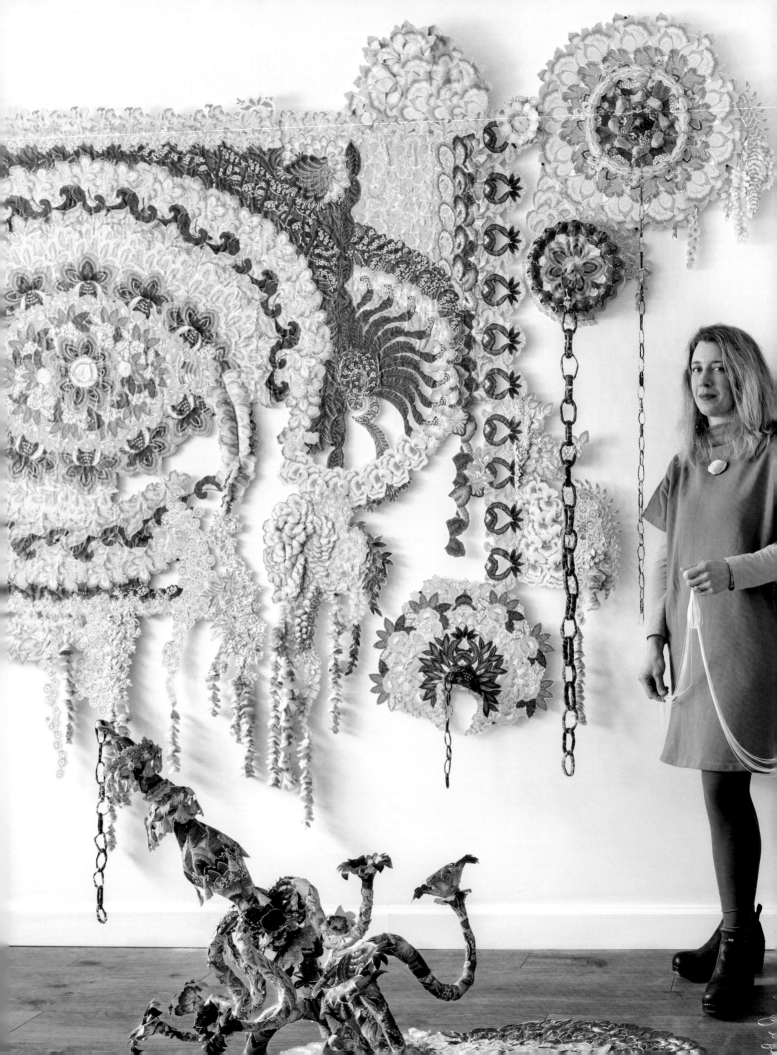

back a little bit and shows more of the emotional state of the space." That state appears to be ever-changing. Like bits of glass in a kaleidoscope or petals on the wind, her flowers and leaves seem to float, twirling into themselves, spinning out, growing tendrils that snake and expand and cover things up; tumbling, too, into intriguing, herbaceous caverns.

As a child growing up in suburban Massachusetts, Alexander spent a lot of time outdoors, grew her own garden, and made many things, as her parents did, with her own hands. In graduate school, she took photos from a book about the formal gardens in Alabama and cut out every flower one by one, then reconstituted them into surreal, superabundant gardens of her imagination.

"There's a lot of push and pull between intention and intuition in my work," she says. When she made the Alabama garden fever dream collages, intuition was pulling. She let it. The next thing she deconstructed was flower-covered fabric. "I just took an X-Acto knife to a chair and cut." She liked the result, but it felt incomplete. "The chair wasn't enough. So I started to build a room around it, and then that wasn't enough." She added wallpaper, and curtains, and made a rug out of the cut-out flowers. Soon she was covering objects like teacups and Jell-O molds and chandeliers with cut-out flowers, and creating lush, flower-drenched domestic tableaus. Next she was making cast paper versions of these things, and furniture, too—hollow paper chairs, and cups, and light fixtures. These, too, soon had leaves and vines and blooms crawling across their surfaces. The pieces of fabric and wallpaper that had been denuded became their own negative-space corollaries.

Since she moved to Winston-Salem in 2015 to teach at the UNC School of the Arts, her work has "become more lush," she says. For inspiration, there's the natural environment, "a lot of hanging plants dripping off of everything," like wisteria and kudzu, and her own garden to tend. Traditional southern decor has also helped, both with ideas and with supplies. "I can find my materials, the floral things, everywhere. The material culture here is very rich," she says.

If she has embraced the South, the South has embraced her back. The Mint Museum has acquired one of her pieces for its permanent collection, as has Crystal Bridges Museum in Bentonville, Arkansas. In 2020, she was featured by the National Museum of Women in the Arts as one of its Women to Watch.

It's hard not to watch as Alexander upends and deconstructs the domestic world, one flower at a time, "inserting chaos into order," as she says, "making something that's very controlled and presented more surreal, like you really don't know what gravity is, and you don't really know what space is doing." ∎

FACING
Frank Campion in his
Clemmons home studio.

FRANK CAMPION

CLEMMONS

Frank Campion's canvases are large, eight feet long and five and a half feet wide. He pulls one, freshly stretched, to the floor of his studio and stares at it for a moment before tipping a bucket of paint onto its blank expanse. The paint is grey, and viscous, and splashes indiscriminately, like muddy water. He studies this a moment, then tips the bucket again, and again, and again, finally picking up a broom-scaled squeegee to push and pull it back and forth. As starry splotches become ghostly shapes beneath a paler scrim, this respected, Harvard-educated painter and onetime advertising executive looks for all the world like a pensive janitor, mopping the floor.

The result, weeks later, will belie these humble beginnings. Sharp geometry, deep blue, soft orange, and acid yellow will layer the grey-splashed canvas with subtlety and contrast, dimension and structure. Pieces of grey will remain, complicating some of the bright shades, swirling in tendrils on the margins. "I like color. I like emotion," Campion says. "I like the

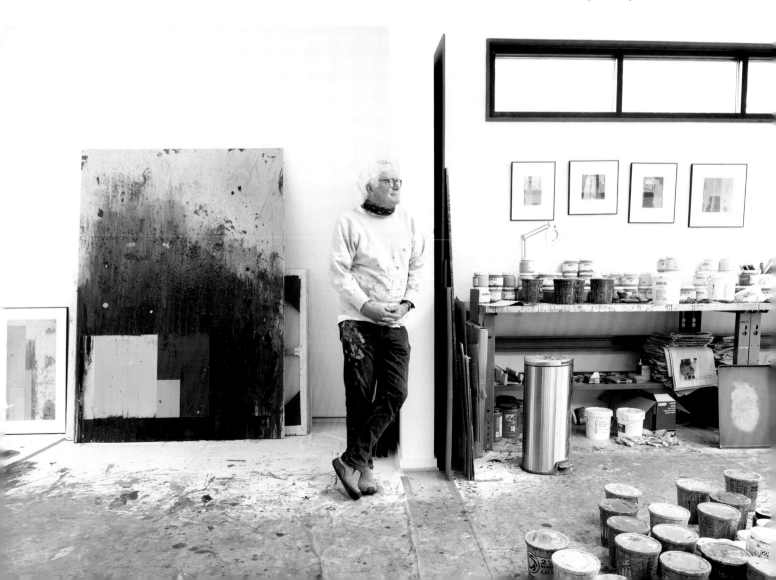

Nazret, by Frank Campion, 2019.
84 × 38 in. Acrylic on canvas.

collision of chaos and order." What viewers see in his work includes all of that, but most of all, he says, it's what they bring to it themselves. "One of the things I like about abstraction is that it's a kind of mirror. It's a challenge."

In the modernist showpiece of a studio he designed and attached to his house in this residential neighborhood (a contractor likened the space to the spot where Ferris Bueller's friend Cameron's father parked his ill-fated Ferrari), Campion is also challenged. Delightedly so. Miles Davis plays on a continuous loop, art books fill side tables, milky winter sun pours through a ceiling of skylights; there's room for giant canvases and places to sit and talk. The floor is a mosaic of speckled paint, and so is he. "He" being "Frank 2.0," a "re-emerging artist," as he calls himself (in writing, anyway), the present-day iteration of a man who came to prominence as a young artist in Boston in the 1980s. He had collectors, critically successful solo shows, and was in group shows at the Institute of Contemporary Art and Boston Museum of Fine Arts (where one of his paintings is in the permanent collection). Then he became disillusioned with all of it, walked away from art completely, and immersed himself for more than thirty years in a successful advertising career.

That's what brought him to Winston-Salem, a top job at ad firm Long Haymes & Carr, where accounts like IBM, Hanes Hosiery, and Wachovia Bank and Trust Company kept things interesting. "It was a great ride," he says, "very creative." After that, painting called him back. A Matisse cut-out show at MoMA in New York sparked it. "The most joyous exhibition I've ever seen," he says. "It just sang. And I remember thinking, God, I love color. I gotta get back in." He started in 2014 with collage, and immediately, "It grabbed me. It grabbed me by the scruff of the neck and dragged me forward."

These days, it's pulled him into a series he calls *Chasms, Canyons, and Corridors*, vertical, geometric color-drenched impressions of the kind of landscapes he glimpsed growing up in Manhattan. Some reflect an earthier palette he adopted after a trip to Africa in early 2020. Some reflect his emotions, some the weather, some the state of the world. After all, he has time, now, and space, and the artist's ultimate luxury: complete independence. He can do whatever he wants to do.

"I really now paint for an audience of one, and if I like it, great. And if somebody else likes it, great." ∎

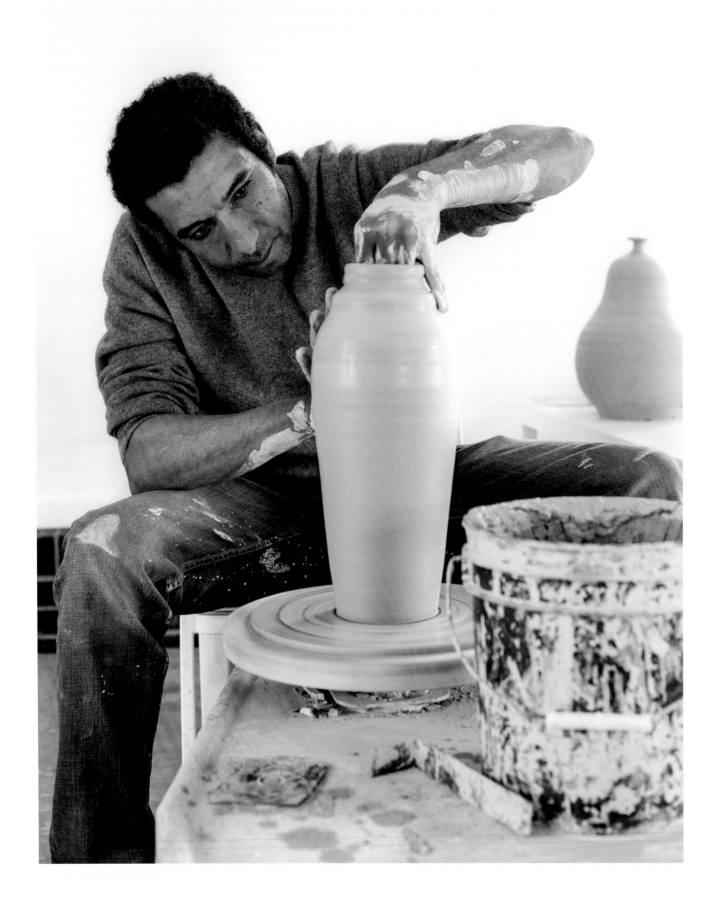

IBRAHIM SAID

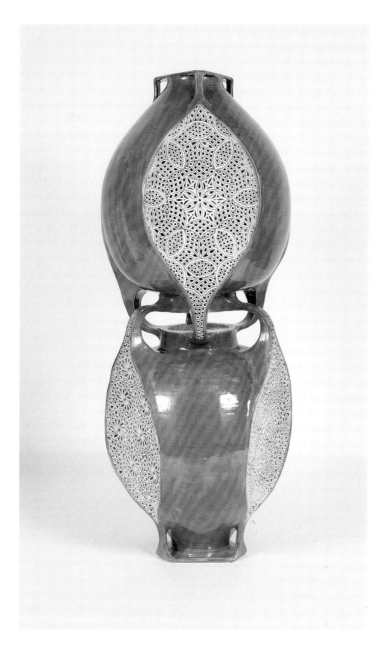

Ibrahim Said makes vessels with lithe, serpentine arms. He nestles them together and tops them with delicate finials. He allows one giant perforated pot to hoist another aloft, four feet into the air, with just a few strands of porcelain. He carves arches with elaborate scrollwork that emerge from one another, recede into the distance, and spiral into themselves. His pieces are plantlike, creaturelike, cosmic, alive.

He makes them in his Greensboro studio, fusing the 13,000-year-old Egyptian pottery designs of his family's heritage with his own imagination to create ceramic art of unusual artistic and technical virtuosity. The floral, geometric, and calligraphic designs of an Islamic jug filter—traditionally used within the neck of a pitcher to filter sediment and other impurities from drinking water—are the jumping-off point for many of his works.

Growing up in a family of production potters in the Fustat area of Old Cairo, Said says he couldn't have imagined as a younger man letting his creativity take him to such extraordinary lengths.

"I spent a lot of time struggling for what I'm doing here," he says. "Here, everything is art. Egypt is different. In Egypt, you have foreign art, and you have production work . . . there, it's very difficult for someone to make something new." He couldn't have known, growing up, that one day he'd be making many new things, living and working in the United States, and that his work would be exhibited internationally and receive major awards from the

FACING
Ibrahim Said in his Greensboro home studio.

ABOVE
Magnolia, by Ibrahim Said, 2018.
53½ × 22 × 22 in. White earthenware.
Courtesy of Ibrahim Said.

American Academy of Arts and Letters, the Korean International Ceramic Biennale, and the Masqat Festival in Oman, among many others; or that it would join the collections of a dozen leading museums including the Victoria & Albert Museum in London, the Philadelphia Museum of Art, and the National Museum of Scotland.

Today, at home in North Carolina with his wife, artist Mariam Aziza Stephan, Said says he misses the tight-knit ties of his Cairo upbringing, but appreciates the freedom and support to pursue his artistic dreams he has found in North Carolina.

"The community of art here is much stronger than the community of art in Egypt, and really is one big family. That's for sure." His late father, he says, was undoubtedly an artist in his own right, but didn't have an ecosystem like North Carolina's to nurture him, and also couldn't "take his chance to be an artist" because he needed to provide for his family with the production pots he made. "My mother told me that he told her: 'My son did what I would love to do.'" It's a weighty legacy. "I feel like Allah, or God, wanted his name to be alive with me. My name is his, Ibrahim Said." He considers himself to be "one-tenth" the man his father was.

And so, every time Said uses traditional shapes to form his vessels, or carves traditional designs upon them, he honors his father and his native Egypt. In the carved, carpet-shaped sculpture standing in his studio, in the finely turned vessels on its shelves, and in the clay in his hands on the pottery wheel, that legacy, familial and cultural, is ever present, even as it becomes something altogether new through his artistry, and made possible by his adopted home. ∎

MARIAM AZIZA STEPHAN

GREENSBORO

To look carefully and long at one of Mariam Aziza Stephan's paintings is to enter a colorless realm where alienation and upheaval have made their own landscape, where the roots of trees have become safe eddies, horizons are dead ends, and the sky is a scarred and leaden expanse—except, maybe, for a bright part in the corner. Or perhaps that's the sea you're looking at. The natural world is both quiet and loud in her work, menacing and embracing, it is all encompassing, it is all you have.

The first-generation American daughter of a father who fled the former East Germany and an Afghan refugee mother who together immigrated to America in the late 1960s, Stephan has a lot of displacement in genes; her upbringing as the stepdaughter of a Black American woman who left Arkansas as part of the Great Migration further complicated the artist's sense of home and inheritance, further underlined for her the defining force of geography.

"The undercurrent of my upbringing is a sense of upheaval," she says. "It's kind of the context, the framework that you feel, that we didn't have history around us, or those deep connections to any of their cultural upbringings."

At home now in Greensboro, where she is a professor of painting at UNC Greensboro, Stephan lives with her Egyptian artist husband, Ibrahim Said, in a house with space enough for two large studios. The work she makes in hers has received many awards, has been the subject of solo exhibitions in museums

Mariam Aziza Stephan in her
Greensboro home studio.

and galleries around the country, and has earned her several grants and residencies. She met Said in Egypt, where she was a Fulbright Scholar. Needless to say, the themes of her work resonate with her husband and in their lives together today.

Still, growing up in America, Stephan says she found it difficult to reconcile her independence and her own relative lack of struggle with those of her father, mother, and stepmother—especially those of the mothers. In her work, she says, "I wanted to take on a burden that they couldn't verbalize. They could never scream or fight back with rage at their circumstances. Both of them had to bury it, as women. . . . It's not just about all migratory experiences. It's about carrying a burden, and the sense of the layers or strata of how we carry, or care for, our lineage, our children, other generations."

Stephan points out that sometimes her work, even with its darkly complex, dystopian imagery, can carry a sense of stillness. Straddling serenity and eeriness, that quiet can invite the viewer to pick a path through the landscape. Often, there is a raft, or an island, or a boat, or the shape of one of these in her paintings. Representing not only a journey but also safety, and the small nexus of family within a much wider world, these oases are often where Stephan starts her work, the places she then builds around.

The stark monochromatic palette she favors is one arrived at as a way of being direct, being honest. Color, or its lack, is just one way the German painter Anselm Kiefer has influenced her work; another, more surprising inspiration comes in the form of the late eighteenth-century Spanish painter Francisco Goya, especially the way he used a near, a middle, and a deep space within a painting to refer to the cyclical experience of humanity repeating itself. Similarly, Stephan says she brings similar motifs into the foreground, middle ground, and background of her paintings "tying it again to the past, present, and the future," and as "a physical embodiment of the unfulfilled wishes of those who came before us that continue to live on through us, and in us through them." ∎

FACING
Jennifer Meanley in her studio
at UNC Greensboro.

JENNIFER MEANLEY

GREENSBORO

Intimate but alienating, lush and allegorical, Jennifer Meanley's paintings appear to capture the moments upon which events hinge. Figures, often out of scale with their environments, gaze at odd angles within untamed, kaleidoscopic settings, more consumed with their interior lives than with the discordant scenes they inhabit. Animals, alive and dead, sometimes share the space. Something's clearly about to happen, or might be happening, or perhaps already has happened. Are her subjects aware?

"There is often a sense of lack of synchronicity between how we experience our bodies and how we experience our mind, our emotional states," Meanley says. Her paintings "often register that paradox, whether that's with the animals, or the symbolism with the space itself . . . or whether the figure seems to be looking and registering and connecting" to reality. Or not.

At UNC Greensboro, where she teaches drawing and painting, Meanley paints these large-scale

depictions of human experience. Simultaneously capturing the spheres of action, memory, participation, and observation, she invites a viewer to examine the parts and absorb the whole. Like poetry, her works reveal themselves in stages and elements: image, rhythm, tone, vocabulary, story. Color plays a major role. "I've always had a penchant for really saturated colors," she says, especially as a way to indicate atmosphere, like light, air, wind, and the grounding element of earth.

Does she begin with a narrative? Not really, or not always. In a painting underway on her working wall—in which a caped, gamine figure gazes upon a flayed animal, possibly a deer, within a riotously overgrown landscape—the New Hampshire native describes her impetus: "I was thinking of this sort of crazy Bacchanal," she says, "or of a surplus, imagination as a kind of surplus." Anything is possible in the abundant realm of the imagined, she points out. The real world is another matter.

It's no surprise to learn that Meanley writes regularly in forms she compares to short stories which emerge from streams of consciousness. It's a process she describes as if it's a place where she goes:

Beloved, by Jennifer Meanley, 2017. 72 × 190 in. Oil on canvas. Courtesy of Jennifer Meanley.

Language is "like a field that I experience, stepping in and noticing punctuation, noticing the spaces between things, or the pauses, the way breath might be taken. That's all really, really fascinating to me." When she's teaching, she tries to create a corollary to visual language in much the same way: "What does it mean to literally punctuate a drawing, in a way that you would take a sentence that essentially had no meaning, and make it comprehensible?" she asks her students. "Through timing, and space, and rhythm, and breath."

All of which connects to physical movement, another practice Meanley credits with fueling her creative process. Long walks with her dog in the woods spark marathon writing sessions, which then engender drawings and paintings.

Those long walks have also attuned Meanley to the natural environment of the South, so different from what surrounded her in New Hampshire, where she grew up, and where she also earned her BFA at the University of New Hampshire, or even at Indiana University, where she received her MFA. In and around Greensboro, she finds nature so lush, so green, so impressive. "I started realizing that there's this battle within the landscape. Just to even maintain my yard, I feel like I'm battling the natural growth here. It did amplify that sense of tension, of creating landscape as a narrative event . . . as an important space to contemplate hierarchies of power." ■

BARBARA CAMPBELL THOMAS

CLIMAX

To enter Barbara Campbell Thomas's studio in rural Climax is to climb directly into one of the remarkable compilations she calls paintings.

A combination of quilting and collage and strips of canvas and yes, painting, her work may have more in common with this color-jangled, many-layered, surprising room—overflowing with textiles, history, tradition, mysticism, books, paints, and threads and fabrics of every imaginable color and pattern and size and shape—than they are like anyone else's idea of what a "painting" might be.

Campbell Thomas's definition of that word is sculptural, involving the careful manipulation of each pieced segment so that the stitches that bind them bend, and pop, becoming a feature in themselves.

"When they get stretched," she says, pointing to a spot on a recent work where conjoined fabric bares its stitches in an irregular arc, "there's this aspect of distortion that happens, and that's something really interesting to me." Interesting seems to be another word for alive. "I like to think that the geometry starts to have this kind of inhalation and exhalation," she says, "like a breath." She called one recent body of work *Pneuma*, an ancient Greek word for "air in motion." "And the geometry softens, too."

There are rules she follows, ones she's made for herself. Lately, she's breaking them:

A while ago, I had this notion that everything had to be paint. And then I broke that rule down by starting to add collage, which is the first shift in the work. And then I had this notion that the first layer of the painting could not be marred, or blemished. And then I started cutting that up. And [lately] I've been so fascinated with the ways the stretching creates these shapes that I've been thinking, well, they've *got* to be stretched. And [now] I have this very clear thought that I need to be making both: paintings and quilts, and letting the conversation between them, which is already there, grow. You know, where does the quilt end and the painting begin?

That dialogue began several years ago with her mother—who taught her then-traditional-painter daughter how to quilt—and extends, through her family tree, to her grandmother and her maternal and paternal great-grandmothers, makers and stitchers and quilters all, and whose names Campbell Thomas has listed on her studio wall as inspiration and as a reminder of her heritage. The art journals Campbell Thomas carefully keeps are bound with cloth covers by her mother, who sends her a regular supply.

FACING
Barbara Campbell Thomas in
her Climax home studio.

Inscape, by Barbara Campbell Thomas, 2020. 72 × 60 in. Collaged
fabric, collaged cut-up paintings, spray paint, acrylic paint on canvas
with insets of pieced and machine-stitched fabric. Photograph by
Dhanraj Emanuel. Courtesy of Barbara Campbell Thomas.

In these journals, the artist examines her process and her purpose. Abstraction, she says, allows her to say things she can't with more literal or figurative types of work. "I'm really fascinated with my sense that there is more to the world than what we can see, and of course that starts to tap into realms of the spirit. On the one hand, I'm engaging in this intensely material endeavor, through paint; through fabric. But I feel as though there's this way that that engagement, which is now well over twenty years for me, is a way into spirit."

There's no question that there's more than color, shape, and volume at work in her unique form of art. It has been exhibited across the nation at museums including the North Carolina Museum of Art, the Weatherspoon in Greensboro, and at the Atlanta Center for Contemporary Art. A professor of art at UNC Greensboro, Campbell Thomas has also been the recipient of prestigious residencies and fellowships including the North Carolina Arts Council Fellowship. ■

Barbara Campbell Thomas holds
open one of her many art journals.

ENDIA BEAL

WINSTON-SALEM

Standing in her childhood home before a life-size photo of a generic office, a young woman in a knee-length dress looks over her shoulder. Her arms are crossed, her gaze is averted. *Am I What You're Looking For?* It's the question her reluctant body language asks, and it's the title of a series of photographs that helped make Endia Beal's name.

"The foundation of my practice is thinking about the unseen and the unheard," says the Winston-Salem artist, curator, activist, and art community leader. "Growing up, I didn't know about curators or artists, I wasn't exposed to that. And so I always wanted to create art that spoke to everyday human experiences, especially individuals who have never seen themselves in art before, or were never part of the conversation."

Beal herself was quickly catapulted into the national conversation through her work. In 2013, the UNC-Chapel Hill graduate was the only Black student studying photography for a master's at the Yale School of Art. She was also the only Black person working in the university's IT department when she found herself fielding a jarring question from her office coworkers: Could they touch her hair? Her abundant Afro was a source of fascination. A rich seam of material opened before her, an opportunity to explore race, gender, and the workplace. *Am I What You're Looking For?* followed, as did *Mock Interview*, a video in which Beal asks young white male students

actual questions that Black women told her they'd been asked in job interviews. "Would you be willing to change your name for the job?" is one. The inquiry confounds the young man in her video's interview chair. Another: "Are you sure you don't have any children?" Yes, the young man is quite sure. "Could I buy that hair in the store?" This man laughs outright.

Can I Touch It, a video documenting the taped reactions of the coworkers who actually touched her hair, went viral. "I received hundreds of emails from women all over the world, Germany, Korea, Africa, saying that they can relate to this, that it speaks to their everyday experiences." It opened Beal's eyes not only to the relevance of her work, but to its ability to make art meaningful to a wider audience.

That's particularly important to her, because when she started studying art and photography, Beal realized there were few stories about women of color, especially as told by women of color. "That history is still being written," she says. "One of my goals is to add new stories to the gallery wall."

Beal's photographs and video pieces have now been exhibited on gallery walls all over the world; they've been featured in the *New York Times*, the *Atlantic*, *National Geographic*, *Newsweek*, *Essence*, and many other nationwide publications; they've been exhibited at museums including the Nasher Museum and the Aperture Foundation in New York; she's had residencies at Harvard, the McColl Center, and the

FACING
Endia Beal on the grounds of the Reynolda House Museum of American Art, where she serves as a trustee.

Center for Photography at Woodstock. Her portrait of the Reverend William J. Barber II for *Time* magazine was chosen as one of its Best Portraits of 2020.

She has also taken on leadership roles in the art community, including serving as a board member for the American Society of Media Photographers, the Public Art Committee of Winston-Salem, and at Reynolda House.

Lately, Beal's work goes beyond its original medium, taking the form of lectures, corporate and institutional workshops, and storytelling with a focus on diversity, equity, and inclusion. Her goal is that individuals "leave that space feeling more connected to a colleague that maybe they didn't know much about before," she says. "If we can build relationships with one another and see each other as human beings, then you can see me as a colleague, then you can respect me as a co-worker or friend.... But if you don't see me as a human first, then you won't." ∎

FACING
Courtney, from the series *Am I What You're Looking For?*,
by Endia Beal, 2017. 28 × 40 in. Pigment print.
Courtesy of Endia Beal.

CHAPTER 4

SEAGROVE &
THE SANDHILLS

In 1983, when the potter Mark Hewitt drove from Connecticut down to North Carolina with his wife, Carol, he was amazed by the world that unfolded before his eyes, and the opportunity it represented. There was clay in the ground, there were forests full of trees, and there was beautiful, rolling farmland in every direction.

"I kept telling Carol: 'That would make a good place for a pottery.'" The once-dilapidated place they chose at the end of a dirt road is the beautiful home they have today. It is easy to see why a potter—or really any artist—would choose to live in a place like Seagrove and its surrounding communities. Gentle hills, lakes, and streams; longleaf pines, meandering roads, and rambling old barns make for an almost unbelievably picturesque setting.

But for the potters in and around Seagrove, beauty is just one part of the equation. The other is practical. As Hewitt described it, all potters need clay, wood,

and affordable space, and Seagrove's got all three.

Like the Catawba and Cherokee who first used the clay here to make vessels 3,000 years ago; like the English and German settlers who moved to the region before the Revolutionary War and needed to make their own dishes and jugs; like the farmers of the 1800s who devised a handy "winter crop" to sell along the Old Plank Road; or the early 1900s founders of Jugtown Pottery, who took the region's wares to New York to sell—today's Seagrove potters take full advantage of the area's natural resources to forge their craft. They come here from far and wide to do it—from places like Japan, Estonia, San Francisco, and Pennsylvania—and also from right around the corner, from families four and five generations deep into clay.

They're working here in greater and more diverse numbers than ever before in part because the local infrastructure to support their work is more robust

than ever before, and in part because the world is simply a smaller place, making an out-of-the-way pottery haven in rural North Carolina accessible to potters and collectors both. As a result, the Seagrove area is producing work that is more complex, diverse, and significant than ever before.

These full-time potters, more than 100 strong, are building on a tradition eons old, born of the clay that runs here in seams wide and deep. Hundreds of these sticky veins, in a kaleidoscope of colors, were deposited millions of years ago, when geologists say the Sandhills and Piedmont area was covered by a shallow sea. Into that sea ran rivers from the adjacent Uwharrie Mountains, one of North America's oldest ranges. These rivers deposited layers of volcanic ash, sediment, sand, and clay into the seabed, creating today's undulating, mineral-rich landscape. The result can be seen in the local clays, which range in color from white to grey to red to brown to yellow, and vary in consistency, composition, and elasticity.

"North Carolina has been made for clay, and will never run out of clay for our potters," says Lindsey Lambert, executive director of the North Carolina Pottery Center.

Today's Seagrove collaborates to find, dig, and refine this clay, which is one of many examples of the fourth ingredient that makes Seagrove work: community. The pottery population here is a loosely organized, generous confederacy of like minds, but it is also a symbiotic system born of practical necessity.

When a potter undertakes the intermittent, monumental effort that is a wood-fueled kiln firing—a several-day process requiring stoking and tending, twenty-four hours a day, as kiln chambers reach temperatures of more than 2,300 degrees—they can count on their fellow potters to lend a hand, take a shift, and put some of their own pots in, too. They share notes on clays and finishes, they hand over recipes for glazes, they train the younger ones up, and they let each other borrow equipment and materials.

They also contribute to the unique community organizations that facilitate their work, including the North Carolina Pottery Center, which is the nation's only statewide facility dedicated to pottery, and which promotes, preserves, and displays their craft; and STARworks, the nonprofit arts incubator and craft center dedicated to boosting the local arts community and the region's economy.

Before 2008, when STARworks launched its clay "factory"—a production facility run by potter Takuro Shibata that digs, refines, and sells the local clay—only the most established Seagrove-area potters could afford the time and equipment needed to make the local stuff workable. Instead, most ordered powdered clay from big manufacturers and mixed it up like cake from a box. Today, they can all buy local wild clay from STARworks, and they all do it—the famous ones, and everyone else, too.

It wasn't easy to make that happen, but the community made sure it did. As a Japanese immigrant with limited English in a rural community, Shibata had hurdles to overcome in turning an abandoned former hosiery factory into one that churned out clay. Leading potters Ben Owen III and Daniel Johnston helped, introducing Shibata to local people who had land with clay to mine. Today, Takuro takes that raw earth and turns it into a viable material for the art and craft that defines the region. On a loading dock at the back of the building, a potter can choose from twelve different varieties, sorted by color, texture, and the temperature at which it best fires. At 60 to 90 cents a pound, the 25-pound bags are affordable for STARworks' 2,000-odd customers, about 1,200 of whom are local.

Shibata constantly tests new clays for viability, and customizes clays to suit particular projects. The unusually dense, particle-laden clay he's made for Daniel Johnston, for instance, ensured the pillars Johnston installed at the North Carolina Museum of Art will stand the test of time. Ben Owen III so admires the exacting process Shibata employs that he now delivers his own raw clay to STARworks for refining, and gave his own equipment to Takuro to refine it with. Mark Hewitt, too, uses Shibata's clay.

Bollides Wake

Joe Grant

STAR

Working against the clock to manipulate molten glass requires the effort of an agile team of glassblowers, all pulling, cutting, and heating in synchronicity. For STARworks glass director Joe Grant, this collective effort represents both the process of his work and its inspiration. Fascinated by the ability of glass to manipulate light and distort optics, Grant plays with texture and space, creating pieces that capture light as a medium. These creations glow with color and radiate with pattern, managing to express the collective and incandescent energy that went into their formation.

In all his work, Grant says, the relationship of science to art is central. "Science is creative, but the language is limiting," he wrote in an artist's statement for an exhibit at Chapel Hill's Frank Gallery. "Art has a wider vocabulary with which to interpret nature . . . there is room for mysticism, transcendence, intuition, hybridization, feeling, and emotion in art."

Grant, who has a MFA in glass from Virginia Commonwealth University, sees his practice as tightly connected to the community in which he works. A public workspace that provides artistic educational programs for the Seagrove area in the area of glass, clay, metalwork, and other mediums, STARworks has grown significantly in the six years since Grant joined its staff. In outreach and influence, the organization has made a name for itself within North Carolina and across the country. "People are finally beginning to know who we are and what we're about," he says, "STARworks makes me feel like anything is possible."

Grant has exhibited his work in museums and galleries around the country, including the Blowing Rock Art and History Museum; the Haystack Gallery in Maine, where he served as an instructor; the Chrysler Museum in Norfolk, Virginia; and the GreenHill Center for Visual Art in Greensboro, among many others. □

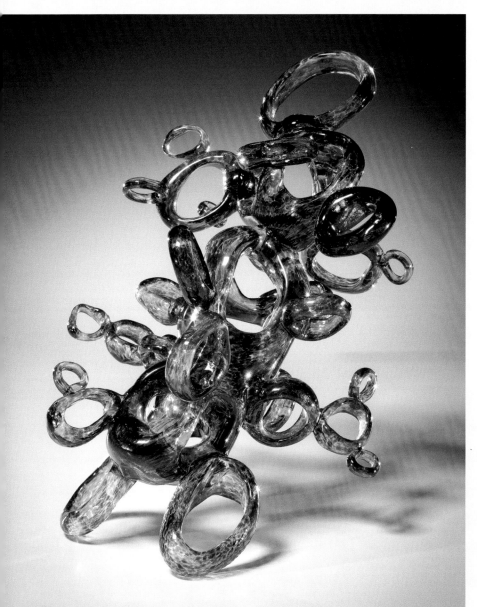

Bollides Wake, by Joe Grant, 2020. 11 × 16 × 9 in. Glass. Courtesy of Joe Grant.

In much the same way potters work together, glass artists do, too. Both mediums require expensive equipment, extra hands, and extreme temperatures; both demand training and rely on an apprentice system. STARworks—which was launched and supported by a Community Development Block Grant through the North Carolina Department of Commerce and the nonprofit Central Park NC, whose mission is to grow the regional economy—provides a hub for these artists, too, a place where they can learn and make their work. With residencies, internships, college classes, programs for at-risk youth, and one of the nation's very few glass blowing programs for high school students, STARworks has made it a mission to build a glass community in the region.

It's a community happily linked with that of the potters. In celebration of the element that makes glass, clay, and metal art forms possible, STARworks holds an annual FireFest.

This community art hub is a place that makes him feel like "anything is possible," says Joe Grant, the studio's glass director, who helped to create STARworks'

Soda Bottle Fruit

Sarah Band

SEAGROVE

Anatomy, evolution, and apocalypse; the rise of new technologies; the transformation of mankind. These issues and the broad possibilities of scientific exploration have long captivated Sarah Band, who tells stories of scientific discovery and demise through detailed anatomical models, peculiar creatures, and natural things, like fruit, made of glass, sometimes even the glass of old soda bottles.

As an artist and the child of physicists, Band, a San Francisco native, says she has long been fascinated by the place where art meets science: "I believe art and science are both explorations of observations and ideas," she writes. "Art is just lucky enough to be limitless."

Using glass, copper, and other mixed materials, Band takes on the implications and the complications of the scientific process. Her detailed glass bodily organs and animal skeletons made of copper tubing and blown glass depict an apocalyptic breakdown of nature.

Glass is an ideal medium with which to explore these ideas, she says. Though it takes a long time to master, glassblowing demands the kind of focus that makes for nuanced work. "There are all of these little subtle details that you don't really see the first time you look at things," she says, "things that I'm not aware of—until I try to mimic it in glass."

Band serves as gallery assistant at STARworks and used her time as an intern there to develop her skills. She has shown her work at the GreenHill Center for Visual Art in Greensboro; The Works in Newark, Ohio; and the Chrysler Museum of Art in Norfolk, Virginia, among other venues. □

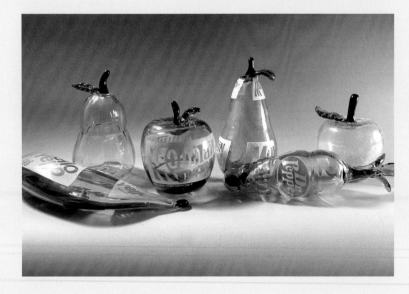

Soda Bottle Fruit, by Sarah Band, 2021.
Pieces range in size; the largest piece is
6 × 3 in. Hot sculpted antique glass soda
bottles. Courtesy of Sarah Band.

residency and internship program, and whose own sculpture is inspired by science and the natural world.

Ed Walker, the owner of Carolina Bronze Sculpture in Seagrove, says the town and region inspire him, too. The facility he built here in 1995 has a nationwide reputation as an artists' foundry, clients from around the world, and a highly skilled workforce of local residents. Together they turn out massive public monuments and sculptures, including all of Chas Fagan's works.

Walker is a sculptor in his own right and an integral part of the Seagrove community. His piece *Pottery Time*, installed in downtown Seagrove, features a clock face with pottery shapes marking the hours, a reminder to visitors to take time to see the region's many artists. An earlier piece, *Balancing Time II*, was installed to welcome sculptors from North Carolina, South Carolina, and Virginia to an annual Tri-State Sculptor conference in 2016, which his foundry sponsored together with STARworks.

MANY HANDS

The growth of the area has relied on the work of other generous leaders and conveners that include the famed modernist architect Frank Harmon, who designed the Pottery Center; the nonprofit leaders Nancy Gottovi of STARworks and Lindsey Lambert of the Pottery Center; the ceramic engineer and part-time clay digger Steve Blankenbeker who sources much of the clay they use; and the legions of collectors across the state and beyond who keep them busy. As a result, Seagrove's glass artists, sculptors, and potters have more opportunities than ever to get their work done, and also more chances to come together, to swap ideas and teach each other, to socialize, challenge, and influence one another.

The result isn't a "school of Seagrove." Some make practical work, some abstract; others produce coffee mugs one day and museum treasures the next. Jars that evoke Ming vases and jugs that look best suited for moonshine are both proud products of this land. "The story of a pot," Lambert says, "is not just the pot itself, it's the potter behind it."

Some of these potters are loners, some are leaders; some eschew tradition, some revere it. In a deeply rural landscape like this one, it's easy to hide, to hunker down and throw pots; it's also easy to find fellow makers eager for company.

With such a diverse population, confluence of support, inspiration, and infrastructure, the pottery and other art of Seagrove is in a moment of real renaissance.

Much of it is forged in the region's wood-fired kilns. Some fire their work in Thai-style chambers. Some, like Estonian Anna Partna, have Bourry Box kilns; others prefer traditional groundhog kilns, the same ones their great-grandfathers used. Resembling massive, half-buried gourds, so organic in shape and design they seem to have emerged from the earth itself, these fire chambers defy the modern age. Emitting a smell of ash and soil, like a campfire recently doused, they're usually oblong and tapered, like the shape of a flame, if seen from above, and built by hand with brick and clay. They represent both the centuries-old traditions and the contemporary influences of this region, and are the soul of its culture.

DANIEL JOHNSTON

SEAGROVE

Daniel Johnston's kilns are not easy to find. Down a long stretch of rolling Randolph County farmland, past wide, sloping fields dotted with cows, the rows of ceramic pillars that suddenly appear by the side of his road are a visitor's first clue. They're the grey of granite boulders and the shape of stubby fingers. Some huddle together like eggs in a nest. Some stand alone, with licks of ash up their sides like ghostly flames. They're among his latest creations.

Beyond them, up on a hill, beside piles of wood slats for fuel, are Johnston's two hump-backed, wood-burning kilns, perforated with portholes and sheltered by a wide roof. One of them, a big, football-shaped, cross-draft kiln inspired by the ones in northeast Thailand where Johnston once trained, has a pointed doorway, like the entrance to some kind of an earthen, Gothic church.

A few steps away, there's a timbered cabin the size of two tobacco barns put together with big pots all around it—some sunken in the grass and some on pedestals. Daniel Johnston emerges, pulling a white T-shirt over his head as he lopes down the cabin's

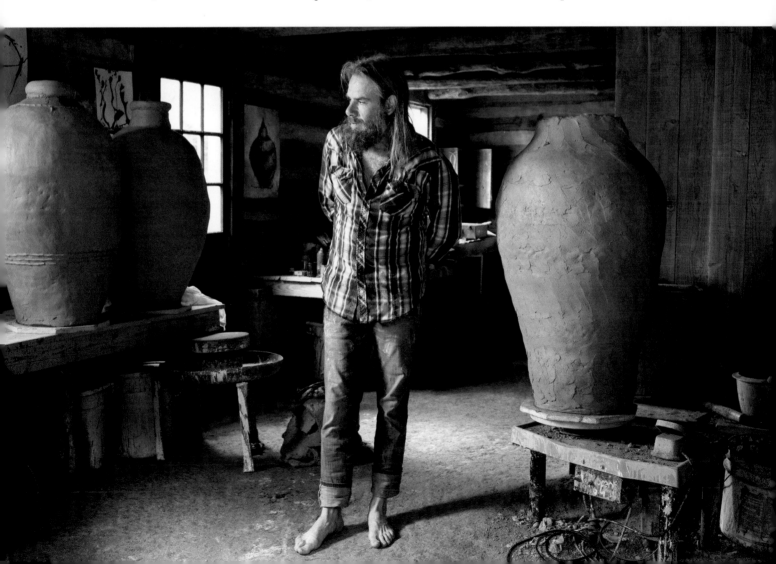

outdoor staircase in jeans and bare feet, asking politely if it would be all right if he smoked.

On the ten acres of land that he bought at sixteen with the money he'd saved for a Ford Mustang—on the land where, at that young age, he built himself a shack to live in alone after he left home and dropped out of school; on the spot where years later he felled the trees to build the timbered barn and studio where he now lives and works—Daniel Johnston does not need to ask anyone's permission to do anything. But with his long, graying beard, back-grazing ponytail, low voice, and downward gaze, Johnston is humble as he surveys his place. Growing up not far from here in extreme poverty as the child of tenant farmers, "in my mind," he says, "land was power." He told himself early on he would make for himself a different kind of fate.

The same could be said of his art.

About a decade ago, after years of apprenticeship with potters in Thailand and with the Seagrove area's internationally revered Mark Hewitt, Johnston became a leading American maker of big pots, famous

for it. He perfected a technique to turn 100-pound lumps of clay into giant vessels that could hold 40 gallons apiece, and made them in huge numbers, a series of 100 pots one time, 50 pots another. The acclaim was exciting, but then became disillusioning. It broke his heart to see them carted away, one by one. It was the groupings, he realized, that held the meaning. "People had to have a piece of it. As soon as they had that jar, it had no context."

Johnston eschews that kind of work today. Now, he's not concerned with demonstrating his finesse or with making beautiful objects unless they have meaning within a conceptual context. And so he exhibits his work now as installations, not as individual pots.

At the North Carolina Museum of Art, Johnston sank 183 of his wood-fired ceramic pillars across the gentle hills of the park landscape to evoke an organic border, fence, or outcropping. It's a massive installation and a prestigious commission for any artist, perhaps especially for a potter. Childhood recollections of his mother's home state of Kansas, where rock fence posts linked with barbed wire dotted the flat landscape, have long lingered in his mind. Issues surrounding borders, boundaries, and privilege also informed the work.

"There's an integrity inside me that I will not ignore," he says, "and it doesn't have anything to do with art or politics," he says. "It has to do with the fact that I'm here in this moment. And we have to do what we do as humans." What he has to do, Johnston says, is make art that is "not self expression, it is an expression of the world. Because art that does not have context does not transcend, it is just an exercise."

In 2021, at NC State's Gregg Museum of Art and Design, he built a massive wire-mesh, house-shaped frame, a temporary building at once empty and full, to hold several giant pots, many irregularly shaped. The pot in his portrait here became one of them, and others he assembled like bricks in a foundation. The result—a house that was not a home, peopled sparsely with beautiful but imperfect creations—seemed a monument to loneliness.

He called it *A Thousand Throws*, because he threw his thousandth large pot in the process of completing it.

"A house and a pot have a lot in common," he said of the installation. "Houses influence the space inside of them, while pots influence the space surrounding them. Both are containers, and both are meaningless without a viewer—the person living in the house, or the person appreciating the pots."

Pottery has become for Johnston a means to an end. "I've never thought of myself as a potter, and I don't really like the title," he says. These days, "I want to work with my mind, not my hands," he says. "Like Duchamp's *Fountain*." He's referring to a porcelain urinal the French conceptual artist Marcel Duchamp exhibited in 1917, considered a seminal moment in twentieth-century art. Duchamp rejected what he called "retinal" art, or art designed to please the eye, and wanted his art to provoke the mind instead.

"I think about that a lot," Johnston says. ∎

MARK HEWITT

PITTSBORO

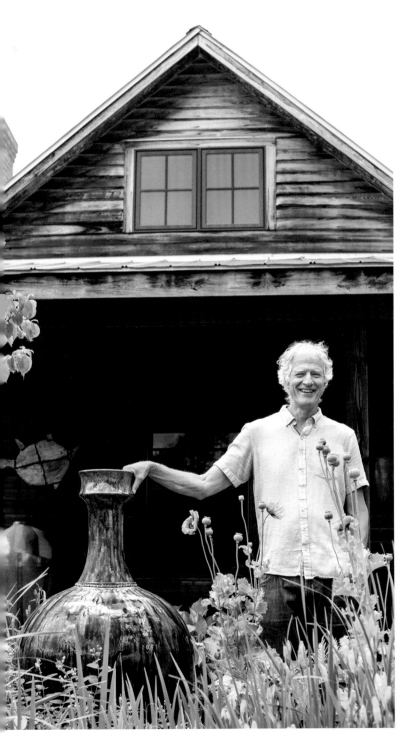

When Mark Hewitt opens up his kilns three times a year, he's opening up his world. At its center is the old farm that's served as his studio and family home for forty years, the gardens and wood buildings he's built and renovated, the damp-aired, dirt-floored former chicken house he uses as a rambling workplace, with its piles of clay and buckets of slip, its ancient tools, its speckled wheels and coffee mugs, its Premier League football posters. There's the festivity of the packs of people who've traveled from all over to see this charming British expat and his work, the amazement of his giant groundhog kilns and the many hundreds of just-cooled pots, there's the chance to hold small ones in your hand and the pleasure of walking among giants in gardens so established it's as if they planted themselves.

When Hewitt opens his kilns, he's opening a window onto an existence fully integrated, where life and nature and work are one, where the mess of hand-hewn process and the elegance of completed works share equal billing. Hewitt stands on no ceremony here. His pots are for using, he says. There's a deep pride in that—in acknowledging what he calls "the quiet heroism of domesticity," and his pots' place in that sphere—as well as their ability to bring beauty into people's lives.

An undisputed dean of the Seagrove community, Hewitt's work has won countless major awards and been the subject of solo exhibitions in London, Tokyo, and all around the United States, including at

Mark Hewitt at his Pittsboro home and pottery.

153

the Nasher Museum and New Orleans's Ogden Museum. His large pots, storage jars, and vases fired with the traditional southern alkaline and salt glazes are in the collections of the Philadelphia Museum of Art, the Smithsonian's Renwick Gallery, the Harvard Art Museum, and the Gregg Museum of Art and Design, among many others. Hewitt does not work alone, and proudly rallies support for his community of potters in all sorts of ways. In 2005, he curated an exhibit of North Carolina pottery at the North Carolina Museum of Art and cowrote a book to accompany it; for nearly fifteen years he served on the board of directors of the North Carolina Pottery Center, regularly ran its annual auction, and served as its president.

Pottery would seem to be in Hewitt's blood, and it is. A native of Stoke-on-Trent, England, Hewitt is the son and grandson of former directors of the Spode fine china company. "There's something elemental, and psychologically confirming, about me continuing to make pots, albeit in a very different way," he says. That way began when he read *A Potter's Book* by

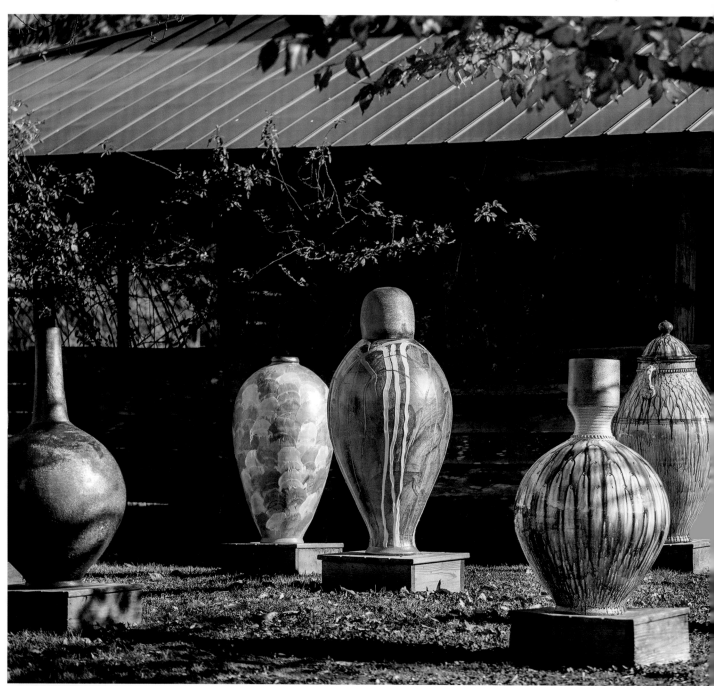

the father of British studio pottery, Bernard Leach. Hewitt knew then he didn't want to run a fine china factory, he wanted to make pots with his own hands and fire them with wood in a kiln he made himself. The book, a treatise on the ancient forms, meanings, and techniques of pottery across Asian and British traditions, became a roadmap. When an opportunity for a pottery apprenticeship in Connecticut arose, Hewitt grabbed it, came to the States, and met his wife, Carol. It was 1983. Together they drove South to visit potters. "I knew the South had clay, and wood

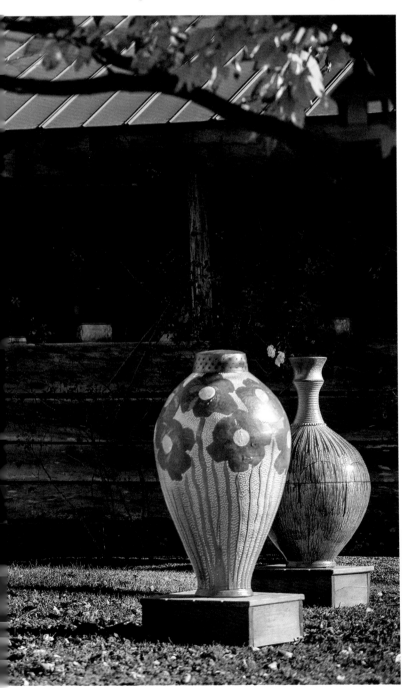

for the kiln, and that land was cheap," Hewitt wrote. "Ramshackle farms dotted the land."

They chose one and transformed it into a place of beauty. Over many years, hurricanes and tornadoes have wreaked damage here; Hewitt has rebuilt and carried on. The pandemic forced him to forgo apprentices and work alone and to cut his three annual firings down to two. "Despite all this," Hewitt said at the time, "our place grows evermore magical." Gratitude weaves its way through much of what he says; humor does too. The cobbled dirt of his studio floor, he says, "is one of the most beautiful clay pieces here." When he asks his apprentices to sweep it, "they have no idea why I want them to sweep a dirt floor!" Over the years, Hewitt has mentored dozens of these apprentices, many of whom have gone on to successful careers. Among the best known are Daniel Johnston and Henri Matisse's great-grandson Alex, who founded East Fork pottery, a fusion of craft tradition, production volume, and twenty-first-century marketing—a very different kind of enterprise than Hewitt's. Indeed, while potters at the highest levels share many things, including a love of their material and its history, philosophically, they have different answers when it comes to questions of art and craft, function and beauty, meaning and purpose.

For Hewitt, the answer is simple. "Why do I make pots?" he asks. "It feels like I have no choice. It is a paramount purpose for me. The pots are like thought, condensed thought, and my best form of expression. It's my gift, my way of making the world a better place." But that gift can't be properly received or appreciated unless it's used, he says. "You're not going to get the full measure of a pot if you just stick it on the shelf," he says. "To me, somebody's hand is as important as the wall of a museum. Actually, that's the forum. That direct, tangible experience." ▪

The pots of Mark Hewitt at his
Pittsboro home and pottery.

BEN OWEN III

On a warm spring morning, Ben Owen III is firing his kiln. It's a sunny day, the fire's been going for twelve hours, and it'll be another thirty-six before it's done. Owen slides a few slats of wood into a slot in the side of the chamber, turning to laugh at a joke from his friend Stan Simmons. A fellow potter, Simmons is here to help stoke the fire, to keep it going at temperatures reaching 2,350 degrees Fahrenheit. It's a group effort, firing a kiln, a multiday, massive effort, only accomplished a few times a year. Another potter, Fred Johnston, is also on hand. Both men have pots of their own in the kiln. They wait.

Pottery is one of the oldest human inventions, going back to pre-Neolithic times. Earth into clay, clay into pots, pots into fire, vessels out. Also unchanged: all hands on deck to get it done. Like farmers raising a barn, potters fire a kiln because they need each other. It's what they do.

Owen was born to this life, born with Seagrove clay beneath his feet. His father and grandfather built the foundations for Seagrove's modern pottery community; before them, as early as the late 1700s, their forefathers arrived from England, and made and sold clay vessels to early settlers. Owen III works today on the same site his grandfather did.

"He was a great teacher and a great mentor for me," Owen says, "showing me the fundamentals, building all those skills." Starting at the age of nine, every day, Owen went out to his grandfather's studio to make pots. During these sessions, his grandfather not only taught Owen technique and aesthetics (the Owen pots have a strong Asian influence, and also draw from the early American influence of Ben Owen Sr.'s time working at Jugtown Pottery), he taught him principles: how important it was to challenge oneself, to learn from mistakes, to greet change with enthusiasm, to eschew mediocrity. To "never sell his seconds."

"It was a good life lesson."

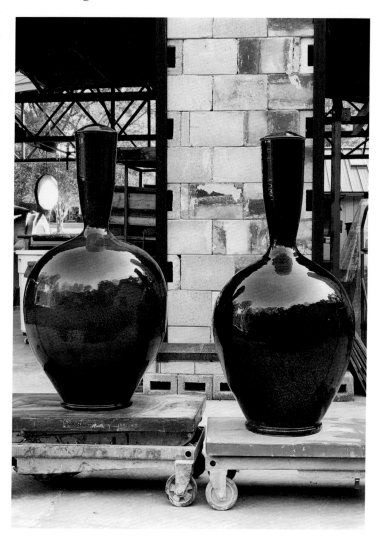

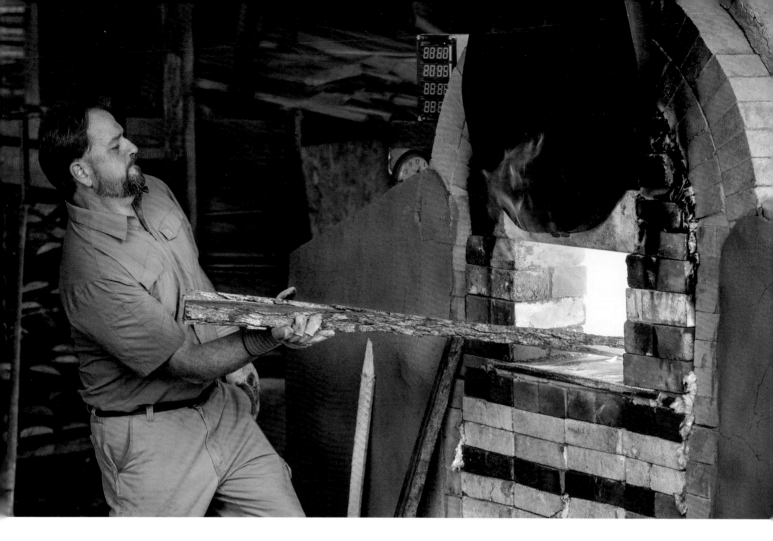

A lesson, and a life. Did the grandson have a choice? Owen III laughs at that question, because he clearly chooses this life every day. He chose it as a child; he chose it as a young man when he studied pottery at East Carolina University; he chose it with relish as an adult. Unabashedly, Owen loves what he does, loves where he comes from, and loves where he's taking it. "I'm continually trying to find ways to refine the technique and my process," he says. "How can I make the piece even better than I did last time?"

That commitment has taken his work all over the world and paved the way for its inclusion in museum collections including the Smithsonian Museum of Art, the Museum of Fine Arts in Boston, the Gregg Museum of Art and Design, and in innumerable prestigious private collections.

"It's like a jigsaw puzzle," he says, gesturing to his kiln, explaining how he fits 400 pots inside. Part of it "is tactical: some glazes do well high up, some pots need to be closer to the fire." Some is logistical. "Right now," Owen says, watching flames shoot out of a blow-hole-like chimney pipe, "right now it's heating up fast. Right now, there's more fuel than there is oxygen."

A few steps from this kiln, in the late 1990s, Owen built his own studio, right behind the one where his grandfather taught him. The newer spot is spacious, with separate workstations for different kinds of clay. There are pots in various stages of completion, one already four feet tall. When it's complete, this pot will be glazed an earthy blue, weigh about 250 pounds, and stand in the entry of a home in Greensboro.

FACING
Bottles in Pomegranate, by Ben Owen III, at his Seagrove pottery. Courtesy of Ben Owen III.

ABOVE
Ben Owen III firing a kiln at his Seagrove pottery.

"In an era of instant gratification, where people can go to the big box stores or a mall for most of their daily needs," he says, "we can offer something different. Especially when they can meet the maker, learn a little bit more about the process, and what makes a potter tick, and their particular style, and why they use that technique. The work becomes part of the fellowship."

Owen pictures his blue vessel in place, mentions the conversations he's had with the collectors who've commissioned the piece. He welcomes the chance to work closely with the people who collect his work—some of whom were also his grandfather's collectors—and to get to know them, just as he does with visitors to his region and his studio. The role of ambassador is another he embraces.

"When you can find a way to develop a relationship with an individual customer or just people coming out to visit the area," he says, "that gives us a springboard to tell people more about what the past has done, and what we've been able to build on over the last several generations."

He's happy to go further back, too, 280 or 300 million years or so, back to when the region was covered in the volcanic ash that gave birth to the clay he loves, and he's happy to bring it back home to now, and to his legacy. "I just count my blessings that we've been able to support our family through the making of earthen vessels," he says. "Really, the end product is how it is received by the people who use it." ■

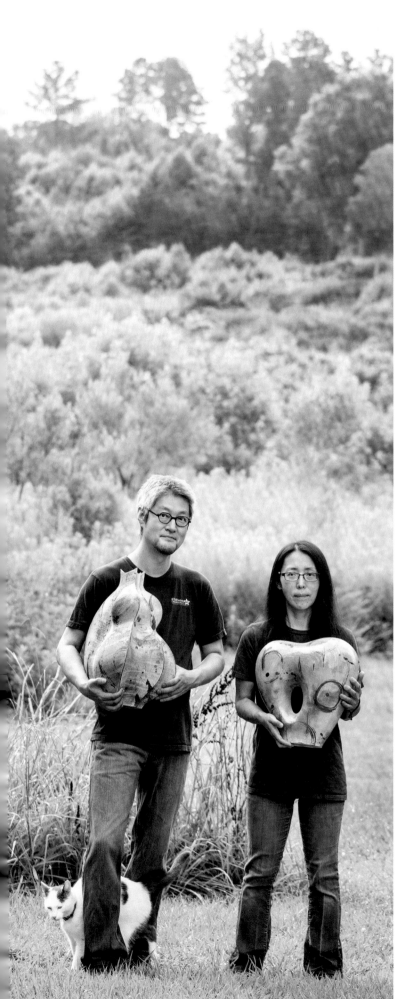

TAKURO AND HITOMI SHIBATA

SEAGROVE

In 2005, when ceramic artists Takuro and Hitomi Shibata moved to Seagrove, North Carolina, from the ancient pottery village of Shigaraki, Japan, they had with them nothing but a couple of suitcases, a rescued stray cat, and plans for a short adventure.

Today they are pillars of the community. Hitomi is a respected and prolific Seagrove ceramic artist, and Takuro, a fellow potter and the procurer and refiner of most of the area's local clay, is a community fulcrum. They live with their two young American-born sons on Busbee Road in a striking modernist house designed by a protégé of the famed architect Frank Harmon, built in part with their own hands. Their wood-fired kilns are a stone's throw from its front door, and the tiny farmhouse where they first lived on the property now serves as a gallery for their works. Their former garage is now their studio.

The art they make here is distinctly their own. Hitomi's sculptural pieces have the rounded, organic shapes of abstract feminine nudes. Takuro's are distinct for their architectural geometry, acute angles, and jutting planes. It's impossible to see the couple's pieces side by side and not admire the harmony of their yin and yang.

The couple credits the Seagrove community and its native clay for nurturing the art they first learned in Shigaraki. The first time they saw this place, they had a feeling it would be important to them. "We were surprised," Hitomi recalls. "There were so many pottery studios. We realized Seagrove was the biggest pottery community in the United States."

Takuro and Hitomi Shibata holding works of their own at their Seagrove home and pottery.

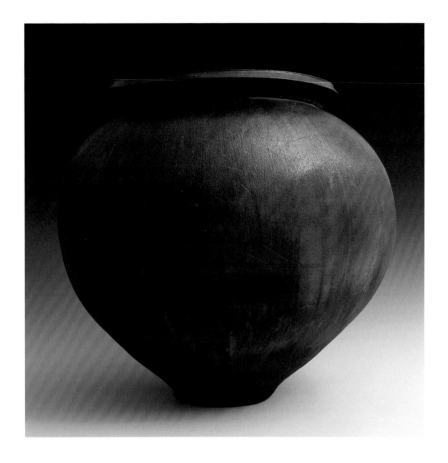

Sunset Sky, by Hitomi Shibata, 2019.
17.5 × 17.5 × 16 in. Photograph by
Takuro Shibata.

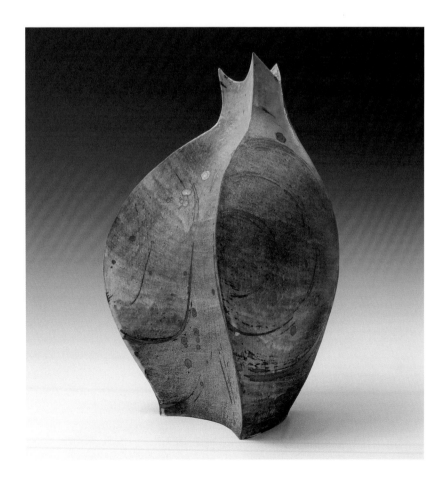

Triangle Jar, by Takuro Shibata, 2021.
11 × 10 × 16 in. Photograph by
Takuro Shibata.

They'd come down from a Virginia artist's residency on a Greyhound bus at the invitation of Nancy Gottovi (now executive director of nearby arts hub STARworks) and Seagrove potter David Stuempfle, who had visited Shigaraki a few years earlier.

The Shibatas loved what they saw, but their visas were up.

Two years later, Gottovi called again. She was working with Central Park NC, an organization dedicated to preserving the natural and cultural assets of central North Carolina, and offered Takuro, who has an engineering and chemistry degree, an opportunity to establish a clay factory to serve Seagrove's potters.

The Shibatas jumped at the chance. People in Seagrove, they believed, truly understood the value of pottery. In other places, Hitomi says, "People love art, but they don't think that pottery is the same thing as art. But here, people are so crazy about pottery. They love the tradition, they have so much appreciation. It's part of the history of the state, and people love North Carolina so much, they love North Carolina pottery."

Today, STARworks Ceramics is an integral part of the Seagrove pottery ecosystem. Takuro takes raw clay from the earth and turns it into a viable material for the art and craft that defines the region.

The equipment Takuro and his assistants use to refine it is massive and low-tech, the stuff of a fairy tale giant's bakery. Some of it is from the 1940s. There's a shredder, a mixer, a separator, and a vibrating screen; there are things called filter presses and pug mills. All of it fills a cavernous warehouse room. Massive buckets of what looks like sticky dirt go in one end; several days of human- and machine-power later, neat clay blocks, twelve by six by six inches, come out the other.

"North Carolina clay is special," Takuro says. "It's high in silica, it can be fired at high temperatures, and it is from this place." ▪

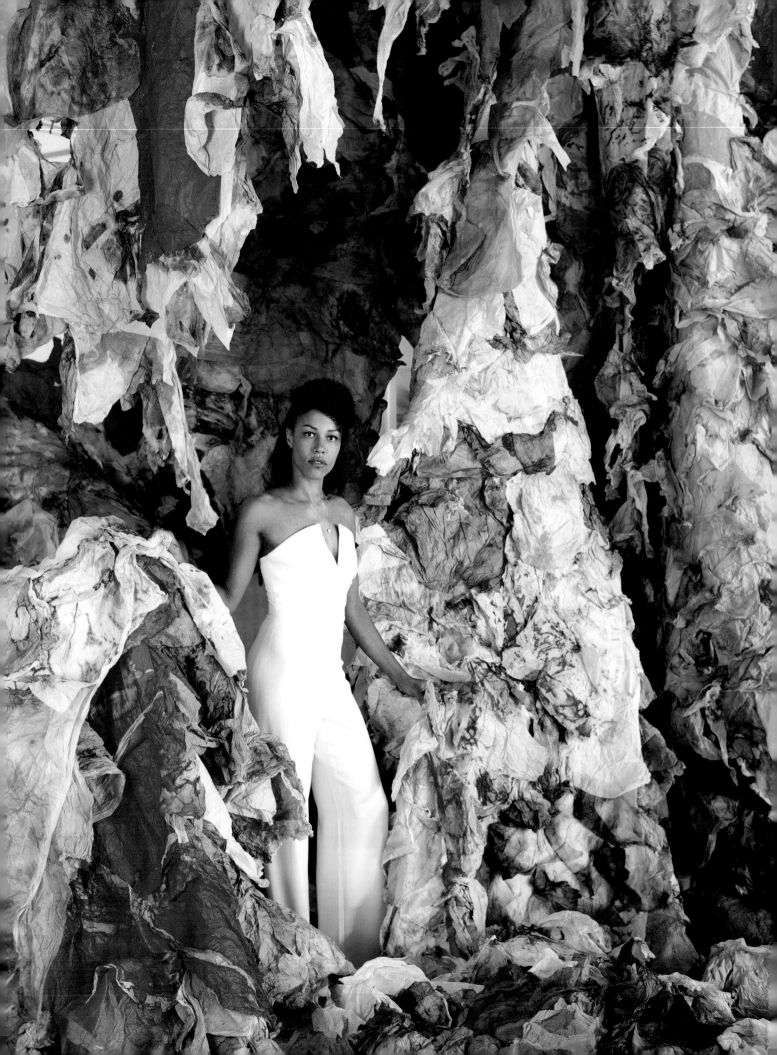

THE TRIANGLE

If you walk up the grassy hill at the east end of the North Carolina Museum of Art's 164-acre park, toward the rings of Thomas Sayre's iconic *Gyre*, you'll see Daniel Johnston's ceramic pillars emerge from the earth and trace a dotted line west. If it's windy, Vollis Simpson's articulated whirligig will give a twirl, and if you head right, toward the glass walls of the museum's sleek West building, Hoss Haley's patinated *Union 060719* will make you stop and look. And maybe it will make you think: these four works of important North Carolina artists, all made of North Carolina material and mettle, are standing here in the grass beside the works of greats like Auguste Rodin, Henry Moore, Roxy Paine, and Ursula von Rydingsvard. Together, they have welcomed you to the site of one of the premier art museums of the South, the only one in the nation built on a collection purchased by the state for the benefit of its citizens.

This art, you realize, is yours.

"It's world class," says Capitol Broadcasting Company CEO James Goodmon. A champion of the Triangle who regularly works with the chamber of commerce to recruit businesses to the area, Goodmon says when he brings these folks to the art museum, they're sold. "This is why your employees will love living here," he tells them. "Art, culture, quality of life."

It is here, on the grounds of our state museum, that art, culture, and quality of life are clearly evident; it's also where the talent and merit of North Carolina artists can be best appreciated, and where the museum's role as a fulcrum of the state's art world is clear.

Both that world and the museum have evolved greatly since the 1924 creation of the North Carolina State Art Society that founded it, and since the April day in 1956 when the North Carolina Museum of Art (NCMA) first opened its doors. By 1994, when Lawrence J. Wheeler took the job of director, the highly respected museum was like many of its time:

That Mimetic Waltz of the Moirai

Lien Truong

CHAPEL HILL

Moving to Chapel Hill in 2014 to become a professor of art at UNC–Chapel Hill changed Lien Truong's life, and it changed her art. The job allowed her space and time to make her art; so did a fellowship from the UNC Institute for the Arts and Humanities. She was freed, she says, to think hard about her own history and her point of view as an artist and as an individual.

As a Vietnamese refugee—the Saigon-born artist came to the United States at the age of two—Truong had a lot to consider. She asked herself: "As an immigrant refugee of color . . . what is my relationship with America, and what is my relationship with Vietnam?" And how did the traditionally European and Western perspective on the history of art correspond with her own art, and her own heritage?

"I decided that I wanted to make an American narrative," she says, "but how do I speak about these complicated identities? These ideas seemed so beyond the ability to represent visually."

With time to experiment, she continued painting but began to incorporate textiles in the works, including silk. These pieces of fabric represented to her the history of trade, and the Silk Road, and also bodies in the process of becoming American or in the process of figuring out a "transnational experience and identity."

The resulting work, like its maker, is a hybrid. It includes representation and landscape, abstraction and concept, the boldness of wafting fabric, the static color and shapes of the canvas.

"The precious, experimental time in my studio helped me so much," she says.

Truong's work has been exhibited at the National Portrait Gallery; the North Carolina Museum of Art; the Weatherspoon Art Museum; Oakland Museum of California; Art Hong Kong; Sea Focus, Singapore; Southern Exposure; and the Nhasan Collective and Galerie Quynh in Vietnam, among others. She has won awards including the Joan Mitchell Foundation Painters and Sculptors grant; fellowships from the Institute of Arts and Humanities and the North Carolina Arts Council; and residencies at the Oakland Museum of California and the Marble House Project. □

That Mimetic Waltz of the Moirai, by Lien Truong, 2018. 96 × 72 in. Oil, silk, acrylic, antique 24K gold-leaf obi thread, embroidery by Vũ Văn Giỏi, and linen on canvas. Courtesy of the artist and Galerie Quynh.

beautiful but staid. Its collection, which included works by some of the greatest artists of Western civilization, didn't go far beyond that canon, and wasn't always seen by a diverse population.

Wheeler had a mission: expand the collection, broaden the audience, bring in other art forms, and build a multifaceted community around it. Make it relevant. "We had to pay attention to the creativity of our own time, and find the underrepresented voices," he says. In the process, Wheeler led the transformation of the museum, putting it on the national map and ushering it into the future.

"I had a good sense of the cultural diversity and eccentricity of North Carolina," Wheeler says. "I knew that all the arts were connected, and fed off the energy of each other as expressions of human creativity, and as unique cultural expressions of our state."

Today, the NCMA collection includes contemporary art from the United States and from everywhere else, too. Its remarkable West building, completed in 2010, has won international architecture awards, and the surrounding Ann and Jim Goodnight Museum Park, the nation's largest museum park, has amassed its own list of accolades. Wheeler also transformed the museum's programming, introducing blockbuster exhibitions, boosting educational efforts, bringing in performing arts, and celebrating individual artists. In the process, the community has grown and been introduced to new perspectives, and the increasingly sophisticated and polyglot culture of our state has been showcased to a wider world.

Today, the museum has a new leader in Valerie Hillings, who took the role following Wheeler's 2018 retirement. A former Guggenheim curator with an international perspective, Hillings previously led a team creating the Guggenheim Abu Dhabi, and brings the uncommonly focused, can-do spirit that fueled that project—plus her creative and knowledgeable curator's sophistication—to our own museum.

Her goal, Hillings says, is to maintain and grow the NCMA's stature even as she explores new ways to engage audiences, including reinstalling the permanent collection and using it as a "dynamic toolbox" to showcase varied perspectives; creating installation-style, immersive experiences with art; and celebrating North Carolina artists alongside those from around the nation and world "to better reflect the diversity of our state."

With all of it, she's keen to draw people in with art and exhibitions that pique their interest, and expand their horizons with new art and ideas once they've arrived. "There are things you can know only if someone gives you that opportunity to know it. And then there are those things you discover on your own. How do we strike that balance? It's something we're always discussing."

Another dual agenda: showcasing the richness of North Carolina's own art while exposing North Carolinians to art being made nationally, internationally, and throughout history.

TRIANGLE ART WORLD

As the flagship museum has transformed over time, the world of art that it anchors statewide and in the Triangle has expanded along with it, giving rise to a growing and diverse population of artists and art organizations to support both them and their audiences.

"The landscape has changed so much in the last 15 years," says Trevor Schoonmaker, director of Duke University's nationally reputed Nasher Museum of Art. The economic growth of the Triangle, the influx of new people, the emerging significance of its universities' museums, and the recent proliferation of grassroots artist-run galleries and workspaces are all part of that change. "We've seen this growth, this influx of creative people, but also support for those creative individuals," Schoonmaker says.

Collectors

Lawrence J. Wheeler and Don Doskey

CHAPEL HILL

Former North Carolina Museum of Art director Lawrence J. Wheeler and his husband, Don Doskey, collect art the same way they collect friends and adventures: exuberantly, gratefully, and with a sense of humor.

The couple's extensive collection, put together over decades, reflects their whole-hearted embrace of life and of art of all kinds, including significant works of photography, sculpture, paintings, pottery, and other works from around the globe. Emerging artists and North Carolina artists, including works by Damian Stamer and Beverly McIver, also feature prominently.

In his nearly twenty-five years as director, Wheeler grew the NCMA into one of the premier art museums of the South. Through blockbuster exhibitions, programs, educational efforts, and the embrace of all forms of art, he brought new audiences to the museum's expanding campus. "I felt that while not everybody wants to go to a traditional art museum, they all like to have a common experience at a high level," he says. "That's where the performing arts came in, and concerts, and films, and why the park is so important. It can be an experience in itself . . . it is beautiful, and healthy, and enriching. That is a very important reflection of what a museum can be."

Wheeler also celebrated artists from North Carolina and those from around the world with the aim of bringing new voices into the permanent collection, and exposing all North Carolinians to different perspectives.

His ability to champion the state and its museum on the national and international stage was a point of pride. To accompany Wheeler on a walk through the galleries of the international Art Basel show in Miami, for one example, is to witness just how widely known, respected, and immensely well-liked he and the museum have become on a national level. Everyone—artists, gallerists, collectors, fellow museum directors—knows him, and he knows everyone.

While at the helm, Wheeler stayed true to the mission of stewarding the collection of the people of North Carolina: "At heart of everything I have done in my career is community, honoring the community you serve," he says. "When you're directing a state resource, you're aware it belongs to everybody. It's a religion with me."

Pictured with their dog Leo at their Chapel Hill home, Wheeler and Doskey stand with a few of their many works of art: above the fireplace is a marquetry work by New York artist Alison Elizabeth Taylor; the totem near the window and the colorful bench are both from Cameroon; the small painting behind Wheeler is by New York artist Shara Hughes; the large figurative painting on a yellow ground is by Cuban artist Carlos Quintana. Two Art Deco bronzes stand on the coffee table. □

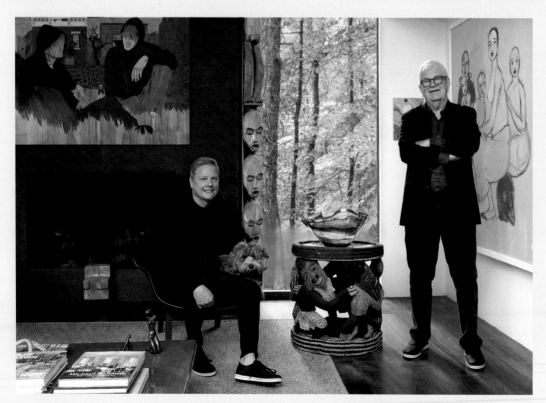

Lawrence J. Wheeler (right) and Don Doskey at their Chapel Hill home with a few of the works in their extensive collection of art.

That creativity and that support shows up in varied ways. In a metro area of more than two million people, ranked as the second-fastest growing in the nation, home to nine colleges and universities, that's to be expected. Even so, the number of unique museums, galleries, and other places to see art in the Triangle is matched only by the variety of places where art is made—and by the diversity of the artists making it.

"We have so much talent," says former four-term Raleigh mayor Nancy McFarlane. "You need to get over the idea that you need to go to New York to see art. It's amazing some of the stuff we have going on here."

Much of that can be seen in and around the area's art museums, which includes Raleigh's Contemporary Art Museum (CAM), the Warehouse District creation of a handful of visionary art lovers including Frank Thompson, Charman Driver, and Carson Brice. As a noncollecting contemporary art museum with a regular rotation of cutting-edge exhibits by living artists from inside and outside the state, CAM emerged as a cornerstone of the Raleigh art community in the 2010s, leading the explosive growth of a once-overlooked section of downtown.

"There have been so, so many changes" in the Triangle's art world, says Rory Parnell, owner of Raleigh's long-respected Mahler Fine Art gallery, "and I love the changes." She cites the stature of the NCMA, the emergence of CAM, the increase of cooperative studios, and the expanding profile and reach of the region's university art programs and museums as drivers of those changes.

Like It Is

Mark Brown

CHAPEL HILL

"Every painting is a challenge. If it's not, it's not art for me. Rilke said something I've taken to heart, which is that all art, or all true art, looks as if it has survived a struggle."

Chapel Hill artist Mark Brown, a much celebrated, widely collected, very private painter, lives deep in the woods. He heats his passive solar house in winter with wood he chops himself. He is not on social media and has only recently acquired a phone.

In the studio behind his house, he paints large, mediative, deeply saturated abstract works, many on distinct lozenge-shaped canvases and panels of birch. Curators and critics have compared his work to Mark Rothko and Frank Stella.

Music, "the perfect abstract art," fills the air as he works, layer upon layer, slowly building his pieces. Mozart, Beethoven, Coltrane, and Brahms's *Requiem* are on current rotation.

Brown's work reflects a distinct interiority, and aims to inspire a similar contemplativeness in its viewer. His geometric pieces "look symmetrical, but they're not," he says. "They reward close looking. . . . I've accepted that that's my role. That's what I'm doing here. I finally understand what it is I am trying to do. I want to change brains while I do my thing. Awareness. That's what I want."

Brown's work has won many awards, including Grand Prize in the 2006 and 2015 North Carolina Artists' Exhibition. His paintings have been widely exhibited in solo and group shows and are in the collections of the Ackland Art Museum, the Capitol Broadcasting Company, and Fidelity Investments, among many others. □

Like It Is, by Mark Brown, 2020.
72 × 45 in. Oil on canvas.
Photograph by Peter Geoffrion.

The blue-chip group of campus museums includes Duke University's Nasher Museum of Art, UNC–Chapel Hill's Ackland Art Museum, the NCCU Art Museum, and NC State's Gregg Museum of Art and Design.

These institutions provide more than an education to emerging artists, Parnell and others say, they provide an ecosystem. By bringing in and producing exhibits that open a window to a wider world, they broaden the perspectives of local artists and audiences in ways that make this a more interesting, relevant, and inspiring place to live and work.

UNC–Chapel Hill professor and artist Lien Truong says the area's university museums are "key to keeping an art community thriving and current." Their effect is multiplied by the fact that each has a different emphasis, as the director of NC State's Gregg Museum, Roger Manley, points out. "You get exposed to a lot of variety, a lot of different ways of thinking and doing," says Manley.

The Physical Properties of the Moon as a Folding Pattern

Heather Gordon

KNIGHTDALE

If art is one way to make sense of the world and mathematics another, Knightdale artist Heather Gordon has found a middle path. The art she makes from numbers, formulas, and geometry is so mysterious, so beautiful and informed, that a viewer can only feel reassured. There is a method to the madness, her work says, and that method is a form of beauty.

Sequences of numbers become intricate visual art in her hands. In *The Physical Properties of the Moon as a Folding Pattern*, data that describe the moon have been turned into a sequence of folds, as in origami. Then she draws or paints that sequence.

"I map the poetry of life using numbers and geometry," she says. "I coax narrative from information."

That coaxing and mapping not only results in beauty; it can also make information visible for the first time. At the Rubenstein Arts Center at Duke University, where she was a Visiting Artist in 2020, she used ninety years of untapped forestry data from the Duke Forest archives to create an installation of taped geometric shapes on interior walls and windows, a process she describes as "bringing the trees inside."

Before she got her hands on it, that information was just numbers on a page in a box in the dark; afterward it was not only beautiful; it was knowable. Gordon has performed similar alchemy upon data with collaborators using music and dance, and intends to do more.

Gordon's work has been exhibited at SECCA and the North Carolina Museum of Art. She has created public art projects at the Ackland Art Museum and the GreenHill Center for North Carolina Art, among other venues. She is the recipient of a North Carolina Artist Fellowship. □

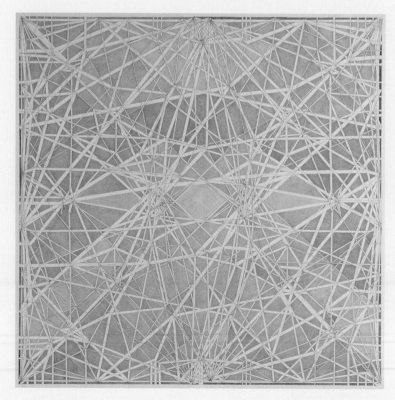

The Physical Properties of the Moon as a Folding Pattern, by Heather Gordon, 2018. 60 × 60 in. Colored pencil on Yupo. Photograph by Alex Maness. Courtesy of Heather Gordon.

His museum—housed since 2017 in an elegant new building on Hillsborough Street—has a diverse collection that includes the state's largest collection of outsider art as well as textiles, ceramics, paintings, sculpture, and photography that span cultures and disciplines. Like all the university museums, the Gregg is used regularly as a teaching resource for the school's undergraduate and graduate art and design students.

One of the state's most significant collections of work by African American artists can be found in the museum at Durham's NC Central University, which ranks as the first public liberal arts institution founded for African Americans. It's a legacy the university takes seriously, as reflected in its undergraduate art and design program and in its collection of art. Works by nineteenth-century artists like Edward M. Bannister and Henry Ossawa Tanner and twentieth-century artists including Jacob Lawrence, Romare Bearden, and Elizabeth Catlett, as well as contemporary artists including Juan Logan and Sam Gilliam can be found at the university's art museum.

At Chapel Hill, the Ackland is considered a flagship of the UNC System. Calling itself a "local museum with a global outlook," it has extensive collections of Asian and European art, a growing group of Islamic works, and plans to expand its collections of photography; African art; American art; and contemporary art, especially by people of color, says Director Katie Ziglar.

Currently housed in a stolid 1958 building that manages to hide in plain sight on Chapel Hill's Columbia Street, the Ackland is making plans to build a bigger, more visibly accessible building nearby before the end of the decade, Ziglar says. The new museum building, still in its planning and fundraising stages, will enable the Ackland to feature the wide range of works in its miniencyclopedic collection, and invite the public to come in to experience its motto: "Look close, think far."

In the meantime, a series of commissioned interactive works on the front terrace and a full rebranding in 2021 included the installation of a giant fuchsia A-C-K-L-A-N-D sign out front, all an effort to "counteract the very staid and closed presentation of the museum's facade," Ziglar says. Inside, there's nothing staid or closed about the museum's exhibitions, its gallery that commissions contemporary artists (most from the Southeast) to install works that reflect the wider world, or its ongoing collaborations with the other museums across the area and the state.

In one such effort, the Ackland will loan UNC Pembroke its sixteenth-century Theodor De Bry engravings of Native Americans in North Carolina, considered to be the earliest known depictions of Native Americans. In another, the Ackland and Duke's Nasher Museum recently made their first joint acquisition, a work by famed Native American artist Fritz Scholder.

The Nasher, meantime, has earned a national reputation for showcasing living artists, artists of color, and artists from the South. With a Schoonmaker-led mission to build a contemporary art collection that embraces diversity, the Nasher has showcased the work of Black artists including Barkley Hendricks, Amy Sherald, Theaster Gates, Ebony Patterson, Hank Willis Thomas, Stacy Lynn Waddell, Radcliffe Bailey, Beverly McIver, and Carrie Mae Weems, among many others, and has brought several of them to campus.

"At an institution of this scale, you actually meet the artists" when they visit, Schoonmaker says. "And so [local] artists want to be in this space, to hear from those artists, see their work, and have that experience." It all helps tremendously to keep talented artists in the area, he says: "If people feel like there's an opportunity here, to be in a place where we can actually live and make work, without having to leave to move to New York, without having to leave to move to Los Angeles," they'll stay, he says. They'll also find plenty of job opportunities, many within

Wayah Bald, NC (1), version 1

Gesche Würfel

CHAPEL HILL

German-born artist Gesche Würfel used 4 × 5 film and a large-format camera to capture the series of photos that make up her series *Trees Are Dying*, which includes *Wayah Bald, NC (1), version 1*.

When North Carolina suffered a drought in 2018, several old trees in Würfel's Chapel Hill neighborhood had to be felled. She learned that when temperatures reach 112 degrees Fahrenheit, trees stop performing photosynthesis. Alarmed, she set out to learn more, both through her own research and as a visiting researcher at Harvard Forest in 2019. She decided to create photographs in Massachusetts and North Carolina forests focusing on six major threats that rapid climate change creates for trees, an effort to make their impacts visible. In addition to heat, these threats include drought, wildfires, invasive pests, sea level rise, and storms. For each type of impact, she used a different photographic process.

For images of drought-affected trees like the one in *Wayah Bald, NC (1), version 1*, Würfel roasted prints in the ceramics kiln at UNC until cracks appeared, taking them out right before they burst into flames.

Würfel found photography as a calling while conducting research for her urban planning degree at the Technical University in Dortmund, Germany. Photography, she realized, was the best way for her to understand the way urban spaces are used, or disused, or abandoned. The medium so captivated her imagination that she moved to England for an MA in photography and urban cultures at Goldsmiths at the University of London, and then to Chapel Hill, where she now lives, for an MFA in studio art.

Würfel's work has been exhibited at London's Tate Modern, Raleigh's Contemporary Art Museum, the Nasher Museum of Art, and Goldsmiths at the University of London, among others. Her work has appeared in publications including the *New York Times*, the *Guardian*, WIRED, and *Slate*. □

Wayah Bald, NC (1), version 1, by Gesche Würfel, 2020. 24 × 20 in. Solarized gelatin silver print. Courtesy of the artist and Tracey Morgan Gallery.

the universities themselves—the faculty rosters of all of these schools are full of talented and successful artists, many of them alumni.

Truong says it's one of many reasons the region is rife with stimulation and opportunities for art students, professional artists, and lovers of art. "This area . . . has just enough of everything," she says. "Culturally, it's so rich; racially, it's rich . . . it has a good combination of nature and other stimuli." Equally important, she says, is the area's collaborative community of artists. "It's small enough to where we actually feel like we know everyone, and everyone is so supportive of one another."

MAKING IT HAPPEN

Which is not to say it's perfect. Artists of color whose voices have not historically been heard have been frustrated by art institutions they perceive to be slow to tackle issues of equity, identity, and history.

Raleigh-based curator Michael S. Williams founded the Black on Black Project to illuminate those issues through the medium of visual art. With art exhibitions, programs, and events, Williams says the project aims to give marginalized people a chance to be seen and heard, and for conversations about social justice and identity to be had.

"When I think about the history of North Carolina, as a North Carolina native . . . I think about all of the Black history, the civil rights history, and what we were not taught via the public schools," he says. "One of my goals is to use all of our [art] mediums to not only tell those stories, but to put them in the context of the issues we're dealing with today." When artists of color can "exercise that agency and do that kind of work," he says, change can happen.

The project grew out of an exhibit Williams mounted with artist Linda Dallas at Raleigh's Visual Art Exchange in 2016. Organized by Black curators,

the exhibit asked artists of color to share their thoughts on identity in their own voices.

Today, the project's mission is a broader effort to create equity in society, but its medium is the same. "I want to use art to connect," Williams says. "Art is the most efficient way to do it. All we can do is plant seeds. Hopefully folks will come along and water them."

The art community Williams is galvanizing is one of many in the area that share a collaborative and entrepreneurial spirit, a drive to gather as a community and get their work made and seen.

Many have resulted in cooperative art exhibition spaces. Nimble, welcoming, and largely noncommercial, these venues provide a vital resource, stoking creativity and encouraging experimentation. Places like these "are really needed for artists to grow and experiment," says the Nasher's Schoonmaker.

Some standouts include Basement, founded in 2019 by a group of UNC–Chapel Hill MFA students (including Chieko Murasugi) in a Chapel Hill basement. This artist-run project space provides a venue for experimental work; during COVID, it ran a digital "residency" featuring a different artist's work on its Instagram page every month.

Chapel Hill's Attic 506 houses gallery and studio space; a monthly film series run by artist George Jenne; The Concern Newsstand, an art bookstore; and a residency run by Bill Thelan called Drawing Room NC. Thelan is the artist who founded Raleigh's Lump Gallery in 1996, a cutting-edge creative hub for emerging artists that's still going strong more than twenty-five years later.

"Bill and Lump were doing this before there were any nonprofit alternative work spaces in the Triangle," says Schoonmaker.

Thelan says he started Lump not because he wanted to be a gallerist, but because he wanted to share studio space and show work that mattered.

Dining Room 1

Pedro Lasch

CARRBORO

"To me, art is not about consumption or for museums," says Mexican American artist Pedro Lasch. "I'm not against that—I love doing museum work—but to me, art that transforms the way we feel, perceive, and think . . . art that once you've been exposed to it, you don't go back, because it's changed you . . . that's the art I would like to make. That's the ambition."

Lasch creates installations, paintings, prints, and interactive and ephemeral works that address issues of citizenship, globalization, identity, history, and culture. His work has been exhibited all over the world, including the Venice Biennale, the Nasher, the Phillips Collection, and the Tate Modern.

Speaking in his Carrboro studio, the Duke professor describes his work as "socially engaged" without being didactic. "I try not to make work that tells people how I think they should think or feel or act," he says. "Instead, I try to make work that puts us in a situation where we must . . . think in more interesting ways."

In *Dining Room 1*, a person wears a mask Lasch made for his *Naturalizations* series, a group of interactive works he has taken all over the world for twenty years. The hallmark of the series is a mirrored mask that gives the wearer the face of the person he or she is observing or speaking with. In this instance, the wearer is at Reynolda House Museum of American Art in Winston-Salem, and the face reflected in the mask is that of John Spooner, as depicted in the John Singleton Copley painting *John Spooner*. (The painting on the wall is *Mrs. Thomas Lynch*, by Jeremiah Thëus.)

In locations as varied as the Korean Gwangju Biennale, a North Carolina farm town, the London Eye, the American Dance Festival in Durham, and the city of Port-au-Prince, Haiti, Pedro has invited participants to wear these mirrored masks as a way to open conversations about identity, individuality, race, culture, power, authenticity, and mortality.

"When people put them on, they feel it's a bit strange. It can be alienating, but it can also be a bit scary, you know, because your face disappears."

He says he calls the series *Naturalizations* because "it can lead to all kinds of interesting exchanges. If you're in an immigrant context, the mask might be understood in different ways, like how immigrants are forced to disappear, or are made invisible, or have to make themselves invisible." □

Dining Room 1, by Pedro Lasch. Painting reflected in the mirror/mask: John Singleton Copley, *John Spooner*, 1763, b. Boston, MA, 1738; d. London, England, 1815. Oil on canvas, image: 30 × 25¾ inches. Bequest of Nancy Susan Reynolds 1968.2.1. Painting on the wall: Jeremiah Thëus, *Mrs. Thomas Lynch*, 1755, b. 1719; d. 1774. Oil on canvas, 3⅛ × 2¹⁵⁄₁₆ inches. Gift of Barbara B. Millhouse. 1972.2.1

"It snowballed," he says. "The only thing I wanted to do was be around art and be around artists, and create a conduit for ideas, a place for artists to talk about work and think about art." Still, Lump's exhibition space, which offered artists complete control, attracted talents who have gone on to starry careers, Thelan points out. These include painter Elisabeth Condon, painter Katherine Bernhardt, and graffiti artist Barry McGee.

An unapologetic critic of the art market and of much of the local art world, Thelan says he's only interested in artists who "make work for the sake of art rather than the sake of money," and is happiest when he can discuss his calling with people who take art seriously. At the same time, he concedes he's grateful to Raleigh and the state of North Carolina. "Being here has enabled me to do something I would never have been able to do in San Francisco or New York," he says.

Other artist-run efforts that provide a venue for avant-garde work include Durham's The Fruit, Carrboro's PEEL, and Chapel Hill–Carrboro's The Dig In. Another beloved spot that provides material for art and artists of all kinds is Durham's Scrap Exchange.

"These nonprofit spaces are invested in very experimental practices," says UNC–Chapel Hill's Truong, allowing emerging artists the chance to make and show their work.

And then there's Cassilhaus. The beautiful modernist house / art gallery / artist's residency of architect Ellen Cassilly and entrepreneur Frank Konhaus has ignited art-making and art appreciation in the area since 2008.

Designed by Cassilly, the house on the edge of Duke Forest was built to serve as an exhibition space and artist residency as well as their own home. For three or seven weeks at a time, resident artists from all over the world come to live in a separate dwelling attached to the house; twice a year, new art exhibits are installed for the community at large.

Each resident—there are about four a year—is encouraged to tackle an ambitious project; Cassilly and Konhaus offer to connect them to scholars and other community resources to help them achieve it. The residents are required only to engage the community with an artist's talk, a workshop, or a performance during their stay.

With artists ranging from photographers to poets, screenwriters to choreographers, the cross-pollination these programs have created among the region's various arts communities is one of Cassilhaus's most interesting effects, say its founders. "We've really come to think of Cassilhaus as a watering hole, stirring up the arts community," says Konhaus.

With Duke and UNC nearby, the expertise available to assist an artist is extensive. When Cassilhaus hosted San Francisco photographer Chris McCaw in 2013, for instance, the project he wanted to complete involved modifying and motorizing an early 1900s camera to track the sun automatically for twenty-four hours, requiring expertise he did not have. Cassilly and Konhaus were able to connect McCaw to the UNC Department of Physics and Astronomy, which (amazingly) created a for-credit class to help develop McCaw's camera.

"Chris's project has become a poster child for what is possible with the resources of this area," says Konhaus, who asks resident artists: "How do you want to stretch, and how can we help you do it?"

"Anything is possible," Cassilly adds. "We are constantly amazed at the resources in this community."

COWORKING

Coworking spaces for artists are another important spoke in the visual art wheel, especially over the last twenty-five years, says the Mahler gallery's Parnell.

"It's really interesting to see how that has changed the dynamic for artists," she says, "because I see that

they collaborate more, and they help one another more because they're together. They're a community."

In southeast Raleigh, Anchorlight offers affordable artist studios, residencies, and regular exhibitions for emerging and established artists; downtown, the venerable Artspace ranks as one of the largest open studio environments in the country, with studios for thirty working artists, three exhibition spaces, and classrooms. Since 1986, it has welcomed the public to interact with resident artists in its airy, 30,000-square-foot building, a onetime city livery.

"That was my ticket in," says Raleigh artist Ivana Milojevic Beck, who was selected for an Artspace residency. "It was really the beginning of everything. It opened up so many good things for me."

Artists like Milojevic Beck have the opportunity to meet potential collectors regularly at a place like Artspace. Exhibits, open studio days, and monthly citywide First Friday openings (in Durham, it's Third Fridays) keep the traffic steady.

Other coworking and exhibition spaces and programs for artists in the Triangle area include Durham's Golden Belt Studios; Hillsborough's Artists Cooperative; Pittsboro's Gallery of Arts; Raleigh's Triangle Cultural Art Gallery; and Hillsborough's Skylight Gallery. Meantime, community-supported nonprofit efforts like Carrboro's ArtsCenter, Raleigh's Visual Art Exchange, Triangle Art Works, and the stalwart Durham Art Guild, founded in 1948, provide residencies, advocacy, classes, exhibitions,

Untitled

James Marshall (aka Dalek)

RALEIGH

For years, the artist known as Dalek has been living incognito in leafy, suburban Raleigh. Widely known for the Space Monkey character that he first tagged on a wall as a graffiti artist in 1995, the artist also known as James Marshall makes psychedelic, technicolor paintings, massive murals, and commercial commissions for companies including Nike, Hurley, American Express, and Microsoft.

When he started tagging walls with the Space Monkey, he adopted the moniker Dalek, referring to the fictional robotic villains in the venerable British TV series Dr. Who. It's a show Marshall watched growing up, which he did as "a misanthropic youth" in cities along the Eastern Seaboard, in Hawaii, and in Japan with his military family. Punk rock, skateboarding, and Japanese pop culture were his fuel; studying art at the Art Institute of Chicago brought it all together.

An apprenticeship with renowned Japanese painter Takashi Murakami led to several highly successful years in New York. Demand for his Space Monkey works hit fever pitch, and then Marshall burned out and literally blew the character up, covering him with multicolored fractals. Since then, his work has focused more on color and geometry, with occasional cameos by the Monkey (which is actually a mouse), or bits of him.

Marshall's work has been shown in galleries and museums across North America, Europe, and Japan. His following includes West Coast skate rats, sporting goods moguls, and serious New York collectors. □

Untitled, by James Marshall, aka Dalek.

and mentorship for artists. The Orange County Artist Guild puts on an Open Studio Tour every November that invites the public into the workplaces of many of its 100-plus members.

The Mahler's Parnell says that many of these organizations have now achieved the level of financial stability that enables them to put up shows that at one time only galleries attempted. "They're bringing in very good exhibitions," she says.

NONTRADITIONAL ART SPACES

And then there are hybrid spaces that make real space for real art, enabling artists to reach broader audiences. These include Durham's 21C Hotel; Carrboro's Gallery OneOneOne; and Durham's Horse & Buggy Press.

A standout among these nontraditional spaces is Cary's Umstead Hotel & Spa, which has made a significant commitment to art, fueling appreciation of North Carolina artists and those from around the world. Owned by Hospitality Ventures, a company owned by the families of SAS Institute founders James Goodnight and John Sall, the Umstead reflects the love of art of SAS CEO Goodnight, and that of his wife, Ann Goodnight. The couple have also made transformative philanthropic gifts to the NCMA and to the expansion of its park, which is named for them.

The Umstead's permanent collection, which Ann Goodnight put together with her daughter Leah Goodnight Tyler, features internationally known artists including glass artist Dale Chihuly as well as North Carolina artists like Herb Jackson, Mark Hewitt, and Ben Owen. The hotel also has a dedicated art gallery that puts on several exhibitions a year; in 2021 it collaborated with Marjorie Hodges and Allen Thomas Jr.'s Artsuite for an exhibition of nature-inspired works by North Carolina artists.

Just a short stroll from the Umstead gallery is another, lesser-known, extraordinary locus of art: the expansive, growing art repository and art studio at SAS Institute. Like the hotel, SAS is well known for its art collection, which was begun in 1981 and now numbers around 5,500 original works from artists all over the world. What is less well known is that about 25 percent of those works have been made by SAS artists-in-residence whose job it is to create art for the buildings that dot the private software company's 900 sprawling acres and its offices farther afield. The effort represents a rare commitment to and investment in art at a corporate level.

Juliana Craig, SAS senior artist-in-residence, has made more than 400 works in her twenty-plus years at the company. She works with other makers—including Holly Brewster Jones, with nearly 700 works in the collection, and, for a few years, with Raleigh artist Pete Sack, who was also an artist-in-residence—in an airplane-hangar-size workshop filled with art materials and archived artworks, and alongside a crew of artisans and craftsmen. This group makes custom sets and booths for trade shows, specialized millwork, and fine cabinetry, and has people dedicated to framing, metalwork, CAD design, and the fabrication, installation, and lighting of art.

Often she and other in-house artists focus on large-scale works. They also collaborate with local artists and help source art from artists around the world. When Craig is not making art, she's leading art workshops for SAS employees, part of an effort to foster creativity and engage them with the art in their midst.

If SAS easily has the most expansive corporate art investment in the area, the North Carolina State Bar has one of the largest collections composed solely of North Carolina artists. Assembled in 2013 with $250,000 from the State Bar Foundation expressly

Enslaved Family Quarters, Stagville Plantation, Durham NC, Built circa 1850

Elizabeth Matheson

HILLSBOROUGH

Before she was known as one of North Carolina's iconic photographers, Hillsborough native Elizabeth Matheson was "a working girl" at a publishing house in New York. It was the 1960s, and her father had just given her a camera he'd previously used to document his work as a county agent. "It was a very, very pretty Kodak Retina III, a good little camera with a pretty leather case," she recalls. "I started just walking around New York with it. . . . Here I was in this silly job that wasn't going to go anywhere. And I'd been really fascinated by the burgeoning of photography in New York. It was the time of the Diane Arbus exhibit at MoMa . . . and Witkin Gallery [credited as an early champion of photography as an art form], and a new gallery called Light," which is considered one of the first art galleries dedicated exclusively to contemporary photography.

Matheson's response: "I just started taking pictures." The decision immediately felt profound. "It felt as though I had control suddenly, and time slowed down, and I had evidence of my passage through it. And I looked at those pictures, just drugstore-developed pictures, and I thought, well, I kind of liked the way they looked. And so I continued."

She continued in New York and Europe and eventually, when she returned to her home state to live in Winston-Salem with her then husband, she photographed in North Carolina, too. Studying in 1972 with John Menapace at Penland School of Crafts ("this place is just luminous," she thought when she first visited, "just throbbing with energy and magic and beauty") gave her "the benediction I needed." She's never stopped.

Photographs followed of North Carolina landscapes and buildings, interiors and trees, daylight and porches, and slices of life; she remained one step removed, with a sometimes reverent, sometimes frank, and always unerring eye.

Her eventual move back to Hillsborough from Chapel Hill, where she had gone to care for her aging father, brought her full circle. "Just walking around Hillsborough, I suddenly felt really good," she says. "I tell people, I could embroider this on a pillow: Hillsborough is the place that I ran away to find." Living a life surrounded by the population of writers that lives there, especially, has been a dream come true, she says.

The photograph *Enslaved Family Quarters, Stagville Plantation, Durham NC, built circa 1850* depicts the interior of one of the four remaining buildings in which enslaved people lived at Stagville Plantation, just north of Durham. "They stand in a grove of trees facing a grand old barn," Matheson says. "It is a haunting place."

Matheson has had one-person exhibitions of her work at the North Carolina Museum of Art, Duke University, the National Humanities Center, and the Gregg Museum at North Carolina State University, among others. Her work is in museum collections including Duke University, the Ackland Museum, the North Carolina Museum of Art. In 2004, she was awarded the North Carolina Award for Excellence in the Arts, which is the state's highest civilian honor. □

Enslaved Family Quarters, Stagville Plantation, Durham NC, built circa 1850, by Elizabeth Matheson, 2003. 20 × 20 in. Pigment print. Courtesy of Elizabeth Matheson.

for the purchase of North Carolina art for the Bar's new Raleigh building, it includes the work of more than fifty North Carolina artists.

The Bar is not alone. Capital Broadcasting Company's extensive collection of contemporary North Carolina art is a prominent feature of its gallery-like headquarters in Raleigh. And law firms including Wyrick Robbins, Brooks Pierce, and Smith Anderson have made a point to build significant collections of North Carolina art in their expansive Raleigh offices.

"When we bring a piece of art into our business, that piece of art allows us to see the world from a different perspective," says Wyrick Robbins partner Larry Robbins, who started the firm's collection of North Carolina art in the early 1980s and makes a point to include artists of diverse backgrounds and viewpoints. "It helps us to understand the world better, and to be better citizens."

Collecting local art has implications beyond the law firm's doors, too, he says: "When we think about

The Archer

Ashlynn Browning

RALEIGH

Raleigh artist and curator Ashlynn Browning's geometric forms are stand-ins for figures, she says, "each one exhibiting its own persona."

Some are fierce, others shy; with lines and shapes Browning evokes sadness and exaltation, chaos or peace. She paints directly on the floor for an aerial point of view, combining what she calls her "cerebral" geometric elements with abstraction she considers more emotional.

"This one has a long way to go," Browning says, gesturing to a work in progress on her studio floor. There are easily twenty layers of paint on one of her panels before it is complete. "I add and subtract," she says. "I have to have them at that point where they tell me they're done," she says. "And they feel honest. To me, there's an integrity to them. When the work is valid, they become their own entity. When they're successful, it's like I'm in a room with people present."

In 2020, Browning curated the exhibit *Front Burner: Highlights in Contemporary North Carolina Painting* at the North Carolina Museum of Art, which included a large canvas of her own.

Her work has been exhibited in London, Paris, Ireland, and Hong Kong. She has received several grants and fellowships in the United States and earned her MFA from UNC Greensboro. □

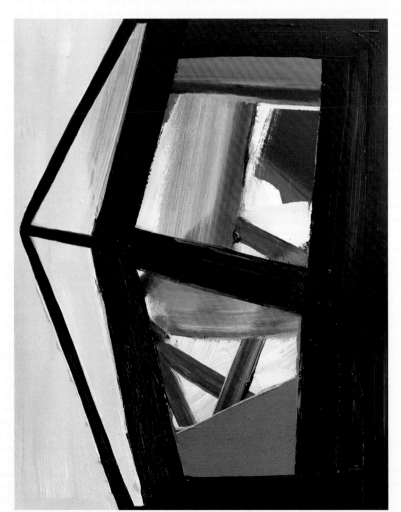

The Archer, by Ashlynn Browning, 2020. 14 × 11 in. Oil on panel. Courtesy of Ashlynn Browning.

the Research Triangle Region as one of the best places in the world, it's really important in attracting and retaining talent here to have a vibrant visual and performing arts community. It makes this a better place to live, work, and play. And if you're going to have that kind of commitment, you have to support local artists and provide them the opportunity to continue to innovate creatively."

There's a kind of pride in such a statement, in such an investment, that's about more than a community's collective belief in the power and importance of art. We've got everything we need right here, it says. Let's invest in our own people, and allow them to shine.

"This area feels like it has a creative soul," says the Nasher's Schoonmaker. "Not every place that has the means to support the arts has that creative soul."

Shedding Skins (Guys Change, but Only after It's Too Late)

Pete Sack
RALEIGH

Pete Sack taught himself to paint in middle school by making watercolor depictions of the baseball players he revered. He moved on to oil paints while pursuing a painting degree at East Carolina University; today his paintings, many figural, combine both mediums in works that look as if they were plucked from a half-remembered dream, more feeling than fact.

Overheard conversations, stranger's faces, fleeting glances, song lyrics, and photographs inspire him; he depicts them all in layered, saturated hues. Many of his images are found in old yearbooks, on baseball cards, and in photo albums. In painting these images, Sack creates new stories for their subjects' lives, puts them in narratives of his own devising.

He exercises this imagination every day, making small paintings he considers experiments and studies for larger works. He begins with a pencil drawing, paints watercolor on top, and ends with oil paint, creating a layered, ethereal ambiguity in the process.

His daily work ethic and enthusiasm for experimentation were put to good use in his years working as an artist-in-residence at SAS Institute in Cary, where he made art for the buildings that dot the private software company's 900 sprawling acres. Lately, he's been experimenting with abstraction. Sack's work has been exhibited in solo shows throughout North Carolina and is in several corporate collections. □

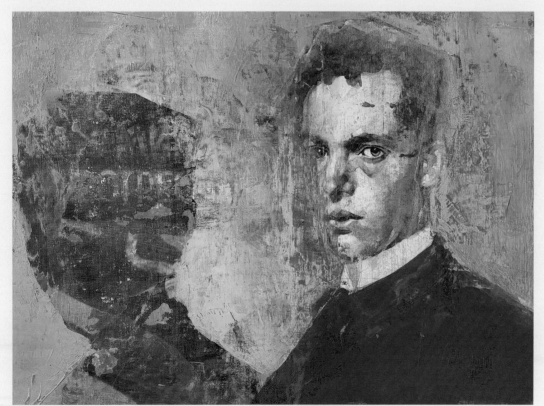

Shedding Skins, by Pete Sack, 2020. 11 × 8.5 in. Watercolor/oil on paper. Courtesy of Pete Sack.

Collectors

Carlos Garcia-Velez and W. Kent Davis

CHAPEL HILL

Carlos Garcia-Velez and W. Kent Davis have a contemporary art collection that would make any museum proud; in fact, it often does, as they loan and donate their works widely.

Pictured here with a sculpture by Spanish artist Jaume Plensa and a painting by New York artist Mickalene Thomas, the couple has works by many other blue-chip names like Kehinde Wiley, Leonardo Drew, Antony Gormley, Rashid Johnson, McArthur Binion, and Nari Ward in rooms beyond.

When they purchased a painting of Ella Fitzgerald by deceased New York artist Jack Whitten, the piece went directly to the NCMA

before they'd even hung it on their own wall. Their larger-than-life Nick Cave *Soundsuit* lived in the museum for about eight years after the couple bought it in the early 2010s and became a major draw

"I always got a kick when I saw a crowd of kids looking at it, and being fascinated by it," Davis says.

Both men collected art before they met more than twenty-five years ago. Once they began collecting together, they focused on photography before broadening their scope to include works in other media from a global and diverse population of artists. Some of the works in their collection have personal significance, like a pencil drawing that was Garcia-Velez's first gift to Davis; others were chosen for "the mastery of the artist," Davis says.

"Our collection represents the time in which we live, which I love," says Garcia-Velez, who has spent many years as a trustee of the NCMA. "So it's changed. The narrative has changed. The themes have changed, the techniques have changed, the processes have changed. And we changed along with it throughout the last twenty-five years." As a result, he says, "you can almost see what's happened in the art world" and in the wider world, too: "our social world, our political world, our environmental world or our social justice world. There are a lot of themes in our collection that we're very proud of, and social justice is one of them." □

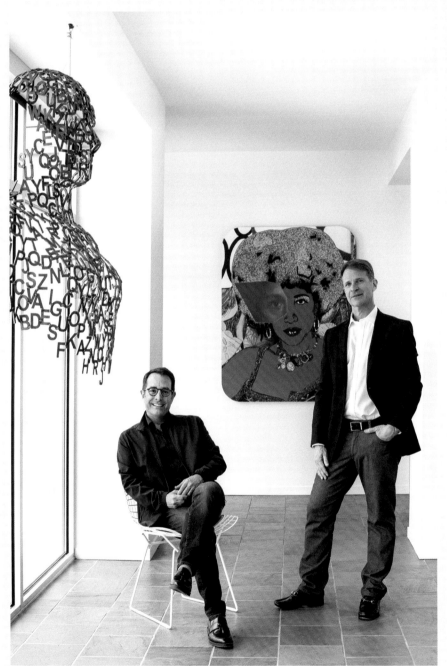

Carlos Garcia-Velez (left) and W. Kent Davis, in a hallway of their Chapel Hill home. In the window hangs a sculpture by Spanish artist Jaume Plensa; behind them is a painting by New York artist Mickalene Thomas.

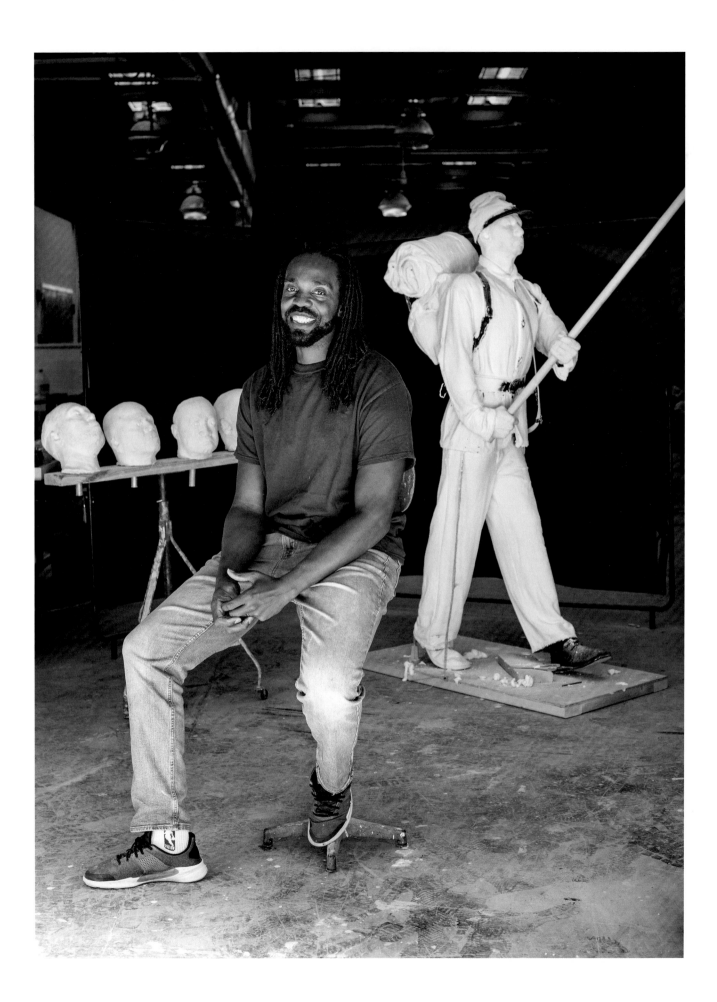

STEPHEN HAYES

DURHAM

When Stephen Hayes was a little boy in Durham, just five or six years old, he made things. Whatever material he could find—Styrofoam or cardboard boxes, Lego or sticks or yarn or school supplies—became something else in his hands. He made rocket ships and cars and rubber-band guns, anything to impress his mom, anything to make his older brother say "wow."

School was less productive. Even at that young age, Hayes struggled mightily in the classroom. But his ability to imagine and make new objects out of whatever he could find was innate. In second grade, his mother gave him a workbench with real tools. She could see that he had "a love for making," that he was "a creator." He'd go on to become the first person in his family to graduate from college, but it didn't come easily.

Thirty-odd years later, the NC Central University grad and Duke University professor still prefers his mother's word, "creator," to "artist." Not because he doesn't believe that what he makes is art, but because the word "artist" reminds him that for most of his life he didn't think he was one. "I guess school kind of scarred me."

Today, as one of the most esteemed and accomplished artists in the Southeast, Hayes can call himself whatever he likes. Among his other self-descriptors: "translator." Many of the women he honors with the sculptures in his *Support Totems* series have helped him translate life into art.

Hayes's latest work, *Boundless*, a monument in Wilmington, North Carolina, translates the story of a local Civil War battlefield to tell it from a little-heard perspective: that of the Black Union soldiers who fought there. Honoring the Fifth Regiment of the United States Colored Troops who led the Union advance in the Battle of Forks Road in 1865, Hayes's bronze sculpture depicts a marching troop of men, more than half of whom lost their lives in the battle.

Hayes's larger body of work, which includes woodcuts and installations in addition to sculpture, often addresses Black lives in America, exploring "America's use or misuse of Black bodies, Black minds, and Black labor."

When the Gibbes Museum of Art in Charleston, South Carolina, named Hayes the 2020 winner of its prestigious 1858 Prize for Contemporary Southern Art, the museum said Hayes's creations "contribute to the understanding of the South and demonstrate a powerful vision from an artist on the forefront of contemporary southern art."

Hayes first made his name in 2010 with his award-winning graduate school thesis project, an installation called *Cash Crop!* that has continued to travel on exhibit for more than a decade. Composed of fifteen life-size cast concrete human sculptures, each shackled to a pallet as well as a replica of a wooden ship, the work represents the 15 million African people brought to the New World in the transatlantic slave trade.

FACING
Stephen Hayes at his Duke University sculpture studio with plaster casts for his Wilmington monument, *Boundless*.

NEXT SPREAD
Stephen Hayes with his *Support Totems* in Oxford, NC.

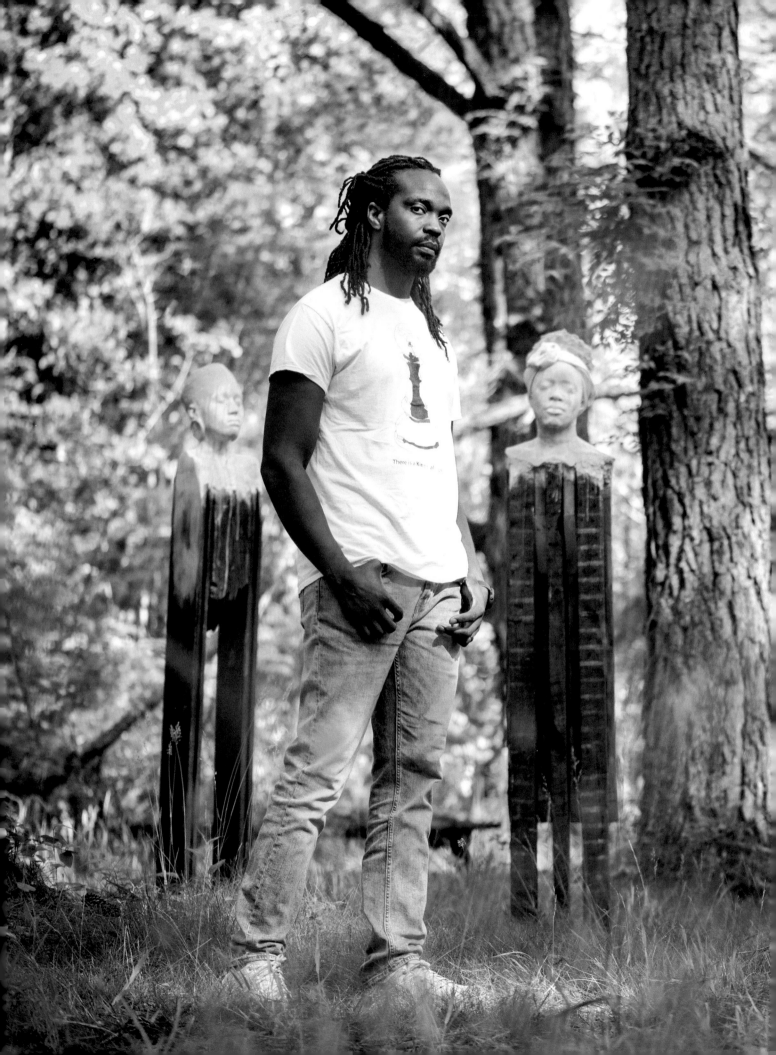

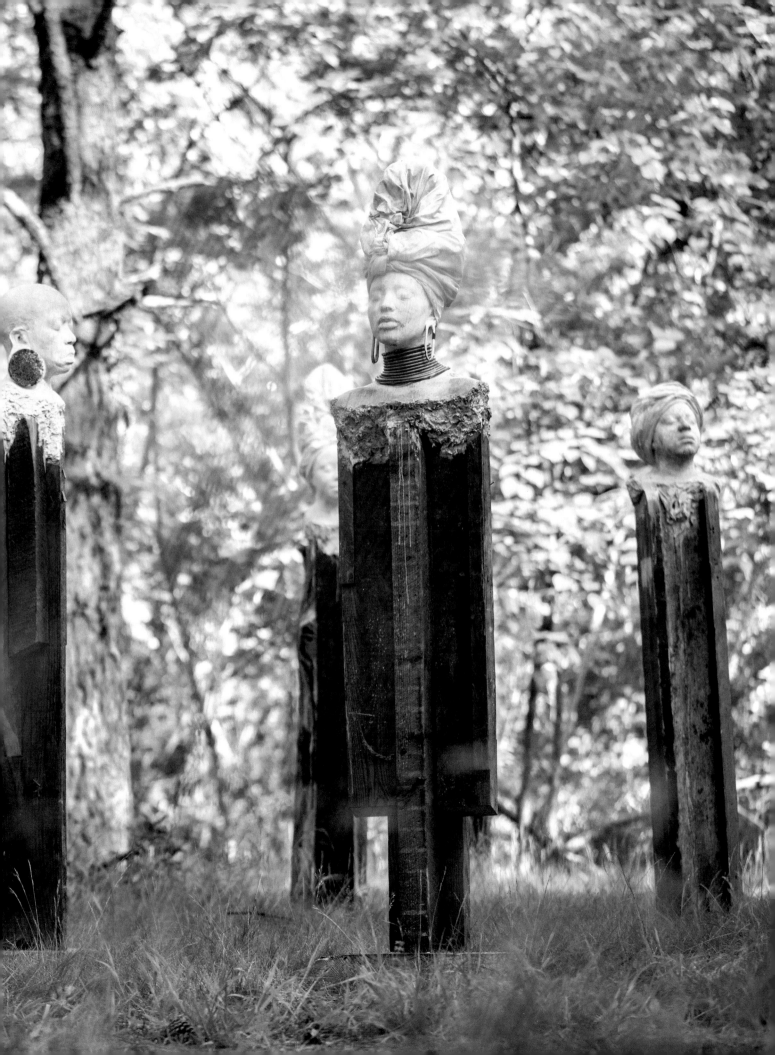

It's a stark, profound piece of art, and a visually arresting one. Beautifully and reverentially crafted, known to bring viewers to tears, it has a clear message, and an important story to tell. That combination of straightforwardness, purpose, and fine craftsmanship is Hayes's trademark.

It's one that evolved from his first, early love of creating. Early on in graduate school at Savannah College of Art and Design, Hayes says he was alienated by the self-referential language of art. "I didn't have the vocabulary to talk about my work, to say, this is what it means. I was just interested in making things."

In his second week there, he crocheted a life-size skeleton, taking the time to depict every bone meticulously. "I didn't have any idea what it meant," he says. "I just wanted to make something that was going to be . . . amazing. I wasn't thinking about the concept behind everything. I didn't want the everyday person to have to walk up to text on the side of the wall to understand what the work means. I wanted him to come with their everyday experience to understand what the work means."

When he came upon the idea for *Cash Crop!*, Hayes combined his love of making things with a deep calling to draw attention to the immorality of trading human beings as commodities. "I didn't know the impact that the work was going to make on people," he says. "I just knew that I had something I wanted to make. I stayed in [the studio] days and nights. Sometimes I didn't even eat or sleep. The studio was probably about 15 foot by 15 foot, in the basement of a parking garage. And it took me five months. Day and night."

Hayes has enough upcoming museum shows and commissions for public art and monuments to keep him just as busy for the foreseeable future: the Charlotte-Mecklenburg Police Department, the Mint Museum, downtown Durham, and the North Carolina Museum of Art are all on his calendar.

His goal with these and any future creations, he says, goes back in part to his motivation as a kindergartener: to make people say "wow."

"I want to make a piece of artwork that's going to stop my audience in their tracks from the first sight of it," he says. Once he has their attention, he hopes to create a conversation. "That conversation adds to my concept as a whole," he says. "I don't want to cut anybody off and tell them, this is what I want you to see. No. I want you to come with wherever you're from . . . and I want us to have that conversation."

He'll need to draw on reserves of focus and productivity, something he clearly has in large supply. "I have this mode that I call 'machine mode,' where I'm just in it," he says. "I'm in it, and I'm just making, and I'm not even thinking about anything else, just get this done. I got a job, I got a task that I need to do, and I need to complete." ∎

DONALD MARTINY

CHAPEL HILL

If color itself could come alive, dance across a wall, and leave its own mark, it might become the art of Donald Martiny. Freed, is what his works look like, colors freed and unbound, let off the hook of representing anything else, finally allowed to be themselves. The gestures that move them are also let loose. Strokes have escaped from the canvas to swirl and leap and run, to expand, to combine with color, to become the art itself.

"I spend a long time mixing colors, trying to get the color just where I want it to be," he says. "I don't really think about paint as paint, or color as color. I don't use it politically or symbolically at all. It's more like pushing sensation around, I'm pushing ecstasy, or I'm pushing tragedy, I'm pushing the whole spectrum of human feeling around." He uses the word "pushing" literally. The viscous polymer that forms his work is something he shoves and moves with his

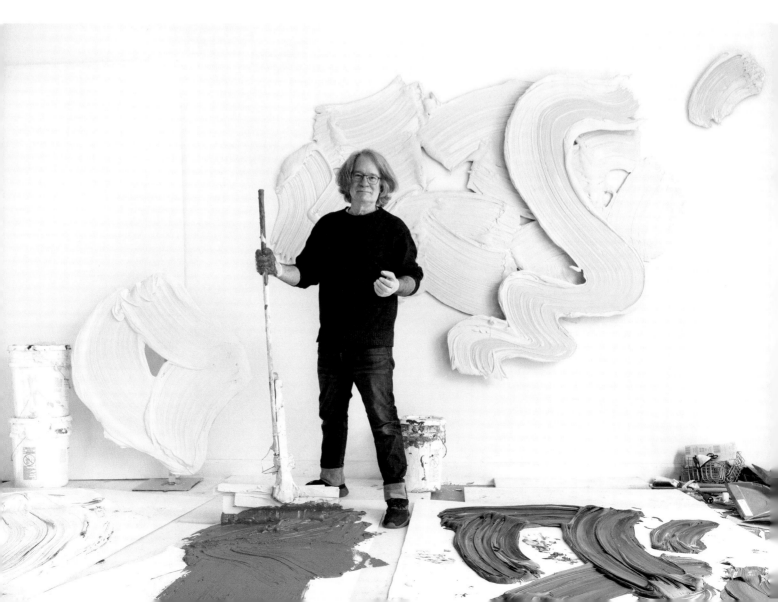

hands, with his arms, with his various tools, with his whole body.

It takes all of him to express the particular feeling he's chosen for a particular piece. "I can get in touch with it, much like a method actor does, I can kind of fall into this place and really become that, and then I can paint. And I'm in the paint. I mean I'm literally covered in paint."

The large-scale, free-form, floating brushstroke works that result, painting-sculpture hybrids that defy categorization, hang all over the world. There's a monumental installation at One World Trade Center and one at LAX airport. He's exhibited everywhere from Hong Kong to Padua and spent the last several years working seven days a week, crisscrossing the globe for solo shows, major commissions, and art fair exhibitions in Asia, Europe, and the Middle East. "It's a lot, but it's good. There's never, ever any downtime. There's always something to do, or something to figure out."

Some of that's conceptual, some is technical. Martiny points out eight different experiments he's running to test drying times for various oil paints, a tricky medium for him. Most of his work is made with a polymer base he developed to allow for his sculptural technique, to enable his several-inches-thick pieces to dry relatively quickly without shriveling, and to ensure they stand the test of time. He actually ran the material through an accelerator test and found it lasted over 500 (theoretical) years without deterioration.

Martiny's color, of course, is also his own. With a Heilscher ultrasonic machine, Martiny pulverizes various materials into fine powders to create customized, hypersaturated pigments. Once mixed with his polymer, these pigments can become paint that's glossy or matte or transparent to suit Martiny's needs. He can change its viscosity; he can tweak its "rheology," making it pour like honey or clot like cottage cheese.

This technical expertise came from years of experimenting to find a way to make his artistic vision possible. A lifelong student of art and art history, Martiny painted "very realistic" landscapes early on but felt hemmed in by the canvas. "It occurred to me that the rectangle is a portal, or a window, that you're looking through to experience the art in a different place. And for me, it was really important to have a very intimate connection with the viewer.... I wanted the art experience to be in front of the portal, not behind the portal. And also, I didn't need a rectangle as a form. That didn't make any sense, really."

It might not make sense for Martiny, but it's important to him that his work honor and refer to work that came before, that it has "a dialogue with the history of art. If art is going to have a lasting presence, it has to have a strong dialogue with the history. So I'm constantly looking back. I'm constantly studying." Every morning, he and his wife, the artist Celia Johnson, study together, mostly art history and philosophy.

The work of second-generation abstract expressionists teed him up to create a medium of his own. "You'll see that they often make a strong gesture, one grand gesture, and then they'll fill in the negative spaces." To Martiny,

That diminished the integrity of the initial gesture, and it also took away from the power of it. So I thought, well, let's get rid of that. So all of a sudden I had to get rid of not only the shape of the rectangle, I needed to get rid of the canvas completely. The whole ground. I had to get rid of the ground. And I didn't know how to do that. So I went through years of trying different materials and trying to figure out how to accomplish that technically, even though I had the concept very clearly in my mind. And after years of fooling around with failed paints, I finally came up with something that works. And it's constantly evolving. ∎

FACING
Alo, by Donald Martiny, 2020.
54 × 40 in. Polymer and dispersed pigment on aluminum.

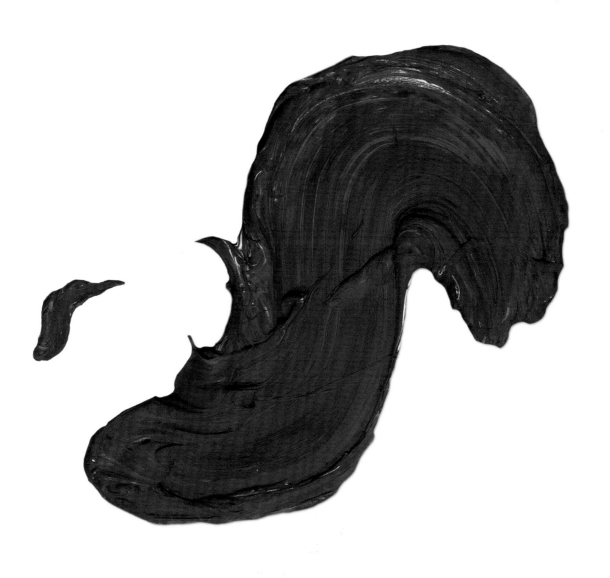

SABA TAJ

People who inhabit dreamlike worlds without the grounding of floors or horizons are the subject of Saba Taj's large-scale portraits. Some float in space, or within fields of color; others recline on beds of flowers or in seats covered with vines. Their gender or race is often ambiguous, and symbolic images surround them, many of which are Islamic, like the Hand of Fatima, an icon of protection; or honeybees, which can represent industry and feminine power; or the evil eye, which protects against the gaze of others. So do glitter and small jewels like pearls and rhinestones, and mirrors surrounded with the distinctive Shisha embroidery typically used to affix small mirrors to clothing. And while her subjects' bodies and faces are partly rendered in fine detail—an arm, a hand, one half of a beautiful face—other parts blur, becoming wisps of smoke or cloud.

These subjects share an abundant mystery, and they share this too: their gaze is direct. With frank and thoughtful eyes, they look right at you. And so in a subtle but powerful twist, with what Taj describes as "an energetic shift," the viewer of the art becomes the looked-upon.

The questions of who looks and who is seen and where the power lies is at the heart of Taj's work as an artist and as an activist. A self-described queer Muslim artist, the Raleigh-born-and-raised daughter of immigrants from Pakistan-administered Kashmir, Taj has many worlds and identities to navigate.

"It's tough to be different," she says. "And I think a lot of folks realize that. It's a very human way to feel. This notion of belonging is a crucial part of our lives." Taj spends a lot of time thinking about belonging, about what it means, how it is nurtured: "One of those ways is through art," she says, especially when people can "see themselves in (art) in ways that are deep and nuanced and interesting."

It's territory she navigates carefully. Lengthy interviews before she paints her subjects enable her to paint them "fully in their dignity, not being objectified." Or labeled. Taj speaks frequently about liminality, about "breaking open binaries" and painting people in all of their complex individuality.

When she served as executive director at the Carrack, an artist-run exhibit space in Durham, Taj was able to put more art in front of more people that did just that. As a post-MFA fellow at the Center for Documentary Studies at Duke, she used her intimate, admittedly subjective process to "get to a truer outcome" in documenting the people she paints. *Laila in Orchids (Interstitial Lush)*, a portrait of her wife, won the top award from among more than 1,500 submissions in the Raleigh Fine Arts Society's forty-first annual North Carolina Artist's Exhibition in 2020. Nat Trotman, a Guggenheim Museum curator, was juror.

Her work has been the subject of numerous other prestigious solo and group exhibits, and she is in

FACING
Saba Taj in the studio where she worked at the Center for Documentary Studies at Duke University, Durham, in front of her *Laila in Orchids (Interstitial Lush)*.

THE TRIANGLE 189

At the Meeting of the Seas, by Saba Taj, 2020. 72 × 72 in. Oil paint and glitter on canvas. Courtesy of Saba Taj.

demand as a speaker on the subjects of gender studies, the power of representation, and resilience. Taj also works in other media, including sculpture and performance; the collages in her *Monsters* series, rife with Islamic imagery, address apocalypse and rebirth. A series of illustrations titled *Nazar*, which includes figures riddled, sporelike, with concentric circles that represent the evil eye, addresses the belief that one can be harmed by the gaze of others.

The ability to raise difficult questions and depict truths through art is one Taj has explored since she was a child. Support from her parents and a broad education, including Raleigh's Ravenscroft School, an undergraduate art education degree from NC Central, and an MFA from UNC–Chapel Hill, enabled her to navigate "a number of different environments that ask for conformity in some pretty intense ways and in ways I could never really deliver."

In her art and through her activism it seems clear that Taj has found her belonging. "The South feels like home to me," she says. "It's everything I've known. Durham in particular—I feel so rooted here, and so surrounded by my people." These are the people of art and also of activism. It's "because of the really important work that happens in the South, the folks who are organizing around . . . how systems are oppressing certain groups of people . . . that makes me feel like I have belonging in a really important way." ■

STACY LYNN WADDELL

DURHAM

"My work started out being about history, and finding a place where I could insert myself in history, specifically American history," says artist Stacy Lynn Waddell. "And then it became more and more about identity. And now it has come to be about the issues of representation. Who gets to be represented and how? Why is it that representation matters, and who gets to decide that?"

Known nationally for her multimedia work that showcases transformative techniques including branding, gilding, and singeing, Waddell's art makes statements about representation and also about beauty, power, and history, and the ways they are marked and recorded.

In this portrait, Waddell holds an emergency blanket, one of many materials that have fueled her work. Representative of an inexpensive heat-conserving material often given to refugees or "people caught migrating," the material itself is a source of power and fascination: inert while flat, life-giving when manipulated. In various pieces, she has mimicked emergency blankets with gilded, crumpled paper. Shapeshifting, literally and metaphorically, is a central theme.

"The idea of me being seen [in this portrait] with materials is apt," she says. "In the studio, a main inspiration is engaging with the materials first, and then thinking about what they can be." The transformation of two-dimensional things into sculptural forms is a recurring process in her work.

Stacy Lynn Waddell in
her Durham studio.

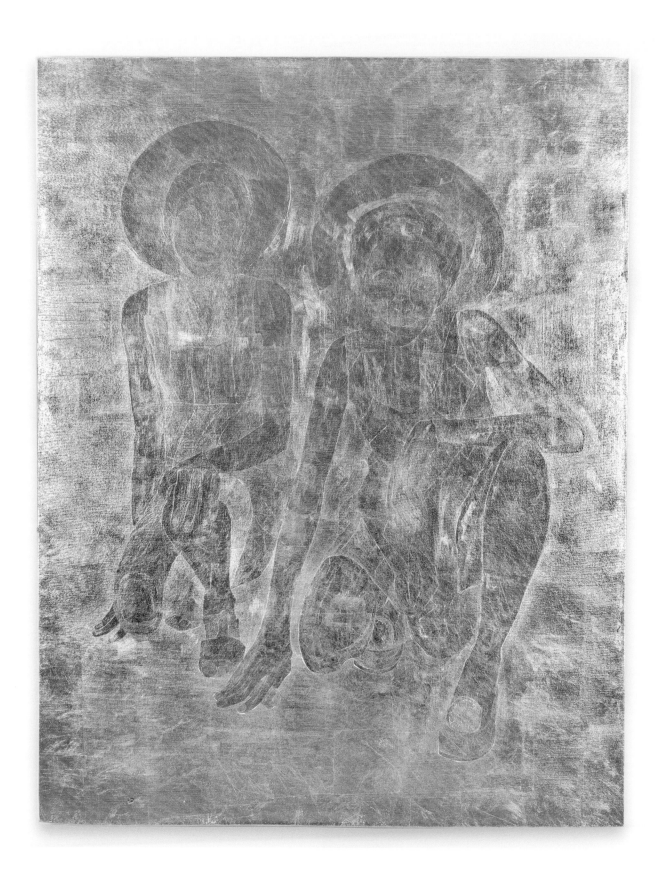

THE TWO OF US CROUCHING DOWN WITH HALOS AS HATS (for M. S.),
by Stacy Lynn Waddell, 1973/2021. 60 × 48 in. Composition gold leaf
on canvas. Photograph by Kunning Huang.

In Waddell's gilded diptych *Battle Royal*, flat sheets of gold-leaf-covered paper are debossed with the images of two guns pointed at one another in a stand-off. One gun is similar to that used by Harriet Tubman, and the other is a standard-issue Glock. These faintly three-dimensional images require careful study, something Waddell encourages. "You have to move your body around the piece to take it all in. In that way it's sculptural," encouraging a "360-degree experience with the work" both physically and mentally.

Her branded and singed paper works—also faintly three-dimensional, as the act of branding or singeing makes not only a burn but an indentation—are also best appreciated with careful study, she says.

"I'm a slow looker," she says. "I find myself returning to work again and again and again. It's the reason I fell in love with museums as a child . . . like libraries, which I also loved and still do, you can return to that same place in the stacks, and look at those books or through those books. In a museum, I can go to the same works that I love in the permanent collections and in galleries and have a relationship with them."

For the Mint Museum's 2021 exhibition *Silent Streets: Art in the Time of the Pandemic*, Waddell worked with quilter Ginny Robinson to create a series of three flags—one red, one white, and one blue—each dedicated to a Black woman or group of Black women. The red flag, made of heirloom textiles, honors her maternal grandmother and her role building a loving family legacy. Made of vintage Cone Mills denim, the blue flag honors a 1960s-era group of women at Raleigh's Shaw University who marched against Jim Crow laws wearing denim, in solidarity with Black farmers and other laborers.

And the white flag, made of nineteenth- and twentieth-century lace, silk, and linen that had been deaccessioned from the Mint Museum's collection, Waddell dedicated to Harriet Tubman, "our Moses, who first chose freedom for herself then led many out from bondage as a conductor on the Underground Railroad, never losing a passenger while carrying a pistol, singing songs of liberation and avoiding those that would call for her death." Waddell's description continues: "Thirty-four years after the Emancipation Proclamation, and a life of faith and tireless service, she accepted gifts of adoration from Queen Victoria, the granddaughter of Queen Sophia Charlotte, Great Britain's first biracial royal of African and German descent, and namesake of the largest city in North Carolina."

Waddell is a graduate of UNC–Chapel Hill's MFA program. Her art has been exhibited widely, including in the State of the Art 2020 show at Crystal Bridges Museum of American Art; in a Dexter Wimberly-curated show at the Harvey B. Gantt Center for African American Arts + Culture in Charlotte; and at the Prizm Art Fair in Miami during Art Basel, among many other shows. Waddell's work is in the collections of the Gibbes Museum of Art in Charleston, South Carolina, the North Carolina Museum of Art, the Studio Museum in Harlem, and the Pennsylvania Academy of the Fine Arts in Philadelphia, among several other public collections. ∎

DAMIAN STAMER

DURHAM

In his pristine, purpose-built studio, with his paints lined up in rows and his brushes clean and sorted, Damian Stamer paints disintegration. Old barns and abandoned houses, abstracted, exposed, collapsed, and undone. They are filled with broken things. Some seem to have exploded, to be in the process of warp-speed deterioration.

Stamer was a kid on a bike with his twin when he first began exploring places like this. On back roads and fields around his Durham County home, forgotten shacks and moldering tobacco barns leaned toward the land and drew him in, fascinating not only as relics of the past but as ruins in continuing evolution. Rusted tools and warped shelves gave way to stained mattresses and empty liquor bottles; nature made its relentless, long-game effort to reclaim. It has never let him go.

Stamer loads a pallet knife with a glob of grey-blue oil paint and smudges it in the lower right corner of a painting underway. It's close to finished, an abstracted greyscale barn interior. The center is pale and bright, as if you've come inside on a sunny day and your eyes are still adjusting. Around the edges, shapes emerge: a broken pipe, a dented washtub, some sort of grate. The longer you look, colors turn up, too. Turns out there are slashes, garish slashes, of bright orangey-red, and swaths of yellow, and scribbles in many shades of green. Texture, too: wood-grain-patterned slats, grit on the floor, mist in the

air, some sort of acid-drop speckles, like dust motes or floaters. It all has the gauzy, open-ended feeling of a memory, of a dream, of a subconscious question: What is home? What do we build? How long does it last?

Stamer stands back to assess the mark he's just made. He goes back, scrapes some off, smears it in the opposite corner.

"I try to keep surprising myself, in a way. Doing unexpected things. Even messing things up." He gestures to a section of the panel where he's now added several marks. "There's stuff about what I just laid down, some things I don't love right now, but then you let it dry, scrape it down, and then there's that remnant coming through. It can be very gorgeous." He looks back again, studies it some more. "I try not to get too attached to any part. To not make anything too precious."

Working on panel allows him to treat it that way, to work the surface hard, to erode and scratch away and then build back up. The studio itself also frees him. Built to his specifications and designed with his father, a structural engineer, it has enormous walls—Stamer prefers painting on them as opposed to on easels, and is able to hang his work on them, even the largest pieces, the ones that are six feet tall and almost eight feet wide. "I see them as museum pieces, or institutional pieces . . . they're on a scale that could really fill up a wall."

They are, in fact, on the walls of museums and institutions around the world. Crystal Bridges Museum placed his work front and center in its *State of the Art 2020* show; he has had solo exhibitions in Tokyo, New York, Budapest, and Charleston among other places in the last few years, and is in several prestigious public and private collections.

A proud graduate of the UNC School of the Arts high school with an MFA from UNC–Chapel Hill, he considers Anselm Kiefer an inspiration and Beverly McIver a mentor and has never forgotten where he came from, or what first inspired him all those years ago, a kid getting lost in the landscape. Because even

as he paints decay, Stamer's subject is also wonder. In every painting of falling-down walls, of mouse-gnawed floorboards, and forgotten furniture, the details betray an ardent fascination. And also hope. Light (there is always a source of light, an exit, or a portal, and sometimes, as in *St. Mary's Rd. 8*, one with an unmistakably celestial aura) is a recurring beacon, a relief, a magnet.

"Creatively," he says, "it really goes back and forth between the plan of creating a space, and then kind of blowing that up, and putting it back together again. It's like an intuitive dance. . . . You try to think and not think at the same time." ■

ABOVE
St. Mary's Rd. 8, by Damian Stamer, 2018–20. 72 × 95 in. Oil on panel. Photograph by Christopher Ciccone.

FACING
Chieko Murasugi with several of her works in her Chapel Hill home studio.

CHIEKO MURASUGI

CHAPEL HILL

Abstract painter Chieko Murasugi has navigated conflicting perspectives all her life. She is a PhD in visual science who works as an artist; she is the Tokyo-born daughter of Japanese immigrants who was raised in Toronto and lives in the United States; she is a former impressionist painter who now uses visual illusion to anchor her geometric art.

"I want to make the elusive, disparate, confusing, multifaceted nature of the world absolutely clear. I want to be clear in my view that the world is unclear."

Illusions underpin this message; her interest in them is one of the few things that has remained constant in her life. As a scientist, Murasugi studied visual perception because she was fascinated by mysteries like 3D illustrations that seem to flip, the ghosts of afterimages, and the way the perception of a color changes depending on the colors that sit beside it. Now, as an artist, she uses phenomena like these to tweak a viewer's perception, to make a picture plane shift before their eyes, to turn it from

one thing into another. She populates these paintings with crisp, unambiguous, flat-colored shapes. "I have clarity and I have ambiguity at the same time," she says. "And that's really at the crux of my art. It's the ambiguity, the clarity, the dichotomy."

Her art creates it, and she's long lived it. Murasugi grew up in a "very white" Canadian suburb, "very clearly a minority." As a child, her father, a descendant of 1600s-era Samurais, showed her maps of Japan's former reach across Asia, and told her "Americans took it away." He told her about how American forces firebombed downtown Tokyo, and how he and her mother barely escaped with their lives.

But these were not facts she'd been taught in school, or heard anywhere else. "I had taken world history, and I had not heard anything about the firebombings of Japan," she says. "And so everywhere I went, I was presented with diverging, often conflicting, but very disparate narratives. Who am I supposed to believe?" When she was studying for her PhD in visual science at York University in Canada, she recalls, her professors proudly touted the department's prominence in the field. Then she went to Stanford to do her postdoctoral work in neurobiology, and nobody had heard of her colleagues at York University. "And again, I had to shift my perspective." Fueling those shifts was an overwhelming curiosity, "always wanting to know why. Why, why, why. Curiosity has been the driving force of my life."

Years later, when Murasugi left her accomplished academic career and the world of science for art (she had always drawn and painted, and studied art in college as well as science), her viewpoint shifted again. In a deeply rooted way, she was coming home. Because, even at the height of her successful scientific career, Murasugi believed that she didn't truly belong. She thought she wasn't quantitative, logical, or analytical enough, that "there was something that was missing in the way that I was thinking." With art, the opposite was the case: "I knew I could do it."

This innate conviction took her back to school, to UNC-Chapel Hill for an MFA, where she met fellow artists she respected and joined with to cofound and cocurate an artist-run exhibit space called Basement.

The art she makes now assumes nothing of a viewer's point of view. It has been exhibited in museums in San Francisco, New York, and across the South and is in the collections of the City of Raleigh and Duke University.

Its abstraction welcomes any interpretation at all; its subtle illusory elements gently subvert them. "People have said to me over the years: Your work is so beautiful. And I think, well, I hope it doesn't stop there. But if they say it's so beautiful—Oh! And then it flips! I think, OK, good. As long as they see that there were two ways of looking at it." ∎

FACING
William Paul Thomas with
several of his works in his
Durham home studio.

WILLIAM PAUL THOMAS

DURHAM

What would it change if the adversity people suffer silently was plainly visible to the outside world? Would we treat one another differently if a person's trauma could be seen on their face?

These are among the questions William Paul Thomas poses with his moving portraits. He calls the series *Cyanosis*, referring to the bluish cast that can color the skin when blood is starved of oxygen. The hue also serves to highlight the natural color of his subjects' skin. "I was interested in finding a different way to express my own relationship to race," he says, one that didn't rely on what he considers negative "tropes."

"I thought if I altered the skin color, then that would be something you would have to talk about: their skin color, if nothing else, being changed. And what that might signify."

As a Black artist, he says, "No matter what you make, it has the capacity to be framed or centered on your identity, but you still have a choice to decide

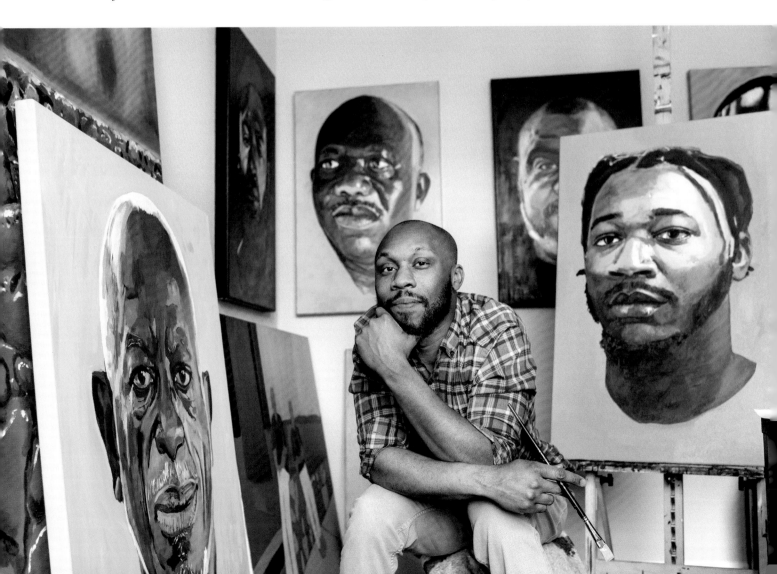

what the content is." In each of his nuanced portraits, the humanity of his subjects is central. He hopes viewers will consider what's beyond the canvas: "A person's emotional expression, your inference about their psychological state, the setting that they're in, their status in life, their vocation . . ."

He names each of these works for a woman who loves the man depicted. "What does it mean," he asks, "if I am celebrating these men, and asking us to consider that they are loved by a woman, or a girl, or a daughter, or a mother. Does that change the way we see their value?"

Viewers inevitably bring their own perspectives, which he welcomes. Some, Thomas says, see his paintings as symbols of empowerment; see the blue, for example, as the color of royalty, of a team, or even of a superhero mask. "There are so many ways to interpret color."

Another color prominent in Thomas's work is hot pink. It's the shade he painted the cinder block brick he uses in a series of video works and photographs. It symbolizes the color his mother painted the cinder block walls of the Chicago apartment they lived in when he was a child. It evokes his origins, his early influences, and his gratitude for a mother who made the best of her circumstances.

Thomas credits both his mother and his grandmother for encouraging him to draw as a child, for nurturing the talent that had him thinking of himself as an artist from a very early age, that took him to the University of Wisconsin to major in art.

North Carolina became home when he came to Chapel Hill for his MFA, and the state has been good to him, he says. His work has been widely exhibited, he has taught art at Duke and at Guilford College in Greensboro, held several prestigious residencies, and curated group shows at galleries, including *Opulence, Decadence* at Lump Gallery in Raleigh. ▪

THOMAS SAYRE

RALEIGH

Thomas Sayre's sculptures serve as beacons and focal points across North Carolina and around the world. His three-ring *Gyre* has become an icon and symbol of Raleigh's North Carolina Museum of Art. His massive spheres and series of roomlike sculptures stretch 400 yards down a central quad at the University of Colorado in Denver. On Thailand's island of Phuket, Sayre's conical tower surveys the Andaman Sea. These works—cast in and of the earth, or made of metal or fiberglass—are as varied as they are numerous.

Some are light and playful, like Tampa, Florida's *Ripple*, which invites pedestrians to the waterfront with stainless steel squiggles. Some are cool and clever, like the thirty giant polished spheres of *Curveball* that represent the path of a sinking fast pitch and a home run at Washington, DC's Nationals Stadium. Many others, like the five curving pillars of *Oberlin Rising* that honor a historic Raleigh freedmen's community, are tributes.

Each of them is also a celebration: of the earth and of humankind, and of how they meet, intersect, and diverge. In that way, they also reflect the artist. The great-grandson of US president Woodrow Wilson and onetime Morehead Scholar at UNC–Chapel Hill is nothing if not cerebral, taking care with each of his works to reflect and honor their place, purpose, and story. He is also an engineer, able to take these abstract ideas and make them massively, physically real.

Thomas Sayre with a recently completed thirty-foot-high earthcast sculpture at the corner of Cary Parkway and Evans Road in Cary, 2021.

When asked to describe how he made a pagoda out of stacked earthcast discs for a Raleigh collector, for instance—Sayre begins with the process, the placement of rebar, the casting of concrete, the role of traction and hand tooling and plate welding, even the awkward angle required of the crane to lift and place each disc. The practical puzzle of it all is clearly satisfying to solve. But it's when Sayre gets to the meaning behind the work that he comes alive. He talks about the purpose of a pagoda as a marker for a place where prayer can happen, of the similarity between the shape of a pagoda and that of a ladder, and of Jacob's ladder, on which angels ascended and descended, and of the last sermon his own father gave about a dream he'd had in which his own mother was one of those angels (Francis Sayre Jr. served as the dean of Washington National Cathedral for twenty-seven years), and about heaven and earth, and the connection between the two.

"For me, it's about living on this earth informed by the God above," Sayre says. "And there are intermediaries—angels—and there are devices—pagodas—that help with this connection."

These are not new themes for Sayre. He grew up not only in the heart of a national house of prayer and the Episcopal Church but also alongside a Buddhist, a Thai boy, the nephew of that country's king, who lived with the Sayre family for eighteen years.

On the day of the Raleigh pagoda's excavation, and again on the day of its installation, Sayre bows to the earth to pray with Buddhist Van Nolintha, who commissioned the work. He prays "that the Buddha,

Thomas Sayre excavating an earthcast disk, part of a stacked pagoda sculpture for a Raleigh collector.

and God, and Yahweh, and Mohammad would smile on this effort that was for the good of the world. And for the energy to do it. And to bring the sacred in."

To understand how Sayre works, it's important to witness these two realms, and how they intersect. Literally and metaphorically, the spaces in which he works represent two sides of his brain: one ruminative, allegorical, creative; the other practical, tactical, physical.

The first of these is Sayre's studio, until recently situated in a series of large open spaces inside a former industrial building in Raleigh's Warehouse District. (He and his late business partner, architect Steve Schuster, were among the earliest residents of this neighborhood.) The studio is where he thinks, where he paints, where he researches and experiments, where he makes the maquettes—or sculptural models—that precede his monumental works.

The second is the field, where he uses heavy machinery to dig sculptural forms in the earth, where he fills them with rebar and cement and earth, where he later digs up hardened shapes, lifts them with a crew and a crane, and situates and embeds them where they belong.

The point where the earth ends and man-made concrete begins, he says, fascinates him.

His wife, Jed, jokes that Sayre must have an especially large corpus callosum, or connective tissue between the left and right sides of his brain, and it probably helps that the artist inhabits both of these sides as physical spaces, worlds that require very different skills. Also that he allows each to inform the other. Sayre's engineering brain is never absent as he dreams up sculptural forms; his artistic brain allows serendipity and insight to inform even the real-time, heavy-machinery-intense completion of his work.

The difference between the shapes he plans and the ones he gets, he'll tell you, is where the magic lies. Along the way, there's a lot that can go wrong, and sometimes does.

That's less often true with his paintings, in which paint is seldom present, and technique is often sculptural. Using browny-black tar as a medium, Sayre smears and scrapes and gouges, creating fields of cotton bolls in one series. In another, flung molten metal creates thickets of trees. The smoke of a welding torch creates other paintings filled with wispy-heavy, cloudlike shapes. In others, the holes and dents that bullets leave in metal form the stars of a flag or the surface of a cross.

Sayre's work can be found in public places across the country and internationally. He has exhibited his work in numerous galleries and museums, and is the recipient of a National Endowment of the Arts Fellowship. He was awarded an honorary doctorate of fine arts from NC State University and the North Carolina Award, the state's highest civilian honor. ∎

BEVERLY McIVER

CHAPEL HILL

Beverly McIver paints to make sense of the world and her life, the people she loves and the things they go through. Her ability to capture humanity in the process—to communicate hard, complicated, and joyful truths—has made her one of the most revered artists painting in America today, named among the Top Ten in Painting by *Art News*.

Portraits of her father she made until his passing at the age of ninety-five, of her mentally disabled sister Renee, and of herself are among McIver's best-known works. Together they examine race and dignity, worth and purpose, persona and authenticity, duty and love.

In 2020, the isolation of COVID brought about a period of introspection and productivity for McIver. Her self-portraits began to take on darker aspects. In many, her face is covered or obscured by slatted shadows, scarves, or tangles of rope. Her eyes are often closed.

"I think the rope and scarf were about being claustrophobic," she says, "about being trapped in this life. And realizing that I am not doing enough. I am not making enough of a difference in the world."

She'd had a taste of making a difference when the People for the American Way commissioned her (and other major artists like Shepard Fairey and Carrie Mae Weems) to create a painting on the theme of "Enough of Trump" in advance of the 2020 election. The group put her work on giant billboards in swing states. "I don't think of my work as being political, but I enjoyed seeing the power of the billboards," she says.

A different form of power is behind another plan to make a difference: the creation of an artist's residency for women and people of color on her Chapel Hill property, one that pays a stipend. Tod Williams and Billie Tsien, the architects of the Obama Presidential Library, have offered to design it for her without charge.

McIver has been inspired to create the nonprofit residency by her own experiences. "I've done some of my best work at residencies," she says, "but I get so worked up and anxious. I know I'm going to be the only Black person. I know they're going to eat food I traditionally don't eat. You have to be so flexible, so open, and extend yourself in a way—it becomes a challenge just to show up."

That was true even during the year she lived and worked in Rome as a recipient of the American Academy's prestigious Rome Prize in 2017. Despite its challenges, McIver found the opportunity remarkable. With swaths of time to paint and no household or familial responsibilities to tend, she "went inside," she says. "To identify who I was without Renee, without my dad standing in front of me, to figure out who I am and what that person looks like." The experience served as a kind of palate cleanser: "The biggest thing I learned in Rome is that if you're willing to be open," she says, "it's amazing what will come your way. The scary part is just being open to it."

The idea that McIver was ever scared of anything is hard to imagine, as fearlessness has long shaped her life, beginning with her childhood in a Greensboro

FACING
Beverly McIver with several of her works in her studio at Duke University, Durham.

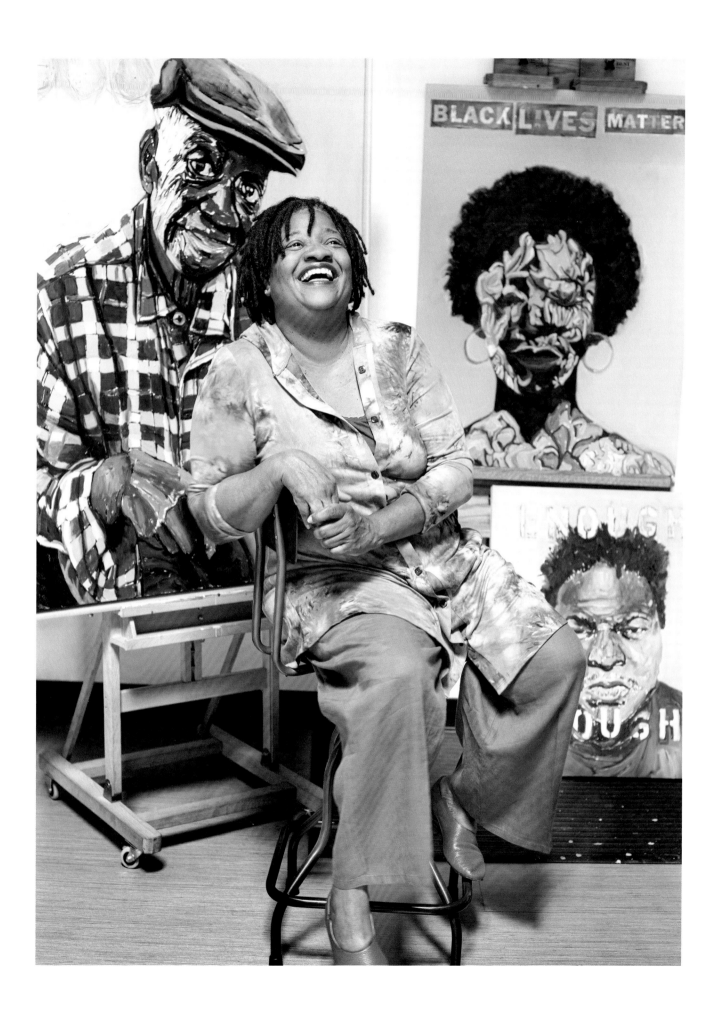

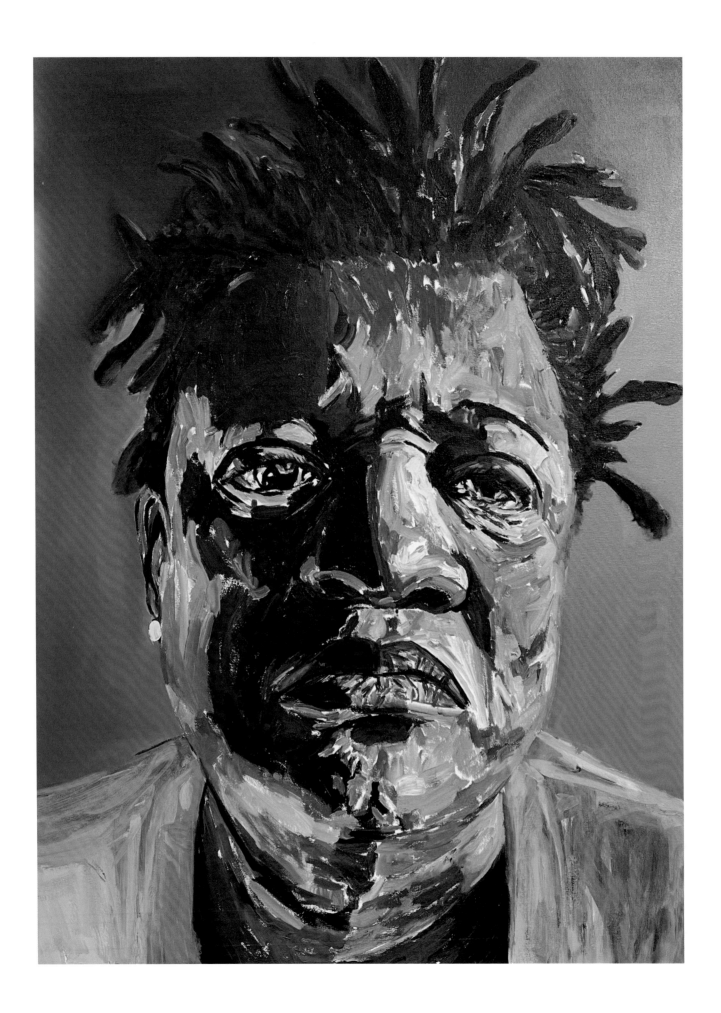

housing project as the daughter of a single mother who worked as a maid and a father she didn't meet until she was sixteen.

McIver only started painting as an undergraduate at NC Central University as a lark. Despite encouragement from her professors, she was wary of pursuing art as a career, worried she'd never be able to support herself. But once she dove in, accolades quickly followed. McIver received a Guggenheim Fellowship, a Radcliffe Fellowship, and many other awards.

At every stage of her career, truth, she says, has always been her aim: "I'm trying to do things that bring me closer to my authentic self. I think that's what people see."

A career survey of her work opened at the Scottsdale Museum of Contemporary Art in 2022 before traveling to SECCA in Winston-Salem. McIver's art can be found in the collections of the National Portrait Gallery at the Smithsonian, the North Carolina Museum of Art, the Weatherspoon Art Museum, the Baltimore Museum of Art, the NCCU Art Museum, the Asheville Museum of Art, the Crocker Art Museum, the Nelson Fine Arts Center Art Museum at Arizona State University, the Nasher Museum of Art at Duke University, the Cameron Art Museum, and the Mint Museum, as well as significant corporate and private collections. McIver is currently the Ebenshade Professor of the Practice in Studio Arts at Duke University. ∎

FACING
Grief, by Beverly McIver, 2022. 30 × 40 in.
Oil on canvas. Courtesy of the artist and
Craven Allen Gallery.

PATRICK DOUGHERTY

CHAPEL HILL

If a potter could live inside a pot, or a painter could dwell within a painting, they might feel almost as at home as sculptor Patrick Dougherty clearly does. The stick sculpture artist lives in a house in the woods that he made from the logs he gathered there. It stands behind a stick fence, beyond a herringboned wooden outbuilding, down a long gravel driveway, and tucked into twenty rural Orange County acres.

The result, like Dougherty's art, is a self-contained environment at one with nature: part of it, informed by it, and also otherworldly. Woven, spun, braided, and twirled, his massive, cocoon-like works of art look like nests shot out of a hurricane. In places that dot the globe—from Belgrade to Sewanee, Charleston to Dublin—they are meant to be entered and explored, experienced and touched. Over the last thirty-plus years, he has built more than 300 of these giant works, ten of them a year, three weeks at a time, and always with a cadre of local volunteers.

The Oklahoma native likens the process of sculpting with sticks to "drawing with lines in the air." The technique is to "concentrate on using the tapers to your advantage," he says. "What happens is you get an implied motion. And so these things have a quality of motion to them, and not by accident, but by design. You try to make these luxurious surfaces that have depth to them, but also an implied way of moving."

There is, undeniably, an alive quality to his art, a sense that one of his peaky huts might give you a wink, or scamper off when you're not looking. It likely has something to do with that movement he's able to contain within them, but it might also reflect their whimsy, or the many hands that helped, or the fact that they are, in fact, alive, have a life, one that will end, will rot and topple, just like all of ours.

That temporality is part of what has kept Dougherty out of what he calls "the normal art system." Galleries "are trying to make money and they want to sell something," he points out, usually something with lasting value. What Dougherty offers is fleeting. "There's an honesty to it," he says, "because it elucidates the most important part of making art and looking at art, and that is how it makes you feel. The intensity of the moment that you view it. And this work tends to capitalize on that. You see the reaction in people. They can't buy it or sell it, they can't collect it."

But they can experience its creation, interact with it from beginning to end, the way they can't with almost any other type of visual art, and even if they aren't part of the making, they can step inside and experience it once it's done. "I don't have any fences up around my work," he says. "People have access to the process during the entire [construction]. So the person who's calling the police on the first day about the material being thrown on the ground is asking you to dinner on the last day." In between, they've witnessed, and maybe helped, turn a pile of sticks into a work of art. They've come to care about it, worry about it, fuss over it, take pride in it.

"The magic of it is conjured by me, but it seems beguilingly simple, because I'm having different

FACING
Patrick Dougherty at work, assembling
Common Ground at Davidson College,
Davidson, NC, 2020.

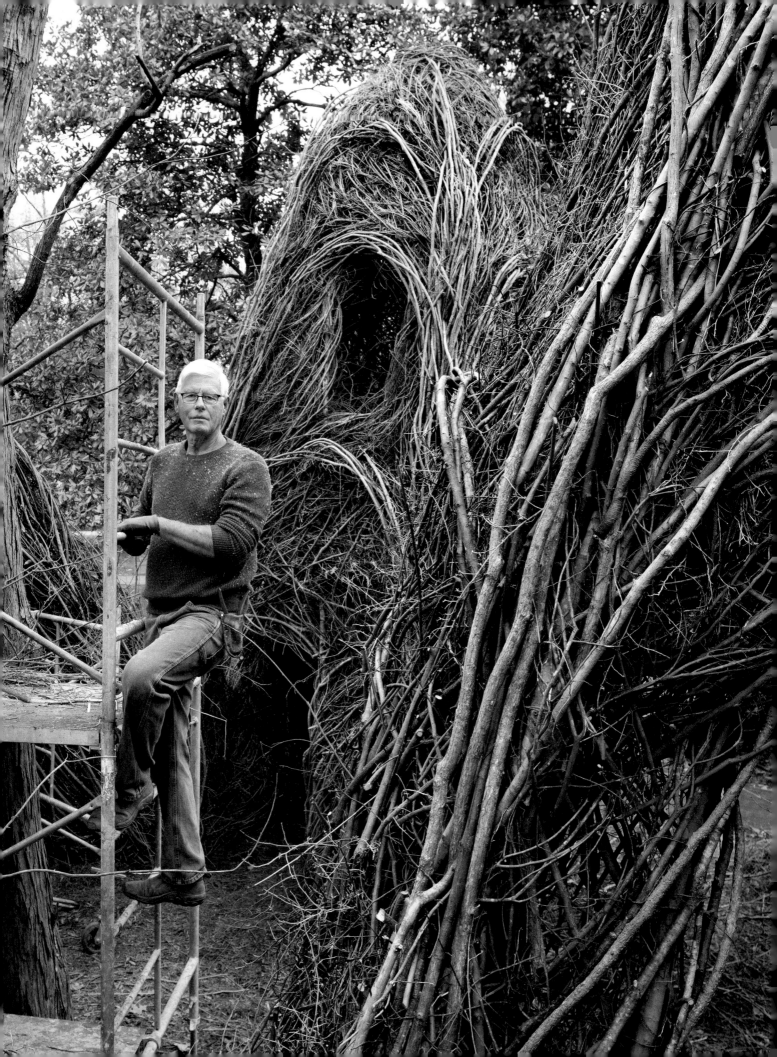

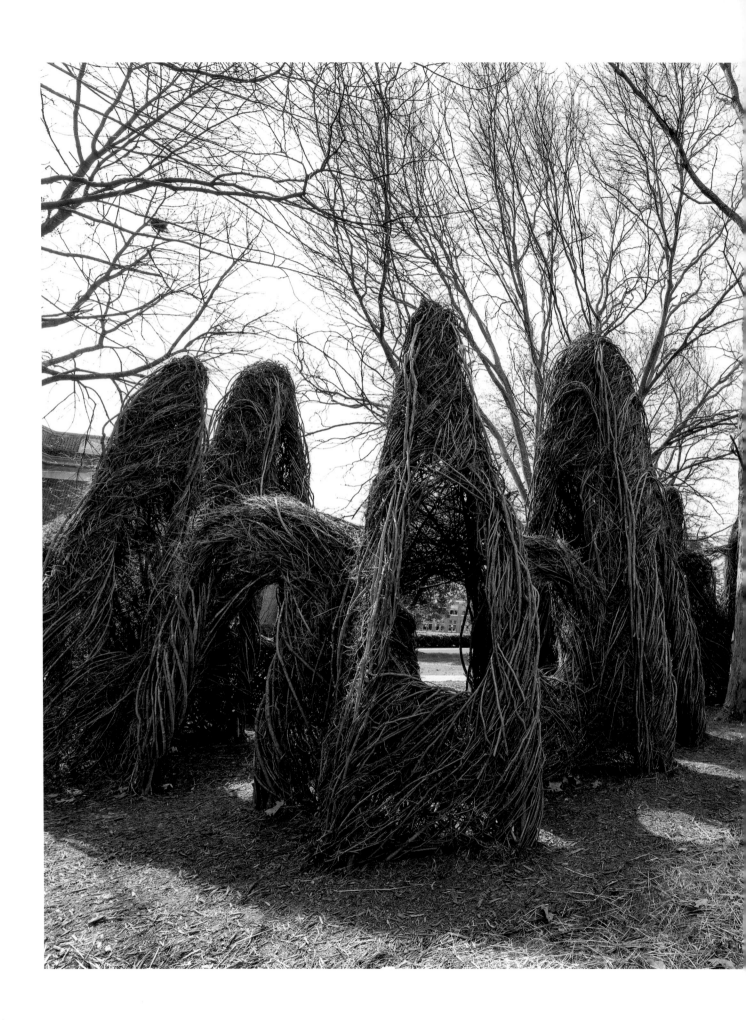

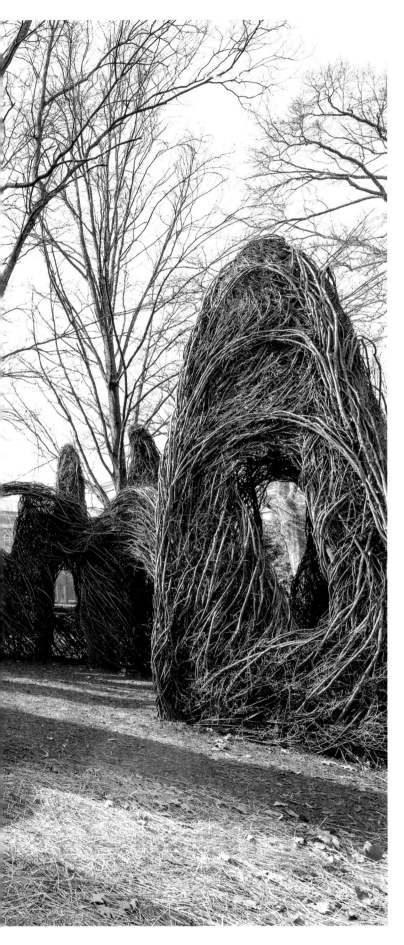

people work on different aspects of it; we're all working fruitfully as a group. Oftentimes, my volunteers say: 'I'm not even sure we needed you.'" He laughs. "That's an illusion they carry because they feel so good about how they worked. And that goodwill translates right into the community at large."

Dougherty, who is married to Linda Dougherty, chief curator and curator of contemporary art at the North Carolina Museum of Art, came into the art world on his own terms, and relatively late. The UNC–Chapel Hill graduate earned an undergraduate degree in English and a master's in hospital and health administration before heading back to UNC at thirty-six to study art. By the early '80s, he was combining his love of nature with his knowledge of sculpture and carpentry to create works made of saplings. From the beginning, he's known he wanted to make art that appeals to "the fine art painter and the house painter."

The first big piece he made as a student, a "mummified-looking thing" made out of "really fine sticks" gathered in his backyard, won a statewide award, got him a show at SECCA in Winston-Salem, and led to residencies, grants, and more awards. Slowly but surely, he was working all over the East Coast. He decided to step onto a wider stage after a visiting professor from Hunter College, the ceramic artist Susan Peterson, told him that it was "just as easy to be a national artist as it is to be a local artist," and that the only difference was "you have to be willing to be in the nation."

"And so," he says, "I've spent the last thirty years being in the nation. . . . And no matter where I go, whether it would be a rural community or an urban community, what I see is that people are intensely interested in a great visual experience. . . . If they see something that stirs them, that speaks to different aspects of the human condition, they're there. They want it, they want to see it, they want to experience it." ∎

The completed *Common Ground* at Davidson College, Davidson, NC, 2020. 60 × 30 × 18 ft. Mixed hardwoods. Photograph courtesy of Davidson College and David Ramsey.

IVANA MILOJEVIC BECK

RALEIGH

When a person moves from a native country to live in a foreign one, they seldom leave the first entirely behind. More often, immigrants inhabit both places, toggling between them, with body, mind, spirit, and culture sometimes in one place, sometimes the other, and sometimes in a third place of their own devising.

Ivana Milojevic Beck, who left her native Serbia as a teenager and now lives in Raleigh with her American husband and young daughter, has turned her bifurcated heart and life into art.

Using the unlikely media of bricks and wax, Milojevic Beck melts, pours, molds, chisels, and forges sculpture that represents her immigrant's duality and commands curiosity. With translucent, delicate bodies and sturdy, structural feet, her work is beautiful but confounding. Art made of wax? Art made of bricks? Art made of bricks and wax? This unlikely combination makes perfect sense in its realization, and perfect sense to its maker. "When you see something in front of yourself that matches how you feel, it's a breakthrough. It's very magical."

Wax in her hands is symbolic of the vulnerable and adaptable body; brick represents durability, place, and strength, "the groundwork" of her life. If one brick is in Serbia, and one is in America, in between is a fluid body, one that can withstand high temperatures, adapt to a mold, melt back again, remold into something new. It is soft and organic and difficult to define. When she made the decision to include some structural support within the wax segments of her work, it was a long-considered, difficult one. She knew the work needed the infrastructure so it could last, but she resisted its symbolism. Then she reconsidered: maybe the addition of cables within the wax was symbolic of something real and important: her own evolution into a person who understands the need for strength within fluidity. "It was a natural progression."

The whole process is organic for Beck. When she pours her melted wax, she lets it set however it chooses, "not trying to force the material to do something that naturally it cannot do." It's important to her that her materials are in all ways natural—wax and brick both products of the earth—and that they are distinctly separate as well as combined in her work (she stirs brick dust into the melted wax in order to strengthen it and create its fleshy color. Making holes in the bricks to create that dust "was the first time I saw the brick vulnerable," she says). Some pieces she sets in molds she makes out of galvanized steel, some in holes in the ground.

When Beck was a child in Serbia, living "a spartan existence" and spending a lot of time at home alone, she had to entertain herself. She recalls looking at herself in her grandmother's mirror as a way to connect with a human face. She didn't know what sculpture was, didn't know that being an artist was

FACING
Ivana Milojevic Beck at her
Raleigh home and studio.

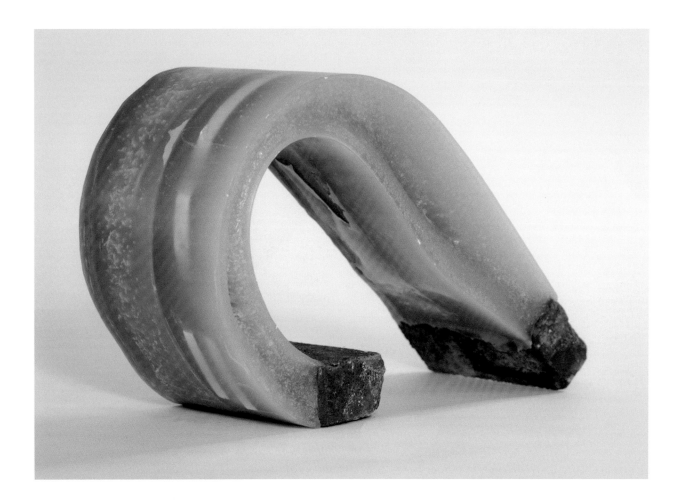

something a person could do. Coming to the United States as an au pair opened up a world she didn't know existed. She went on to earn an undergraduate degree and an MFA from UNC Greensboro, and become a studio artist at Artspace in Raleigh. Her work has since been in several prestigious group shows, and won the International Sculpture Center's top student award in 2016.

Today Milojevic Beck is doing a lot of drawing and considering new ways her work can evolve. On her worktable is the first in a series of horseshoe-shaped forms she intends to stack, one on top of the other, several of them in a tower. She gestures with her hands: "I want to see them on top of each other like a column," she says. "I want to see them my height." ∎

Untitled IV, by Ivana Milojevic Beck, 2016. 22 × 16 × 8 in. Brick, wax, and wire. Courtesy of Ivana Milojevic Beck.

JOHN BEERMAN

HILLSBOROUGH

Before John Beerman paints a landscape, he studies the place that's caught his eye and he picks a particular day and time. Maybe it's a low-lit evening in fall, or maybe it's a morning hour that only exists over a span of days in spring, when the angle and energy of the sun provides a certain glow. And then he goes there, day after day, at that appointed hour, to capture that place and that time, building his painting bit by bit until the moment is over, the hour has passed, the shape of light has changed, that bit of season is gone.

To accompany him on one of these plein air excursions is to realize that Beerman doesn't just look like Monet at Giverny, with his straw hat, his wooden easel, his linen shirt and leather shoes, he *looks* like him, looks out through his own eyes at the natural world with the same kind of reverence, looks at it as if it had a soul, a character, and moods, and nuanced beauty, and he learns it, out of a deep respect, and only then does he paint what only he can see.

"I have always found the natural world a gateway to the greater mysteries and meanings of life," Beerman has said. "I've been back here for ten years, in North Carolina, after thirty, forty years up north. And my appreciation and love of the North Carolina landscape continues to grow. I feel we are so fortunate to be here, in this landscape." At a time when the world faces so many problems, he says, "It's important to see the beauty in this world. It is a healing source."

John Beerman at work on *Chatwood Field,*
Early Morning at Chatwood in Hillsborough.

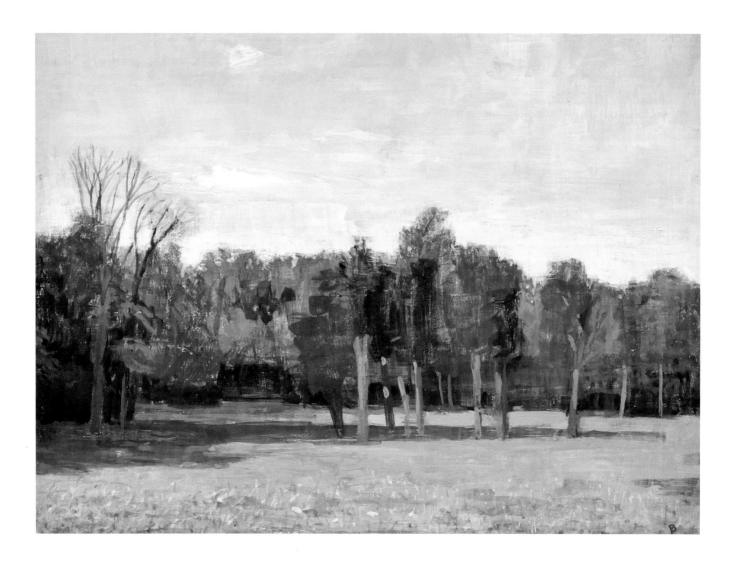

When he arrives at his chosen spot—on this spring morning, a field at Chatwood, the beautiful Hillsborough estate owned at the time by his close friend, the author Frances Mayes—he does it well in advance of his chosen hour, because it takes some time to set up his easel with the idiosyncratic system of clamps and slats he's devised to hold the boards in place that will serve as a perch for his canvas and for the egg tempera paint he's made at home out of pigment and egg yolk and keeps in an airtight jar.

"I've always felt a little bit apart from the trend," he says. "I love history. And one also needs to be in the world of this moment, I understand that. I'm inspired by other artists all the time, old ones, and contemporary ones . . . Piero della Francesca. He's part of my community. Beverly McIver, she's part of my community. One of the things I love about my job is that I get to have that conversation with these folks in my studio, and that feeds me [and the work]." Beerman's work keeps company with some of "these folks" and other greats in the permanent collections of some of the nation's most prestigious museums as well, including at the Metropolitan Museum of Art, the North Carolina Museum of Art, the

Chatwood Field, Early Morning, by John Beerman, 2020. 9 × 12 in. Egg tempera on linen. Photograph by Sara Hecker.

Whitney Museum of American Art, in addition to governor's mansions in New York and North Carolina and countless important private collections.

The paintings that have made his name, celebrated landscapes of the Hudson River, early in his career (he is a direct descendant of Henry Hudson, something he learned only after twenty-five years painting the river), and of North Carolina in later years, and of Tuscany, where he spends stretches of time, share a sense of the sublime, a hyperreal unreality, a fascination with shape and volume, space and light, a restrained emphasis on color, and an abiding spirituality.

Chatwood Field, Early Morning in progress, en plein air, at the Chatwood estate in Hillsborough.

"Edward Hopper said all he ever wanted to do was paint the sunlight on the side of a house," Beerman says. "And I so concur with that. It's as much about the light as it is about the subject." A recent painting of the lighthouse at Nag's Head includes only a looming fragment of that famous black-and-white tower, but it's the glow of coastal sun Beerman has depicted on its surface that makes it unmistakably what it is, where it is.

"With some paintings, I know what I want, and I try to achieve that. And other paintings start speaking back to me." He's talking about another fairly recent painting, of the wide rolling ocean and a fisherman on a pier. As he painted it, childhood memories of Pawleys Island, South Carolina, came into play: "In this old rowboat, we'd go over the waves. And in doing this painting, that came in . . . ahh, maybe that's where I am. Sometimes it bubbles up from memories that are right below the conscious."

Whatever he's painting, Beerman says he's always trying to evolve. "One hopes you're getting closer to what is your core thing, right? And I don't want to get too abstract about it, but to me, that's an artist's job, to find their voice. And even at this ripe old age, 61, I'm still in search of that. And at this time in my life, I feel more free to express what I want to express, and how I want to express it. I don't feel too constrained." ∎

CELIA JOHNSON

CHAPEL HILL

The self-contained shapes and colors that move across Celia Johnson's birch panel paintings seem to speak to one another, to react, to bounce, to move aside or collide on purpose. Sometimes they leave a trail as they go. Sometimes they tell a story.

Like a poet with an arsenal of words, Johnson riffs with a "core vocabulary" of shapes. "I've always been attracted to definite shapes. I took watercolor. I took figure drawing. I did all the academic preparation. But from my childhood, I was always codifying things of different colors and different shapes." She

sorted rocks, marbles, and pieces of bark; she found that Colorforms, those plastic, primary-colored circles, squares, and triangles that kids can stick and restick into endless configurations "made a vivid impression."

Much later, Johnson became inspired by Constructivism, the Russian theory that believed art should literally be "constructed" out of component parts and should reflect and live within the modern industrial world. She also studied the work of the Bauhaus, the early twentieth-century modernist German art school

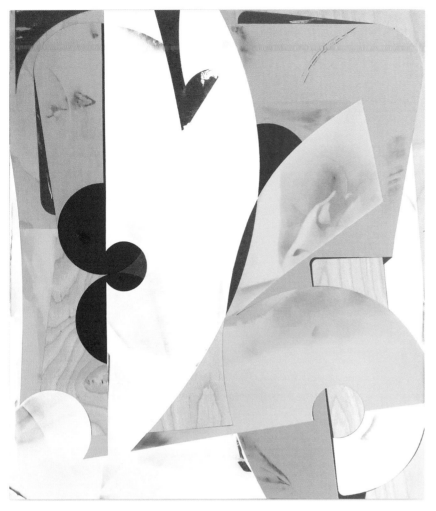

even oblique, but those shapes all mean something important to her. She uses them with a "collage sensibility," a practice that feels innate. Back when she was a graphic designer at Condé Nast, laying out pages for *House Beautiful* in the predigital era, she used a similar process to put together spreads.

Her material these days includes special formulations of gesso and acrylic paint made by Golden, the company that pioneered acrylic paint for abstract expressionists in the 1950s and provided Johnson with one of the many prestigious residencies she's won in recent years. She's also been exhibited widely. A group show at her gallery in New York, Kathryn Markel Fine Arts, was one of three that showcased her work in the mostly COVID-barren art world of 2021.

This recent work showcases the careful precision that has long focused Johnson's creations. "I'm taking these chaotic things and I'm putting them in order," she says. "I know there are many painters who take the blank canvas and throw themselves at it without a preconceived idea . . . but I am someone who is making a puzzle, solving it as I get through it, and finding my way out."

that fused design, craft, and fine art with function (several of whose teachers and students would go on to found North Carolina's own Black Mountain College). But it was when she spent a decade working and studying in Germany that Johnson came upon a source of inspiration that continues to inform her work today. It was heraldry, the system that underlies the creation of coats of arms, flags, and armor. She was immediately drawn to its components and its order, its symbolism and classifications.

At home today, deep in a rural corner of Chapel Hill where she lives with her husband, Donald Martiny, Johnson creates a heraldry of her own. It's subtle,

Lately, she's experimenting with taking the shapes from the surface of her paintings off of it entirely and turning them into independent pieces that can stand alone or form part of a grouping. Birch panels cut to her specifications in irregular shapes hang on her studio wall to "orbit," so she can "let them loose and let them fly around." It can't be long before they come in to land. "I absolutely know that there's a transition from chaos to order" in her work, she says. "That's a bedrock thing for me." ∎

MAYA FREELON

DURHAM

Maya Freelon's tissue paper sculptures are abstract, a confluence of kaleidoscopic color and organic shape. They move with a breeze, the passing of a person, the opening of a door. They make powerful, lasting statements with impermanent, inexpensive materials. Most of all, they are inquisitive. *What is art?* they ask. *What's it made of? Who gets to make it? Who decides?*

The work is about "challenging norms—social norms, economic norms, and art norms—by turning tissue paper into a fine work of art," says Freelon. "It's about the fragility of life, and transformation, and the ability to see beauty in a lot of different things."

Often made in collaboration with groups of people, her work celebrates "the communal aspect . . . the ancestral heritage, the connection to quilt-making in my family and the African American tradition of making a way out of no way." Metaphorically and literally, Freelon's work is a manifestation of its maker: beautiful and forthright, vulnerable but unflinching; lithe, elegant, and defiantly individual.

At Miami Art Week in 2019, she was named one of five young artists to watch. She installed massive, wafting tissue paper stalactites at the Smithsonian Arts and Industries Building in Washington, DC, in 2018. She's lived and worked in Madagascar, Eswatini, and Italy as part of the US State Department's Art in Embassies program. She's collaborated with Google and Cadillac, and her work is in the collections of the Smithsonian National Museum of African American History and Culture, the University of Maryland, and UNC–Chapel Hill, among others.

Freelon's talent and expressive ability were apparent early on, and she comes by both naturally as the daughter of two renowned artists and the great-granddaughter of another. Her mother, the jazz singer Nnenna Freelon, is a six-time Grammy Award nominee. Her father was revered architect Phil Freelon, the architect of record of the National Museum of African American History and Culture on the Mall in Washington, DC. His own grandfather was Allan Freelon, a noted impressionist painter whose work was celebrated during the Harlem Renaissance. Her namesake and godmother was the poet Maya Angelou ("Auntie Maya"), a close friend of "Queen Mother" Frances Pierce, Freelon's beloved grandmother. Angelou once described Freelon's work, which she bought for her own collection, as "visualizing the truth about the vulnerability and power of the human being."

When Freelon was a graduate student at the School of the Museum of Fine Arts in Boston, living with her grandmother Pierce, she came upon a stack of multicolored tissue paper in the basement of the house. The paper had most likely been in the same spot for fifty years. Drips from a leaky pipe had mottled the stack over time, moving the color from piece to piece, turning the sheets into gossamer rainbows. Freelon was transfixed, and soon consumed with turning the water-stained tissue paper into art, and using water herself to mark and alter tissue paper, intent on "making something out of nothing." That discovery, born out of her connection to her family, became her signature medium.

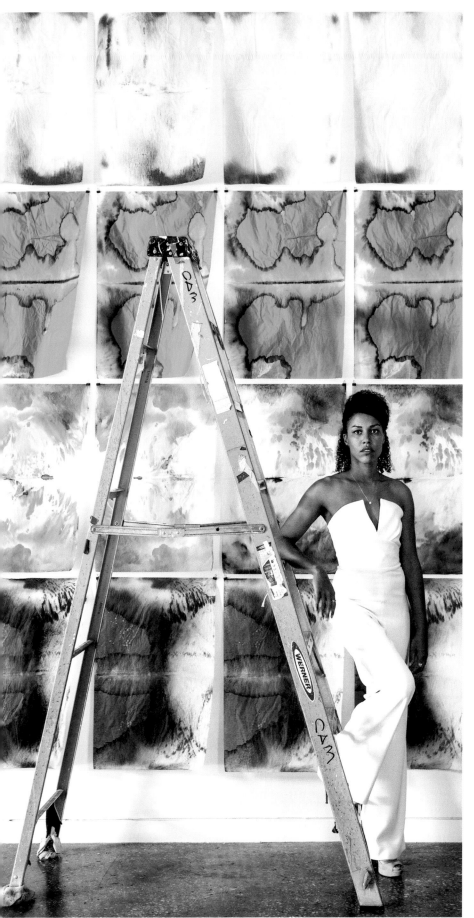

Making something out of nothing is part of the inspiration. "I think of a quote from my grandmother, which is that we come from a family of sharecroppers who never got their fair share," she says. Grandmother Pierce's grandchildren and "every Black person making the world a better place" were "our ancestors' wildest dreams," she also said. Freelon considers: "To have survived what it took to get here, and then slavery, and then segregation and racism—we're living within it, and we're still existing, and now we have a chance to thrive."

Personally, Freelon says she's more than thriving. "I've never felt prouder, or better or more grateful that I took the leap, that all of my focus goes to making art and sharing it with the world. . . . I feel like I'm just getting started." ▪

Maya Freelon stands before a portion of *Greater Than or Equal To*, her solo exhibition at Raleigh's Contemporary Art Museum in 2020.

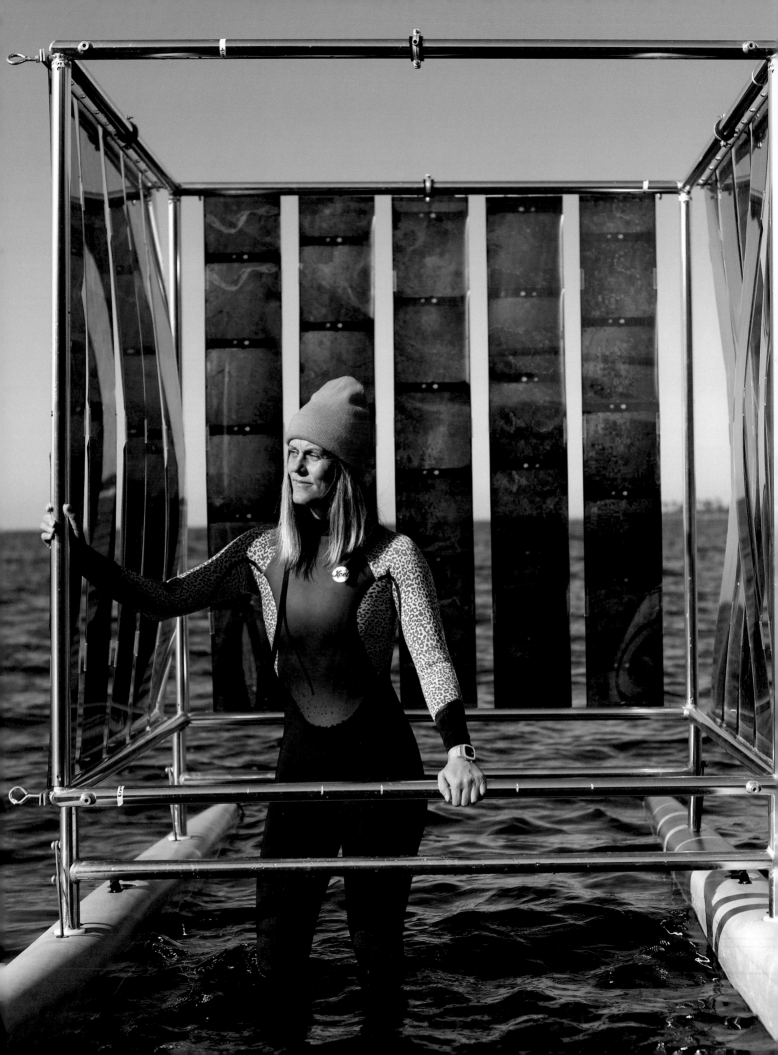

CHAPTER 6

EASTERN NORTH CAROLINA

School's out for summer, but three young high school students are walking the empty hallways of their old Kinston middle school. They're back because they're proud of the art they made in these halls and they're proud of the people they became in the process.

"I painted the girl with the Afro," says Madysen Hawkins, pointing out a larger-than-life figure within a fifty-foot mural. "We are looked down on as being women, and also being Black, and I wanted the little girls here to know that they are somebody that can be heard."

She helped create the mural at Rochelle Middle School in 2018 with fellow students, including K'ala Green and Ja'maya Outlaw, part of a project led by nationally renowned muralist Catherine Hart under the auspices of the smART Kinston organization. The project made her believe in her own creativity, says Green, who plans to become a veterinarian. It also made her proud of her school, where 99 percent

of students are eligible for free lunch. "People think that Rochelle is a bad school, and this showed that we were much more than that."

Founded by Kinston entrepreneur, civic leader, philanthropist, and arts advocate Stephen Hill and administered in conjunction with the North Carolina Arts Council, smART Kinston not only brings arts education to public schoolchildren like these girls, it has used art to breathe new life into the city's once-fading downtown. With Hill's funding, smART Kinston has spearheaded the creation of a twelve-block Arts & Cultural District that includes fifty-four rehabilitated, rainbow-painted, picket-fenced former mill homes, and recruited artists to live in them. It has forged a residency program with Penland School of Craft, commissioned murals and public art throughout downtown, founded an art gallery, and brought art education to the community at large.

FACING
Christina Lorena Weisner with a piece
from her floating *River Cube Project* in
Kitty Hawk Sound.

"He is a visionary," says Rochelle Middle School principal Felicia Solomon. "He is able to stand where there is nothing, and see something. He is able to see beyond what many of us see." Painting the mural at Rochelle made a huge impact on the kids who made it, she says, but it also materially changed the school in lasting ways. "I moved from believing in the power of art to make a difference to actually knowing that power."

Hill himself first understood art's ability to foster change when he took a trip years ago with the North Carolina Arts Council (an organization he has gone on to serve for many years as board chair). The group traveled to Blannahassett Island, a ten-acre refuge in the middle of the French Broad River in the Blue Ridge Mountains, just a bridge-stroll away from the mountain town of Marshall. Funded in part by the arts council, an abandoned old high school there had become studios for twenty-six working artists. As a direct result, galleries, small businesses, more art studios, and tourism had sprung up. "I saw all of these great things that were happening," Hill says. He thought: "Art is transforming this community. Why can't it do the same thing in Kinston?"

Collector

Stephen Hill

KINSTON

Kinston entrepreneur and civic leader Stephen Hill is an avid collector of art, a booster of art, and a believer in the power of art to change lives.

His contributions to the cultural life and economic success of his hometown—including his purchase and restoration of fifty-four former mill houses for artists to live in and his work to create a specially zoned arts and cultural district—have been widely recognized, earning him the Esse Quam Videri Award from Visit NC and the Designlife Award from NC State's College of Design, among many others.

The impact he's proudest of making, though, might be the least visible to a visitor. It's the way that art education supported by the smART Kinston program he spearheaded is changing the lives of the city's children. Because the artists who are given the opportunity to live in the subsidized, refurbished houses of Kinston's Arts and Cultural District agree to work in the city's schools, Kinston kids have the opportunity to learn from working artists.

At Rochelle Middle School, artist Catherine Hart "let [students] express themselves, and it made such a difference," Hill says. "They could voice themselves and be proud of their school and themselves. Art has just changed that school. I want to continue to do that." □

Stephen Hill at Rochelle Middle School with (left to right) K'ala Green, Ja'maya Outlaw, Rochelle Middle School principal Felicia Solomon, and Madysen Hawkins.

Tobacco was good to this once-prosperous city in its heyday; so were cotton and textiles. The decline of all three, coupled with devastating flooding from Hurricanes Hazel, Fran, and Floyd, took a major toll. But the beginnings of a real renaissance have taken place over the last decade, spurred largely by art and the creative businesses that have sprung up around it, and they're not all Hill's. Celebrity chef Vivian Howard's The Chef and the Farmer restaurant—and the blockbuster PBS documentary series it generated, *A Chef's Life*—attracts diners from all over the world.

"It's amazing what art does for a community as an economic driver," Hill says, standing on the rooftop of the O'Neil, the luxury boutique hotel he created in the hull of Kinston's long-dormant Farmers & Merchants Bank building. It's just one of a half-dozen historic downtown buildings he's revitalized in his hometown. Over his shoulder stands Mother Earth Brewing (the nation's first LEED-Gold certified brewery, with local art on every wall and on every label), which he founded with his son-in-law Robert Mooring in 2008. His Mother Earth Motor Lodge and Red Room music venue are around the corner. Behind him stand the seven earthcast tobacco barn silhouettes that make up *Flue* by artist Thomas Sayre, which Hill, smART Kinston, and the North Carolina Arts Council commissioned to honor the city's tobacco heritage.

ROCKY MOUNT, WILSON, AND ENFIELD

Other Eastern North Carolina towns with similar boom-bust histories have also found new life through art. Wilson, once known as "the world's greatest tobacco market," was brought to kinetic life in 2017 when thirty massive whirligigs made by outsider artist Vollis Simpson were moved from his farmland in nearby Lucama to the mostly derelict city center. The North Carolina Arts Council, the National Endowment for the Arts, and private foundations provided funding.

Wilson resident Henry Walston, original chair of the Whirligig Park and Museum, says the idea for the park centered on "creative placemaking," a conscious plan to create an artistic vehicle for economic development. Between its opening and the summer of 2021, Walston estimates the project has sparked more than $50 million in downtown investment and the creation of several new businesses, art galleries, studios, restaurants, bars, and apartment buildings. Whirligig Station, a tobacco warehouse turned apartment building across the street from the whirligigs, rented its ninety-two loftlike units almost immediately upon opening.

The project "really has taken flight," Walston says. He and his wife, Betty Lou, have devoted endless time, energy, and constant warm hospitality not only to the park but to Wilson's creative community, which is booming. "I always said, when we were working on the park, that we could be a poster child for creative placemaking for a town our size," Walston says. "And we are achieving that status."

Artist Elizabeth Laul Healey says it's a vision shared by the creative community. "There's a great communal sense of building back the downtown, a sense of common cause," says. "And all of us artists, especially, support each other."

Celebrated photographer Burk Uzzle may be the best known among them, but he's not alone. California native Healey bought a defunct Amoco gas station across the street from the whirligigs and spent two years turning it into a studio/gallery to make and show her art, which includes larger-than-life figures she calls "Iconostars." Every day, Healey says, she asks gallery visitors where they're from. "Forty percent of them are from out of state," she says. "From Florida to Maine, every single week."

They've read about the whirligigs online or in the *Wall Street Journal* or *Washington Post*. Because Wilson is just about exactly halfway between Florida and New York, it's a good place to make a stop. "I'm getting a lot of that overflow," she says. So are the other artists and shops, including the Selkie, a next-door store and gallery owned by North Carolina artist Amanda Duncan and featuring work of many others.

Barbara White is another beneficiary of and contributor to the scene. The Chapel Hill artist was so taken with the town's emerging creative community and its stock of interesting, affordable old buildings that she bought a handsome but badly neglected 1920s-era corner building a few blocks from the whirligigs and painstakingly renovated it into The Edge, a combination gallery-studio-loft-apartment. The result is so impressive—and the idea of moving just thirty-five minutes east of Raleigh so easy to imagine—that several artists have followed her lead, says Allen Thomas Jr., a lifelong Wilson resident, art collector, and civic leader. "Barb was kind of the beginning." Now, he says, downtown is becoming an at-

Nautilus (from rePiano)

Jeff Bell
WILSON

Jeff Bell takes apart everyday objects, like pianos or rocking chairs, and turns the pieces into sculptures that tell new stories.

When a piece of a dismantled 1911 piano reminded him of the shape of the *Nautilus*, Captain Nemo's submarine in the 1954 Disney film *20,000 Leagues under the Sea*, he was inspired to make his own version, which became *Nautilus (from rePiano)*.

A similar imaginative leap resulted in *ReNautilus*, an elegant and intricate work of art he built for the 21C Hotel in Durham. It started with research, beginning with the year 1937, the year the hotel's Art Deco building was built. He learned that the Golden Gate Bridge was also completed that year, that the Hindenburg Blimp exploded, and that a beautifully illustrated edition of Jules Verne's *20,000 Leagues under the Seas* was published. The resulting work expresses the adventure, duality, and danger shared by all of them.

It was a far cry from Bell's earliest days as an undergraduate artist at UNC Wilmington focused on painting. An internship with a local artist, Al Frega, first opened Bell's eyes to the potential of sculpture, and of art as a profession. "I grew up in Goldsboro and had limited experience being around the arts, even though I always made things and drew, but I didn't really comprehend that a person could be a working artist."

These days he's doing just that, and also involved in the world of art, broadly speaking, as the executive director of the Vollis Simpson Whirligig Park in Wilson.

Meantime, his own work continues to evolve. Most recently, he's focused on letting creativity—not laborious planning—guide his creations. He's doing that by zeroing in on what's most important about a particular work. "I've narrowed my focus in order to become more creative," he says. □

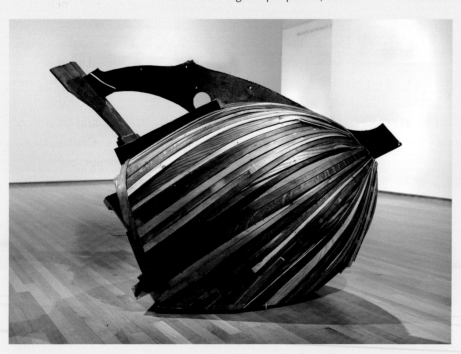

Nautilus (from rePiano), by Jeff Bell, 2014. 60 × 72 × 40 in. Wood and metal. Photograph by J. Caldwell.

tractive place to live. "It's booming. It's legit." He credits the city of Wilson for responding enthusiastically, welcoming artists and helping them find grants to help with restoration.

Also to thank: the new 20,000-square-foot Wilson Arts Center. In a formerly boarded-up downtown department store, the center now boasts 5,000 feet of gallery space that's drawing artists and audiences from around the state. An exhibit of photographs from Thomas's own important collection of photography launched the space in May 2021. "It's a lot of fun" to share some of the work he has collected over thirty-five years, he says; it's also the fourth or fifth time he's shared pieces from his 600-work collection with the city for exhibits over the last twenty-five years.

Art contagion is visible on any short stroll around the Whirligig Park. Just a few blocks away, on the corner of Barnes and Tarboro Streets, a circa 1900 building originally built as a saloon is now an art gallery. Around the corner is the Eyes on Main Street Wilson photo gallery, headquarters for the international street photography festival that began here in 2015 and that every year fills downtown storefronts, walls, and buildings with 100 large-scale photographs of street life around the world taken by photographers from dozens of countries. The festival, described as "bringing the world to Wilson," has been covered in *Vogue Italia* and other international publications, and also runs a National Endowment for the Arts–funded visiting artist program that hosts photographers from all over the world in Wilson year-round. The Walstons have hosted several and now count photographers from Lithuania, Mexico, England, and Australia as friends.

All of this art is a magnet for people and for the businesses that follow. As many as half a dozen restaurants and bars popped up in the space of a year or two, Thomas says—Casita Brewing across from the whirligigs is a hot spot, and so is Bill's Grill a few blocks away on Nash—and others are in the works. "Art and food are really reviving our downtown," he says.

Barton art gallery at Barton College might not be new, but it's getting new attention and energy from Wilson's art boom. The gallery regularly showcases the work of North Carolina artists, including a recent exhibition by William Paul Thomas, and hosts a regular rotation of prestigious artists-in-residence. Its undergraduate art program is considered one of the best small-college art programs in the state.

The formula so successful in Wilson—art plus place equals prosperity—is inspiring to even a small town like Enfield, founded in 1740, about halfway between Rocky Mount and Roanoke Rapids, population 2,500, with a downtown that reflects its late-1800s tobacco-and-peanuts prosperity. Art has brought life to its quiet streets in recent years, mostly thanks to artist Myra Wirtz and her husband, Andrew Wirtz. The couple moved to Enfield from New Jersey in the 2010s, bought a historic house, scooped up the one across the street to serve as her studio and as an art gallery, and bought the town's historic Masonic Temple to turn into a performing arts center. In 2019, artist and curator Charles Philip Brooks helped them put together an exhibit of contemporary art by North Carolinians (including Chieko Murasugi and Ashlynn Browning) in a onetime department store building in downtown Enfield. The show was the first of a series.

Not far away, in the long-beleaguered former textile and tobacco hub of Rocky Mount, a 135,000-square-foot nineteenth-century site of the Imperial Tobacco Company of Great Britain and Ireland was transformed in 2005 into the Imperial Centre for the Arts & Sciences, home to art galleries, community art programs, a children's museum, a planetarium, and community theater. Among the many programs

Collectors

Allen Thomas Jr. and Marjorie Hodges

WILSON AND RALEIGH

Allen Thomas Jr.'s collection of art by living artists, many of them photographers, is widely known for its breadth, depth, and quality. Amassed over the past thirty-five years, the 600-piece-plus collection—one of the state's largest individual collections—has been exhibited in major solo shows at museums including the North Carolina Museum of Art, Raleigh's Contemporary Art Museum, Winston-Salem's SECCA, and the Blowing Rock Art & History Museum, and has been loaned to more than fifty exhibitions worldwide. The collection was bigger before he started giving it away—125 works to the NCMA and others to the Turchin Center for the Visual Arts in Boone and the Taubman Museum of Art in Roanoke, Virginia, among others.

"I don't have a good eye,'" says the Wilson resident. "I just buy what I like." What he likes are works of art that "people can't walk by without a response," he says. "I'm less into pretty things and more interested in strong images."

His business partner, Marjorie Hodges, a longtime art professional and art consultant who has held senior roles at the NCMA and Raleigh's CAM, is similarly inclined. The Raleigh resident's collection includes painting, sculpture, photography, and textiles from the region and beyond. "I think of art collecting as a practice," she says. "I thoroughly enjoy the process of online viewing, studio visits, art fair hopping, and connecting with artists wherever I am in the world. Living and learning from art are two of life's greatest pleasures."

Hodges has lived in North Carolina for twenty years and says the wealth of artistic talent here is more impressive than ever. "Some of the most innovative and compelling artists I know live and work in the state, and are increasingly participating in the global art market," she says. "Talent abounds."

In 2020, Hodges and Thomas, the two longtime friends, launched an online platform and marketplace for artists and collectors called Artsuite. With a roster of artists including many North Carolinians (for example, Barbara Campbell Thomas, Beverly McIver, Donald Martiny, Jeff Bell, Peter Glenn Oakley, Thomas Sayre, and William Paul Thomas), Artsuite's goal is to demystify art, advocate for artists, and connect people with art. □

Business partners Allen Thomas Jr. and Marjorie Hodges at Thomas's Wilson house in front of his large-scale painting by Raleigh artist Corey Mason.

sponsored by the city-owned Centre are three annual national juried exhibitions. The Sculpture Salmagundi is a national outdoor sculpture competition that results in a yearlong exhibition; the Juried Art Show is a national multimedia exhibit installed every year from May to August; and Handcrafted focuses on art made of craft materials for a show that's up from January to April every year.

Not long after the Imperial Centre was complete, plans to turn the derelict 150-acre campus of Rocky Mount Mills into a work-play-live complex began to take form. The 1818 cotton mill and adjacent sixty-odd mill houses on the Tar River had been abandoned for nearly twenty years before the Capitol Broadcasting Company, owned by the Jim Goodmon family, bought and overhauled the campus, turning it into apartments, office space, event space, a tiny-house boutique hotel, a beer brewery incubator, and dozens of rehabbed mill houses that were fully occupied in no time.

Bessie Coleman

Richard D. Wilson Jr.

GREENVILLE

Bessie Coleman, by Richard D. Wilson Jr., 2015. 24 × 26 in. Pastel on archival sanded pastel paper. Courtesy of Richard Wilson.

"When I first started painting, I wanted to put out positive Black images, because whenever I looked at the paper I always saw the negative side," says Greenville artist Richard D. Wilson Jr. "Especially with children, if they keep seeing that stuff, they will believe that's all they are, or that's all they can be. I wanted to put out there what I knew was true about my community."

He also wanted—and wants—to educate people, and not just children, about the proud legacy of Black heroes from the past. In his Shadow series of paintings and pastels, Wilson depicts young Black children standing beneath ("in the shadow of") these people, among them Barack Obama, Muhammad Ali, and Michael Jordan. He also paints lesser-known heroes like Lee Elder, the first Black American to play in the Masters golf tournament; Jack Johnson, the first Black American world heavyweight boxing champion; and Bessie Coleman, the first Black American woman and first Native American to hold a pilot license.

"All through school, I heard about Amelia Earhart, but I never heard about Bessie Coleman," Wilson says. Born in 1892 to a family of Texas sharecroppers, Coleman "taught herself a whole new language, French, because she was denied [flight school] education in America," Wilson says. With the encouragement of Robert Abbott, the publisher of the Chicago Defender newspaper (whose chronicles of her achievements and untimely death provide the background of Wilson's painting), Coleman earned her pilot's license in France.

For most of his life, Wilson has been driven to draw and paint people who inspire him. Growing up in Robersonville, NC, he was encouraged by his artist father (who worked as a clothing-pattern maker, sign painter, and math teacher) to develop his talent. For many years, Wilson juggled a burning desire to paint with school and a series of unfulfilling jobs that paid the bills. The difficult decision to paint full time has led to a more successful career than he could have dreamed, he says today.

"I've never looked back." □

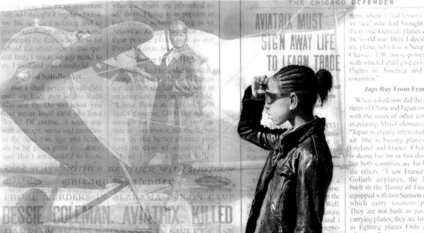

EITHERWAY

Gabrielle Duggan

GREENVILLE

Gabrielle Duggan was pursuing a fashion degree when she realized that her longtime fascination with textiles could become a wellspring for an art career instead.

Textiles had captivated her since she was a child. "I remember staring at the back of my mom's couch, saying 'How did that thread go under and then over, and then under that other thread, thousands of times? How did this happen? How is this something nobody's talking about?'"

When she learned how fabric was woven, "it felt like the foundation of the universe . . . it showed me that the world is held together in suspension . . . by this potential energy of intertwining and twisting things so that they are not allowed to fall apart. You build up this tension, and then lock it in place."

This interest has only grown through her art, inspiring her to spin giant, magnificent spiderwebs; to weave intricate woven images; to bind geometric steel shapes with gossamer threads and suspend them in midair. These category-defying creations refer to the tension between opposing forces, the ways those forces define each other and the dynamics between them. They are beautiful and abstract and also "reflect social, political, and historical implications of power," Duggan says.

At NC State, where she earned a master's degree in art and design, Duggan explored what she describes as the "deep-rooted connection between looms and computers,

and technology and coding, and of course patterns, and math, and music." Since then, her work has been exhibited extensively in solo and group shows across the Southeast. Currently a professor at East Carolina University's School of Art and Design, Duggan has created several public works and won many grants and awards.

Her interest in fiber and its potential seems inexhaustible. Duggan grew her own cotton at one point and spun her own yarn, "working from the fiber up," as she says. "I just dug in. I wanted to understand everything."

In the fall of 2020, she created a 300-foot-long temporary woven outdoor installation called EITHERWAY across an "off-shoot of an off-shoot" of the Tar River on Tuscarora land outside Greenville. She used simple crochet techniques to connect strands of a surplus ballistics textile called DSM Dyneema across the water from her floating kayak below, spelling out the word "eitherway" as she went. It stretched and dipped and fell in parts. The word, even in its imperfection, reflected for her the resilience required by the pandemic, the sentiment that "we will survive this either way."

Water is an important part of this piece and many others, she says. "There's a lot that I'm fascinated about with water," especially the phenomenon of surface tension. The place where a mass of air meets a mass of water, she says, is particularly interesting: "It is not a finite point." □

EITHERWAY, by Gabrielle Duggan, 2020. 40 × 300 ft. Surplus ballistics textile. Photograph by Kevin Cirnitski. Courtesy of Gabrielle Duggan.

GREENVILLE, FAYETTEVILLE, PEMBROKE, WILMINGTON, AND THE OUTER BANKS

Farther toward the coast, the city of Greenville has long known the importance of art. With a growing reputation as one of Eastern North Carolina's cultural hubs, Greenville is home to East Carolina University and its respected art department and MFA program, founded by Leo Jenkins, the school's sixth chancellor.

It's also the site of the Greenville Museum of Art, founded in 1960 by a local group determined to foment and support the arts in the East. Spurred on by Greenville native Robert Lee Humber, who'd been instrumental in founding the North Carolina Museum of Art, the group was inspired to create their own arts appreciation society. That society went on to purchase a historic home and found a museum. Today it boasts the world's largest public collection of watercolors by American artist Andrew Wyeth, a significant collection of paintings and prints by contemporary artist Jasper Johns, an important collection of North Carolina pottery, a gallery devoted to the work of beloved twentieth-century North Carolina artists Francis Speight and Sarah Blakeslee, and a survey of American art from colonial times to the present.

Another notable small museum is farther south in Fayetteville, where Methodist University's David McCune International Art Gallery has exhibited the works of Rembrandt, Andy Warhol, Marc Chagall, and Pablo Picasso, in addition to that of students and North Carolina artists.

About forty-five minutes farther south in Robeson County is Pembroke, considered the cultural, social, and political home of the Lumbee Tribe. Recognized as North Carolina's largest tribe with more than 55,000 members, the Lumbee have long-standing art traditions celebrated by contemporary artists like Alisha Locklear Monroe and by UNC Pembroke's Museum of the Southeast American Indian, which was founded in 1979 with a mandate not only to preserve Native American culture in the region but also to "encourage American Indian artists and crafts persons."

The art department at the university has a similar mission. Billed as the only state-supported university in the United States created "by American Indians for American Indians," UNC Pembroke was founded in 1887 near the banks of the Lumber River, which gives the tribe its name.

Eighty miles farther is Wilmington, home to the Cameron Art Museum, widely considered the premier museum in Eastern North Carolina and one of the most important small museums in the state. Housed in an elegant 2002 building designed by groundbreaking architect Charles Gwathmey on land donated by the family of Bruce B. Cameron and Louise Wells Cameron, the museum, originally founded by volunteers in 1962, has a commitment to showcasing and collecting the work of North Carolina artists as well as artists from around the world.

Outdoors alone, the Cameron has one of the state's few public sculptures by Mel Chin, a work called *The Structure of Things Given and Held*, a Vollis Simpson whirligig, and ceramic tile seating by famed Little Switzerland–based ceramic artist and painter Tom Spleth. Other important North Carolina artists in the museum's collection include renowned Asheville-born, New York–based painter Donald Sultan, Penland-area basket maker Billie Ruth Sidduth, and deceased groundbreaking twentieth-century artists including Romare Bearden, Minnie Evans, and Maud Gatewood. In 2021, the Cameron Art Museum installed a significant exhibition of the works of Davidson's Elizabeth Bradford, and commissioned Durham's Stephen Hayes to create a life-size bronze monument to the United States Colored Troops who fought in the 1865 Civil War battle of Forks Road on the site of the museum.

"We have no parent institution, we are not state supported. We are community owned," says Director Anne Brennan, a Wilmington native. Philanthropic support from the Bruce Barclay Cameron Foundation has always been a cornerstone, she says, but additional philanthropic support is vital. "We're built by the community and sustained by the community," Brennan says. "It keeps us, without question, accountable to our region. We have got to be in service, we have got to listen and act, or we're gone."

The fact that the Cameron is in fact alive and well speaks highly for Wilmington's legacy as a place that has long valued the importance of art in many forms. The city has its own symphony, the Wilmington Symphony Orchestra, and boasts one of the country's few NPR member stations that are wholly community supported, unaffiliated with a college, university, or public television station.

There's a frontier spirit behind these community-generated institutions, Brennan points out. "Wilm-

Waiting for Author

Cynthia Bickley-Green

GREENVILLE

Cynthia Bickley-Green's art mines the worlds of neurobiology, geometry, and the visual phenomena that reside within the eye. "The visual field is not necessarily out there," she says. "It's in your head."

Examples that fascinate her include floaters, or slowly-drifting shapes that move across a plain of vision, or the swiftly moving, tiny white dots that sometimes whiz past before a bright blue sky.

"I feel that elements of entoptic imagery show up in . . . painting from abstract artists," she says. Bickley-Green spent a couple of years painting "what you see when your eyes are closed," but the resultant black paintings

didn't work as well as she'd hoped. So she took the entoptic forms and combined them with the hues she'd explored as a member of the Washington Color School group of painters in the late 1960s and early 1970s.

Her work is also inspired by sound. "Our visual perception is linked to our hearing," she says. Birdsong is something she sees in her mind's eye; music, is, too. "You can listen to some loud, loud music, and close your eyes, and then listen to some classical music and close your eyes. And I think that you will find you'll see a different movement in that . . . sparkly field you see when you close your eyes."

Bickley-Green's paintings have been shown in more than 100 exhibitions and are in public collections including those at the Corcoran Gallery of Art in Washington, DC, and American University. She is the author of the book *Art Elements: Biological, Global, and Interdisciplinary Foundations*, has been a professor of art at East Carolina University for nearly thirty years, and has received grants from the National Endowment for the Humanities and the NC Arts Council. □

Waiting for Author, by Cynthia Bickley-Green, 2014. 42 × 42 in. Acrylic paint on canvas. Courtesy of Cynthia Bickley-Green.

ington is more like an island, the way the Cape Fear River and the ocean define our spit of land. And so it's really made our thinking [similar to] the way island people think," she says. Until I-40 was extended to the coast in 1990, "We were cut off from other parts of the state, and that makes us very scrappy people," Brennan says. "On islands, whatever it is that you choose, that you value, that you want for your community, you've got to make it yourself. And I hope that we don't lose that." The resources that spirit has built are important factors for the area's economic health and growth, she points out. "It's not just proximity to the beach" that inspires people to move to Wilmington, she says; it's proximity to culture, too.

If North Carolina's coast provides an inspiring setting for the appreciation of art, it's also ideal for the making of it, Brennan points out. "This has always been a great place for artists to work. It's been relatively low cost," she says, and "the muse is here."

Chemical between Us

Alisha Locklear Monroe

LUMBERTON

Artist Alisha Locklear Monroe, who works primarily in acrylic, describes herself as a proud member of the Lumbee Tribe. She shares her cultural history not only through her work, which uses abstraction and symbolism to reflect her individuality as well as her heritage, but also as museum educator at the Museum of the Southeast American Indian at UNC Pembroke.

"I love advocating and representing," she says. In 2012, Locklear Monroe cofounded the River Roots Arts Guild to promote fellow artists from Robeson County, the home of the Lumbee people and the place she was born and raised. She also launched a seasonal marketplace for local artists.

As devoted as she is to promoting her fellow Lumbee artists and preserving the Lumbee culture, Locklear Monroe says when it comes to her own art, she wants it to stand on its merits.

"I want to be valued as an artist first, and then for my message," she says. She's been drawing since she was a child but didn't think of herself as an artist until she was a freshman at UNC Pembroke and was encouraged to paint from her own imagination, rather than replicate something she'd seen before. "That was the moment that turned things around for me," she says.

Today her art reflects both her imagination and her culture. "I'm committed to being a keeper of history and a communicator of that history," she says. Many of her fellow local artists feel the same way, she says, but it can be difficult to get that message out. "Our Native artists, especially in Robeson County, feel like we don't have an outlet, a place or a platform, outside of the museum [of the Southeast American Indian]," she says. "It can be really frustrating. . . . Native southeastern art is lost to many people."

For her part, Locklear Monroe has found a wider audience, exhibiting her work throughout the state, including at the Center for the Study of the American South. She has won the award for Best in Contemporary Artists at the NC Tribes Unity Conference, and her work is in the collections of UNC Greensboro and UNC Pembroke. □

Chemical between Us, by Alisha Locklear Monroe, 2018. 24 × 36 in. Acrylic. Courtesy of Alisha Locklear Monroe.

233

February Window

Sue Sneddon

SHALLOTTE

When Sue Sneddon was a child growing up in Boston and wanted to understand how nature worked, she drew it. For the rest of her life, nature's mysteries had her in their thrall, and art remained her response. Sneddon spoke at length about her art and her life in an April 2021 interview. She died in January 2022.

Her paintings of sea and land and the places they join are reverential. Photographically realistic but also dreamlike, they capture the light as tangibly as they do the water; somehow, temperature, smell, and sound are in there, too. She began *February Window* on Emerald Isle in 2018, at a moment when "Emerald Isle did its emerald green thing, right out[side] my bay window of the third floor of the cottage. And I just sat there and did one pastel after another, and took notes."

She took notes and sketched on Emerald Isle for more than forty years, several weeks at a time, usually around the September equinox. She chose it as the ideal place to paint after traveling to every coastal town in North Carolina in the late 1970s. The state had originally lured her during childhood car trips down to the beaches of South Carolina with her family. "I had to be awake when we went through North Carolina," she says, "because the tobacco barns fascinated me, the fields and the trees." The feeling never left her, and as an adult, she made the state her home.

Her fall stays on Emerald Isle were pilgrimages. Because it sits on the east-west-oriented barrier island of Bogue Banks, Emerald Isle's beaches face south. "The light on the water, especially for an East Coast beach, is just different," Sneddon said. "You get to see the sunrise and the sunset standing in the same spot, especially at equinoxes."

For many years she made the trip from her longtime home in Durham; in recent years she lived in the equally beautiful Shallotte but still made the trip to Emerald Isle every September to paint and to teach.

"It's the beginning of a creative process for me," she says. That process was highlighted by an annual sunset swim in Bogue Sound on the date of the equinox. "I go in, usually up to my chin . . . and physically watch the season change." Instead of setting over the mainland, the sun at that moment goes down behind the bridge to Emerald Isle, on its journey toward the ocean side. "It's a physical feeling. We're moving to another place in the sun."

Her ability to capture that visceral connection and communicate it in paint is what fueled her career. Sneddon had solo exhibitions at galleries throughout North Carolina and South Carolina, including fourteen over twenty-five years at Durham's Craven Allen Gallery. □

February Window, by Sue Sneddon, 2018. 30 × 24 in. Oil. From the collection of Donna Nicholas, Edinboro, Pennsylvania. Courtesy of Sue Sneddon.

It would be hard not to find that muse along the inland shores or on the unspoiled beaches of North Carolina's Outer Banks. On nearby Bald Head Island, artists from all over the world vie every year for residencies at the island's No Boundaries International Art Colony. Housed in three historic cottages that overlook the state's southernmost coast, this rotating group gathers to make art and exchange cultures and ideas for two weeks every November. While they're there, they create pieces for a group exhibition at the Wilma W. Daniels Gallery on the campus of Cape Fear Community College and collaborate with the UNC Wilmington Department of Art and other organizations.

Another group welcoming artists from all over is Pocosin Arts School of Fine Craft, which stands on the banks of the Scuppernong River just before it reaches Albemarle Sound.

Founded by Feather Phillips in 1994 to "connect culture to the environment through the arts," Pocosin plays an important and growing role in the art ecosystem of Eastern North Carolina. As Penland does in the mountains, Pocosin on the coast offers year-round artist residencies, workshops, classes for all ages, and a teaching studio and art gallery in nearby Columbia, which carries a large number of paintings by Sue Sneddon.

The school began a significant campus expansion in 2021 to build a gallery and expand studios for more and bigger classes and workshops, reflecting a growing number of artists in the region and more people of all ages interested in art and art education. No doubt it also reflects the "muse" that the Cameron Art Museum's Anne Brennan cites: the area's unique coastal beauty, an inspiration as old as time.

It was enough to make a painter out of North Carolina writer and Wilmington resident Clyde Edgerton, the author of ten novels and a Guggenheim Fellow known fondly as "North Carolina's Mark Twain."

"When you're in a place near the ocean, or perhaps the mountains, something happens that is so deep you can't understand it," Edgerton says. "A lot of people want to go one step beyond just appreciating it . . . to creating something that resembles what you see, so that you can maybe get at what you feel."

CHRISTINA LORENA WEISNER

KITTY HAWK

Christina Lorena Weisner assembles her sculptures, zips up her wetsuit, and wades into the March-cold waters of Kitty Hawk Sound. It's barely six A.M., the sun's not fully up, the air's barely forty degrees, and the art she's wrangling is bigger than she is, but Weisner takes it all in stride. The next thing you know, she's glided fifty yards from shore and her art's floating all around her.

It makes sense that this sculptor and installation artist is at home in the natural world, that she's unperturbed by cold water, early mornings, and ungainly physical feats. A former competitive swimmer and beach lifeguard, her work taps into the intersection between people, objects, and the natural environment, illuminating the way we live within the world and the way the world lives with us. The largest of the

three sculptures bobbing beside her on this morning is the one she attached to her outrigger kayak and towed 275 miles down the Eno and Neuse Rivers and through the Ocracoke Inlet in 2019, recording audio-visual information and environmental data (including a panther sighting) along the way.

A Richmond, Virginia, native, Weisner says she can trace the beginnings of her work as an artist to a job she had with Nag's Head Ocean Rescue in her early twenties. When she wasn't saving swimmers, she stared out at the ocean for ten hours a day. "I would watch the sun move across the sky, the moon come up, and you just become very aware of these bigger processes . . . these large-scale movements, like the waves coming over from the coast of Africa . . . that we're not often aware of."

Other little-seen influences in her work come from her wide-ranging education (which includes an MFA and separate undergraduate degrees in both world studies and fine arts), and include the relativity of time, the metamorphic properties of natural elements like silica, and "the interesting phenomenology" of Tibetan Buddhism, including its appreciation of the "fullness and emptiness of forms."

From her home in Kitty Hawk, Weisner rides a bike or runs along the beach every day to note its transformations. "It's the same beach, but it's completely different, the water color, the form of the waves, the temperature of the wind." Sometimes she finds objects to incorporate into sculpture as she goes, like the discarded beach chairs that form the two smaller works with her in the water on this day.

Waves and wavelengths—audio, seismic, and light—all inspire her. The Nördlinger Reis meteor impact crater in Germany was the subject of sculpture and installation art she created with the Fulbright Grant she was awarded in 2013; she used seismometers to record earthquakes as part of a Mint Museum installation in 2018.

Her approach with every subject, she says, is to embrace what she doesn't know, and to let her new knowledge as well as her material—which is sometimes composed of found objects and scientific instruments and sometimes is the landscape itself—to guide her.

"I'm still a process-oriented artist," she says, one focused on "openness to material and play, not taking my work too seriously . . . and not being too pigeonholed." She thrives when she can employ all her senses in the making of her art, especially work that involves nature. "It's super important for me to use my body to understand the landscape," she says. "I ride my bike, and run, and hike, and walk the whole thing as a way to understand the space. I always think about embodying kinesthetic experience, learning through moving your body . . . and it's magnificent." ∎

FACING
Christina Lorena Weisner with works from her floating *River Cube Project* in Kitty Hawk Sound.

BEN KNIGHT

DEEP RUN

Ben Knight is not an abstract expressionist. His paintings, he says, are not abstractions. They are realistic: "realistic expressions of emotion."

These range, clearly, from rough and furious to placid, from inward and muddy to bright and engaging. "The effect that my day has on my emotions, and how I choose color . . . is very intuitive, but also very intentional," he says. "I'm drawn to certain colors in certain moments on certain paintings at certain times because they have an emotional context."

Knight credits renowned abstract painter Larry Poons, with whom he studied in New York, with

"setting something loose for me," for helping him tap into the fluidity and intuition he already had as an athlete. As it did on the basketball court, it began on the canvas with speed. "He'd say faster, faster, more color, faster. It allowed me to use my instinct and my eye."

Now an established working artist, Knight has time to explore color, technique, and tempo in the modernist studio behind his family house that sits deep in a Deep Run soy field.

It's all a long way away from Knight's Chicago childhood. A self-described "jock" growing up, he

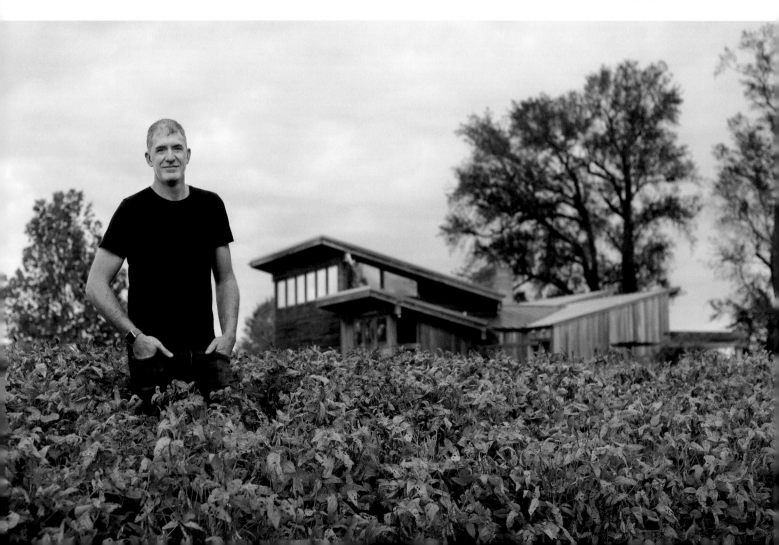

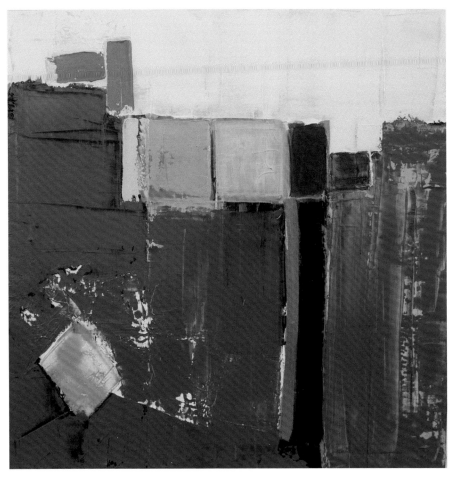

but he doesn't think of them that way. They're more like siblings, relatives that share some, but not all, essential DNA. The first time Knight took on multiple paintings at once was with three works called *The Hand*, *The Heart*, and *The Eye*, a reference to daily Jewish prayer, "connecting hand, head, and heart three times a day to center and focus yourself."

Other titles for his work come to him less directly, applied to various paintings after the fact. A wall of his studio is covered with these Sharpie-scrawled phrases and words: "Uncooked Soul" and "Light Don't Think" are checked off. Among the dozens still up for grabs are "How's It Tasting" and "Chopped Liver Man."

If the titles are haphazard, the painting is not. An underlying geometry is at work, scaffolding what he describes as a "thick and chaotic" surface. It's a practice inspired in part by the abstract expressionist Barnett Newman, who described painters as "choreographer[s] of space" and used a vertical band of color he called a "zip" to focus and unite a canvas and its viewer.

Knight is also fascinated by the interaction between viewer and canvas, by what a painting becomes when it is beheld. "As I work now: what is the intent or the emotion that I am leaving for people to feel? That's the next thing I'm very interested in. Combining this idea of putting emotions on something through color, and then documenting what viewers think." ▪

was also immersed in art thanks to his artist grandmother, who picked him up after school every day and took him to the classes she taught at Lake Forest College and other schools. But it wasn't until Knight became an English major in college that he tapped into his own creativity. Jack Kerouac's *The Subterraneans*, in particular, made a huge impact. "I got very into that book because I loved the spontaneity of it," he says. "And I think more than anything, that really influenced how I make art."

He does it in fast bursts, three or four canvases at a time on his working wall, and paints them simultaneously, most often with a wood-handled Venetian plaster knife he found in a local hardware store. Occasionally, he uses a brush. The result is series-like,

SEPTEMBER KRUEGER

WILMINGTON

With subtle, watery colors, delicate stitching, layered images, and the unexpected juxtaposition of organic and designed shapes and lines, September Krueger's intricate quilts and silk paintings celebrate nature, birds and plants, and the environments they share. They are the work of an artist with a deep, sensory appreciation for her subject and her medium.

From an early age, Krueger loved to draw. She studied textiles as an undergraduate in Philadelphia with the idea of becoming a fashion designer, but her graduate work at East Carolina University opened her eyes to the potential of textiles as an artistic medium, and inspired her to "develop layers of information on woven cloth."

A kimono she made at ECU was the turning point. She was on familiar ground when it came to the sewing and structure of the garment but found herself pulled in a new direction with the fabric itself and the stories it told. "All of the motifs were of cloth that had been batiked, and all of the batiked imagery... related to religion, which comes up a lot in thinking about myself and my family." From that point forward, function took a back seat. "Wearable became less and less important."

She uses silk and other fluid fabrics in her work today, enabling her to "build up the surface in so many ways, almost like a collage artist," often repeating motifs like a small bird or a leaf. These also show up in her finely wrought woodblock prints, which mine much of the same territory of the natural world.

September Krueger with one of her quilts in Wilmington.

Krueger's community focus goes beyond Wilmington. In Kinston, she and Anne Brennan (the executive director of the Cameron Art Museum and a fellow artist) designed tile mosaics—inspired by the work of iconic North Carolina artist Romare Bearden, and created together with the young women of a community development organization called The Gate—for installation in Kinston Music Park.

And her work as head of the art department at Southeastern Community College takes her to Whiteville, North Carolina, regularly. "I found a community immediately here in Wilmington, between the university and the community college. I found that there are outstanding artists in our community college system. And I also met people who were at different stages of life and were going back to study and figure out what they might want to do. . . . Art connects them all." ▪

Central to Krueger's artistic calling, she says, is an instinct to share it, and use it to build community. As director of lifelong learning at Wilmington's Cameron Art Museum, one of her central goals is to open the museum's offerings to new populations. Paradoxically, she says the pandemic might have helped with that effort, because people who might not have taken themselves to the museum in person to see an exhibit in ordinary times have been compelled to visit virtually. "Having shifted some of those barriers that people may have had about the museum" as a place that might seem intimidating, "it would be wonderful" to have them become a regular part of its educational and artistic community, she says.

The Wren Would Be King, by September Krueger, 2010. 12 × 19 in. Machine embroidery on silk paper. Photograph by Curtis Krueger.

BURK UZZLE

When Burk Uzzle opens the double red doors of his studio, gallery, archive, and home in downtown Wilson, North Carolina, it's impossible not to feel as if you're being let in on a wonderful secret. It's not just the realization that one of America's most accomplished and celebrated photographers is right here, living at the center of this former tobacco town, or the surprise of seeing his iconic historic photographs and striking new ones on the walls.

It's that he is so disarmingly informal, so charming in his flat cap, wool vest, and jeans, so willing at eighty-one to leap upon a waist-high platform for a portrait, to frankly discuss his inspirations, to dig into his archives, to describe at length the ways he uses lighting and state-of-the-art digital tools to refine the large-format photographs he prints himself, "making it feel dimensional and tactile."

"It's all theater, so I usually pump the theater," he says. "I'm not a believer in very quiet, passive, uninteresting colors." Or days. Uzzle rises at 4:30 every morning to ride his mountain bike outside for an hour, "getting a hell of a workout and looking for

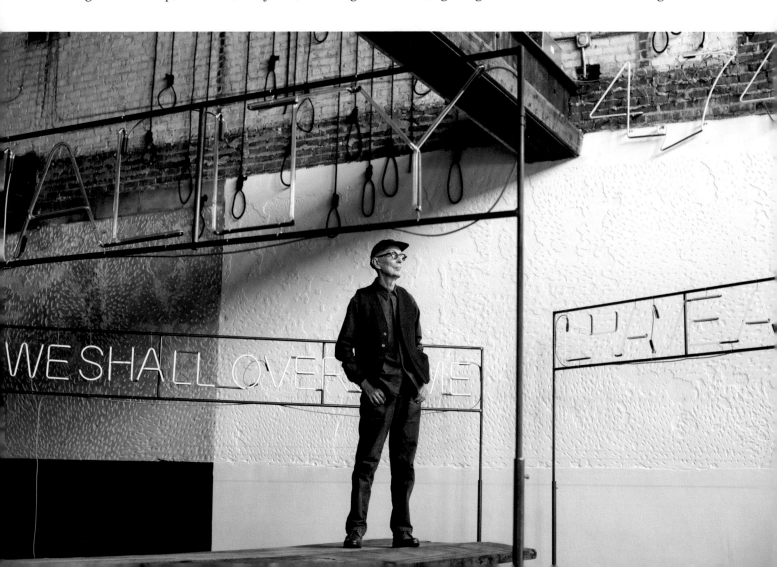

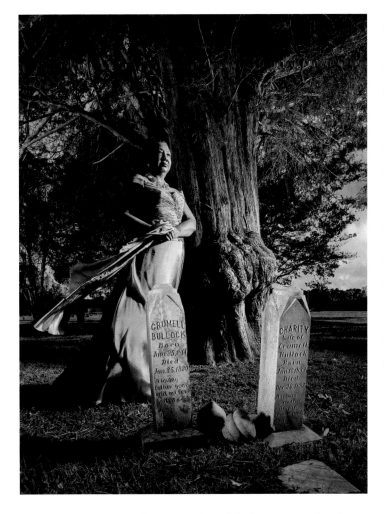

unforgettable photo of the young couple embracing under a blanket at sunrise amid a sea of bedraggled bohemian concert-goers on the cover of the *Woodstock* album is his. The indelible picture of Martin Luther King Jr. in his casket, published on the cover of *Newsweek* magazine the week he died, is also his. Mentored by Henri Cartier-Bresson and a longtime member of famed photographers' cooperative Magnum Photos, Uzzle for decades captured memorable American images of urban and rural life: politicians, farmers, athletes; parades, peace protests, places.

He's a master of composition and of light—he says his best lessons have come from museum paintings—but his photographs have something bigger at their core. In his words, "a big heart and a strong eye."

An expansive frame of reference doesn't hurt. "Photography's more like music than it is like anything else," he says. "Good photographs are an opera. The ones that really work have a narrative, as an opera does, and then they have the structure, the drama, the visual, and the music. A combination of a lot of different components that come together to make a form."

After decades spent around the world making operatic photographs, Uzzle made the decision in 2007 to return to his home state to document life here now. Some of that work takes the form of the images he spots on those early-morning rides—landscapes that tell stories, everyday people going about their lives—and much of it takes the form of portraits he creates to draw attention to the remarkable individuals he encounters and the difficult issues that grip him most: gun violence, rural poverty, racial justice, and Black lives.

"It's taken me a lifetime to understand how important it is to do this," he says. "When I die, this will be my signature work in North Carolina." ∎

pictures at the same time," before returning home for yoga. After that, he works "like a sumbitch in the studio all day."

The conjoined city buildings he's made his own had previous lives as a car dealership and a coffin factory. It's doubtful they've ever seen industry quite like Uzzle's.

A staff photographer for the *News & Observer* at eighteen, Raleigh-born Uzzle became *Life* magazine's youngest-ever staff photographer at twenty-three and made his name documenting the youth culture and civil rights movements of the 1960s. That

ROBERT B. DANCE

KINSTON

When Robert B. Dance was a high school student in Kentucky, he had his own radio program. He was talkative and outgoing, interviewed musical guests, played the guitar and ukulele, sang, and thought he might have a full-fledged career in the music industry. Instead he became one of the nation's leading nautical artists, his work exhibited in the Great Hall of the Smithsonian, at the North Carolina Museum of Art, and in the nation's foremost gallery for marine art, the Maritime Gallery at Mystic Seaport. Dance's painting of the Cape Hatteras lighthouse became the nation's first National Park stamp; our state's own Maritime Museum opened with an exhibition of his works; and twenty years ago, our Southeastern Center for Contemporary Art installed a twenty-year retrospective on his career.

He says it was a love of art and the natural world that combined to turn his life's focus to painting. A courtly gentleman, Dance describes himself these days as quiet and introspective, but he welcomes visitors to his Kinston home studio with the energy of the teenage radio personality he once was,

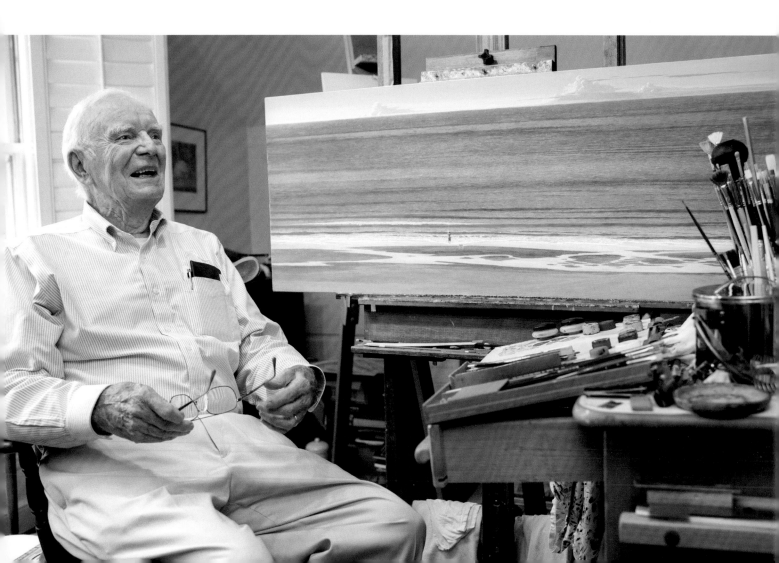

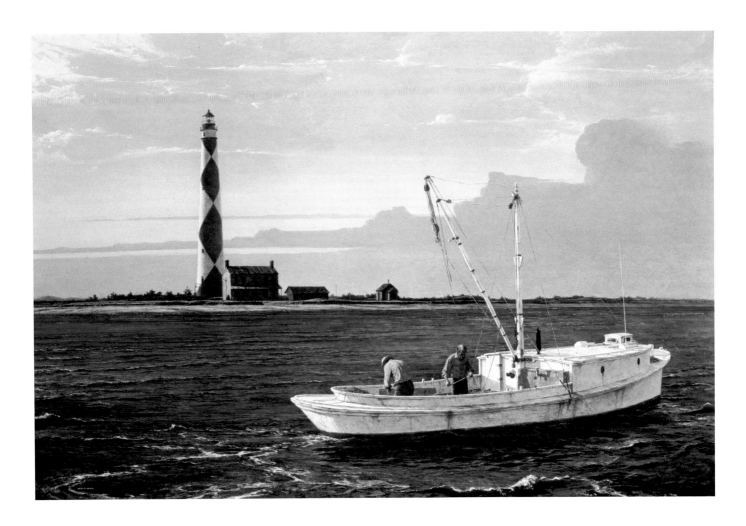

answering questions not only about his paintings—there's a finely detailed painting of a set of breaking waves at Atlantic Beach recently begun on his easel—but about the many, many other artifacts, bits of nature, and things he's made by hand that crowd the space, each of them a physical representation of his lifelong fascination with nature, animals, boats, and music.

There are the models he makes to paint from, like a small Maine lobster boat, and the birds he paints and even flies, including a radio controlled, full-scale red-tailed hawk. There's the ukulele he's making by hand (arthritis in his left hand has made it hard for him to play chords these days, so he "thought it would be interesting to try lutherie"). There are the pieces of nature he's brought inside to replicate, including an extraordinary collection of feathers.

"I love birds," he says. "I wish I could fly." He holds a little lifelike hummingbird he carved by hand. "I would sit outside in the yard with a flower in my mouth, leaning up against the house, hold this [little hummingbird], and wait, and wait, and wait to see if a hummingbird would come and try to get honey out of the flower in my mouth. I'll tell you: artists are crazy."

Born in Tokyo in 1934, the son of an American tobacco executive, Dance says that he soaked up the artistic sensibility of the Japanese from an early age.

FACING
Robert Dance in his
Kinston home studio.

ABOVE
Cape Lookout Morning, by
Robert Dance. Courtesy
of Robert Dance.

"The first thing I ever painted was a watercolor of an iris when I was six years old," he says, "and I've been painting ever since." He would go on to study illustration, creating woodcuts for *Playboy* magazine, and working as an illustrator and designer for books and companies that ranged from furniture makers to General Electric and Wachovia Bank.

A great admirer of the painters Thomas Eakins and Andrew Wyeth, Dance found his life's true calling when he began to paint the natural world. It's no small feat to begin a new work: He immerses himself fully, taking months at a time to perfect each canvas, putting himself fully into the painting, feeling the wind, or the shade of the passing cloud, or the nervous-making swell of a wave, hearing the birdsong, smelling the brine.

"Nothing is more vital or interesting than nature," he says. At eighty-six, his enthusiasm only grows. "I have a childlike curiosity, still. I constantly learn." ∎

JACK SAYLOR

ATLANTIC BEACH

Every evening, Jack Saylor walks a couple of blocks from his airy studio to the wide sands of Atlantic Beach. There, he sets up his easel to paint the sunset. He's making studies, mostly, sketches of the sea, of the sky, of the light. It's "a means to an end," a way to "inform the environment for my still life work in the studio." Unless he's outdoors, painting the world around him, he says, he misses out on "the breeze, the magic, the whole spectrum of the color of the sky when the sun finally sets."

Known widely for meticulous, photo-realistic landscapes and seascapes of the North Carolina coast, Saylor has recently shifted his focus to still life, but his passion for the sea, for the play of light and color, and for the expansive natural world continues to fuel his work. Back in the studio, when he zeroes in on the velvety petals of a rose, a single reflective drop of water on a curl of lemon rind, or the transparency of a leaf, he's channeling that energy. He's also tapping into techniques he learned as a young man in Spain and Italy, where he studied the works of Italian Renaissance painters and those of the Dutch seventeenth century. Those painters' ability to harness light and dimension, to refine detail and honor beauty, made a lasting impression. And so as Saylor paints, his brushstrokes disappear, the two-dimensionality of his canvas disappears, color, light and shadow dominate, and everything but his subject falls away.

Jack Saylor painting the afternoon sun on Atlantic Beach.

Ode to Victory,
Grace and Glory,
by Jack Saylor,
2021. 24 × 28 in.
Oil on canvas.
Photograph by
Scott Taylor.

Doing this kind of work in the home state he loves was his ultimate goal as a young Barton College graduate from Wilson, North Carolina, traveling through Europe as a product designer for Sarreid, a US importer. Working with artists and craftsmen and learning as he went, Saylor longed to put it all to use closer to home.

Moving back to the North Carolina coast, he saw the ocean and coast with new eyes and abilities, and made his name depicting it. In 2007, when the state of North Carolina sought a still life painter to depict artifacts recovered from the shipwreck thought to be the pirate Blackbeard's *Queen Anne's Revenge* as part of its QAR Shipwreck Project, it was the ultimate opportunity. Saylor filled a large canvas with the pirate's flag, cannon, cannon balls, and other objects. *Under the Black Flag* is hyperreal and historically accurate but manages to hint at the pirate's mendacious legacy.

The shift from the kinetic world outside to the still life within represents a natural progression. He recalls a critic early on describing his landscapes as similar to still lifes. "It got me thinking: That is how I approach things. I wasn't necessarily an atmospheric painter," or one focused on perspective or depth of field. Instead, "I went in and painted this tree, that tree, this tree—individually. And that's the way you approach a still life. They're objects. A gathering of objects." His seascapes were the same: "That wave. . . . And then the foam. And then the next one. And the next one. As if it were a still life. It's the way it works for me, for what I'm after." ∎

ANN CONNER

WILMINGTON

Bright colors, sharp shapes, and irregular, organic material combine to make Ann Conner's woodcut prints unmistakable. Look at me, her work commands, enjoy me. Then try to figure me out.

Large-scale and distinctive, her art may appear simple from a distance, but reveals its rigor and complexity as a viewer approaches. The wood grain of these pieces is swirling, unpredictable, "seductive," as she says; so is its marriage with her opaque, precision marks, her saturated, man-made hues.

These pieces have pride of place on the walls of the Ackland Museum in Chapel Hill, the Cameron in Wilmington, and the North Carolina Museum of Art in Raleigh. They're also in more than fifty other major museum and corporate collections across the country.

Originally a painter focused on portraiture and the natural world—Conner earned an MFA in painting at UNC–Chapel Hill and taught studio art at UNC Wilmington, serving as department chair—Conner says she became "disenchanted with reality" after a number of years and decided to focus her imagination on abstraction. She was inspired to explore it through woodcut prints after becoming fascinated by the antique Japanese woodcuts of Kabuki actors on her mother's wall.

Woodblock printing, Conner points out, is the oldest form of printmaking. She carves her blocks here, four or five days a week, in a contemporary sunsoaked Wilmington studio, using oak and other woods like walnut, elm, cherry, or birch and a hightech Japanese-made Automach power chisel. Before

Ann Conner with two of her woodcut prints in her Wilmington studio.

she carves, Conner does extensive drawings with a technical pen called a Rapidograph, designed for engineers and architects to produce sharp, consistent lines. She also uses templates to delineate some of her shapes. The carving itself is tiring work, best completed no more than a few hours at a stretch. An air mattress and sleeping bag in the back allow her to grab a quick nap before picking up her chisel again.

"If I had another aspiration, it would be to be a sculptor." Her prints, she points out, "are very sculptural. That's kind of where I'm coming from." But she's not interested in stepping away from her current work to do it: "It's just the wood cut. I'm just so into it."

"There's no hidden meaning," she says of the stars, flowers, loops, and swirls that fill her picture planes. "They are just pure abstractions." She finds her templates in unlikely places like Lowe's or Williams Sonoma, where she picks up cookie cutters and other objects. She knows she's got a good one when they "just click."

Then Conner takes pains to match these designs and shapes to the particular grain of wood before her. But most important is color. "Color is paramount," she says. "Certain colors don't go with certain designs."

Once she's completed her carvings—a process that can take a few months—she sends them to a specialty printer in Austin, Texas. She travels there to meet her work and then begins the proofing process, experimenting with colors. The hand-printing process itself is laborious and time consuming, sometimes taking two to three people working together to complete.

And then she's back to her studio and to the inspiration that comes to her not through the beautiful coastal scenery outside her door, or through music, or current events, or her own interior thoughts, but through the work itself.

"It's concentration. I feel like you have to generate your own inspiration, through materials, materiality, and that goes for colors, and ink and wood. I think materiality is something I have come to appreciate from the minimalists: Donald Judd, Joel Shapiro. The materiality of what you're working with is important." ∎

AFTERWORD

Before I began this book, I knew there was a great story to tell about the visual art of North Carolina. As a journalist, I had written, assigned, and edited countless feature stories about the artists of the Triangle. I was amazed by the depth of their talent and the ecosystem that supported them, knew their numbers reached across the state, and couldn't wait to start reporting.

But when I did, I quickly learned that what I'd glimpsed was only the shimmering surface of a much deeper ocean. This story was bigger, more diverse, and more relevant than I'd imagined. It had a complex history, was populated with fascinating characters, and illustrated something important about our state, about its pride, creativity, and ingenuity, its self-awareness, and its ability to manifest what it valued most.

I couldn't believe my luck. A huge story lay before me, one that had been told in bits and pieces but never comprehensively, a story about North Carolina's visual art of all kinds, all mediums, and all messages. A representative sample of the extraordinary diversity of art and artists who live and work in North Carolina. How and where and why was all of this art happening here? When did it all start? Who was making it, and what they were making?

I knew the book had to have excellent original photography and was delighted when the talented Lissa Gotwals agreed to photograph the artists and collectors for the project. I also knew that the photography wouldn't be possible without meaningful philanthropic support. I was honored and immensely grateful when the Lewis R. Holding Fund agreed to become the book's presenting sponsor. I was also thrilled when the North Carolina Community Foundation, the Thomas S. Kenan III Foundation, the Mary Duke Biddle Foundation, the A. J. Fletcher Foundation, First Citizens Bank, the Josephus Daniels Charitable Fund, and patron of the arts Jim Romano agreed to become supporting sponsors.

And then COVID hit.

How was I going to interview artists? Not to mention curators, collectors, museum directors, gallerists? How was Lissa going to photograph them? As with many aspects of the pandemic, this forced pause had a silver lining, though that wasn't immediately apparent.

I knew I had to find a different way to work. Because I didn't have the luxury of connecting the dots of this story over an extended period of time, in-person interview by in-person interview, I had to hone my focus at the outset and conduct my initial interviews over the phone—something I usually avoid, as face-to-face conversations can be so much more nuanced, informative, and engaging.

As it turned out, these many initial telephone interviews were a godsend. When it came time to speak in person, I had compiled a far more comprehensive understanding of the statewide community of art than I otherwise would have.

That understanding was the culmination of more than 200 interviews with artists, gallerists, curators, collectors, art entrepreneurs, and museum professionals across our wide state. These generous people told me everything that books could not. How was art being made here today, and who was making it? Every person had a valuable perspective on who, and what, and how. How did it all evolve? Many had seen it happen firsthand. Whom else should I speak with? The list grew, and grew, and grew.

When the strictest COVID lockdowns had begun to lift and Lissa and I started traveling the state to visit artist studios, continuing precautions made it practical for my in-person follow-up interviews to take place at the same time as Lissa's photo shoots. I think we were both surprised at how enriching this turned out to be.

"Due to COVID, there was much more double-duty work to do," Lissa says. "I really enjoyed toggling back and forth between the photos and the interviews. Often, I am not fortunate enough to have so much understanding and information about the people I get to photograph. It both helped inform some of my choices photographically and made for a more fulfilling experience all around."

The same was true for my reporting. As we together explored studios with artists, moved things around to set up for photographs, and chatted informally before any actual interviewing took place, I was able to learn more about each artist as a human being than I would have in a typical sit-down format.

As our work drew to a close, Lissa and I were both wistful—it has been an extraordinary, meaningful adventure—and we were also determined. Determined to keep telling stories about art and artists, determined to keep shining a spotlight on the extraordinary people making North Carolina one of the most dynamic, creative, and exciting places there is.

ACKNOWLEDGMENTS

This book would not have been possible without the generosity of countless kind, thoughtful, and knowledgeable people in every corner of our state. In true North Carolina fashion, these artists, curators, collectors, museum directors, gallerists, and civic leaders opened their doors and invited me into their homes and offices and museums and galleries and studios; they drove me around their cities and towns and regions and showed me their art; they endured my COVID-era requests for Zoom interviews and long phone calls; they let me ask them far too many questions. Most of all, they trusted me with their stories.

When the time came to photograph the artists and collectors among them, these wonderful people welcomed the talented photographer Lissa Gotwals in, too, and let us take over their entire mornings and afternoons with photo shoots and more interviews. In every encounter was the sense, spoken and felt, that the endeavor was meaningful because the art of North Carolina needs to be known and acknowledged, that it is important culturally, economically, and spiritually, and that it deserves celebration.

That same understanding was shared by the generous donors who believed in this project from the beginning. Their contributions underwrote Lissa Gotwals's photographs and helped these stories come alive. These donors include the book's lead sponsor, the Lewis R. Holding Fund, as well as a remarkable group of supporting sponsors including the North Carolina Community Foundation, the Thomas S. Kenan III Foundation, the Mary Duke Biddle Foundation, the A. J. Fletcher Foundation, First Citizens Bank, the Josephus Daniels Charitable Fund, and patron of the arts Jim Romano. I am greatly honored by their support and deeply grateful to each of them for providing it.

I am also grateful to the following people for their kindness, time, expertise, and support in the course of reporting and writing this book: Carmen Ames, Mia Hall, Libba Evans, Frank and Julia Daniels, Peter Bristow, Jim Goodmon, Mimi O'Brien, Damon Circosta, Thomas S. Kenan III, Jennifer Tolle Whiteside, Pamela Myers, Allison Perkins, Stephen and Erin McDonald, Andrew and Harper McDonald, Becca Roberts and Dan Hartman, Steve Roberts, Marjorie Hodges, Allen Thomas Jr., Chandra Johnson, Valerie Hillings, Linda Dougherty, Kristin Replogle, Beth Moye, Van Nolintha, Orage Quarles III, Joyce Fitzpatrick, Joel Fleishman, David Woronoff, Henry and Betty Lou Walston, Johnny Burleson, David Brody, Marion Church, the late Joe Rowand, Melissa Peden, Carole Anders, Jo Cresimore, Renee Snyderman, Mina Levin, and the Watauga Club.

Thanks also to the late Ola Maie Foushee (1931–1999) for her independently published 1972 book, *Art in North Carolina: Episodes and Developments, 1585-1970*, which provided important historical context. So did *Two Hundred Years of the Visual Arts in North Carolina*, a 1976 publication of the North Carolina Museum of Art.

A huge thank you also to my editor, Lucas Church, for championing and shepherding this book from concept and proposal to manuscript and completion, and to my smart, capable, and enthusiastic research assistant Tennessee Woodiel for making sure the details didn't get lost in the shuffle.

When Lindsay Starr became art director of UNC Press just in time to design this book, I knew that she was great at what she did and that I was lucky. Now that I know she is also patient, kind, and not just good at what she does but beautifully talented, lucky seems a paltry word. Thank you, Lindsay.

Of course I knew I was lucky when Lissa Gotwals agreed to be the photographer for this book. We had worked on many stories together at *Walter* magazine, and I considered her the most talented photojournalist I knew, particularly adept at capturing creative people in their environments. The results are more beautiful than I could have imagined, and it was wonderful to become such great traveling companions, friends, and collaborators. Thank you, Lissa.

I would also especially like to thank Lawrence J. Wheeler for sharing his extensive knowledge, for his unflagging support, and for his generous friendship, all of which are exhibited most recently in the foreword of this book. Thank you so much, Larry.

I would like to thank my parents, Judith and Stephen McDonald, for exposing me to art from a very young age, for showing me the power of curiosity, for encouraging me to follow my instincts, and for believing in me. Thanks also to my children, Regan, Hale, and Cecilia Roberts, for their sustained and ardent enthusiasm and curiosity about this book. I can only hope that they feel as supported, loved, and encouraged by their parents as I have always felt by mine. And finally, I would like to thank my husband, Lee, for making sure all of that is true for our children, and for always doing the same thing for me.

INDEX